THE REAL GHOSTBUSTERS

A Visual History

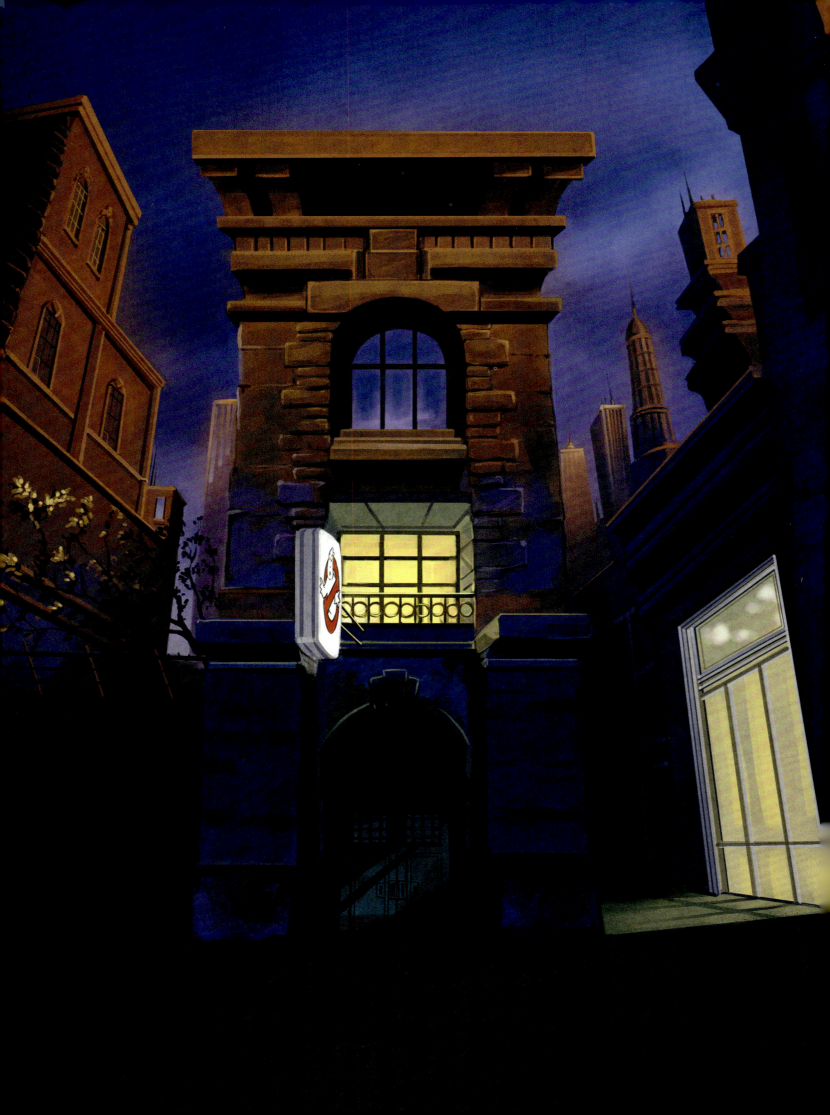

THE REAL GHOSTBUSTERS™

A Visual History

By
Troy Benjamin &
Craig Goldberg

Dark Horse Books

In Memory of Those Who Made *The Real Ghostbusters* What It Was:

Ivan Reitman
Harold Ramis
Michael C. Gross
Herman Rush
Chuck Menville
Lorenzo Music
Lester Borden
Mark Boudreaux

Hampton Woodhouse
Larry DiTillio
Michael Edens
Michael Reaves
Everett Peck
Dave Rodriguez
Philip Felix
Buster Jones

Gordon Bressack
Jim McDermott
Jim O'Brien
Carl Anderson
William Barry
Carol Guthrie

And to all those not listed . . . we'll see you all on the other side.

President & Publisher **Mike Richardson**

Editor **Ian Tucker**

Assistant Editors **Jennifer Wurtele, Anastacia Ferry**

Designers **David Nestelle, Skyler Weissenfluh**

Digital Art Technicians **Betsy Howitt, Chris Horn**

Prepress Technician **Rikki Midnight**

The Real Ghostbusters: A Visual History
TM & © 2025 CPII Holdings, Inc. All Rights Reserved. Dark Horse Books® and the Dark Horse logo are registered trademarks of Dark Horse Comics LLC, registered in various categories and countries. All rights reserved. Dark Horse is part of Embracer Group. No portion of this publication may be reproduced or transmitted, in any form or by any means, without the express written permission of Dark Horse Comics LLC. Names, characters, places, and incidents featured in this publication either are the product of the author's imagination or are used fictitiously. Any resemblance to actual persons (living or dead), events, institutions, or locales, without satiric intent, is coincidental.

Published by Dark Horse Books
A division of Dark Horse Comics LLC
10956 SE Main Street
Milwaukie, OR 97222

Represented in the EU by Authorised Rep Compliance Ltd.
Ground Floor, 71 Lower Baggot Street
Dublin, D02 P593, Ireland

ARCCompliance.com
DarkHorse.com

First edition: July 2025
Ebook ISBN 978-1-50675-005-7
Hardcover ISBN 978-1-50674-927-3
Deluxe Edition ISBN 978-1-50674-928-0

10 9 8 7 6 5 4 3 2 1
Printed in China

Library of Congress Cataloging-in-Publication Data

Names: Benjamin, Troy, author. | Goldberg, Craig, author.
Title: The Real Ghostbusters : a visual history / by Troy Benjamin & Craig Goldberg.
Description: First edition. | Milwaukie, OR : Dark Horse Books, 2025.
Identifiers: LCCN 2024047081 (print) | LCCN 2024047082 (ebook) | ISBN 9781506749273 (hardcover) | ISBN 9781506750057 (ebook)
Subjects: LCSH: Real ghostbusters (Television program)
Classification: LCC PN1992.77.R4 B46 (print) | LCC PN1992.77.R4 (ebook) | DDC 791.45/72--dc23/eng/20241007
LC record available at https://lccn.loc.gov/2024047081
LC ebook record available at https://lccn.loc.gov/2024047082

Table of Contents

Foreword by Joe Medjuck 7

Introduction 9

A Brief Timeline of *The Real Ghostbusters* 10

Chapter 1: Manifestation 14

Chapter 2: Heroes, Ghouls, and Marshmallow Men 74

Chapter 3: Tools for the Talent 108

Chapter 4: The Franchise Rights Alone: Toys, Merchandise, and the Rise of Ecto Cooler 126

Chapter 5: Sequels and Spinoffs 218

Chapter 6: Total Protonic Reversal 232

Acknowledgments and Contributors 248

Industry magazine advertisement differentiating the series from a very specific competitor.

Foreword by Joe Medjuck

I've just finished reading the book you're about to begin. I may be biased, but I think it's terrific. The authors have done an extraordinary amount of research: watching the shows, tracking down people for interviews, and digging through old files that I thought had been discarded years ago.

It's full of information that I never knew, things I barely remember, and things I misremember. (For example, in one of my interviews, I talk about Andy Heyward's reactions at the infamous Q5 meeting. But an interview with Robby London makes it clear that Andy wasn't there, and we didn't talk until Robby had reported back to him after the meeting ended.)

Page 4 of this book took me aback: a list of more than twenty people who contributed to the show and have since died. I worked closely with some of them, others I never met, but all gave a bit of themselves to *The Real Ghostbusters*. The first three names on the list hit me the hardest. I'd known Ivan since he was a student filmmaker. He brought me to LA, where I met Harold and Mike while working on *Stripes* and *Heavy Metal*. Then we all went to work on *Ghostbusters*. I miss them. And I wish they were here to see this book.

It's been nearly thirty-five years since the last episode of *The Real Ghostbusters* was completed. Eventually, more of us will be added to that list of those who have died. But the 140 episodes of *The Real Ghostbusters* and 33 of *Slimer!* remain. They've been shown on network, syndicated, cable, and streaming TV; you could buy them on VHS, DVD, or as downloads. I like to think that whenever a new medium appears, you'll be able to use it to enjoy the adventures and misadventures of Ray, Peter, Egon, Winston, Janine, and—of course—Slimer. After all, ghosts can never die, and there will always be a job waiting for the Real Ghostbusters.

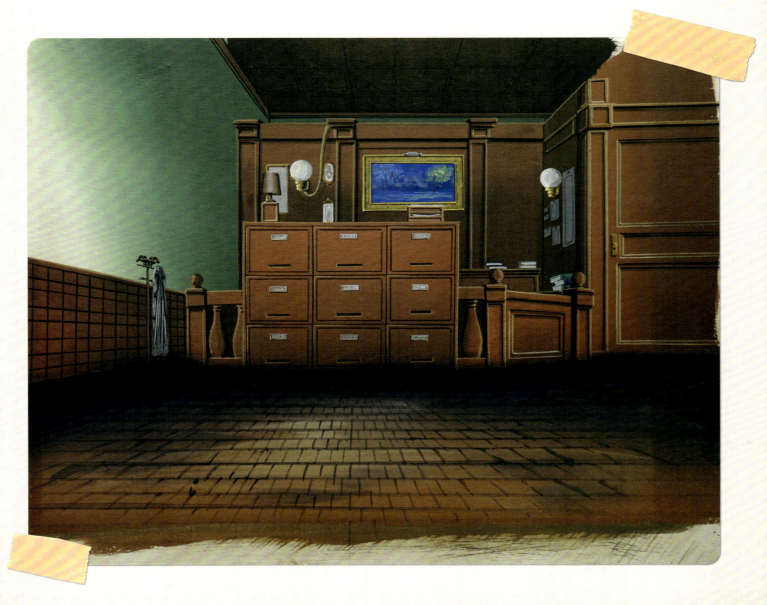

Introduction

The 1984 classic *Ghostbusters* introduced the world to Peter Venkman, Ray Stantz, Egon Spengler, Winston Zeddemore, the Ecto-1, Proton Packs, PKE Meters, the Stay Puft Marshmallow Man, and Slimer. Two years later, the reach of *Ghostbusters* was so expansive, a kid woke up in their *Ghostbusters*-themed sheets, nestled in an Ectomobile-shaped bed, ate *Ghostbusters*-shaped cereal for breakfast, listened to the *Ghostbusters* soundtrack on the bus, wore a *Ghostbusters* T-shirt with Stay Puft shoelace stoppers, then after school ran around with a Kenner Proton Pack strapped on their back or played a *Ghostbusters* video game, then rinsed and repeated. One could eat, sleep, and breathe *Ghostbusters*. There was one catch: most, if not all, of those interactions were based on an animated spinoff, not the 1984 film itself.

It was a curious phenomenon. For many young kids around the world, particularly those ages eight and younger, the only iteration of those iconic elements introduced in the popular live-action film was the animated *The Real Ghostbusters*. In fact, that's how one of the authors of this book was introduced to *Ghostbusters.* Having not yet been ready to see the film, Troy didn't see it until it aired on broadcast TV as a Sunday night movie—over two years after *The Real Ghostbusters* debuted in 1986. But, as this book will reveal, that was the plan all along. The creative team behind *Ghostbusters* unexpectedly captured the imaginations of young kids. To keep the property in the zeitgeist, particularly when a sequel to the film faced delays and would ultimately be five years away, and to feed a merchandising machine that didn't exist at the time of the original film's release, *The Real Ghostbusters* was a necessity. And it would become far more than an engine to sell toys and breakfast cereal.

The Real Ghostbusters was acclaimed for its mature storytelling, fantastical animation, and a voice cast that became as synonymous with the characters as the live-action actors who originated them. A simultaneous toy launch by juggernaut Kenner breathed ectoplasmic action figure life into the property. Through *The Real Ghostbusters*, Kenner created the most memorable, most beloved, weirdest, and best-selling toys in popular culture. Kids were running around on playgrounds, zapping and trapping ghosts with their own role-playing Proton Packs and Ghost Traps while also using action figure versions of the Boys in Gray to defeat strange ghosts like Tombstone Tackle and Granny Gross.

The Real Ghostbusters: A Visual History is the ultimate collector's dream. Its humble authors were also guilty of being those kids running around on the playground pretending to circumnavigate an Ecto-Containment Unit meltdown by overloading the Proton Packs and fleeing in the Ecto-2. It has been our pleasure to research and analyze this beloved cornerstone of the franchise. Most importantly, we consider ourselves fortunate to have spoken with the creative minds behind the show and the toy designers who made the show popular beyond the screen for their first-person perspectives. Sometimes stories differed or contradicted each other. Perspectives and points of view provided different takes on certain events. Several key figures became our resolute sounding boards to find the space between and tell the entire story.

Enormous thanks and gratitude to our interviewees, cast and crew contributors, and those whose firsthand accounts were invaluable to the creation of this book, including (in alphabetical order): Kevin Altieri, Duncan Billing, Winnie Chaffee, Kathryn Drennan, Ken Duer, James Eatock, Tim Effler, James Gallego, Marsha Goodman, Diane Haithman, Terry Healy, Andy Heyward, Pamela Hickey, Marian Ihlenfeldt, Joe Indelli, Gil Kenan, Robby London, Dennys McCoy, Joe Medjuck, Harry Moore, Richard Mueller, Tom Osborne, Ray Parker Jr., Gabi Payn, Jerry Perez, Steve Perry, Brad Rader, Richard Raynis, Eric Reich, Jason Reitman, Dan Riba, Rick Rosen, Herman Rush, Violet Ramis Stiel, J. Michael Straczynski, Laura Summer, James Van Hise, Art Vitello, Bruce Zick, and Ed Zobrist.

A Brief Timeline of *The Real Ghostbusters*

June 1984: *Ghostbusters* is released in theaters.

July 1984: The pilot script of *Filmation's Ghostbusters* is completed, and the show is already well into preproduction.

March 27, 1985: Parent company General Mills announces it is spinning off Kenner Products, Parker Brothers, and Fundimensions into a newly formed company.

August 1985: *Variety* magazine reports that Columbia Pictures Television is working on an animated series based on the popular *Ghostbusters* film.

Fall 1985: Richard Raynis, Kevin Altieri, Eddie Fitzgerald, Gabi Payn, and others begin their work on the animated *Real Ghostbusters* promo pilot.

January 1986: Columbia licenses thirteen episodes of an animated *Ghostbusters* series to ABC. Meanwhile, Herman Rush and his team at Columbia Pictures Television sell sixty-five additional episodes of *The Real Ghostbusters* in syndication at NATPE.

February 1986: *The Real Ghostbusters* is sold into syndication to 76 percent of the country.

August 17, 1986: *The Real Ghostbusters* is announced to the general public during the ABC Sunday night movie.

September 13, 1986: First ABC episode, "Ghosts R Us," airs on Saturday morning.

October 1986: Consulting firm Q5 is brought in by ABC to advise on the next batch of episodes. Robby London joins the show; his first day of work is a tense meeting with the filmmakers, ABC, and Q5.

January 1987: First seventy-eight episodes finished; work begins on the next round of season 2 episodes. The first Kenner Real Ghostbusters products hit store shelves.

January 20, 1987: Andy Heyward teams with an investment firm and purchases 85 percent of DIC.

February 25, 1987: Second-season bible finalized by Len Janson and Chuck Menville.

May 1987: Sound recording for season 2 begins.

May 1987: ABC announces that it's fine-tuning the Saturday morning lineup, and *The Real Ghostbusters* moves to the 10:30 a.m. slot.

Saturday morning lineup for 1987.

June 1987: Rick Rosen leaves Columbia Pictures Television and joins DIC as VP of production, development, and sales.

September 4, 1987: Tonka and Kenner merge in a $612 million deal, making them the third-largest toy company, behind Mattel and Hasbro.

September 14, 1987: First syndicated episode airs, "Janine's Day Off." According to *Broadcasting* magazine's First-Run Syndication scorecard, 112 markets, covering 82 percent of the United States, carried *The Real Ghostbusters* at that time.

September 24, 1987: ABC airs *Ghostbusters* as its Thursday night movie.

October 26, 1987: Columbia Television publishes an ad in *Broadcasting* magazine touting household ratings increases for *The Real Ghostbusters* over the past year, including Seattle being 430 percent higher than the previous year.

November 1987: *The Real Ghostbusters* enjoys a 9.1 share rating among kids aged two through eleven—second only to *DuckTales*, which carried a 12.5 share.

A Brief Timeline of The Real Ghostbusters

Left: *The newly formed Coca-Cola Telecommunications highlights the show's ratings bump from the previous year.* Right: *Saturday morning circa 1988.*

December 1987: *Slimer* show development hits full swing. The first series bible for *The Slimer Show* is finished. Initial premises are submitted to ABC for a *Real Ghostbusters* primetime special.

February 1988: *The Real Ghostbusters* is the third-ranked show among children with a 13.5 share, once again trailing *DuckTales* (with a 15.5 rating), and *Double Dare* (15.4).

March 7, 1988: A series bible for the third season is submitted by Len and Chuck. The cover page ironically says, "There is no wish this year to fix what ain't broken." But the pages then proceed to detail severe changes to the show, including totally revamping Janine and introducing the Junior Ghostbusters.

March 9, 1988: After it had been selling the series' barter time, ad sales company LBS acquires the distribution rights from Coca-Cola.

May 9, 1988: ABC announces its new Saturday morning lineup, which expands the show now christened *Slimer! And the Real Ghostbusters* to an hourlong program and moves it to 9:30 a.m., opposite *Garfield and Friends* and *The Karate Kid* on rival networks.

September 10, 1988: First episode of *Slimer! And the Real Ghostbusters* airs.

September 17, 1988: First episode of season 3 of *The Real Ghostbusters* airs with "Flip Side."

December 5, 1988: CBN announces that it's signed a deal with DIC Enterprises to carry their programming, thus adding *The Real Ghostbusters* to the Family Channel.

February 3, 1989: Group W sells Filmation and closes the doors to their Woodland Hills office.

April 8, 1989: Last new episode of *Slimer! And the Real Ghostbusters* airs.

June 16, 1989: *Ghostbusters II* is released in theaters.

8	▼	19.7/34	N	Golden Girls	34	▼	14.2/22	C	Major Dad	62		9.8/17	C	Island Son
9	▲	19.6/33	A	Monday Night Football	35	▼	14.1/22	N	Hogan Family	62		9.8/18	N	Mancuso, F.B.I.
10	■	19.2/29	N	In the Heat of the Night	36	▼	13.5/21	C	Designing Women	62		9.8/18	C	Paradise
11	▼	18.8/33	N	Empty Nest	37	▼	13.3/22	A	Anything But Love	66		9.3/15	C	Top of the Hill
12		18.7/29	N	NBC Monday Movie	38	▲	13.2/20	F	Married...With Children	67	▲	9.1/15	A	Mission: Impossible
13		18.6/30	A	Who's the Boss?	39	▲	13.0/20	N	My Two Dads	67	▼	9.1/16	N	PrimeTime Live
14	▼	18.5/34	C	CBS Sunday Movie	40		12.9/24	A	China Beach	69		8.9/15	C	Bugs Bunny Howl-Oween
15		18.1/31	N	Tonight Show 27th Anniversary	41	▼	12.8/23	N	Amen	69		8.9/15	A	Free Spirit
16	▲	17.8/30	N	Unsolved Mysteries	42		12.6/19	C	Newhart, special	71		8.8/18	A	World Series, pregame
17		17.5/32	A	World Series, Game 3	43	▼	12.2/18	C	Famous Teddy Z	72	▲	8.0/15	C	Sat. Night with Connie Chung
18		16.6/25	A	Chicken Soup	44	▼	12.1/19	N	Sister Kate	73	▼	7.8/13	F	Open House
19	▼	16.4/28	N	Growing Pains	44		12.1/22	C	Wiseguy	74		7.6/12	A	Slimer-Ghostbusters Halloween
19	▲	16.4/25	N	Matlock	46	▼	11.3/18	C	Nutt House	75	▼	7.5/13	C	Tour of Duty
21	▼	16.2/30	N	Hunter	46	▲	11.3/18	C	Rescue: 911	76		6.8/10	C	Wolf
22	▼	15.8/26	A	Head of the Class	48	▼	11.0/19	C	Newhart	77	▼	6.2/10	F	Booker
23		15.4/25	A	Doogie Howser, M.D.	48	▲	11.0/18	A	Young Riders	78	▼	5.6/9	F	21 Jump Street
23		15.4/25	N	Night Court	50		10.9/20	A	Baywatch	79	▼	5.5/10	F	Cops
25		15.3/25	C	Jake and the Fatman	50	▲	10.9/18	C	MacGyver	80	▲	5.1/9	F	Tracey Ullman Show

The primetime special cracks the top ratings in 1989.

October 4, 1989: Andy Heyward sends a memo to Ivan Reitman, Michael C. Gross, and Joe Medjuck talking about being troubled by problems of late and expressing "disappointment that you would consider having anyone else produce your show." He sends Winnie Chaffee, Mel Woods, and Will Meugniot to Japan to get the animation studio KKC&D in order and begin transitioning the show to Toei.

October 9, 1989: The *Real Ghostbusters* hour block on Saturday morning continues to win both of its half-hour slots with ABC claiming the top Saturday morning network stake. Jennie Trias tells *Broadcasting* magazine, "We were as surprised about the 1988-89 season as everyone else, I'd like to think we made the right programming moves, but I don't think you can point to any one thing to explain last year."

October 19, 1989: ABC orders four scripts and storyboards for *Slimer! And the Real Ghostbusters* in order to "be in the position to have material ready to go should we pick up the show for next season."

October 29, 1989: The primetime "The Halloween Door" special airs to a 7.6/12 rating, making it the #74 show for the week of October 23 through October 29—for comparison, the #1 show of that week was *Roseanne* with a 24.9/37 rating.

December 4, 1989: DIC puts pressure on Reitman, Medjuck, and Gross to produce an animated *Real Ghostbusters* feature for release in 1990 or 1991.

February 6, 1990: Len Janson sends an excited memo to Michael and Joe from Thailand relaying that *The Real Ghostbusters* has been picked up for a fifth year. Among the premises he submits are "Spacebusters," "Ghostworld," and "Janine, You've Changed."

March 26, 1990: ABC announces it's moving *Slimer! And the Real Ghostbusters* to the 9:00 to 10:00 a.m. hour block to be followed by *Beetlejuice*. The show now runs opposite *Garfield and Friends*, *Captain N and the Adventures of Super Mario Bros. 3*, *Rick Moranis in Gravedale High*, and newcomer Fox's Saturday morning offerings, *Bobby's World* and *Attack of the Killer Tomatoes*.

May 21, 1990: First draft of the 1991 season, "20,000 Leagues Under the Street," is turned in by Jules Dennis and Richard Mueller.

October 10, 1990: George H. W. Bush withholds signing the Children's Television Act. It becomes law without his signature. With *The Real Ghostbusters* not qualifying as an educational program, it suffers from the networks' shuffling to accommodate the mandates.

January 1, 1991: Hasbro and Tonka/Kenner come to terms on a $516 million acquisition that will be completed on May 7, 1991.

May 13, 1991: *The Real Ghostbusters* is nominated for a Daytime Emmy.

Fall 1991: The hourlong show moves to the 12:00 p.m. time slot on Saturday mornings.

October 5, 1991: Last new episode of *The Real Ghostbusters* airs: "20,000 Leagues Under the Street."

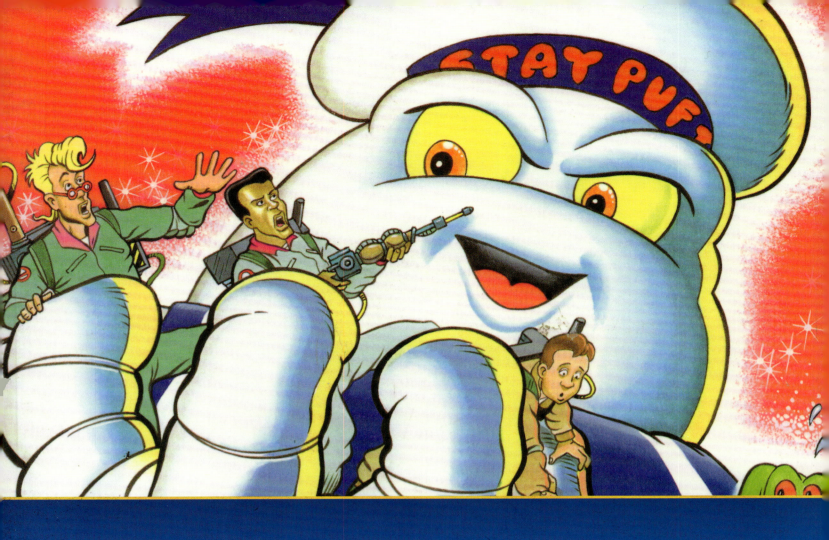

CHAPTER 1: MANIFESTATION

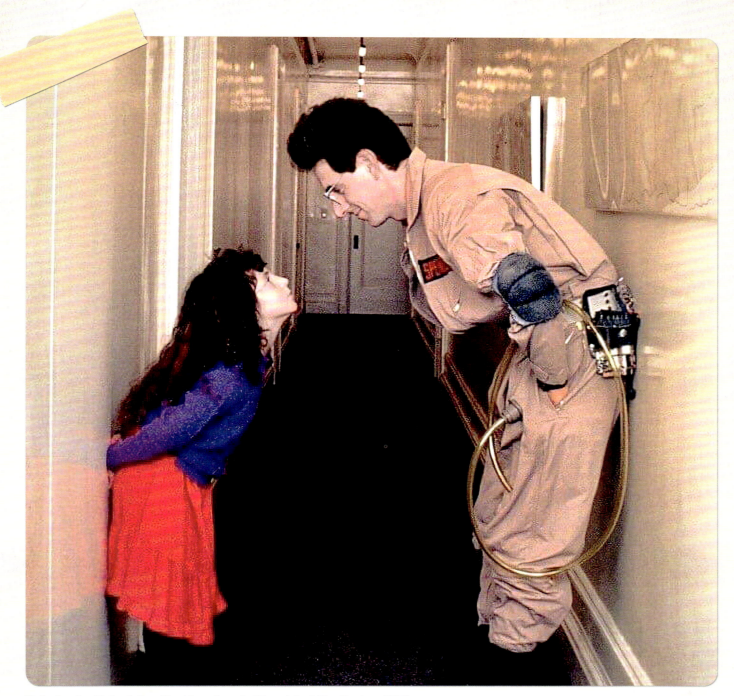

Violet Ramis with her father, Harold, on the set of the original Ghostbusters *(1984).*

Harold Ramis was having second thoughts about his scheme. He had recently wrapped filming on a production that brought traffic at Central Park West to a standstill. The inconvenience drew the ire of New Yorkers—at least until they saw the traffic's cause. A bevy of stars were filming at the location: *Saturday Night Live* icons Bill Murray and Dan Aykroyd joined Ernie Hudson and Ramis himself in front of the cameras. They sported khaki jumpsuits, carried dangerous-looking nuclear backpacks, and arrived in a converted '59 Cadillac Miller-Meteor to riotous cheers from the onlooking crowd. Those who witnessed the scene firsthand knew something special was being created at that moment. Thanks to a top-notch marketing campaign for the film, the same fervor that infected the on-location crowd was spreading like wildfire. The world clamored for even a glimpse of this new high-concept summer comedy. The sage-like being Ramis was, he devised a plan. He brought the then-unreleased film to screen at his daughter Violet's school in California, believing the demand to see it would be a surefire way to raise funds. The crowd of parents and children alike were abuzz as they waited to walk into the show. "It was the first thing my dad had done that anyone around my age cared about," says Violet Ramis Stiel, who was seven years old at the time. "It was a small school, only about sixty total students in the whole class. Everybody was there. It was a big deal." But as Ramis scanned the excited crowd, he had second thoughts, sparked by a sudden realization as he saw the younger set accompanying the adults.

Chapter 1: Manifestation

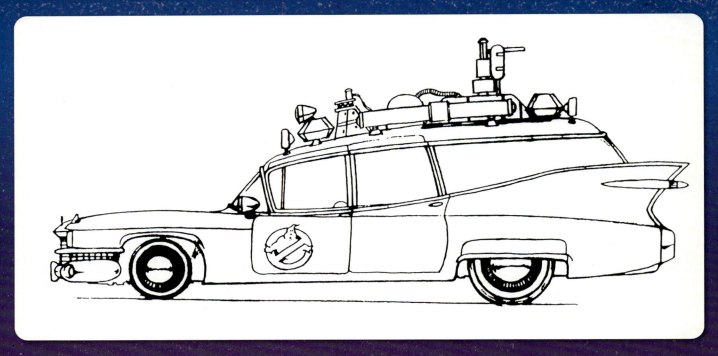

Car enthusiast James Gallego's initial model sheets for the Ecto-1.

"Harold was running around telling all the parents, 'Hey, this may be too scary for your kids,'" says Joe Medjuck, who was an associate producer on the original *Ghostbusters*. The film was peppered with jarring jump scares, macabre creatures, and sharp humor geared toward an older crowd. Simply put, the film was designed for a wider appeal; it hadn't been made with younger audiences in mind.

"His main concern was the library ghost at the beginning of the film," says Ramis Stiel, referring to the moment that Steven Spielberg himself once proclaimed among the best jump scares of all time, where an apparition in the form of a librarian suddenly grotesquely transforms into a horrid creature. Ramis's concern had merit. "Special effects had come so far and the creatures were so realistic; I think he was worried that people would run screaming from the theater right off the bat."

But, to Ramis's great relief, that screening would prove to be the start of a global sensation. Just as they had been on the streets of New York City, the Ghostbusters became rock stars. And, in Dr. Peter Venkman's own words, the kids loved them. "People were not scared; people loved it," says Ramis Stiel. "The next day at school, all the boys were playing Ghostbusters."

"I think we have a tendency to hold on to those first few memories of being scared," says Jason Reitman, son of the director Ivan Reitman. The younger Reitman has been passed the creative torch to oversee the two most recent live-action *Ghostbusters* movies and usher the franchise into a new era, having cowritten and directed *Ghostbusters: Afterlife* (2021) and produced and written *Ghostbusters: Frozen Empire* (2024). "*Ghostbusters* often ends up being one of the first horror films that any child

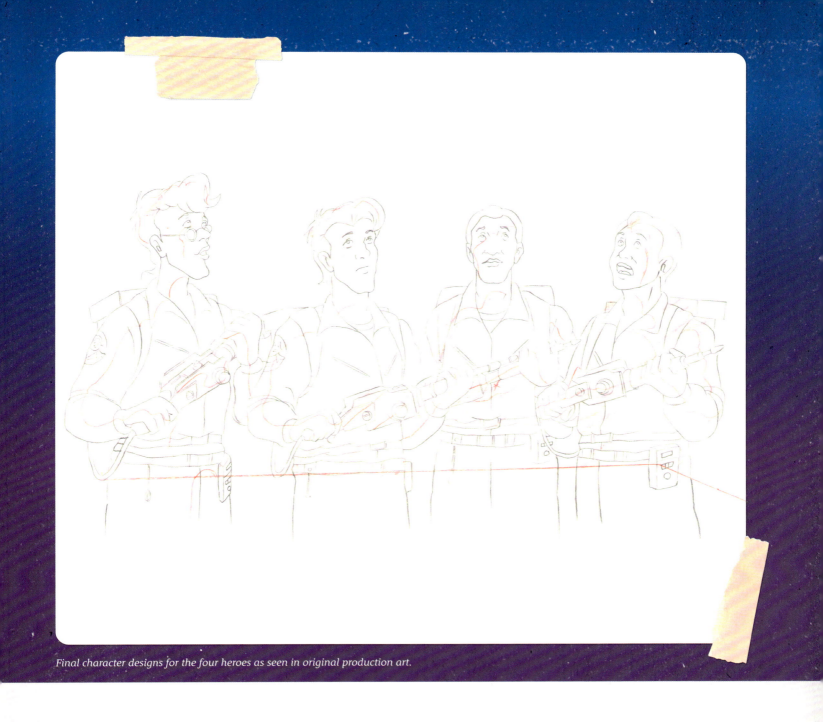

Final character designs for the four heroes as seen in original production art.

ever sees, because it's a hybrid movie. Parents want to see it, so they bring their kids. I think it's the reason why the library ghost scare is so indelible."

Gil Kenan, who cowrote *Ghostbusters: Afterlife* and directed *Ghostbusters: Frozen Empire,* recalls seeing the original film when he was seven years old and was among those who were entranced with the tone and the world that it presented. "I think there's something so primal about being told a ghost story or a scary story," says Kenan. "Going to camp and sitting around a fire and hearing a ghost story is a rite of passage. Whether that accessibility was intentional or not, people saw the film and its characters and this world as an access point to that primal experience. Whatever it was, it was instant. And our generation, and the generations that have come after it, are a testament to the fact that *Ghostbusters* has staying power."

"I probably felt like I loved *Ghostbusters* more than anything on earth at the time," says Jason Reitman. "Which I think is how a lot of people felt. I think a lot of people had a personal connection with it. The crazy thing about going to the movies is that you're in an audience having a collective experience. But particularly as a kid, you're having this one-on-one experience with the screen and the characters. The individual scares you get from the Terror Dogs and the library ghost. The way you fall for the characters and they become your heroes. This was the feeling I had every time I watched the movie as a kid, and I think kids across the country were having the same."

Amid a summer landscape that included *Indiana Jones and the Temple of Doom, Gremlins, Police Academy, The Karate Kid, Footloose, Splash,* and a third *Star Trek* film, *Ghostbusters* skyrocketed. It surpassed $150 million at the

box office in just sixty-six days. *Screen International* claimed that *Ghostbusters* gave Columbia Pictures the four biggest weeks of box-office success in the studio's sixty-year history. It would go on to claim the second-highest box office of the entire year, yielding the top spot only to the iconic adventurer with a fedora and bullwhip. *Ghostbusters* was far beyond successful—it was an otherworldly phenomenon. *Ghostbusters* achieved greater status than a summer high-concept comedy; it ascended to *Star Wars* levels of popularity. It wasn't just a film; it was a *franchise*.

A follow-up sequel was a given. But the commitments of the enormously popular key players meant another *Ghostbusters* film would take an extended period of time to reach theaters. In the 1980s, as now, a franchise remains hot only when it constantly finds a way to capture the attention of consumers ready to open their wallets. If and when that momentum ceases, a franchise risks losing its evergreen appeal. If a sequel was going to take an undefined amount of time, the major stakeholders behind the franchise absolutely had to find a way to keep the engine running until another tent-pole release. Luckily, as Harold Ramis had learned that day at PS1 Elementary School in Santa Monica, *Ghostbusters* found tremendous popularity with kids. It was the younger audience that would be the key to giving the franchise the legs it needed.

Kids latched on to *Ghostbusters*' fantasy of wish fulfillment. Kids daydreamed about becoming Ghostbusters themselves, combating supernatural bumps in the night

> **Kids daydreamed about becoming Ghostbusters themselves, combating supernatural bumps in the night in their imaginations.**

in their imaginations and, unlike some fantastical superheroes, kids didn't have to absorb gamma radiation or be born on the distant planet Krypton—busting ghosts was an achievable fantasy. In fact, *Ghostbusters* had armed a younger generation with the courage to not be afraid of what might lurk in the dark. Parents and teachers embraced *Ghostbusters*, witnessing children on the playground come together to play and achieve goals as one, rather than in competition. Because it wasn't competitive, it also wasn't aggressive or violent. Psychologists published in the *Chicago Tribune* on May 25, 1988, found that kids reenacting and imagining being Ghostbusters was healthful and beneficial to their development. It inspired problem solving and using technology to overcome obstacles, rather than fighting physically to save the day. There weren't a lot of hurt feelings among kids when playing as Ghostbusters. "It gives them a sense of power over their environment," said Althea Huston, a codirector of the Center for Research on the Influence of Television on Children, to the *Tribune*.

"I had just had a son, and on Saturdays he and I would watch cartoons," says Rick Rosen. Rosen, then the vice president of Columbia Pictures Television, had come from cable and home video sales at the studio. He had a natural instinct for tracking down and identifying marketable properties. Sitting there with his son, inspiration struck. "*Ghostbusters* was a fantastic movie. I thought we ought to make it into a cartoon. I approached Herman [Rush] with

Left: *Herman Rush*. Right: *Ivan Reitman*.

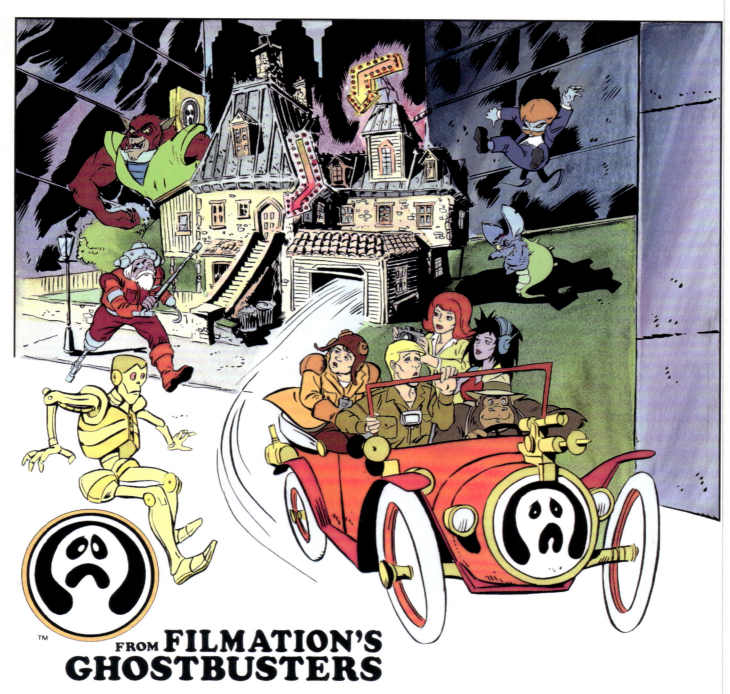

An advertisement for Filmation's Ghostbusters placed in industry trade magazines prior to 1985's NATPE conference.

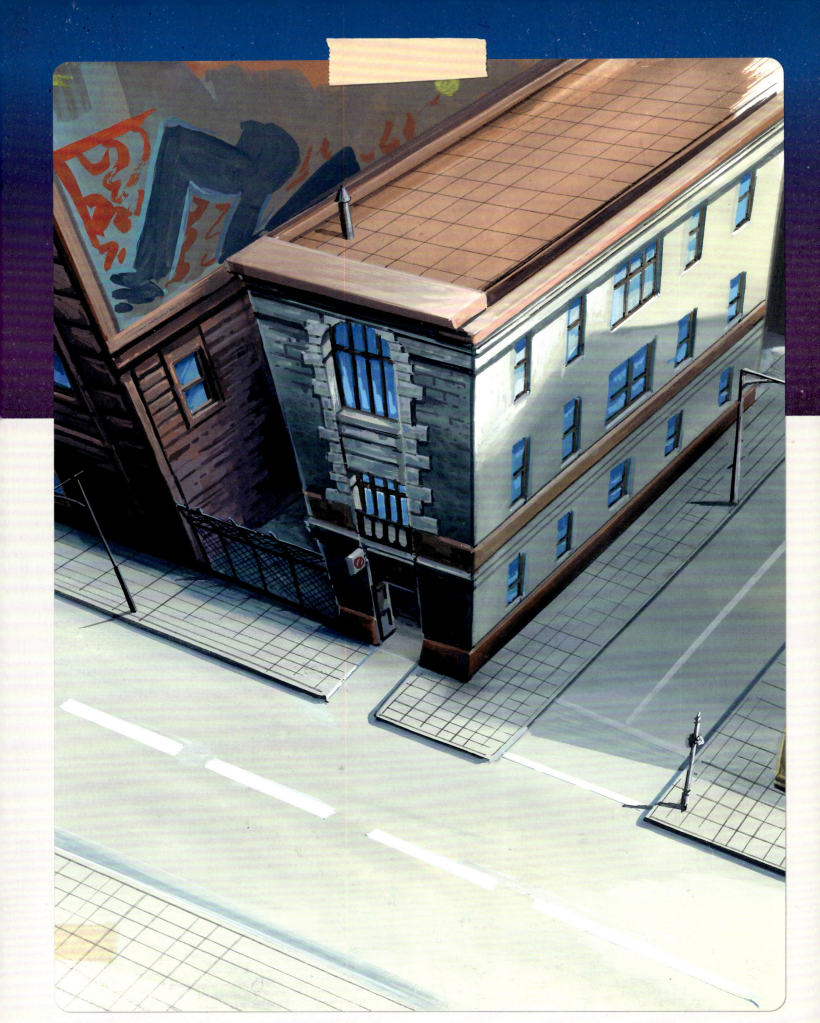
A hand-painted background of the Ghostbusters' firehouse headquarters.

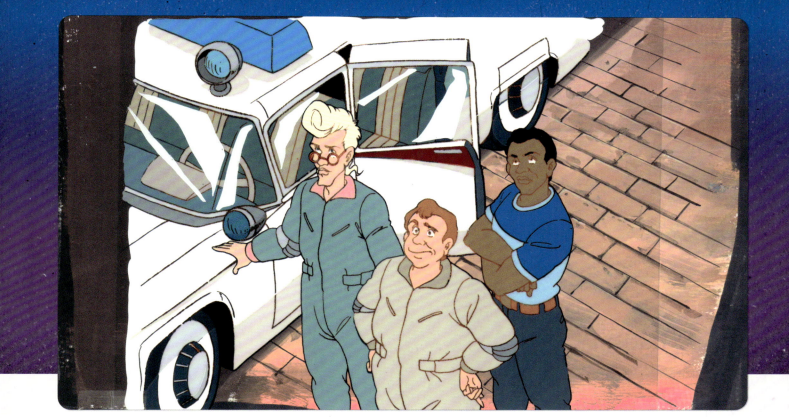

Heroes to adults and children alike, the Ghostbusters were an achievable fantasy. They inspired problem solving and using technology to save the day.

the idea. He was also someone who loved to sell, and he liked it but said, 'Talk to Ivan.'"

"It could have been Rick, but I remember it was Henry Siegel, who was the head of LBS Communications, who went to Herman and asked him to take a look at *Ghostbusters*," says Joe Indelli. Indelli, who had joined Columbia Pictures Television in 1980, had worked his way up to become the president of the studio. It's possible that great minds think alike and multiple people approached Herman Rush with the idea to bring *Ghostbusters* to series. Then again, because of his prowess, it's also possible that Herman Rush, a legend of television with the résumé to provide the receipts, even had the idea himself.

Herman Rush, famously responsible for helping broker the deal that brought *All in the Family* to American televisions, had also created a television syndication company and was responsible for packaging and selling a veritable who's who of television series during his career—including *Lost in Space*, *Land of the Lost*, *The Time Tunnel*, *Land of the Giants*, and more. In 1980, he joined Columbia Pictures Television and aimed to utilize his deep knowledge of the syndicated landscape to help the studio thrive. (Unfortunately, Rush passed away in 2024 at the age of ninety during the writing of this book.)

Rick Rosen believed Rush to be a consummate salesman. When he approached Rush with the animated *Ghostbusters*

> **"All Ivan knew about TV was that it was 'no fun,' because his only experience had been the *Animal House* spinoff *Delta House*."**
> —JOE MEDJUCK

idea, they agreed that it would sell. However, one key factor would make or break the project: the original film's director and one fourth of the stakeholders in the new *Ghostbusters* property, Ivan Reitman. And he was less than enthusiastic. At least, at first. "Reitman wouldn't do it, because he was afraid it would hurt his sequel," says Joe Indelli.

"Frankly, the TV people at our studio may have been a little intimidated by Reitman," says Rosen. "They had this massive blockbuster hit movie and these were the days that television was very much the bastard stepchild of the entertainment business. Then when you're talking about a cartoon, at the time that was the bastard stepchild of the bastard stepchild."

"All Ivan knew about TV was that it was 'no fun,' because his only experience had been the *Animal House* spinoff *Delta House*," says Joe Medjuck. Universal had been enthusiastic about an *Animal House* spinoff, so much so they built a full replica of the Delta frat house on their iconic back lot for filming. *Delta House* initially connected with audiences and was highly rated. But Ivan Reitman and executive

Chapter 1: Manifestation

producer Matty Simmons were constantly at odds with the network. After all the effort, *Delta House* was canceled after just a single season. The experience had left Reitman disenchanted with television adaptations of his creations.

"I think his fear with anything is watering down the original, be it a TV show or a sequel," says Jason Reitman. "My father wore many hats. But he was a director first, and at the end of the day, film is a director-driven art form. Television is a writer-driven art form."

"He wasn't a snob about stuff. Ivan, as did Joe [Medjuck] and Michael [Gross], had incredible commercial sensibilities and creative instincts," says Rick Rosen. "Ivan was a little gun shy about things. If he thought he could do it well, he was in. If there was a chance it would be shitty, he wouldn't."

"I'll never forget, I had lunch with Reitman on a Thursday trying to sell him on the animated series," says Joe Indelli. "He still wouldn't do it. The next day, Herman Rush calls me and says, 'Hey, Joe. Westinghouse is going to announce that they and Filmation have made a deal with Tribune Broadcasting for their *Ghostbusters* show.' Tribune was one of the top two independent groups along with Metromedia. Sure enough, they announced it. That incensed Reitman. He said, 'They're taking my show.' And we said, 'Yeah? Just wait until you see it.'"

In order to understand why Reitman felt pressure from Filmation's *Ghostbusters* series, a quick step back in time is necessary. *The Ghost Busters*, a live-action show that ran in 1975, was dramatically different from the *Ghostbusters* created by Aykroyd, Ramis, and Reitman in 1984. Produced by Norm Prescott and Lou Scheimer of the production company Filmation, the campy series shared a few aspects with the 1984 *Ghostbusters* but tonally could not have been more different. "Lou Scheimer, who was the head of Filmation, was one of the greatest human beings who ever lived. Somebody whom I idolize to this day. I'd worked as a writer at Filmation for several years, and I'd been promoted to a new unit that was going to focus on development," says Robby London. London had been a prolific writer at Filmation, working on *Fat Albert and the Cosby Kids*, *Blackstar*, and *He-Man and the Masters of the Universe*, among others. This would be the start, but not the end, of his *Ghostbusters* story. "One of the first things that we were assigned to do was develop an animated series based on the live-action *The Ghost Busters* with Forrest Tucker and Larry Storch. The *Ghostbusters* movie was coming and it was getting so much heat, and Lou recognized the value in the name *Ghostbusters* and that he had this asset [that was] valuable just by virtue of its name."

Ivan Reitman surmised that kids would tune in to a show with any variation on the name *Ghostbusters* believing they were watching a continuation of his popular movie. When they were met with strange characters named Jake and Eddie, driving around in a jalopy with an anthropomorphic gorilla, Reitman worried kids would be so turned off by the bait and switch that they would lose their appetite for more. And that reaction wouldn't just hurt demand and performance of a *Ghostbusters* sequel but could potentially destroy his blossoming intellectual property completely. Essentially, Filmation forced Reitman's hand. "That's very Ivan, to take control and put his foot down. He puts his creative stamp on something to make sure it's as good as it can be," says Eric Reich, who worked with Reitman for over fifteen years and now oversees the *Ghostbusters* brand for the late filmmaker's company Ghost Corps.

"When Filmation announced they were going ahead with their series, Ivan Reitman decided to come out with one of his own, lest his franchise be damaged," explained Andy Heyward, the president of the animation production company DIC Enterprises, to the *Los Angeles Times* in 1986.

"Reitman calls Herman and says, 'Go get it,'" says Joe Indelli. "While we're trying to figure out strategy on what to do with this show, I get a call from Squire Rushnell, the head of kids' programming at ABC. He wanted the *Ghostbusters* show. The problem was that Herman Rush didn't want to deal with the networks. He wanted to stay in syndication. Herman and I went around and around if we'd make a deal with ABC. I couldn't get him to budge. Finally Squire calls me and says, 'I'm announcing my schedule on Friday. Today's Tuesday. If we're going to make this show, I've gotta know now.' I told Squire to stand by his phone and he'd get a call from Herman in a half-hour. I called Herman and thank god, he was in his office. I resorted to telling him that I would deal with the networks. He wouldn't have to do anything. God bless his soul, he still didn't want to make a deal with the network, but he made the call. We got the deal with ABC and we got a Saturday morning show."

The Promo Pilot and Enter Medjuck and Gross

Kevin Altieri, a graduate of the Kubert School, was on staff at DIC, storyboarding the animated series *Kidd Video*, when he saw a film that transformed him. "*Ghostbusters* was fucking perfect," says Altieri. "When I teach classes, I point my students to *2001: A Space Odyssey*, *Young and Innocent*, *North by Northwest*, and *Ghostbusters* as perfect films. The characters are so great and so well defined. Richard Raynis and I were at DIC working on *Kidd Video*, and I would yammer on and on about *Ghostbusters*, and how perfect a film I thought it was."

Richard Raynis's animation experience went all the way back to working with famed animator Ralph Bakshi on *The Lord of the Rings*. He had recently finished study at UCLA with a literature degree when he began working for DIC as a background designer on *Kidd Video*. Raynis may only be credited for the initial thirteen network episodes as director, but he oversaw the entirety of the first seventy-eight episodes in the run. He would go on to spend thirty-plus years overseeing animation on *The Simpsons*. "Richard is brilliant. He brought incredible creativity to the property," says Andy Heyward. "He was a superstar. A very gifted talent."

"Richard Raynis was the 'quality unit' at DIC," says storyboard artist Brad Rader. "They put him on all the high-profile shows."

"Richard can really spot talent. I remember one day he told me, 'All these people around me can draw better than I can, they can storyboard better than I can, they can write better than I can.' His function was to grab those people and have them work together," says production supervisor Winnie Chaffee. "At first, I had a hard time working with him. The normal mentality in Hollywood is that, in my role, I'm in charge of the budget and schedule. So I have a whip in my hand. Richard was in charge of creative, so we were supposed to fight all the time. And he's a fighter. But that was only in the beginning. After we got to know each other, we worked really well together."

"Richard's team had all worked together on *Kidd Video*, and in the entire animation business there was nobody quite like these guys. The standards of quality were really remarkable. Richard was quite a hands-on artist on the project," says series key background designer Bruce Zick. "There was a brilliant amount of incredible artwork that he did, including key set locations and creating the bible for the series. Just some of the most intricate, precise, mechanical, and beautiful illustrations of the sets. It was really intimidating artwork."

ABC wanted the show. Ivan Reitman had agreed to it. Herman Rush, Rick Rosen, and Columbia Pictures Television closed a deal with DIC to produce the animated *Ghostbusters* show. Everything had fallen into place. But there was only one problem. There was no show. They didn't have anything to help sell the series to advertisers and affiliates. Some sort of demonstration pilot was absolutely necessary. And it was needed yesterday.

"There was no show until that was done," says Andy Heyward. "That reel was basically what was used to sell the show." Not only would that animated pilot help sell the

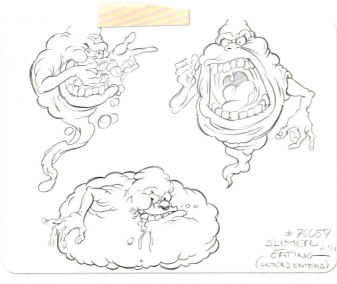

Original character and logo designs for the three-minute promo pilot.

series to syndication networks, advertisers, and potential licensees, but it would act as the template for production from which the rest of the episodes could be derived. It was important from a number of directions, and Heyward turned to his "quality unit" to make things happen.

With their constant water cooler discussion about *Ghostbusters* in mind, Richard Raynis approached Kevin Altieri with a knowing smile. "One day, Richard came in and said, 'How would you like to do *Ghostbusters* as a cartoon?' Yes. Absolutely. I'm onboard. What he didn't tell me is that we basically had one day," says Altieri.

"This was a proof of concept that we were doing. We turned stuff around so fast back then," says Richard Raynis. An enormous amount of trust was placed in Raynis and his team to create something that looked, felt, and played out like what a *Ghostbusters* animated series was capable of, but under the pressure of a reduced and expedited schedule. As far as what that promotional reel could be, the sky was the limit.

"The only direction we were given was that we couldn't use the actors' likenesses," says Altieri. "Richard, Eddie Fitzgerald, and myself only had a couple hours to sit in the room together and hammer out concept drawings and character designs. Eddie was hyperfocused on the introduction, where the ghost from the logo is strutting down the street. For whatever reason, I latched on to the green ghost—he wasn't called Slimer at that point yet." The green ghost character would be the object of the Ghostbusters' pursuit. Throughout this madcap chase, the Ghostbusters would encounter all sorts of ghouls and monsters. The green ghost also gets the last laugh in the reel. "At the end, he ends up inside the trap and reaches out to grab his hot dog. I think Slimer's involvement in the series had a lot to do with how people reacted to him in that promo."

"I was on John Dorman's crew at Ruby-Spears," says Dan Riba. Just down the street from DIC, Riba was working as a story director and storyboard artist at the Ruby-Spears animation production company when he indirectly came into contact with *Ghostbusters*. "There was an artist there named Tom Enriquez working with us on *Mister T*. He was amazingly talented. One day Michael Gross, who knew John Dorman and Kurt Connor from *Heavy Metal*, came into the office and said he was working on this thing called *Ghostbusters*. He needed artists to do boards and concepts.

Tom's work was macabre and a lot like EC comics, and Gross latched on to him right away. Tom had to take a little sabbatical to work on *Ghostbusters*, but he'd be in the Ruby-Spears offices working on these drawings. So we'd see him working on this 'Onionhead' character [the creature in the original film that would eventually become known as Slimer]. I was watching *Ghostbusters* come to life in front of my eyes. Eventually, I made my way over to DIC. I had been sent to Japan to supervise lip-synch animation for *Inspector Gadget*, and I loved it. I came back to Los Angeles fully planning to go back and live in Japan permanently. But DIC said, 'No, Dan. We need you here. We just got this thing.' While I was in Japan, DIC made the deal and had already finished the promo pilot for *The Real Ghostbusters*."

"Dan says he was in Japan, but I seem to remember him being in the room," says Altieri. "They pulled him back from Japan kicking and screaming. He was having such a good time there. Dan was someone you really needed on this show. His art style and storyboards are just too perfect for it." Everyone's memory could be hazy because of just how quickly the team produced the reel. "It all happened so fast that I essentially had to create the story of the whole reel on the spot. Just made it up. All in all it was done in probably three hours. Starting with the characters waking up in bed and seeing all of their clearly defined personalities: Ray being an eager beaver, Venkman piled at the foot of the bed, etc. I wanted Ecto-1 to be one of the main characters of the reel, because I'm such a fanboy for that car. You see the Ecto-1 with all the characters in it and Ray has this look of wonder, Peter's in the back reading a magazine, Winston is intently focused on driving, and Egon's completely serious. It tells you everything you need to know. You immediately know all four characters. That was all intentional. That's our pure invention. We chose to start with that mindset from panel one and not stop because we were intent on getting this show."

> "It all happened so fast that I essentially had to create the story of the whole reel on the spot. Just made it up. All in all it was done in probably three hours."
> —KEVIN ALTIERI

It was all hands on deck, as several artists had to chip in for even small contributions. Background painter James Gallego, who would later create a promotional painting with Gabi Payn (see page 29), was tasked with designing the ghost flying the Gee Bee racer through the air. "I started at DIC in 1984. Back then they would bounce us around from show to show. But I was so green. *Kidd Video* was my very first show in the industry," says Gallego, who has gone on to have a storied career at Disney painting backgrounds for shows like *TaleSpin*, *Adventures of the Gummi Bears*, *Darkwing Duck*, and more. "I went to ArtCenter in Pasadena

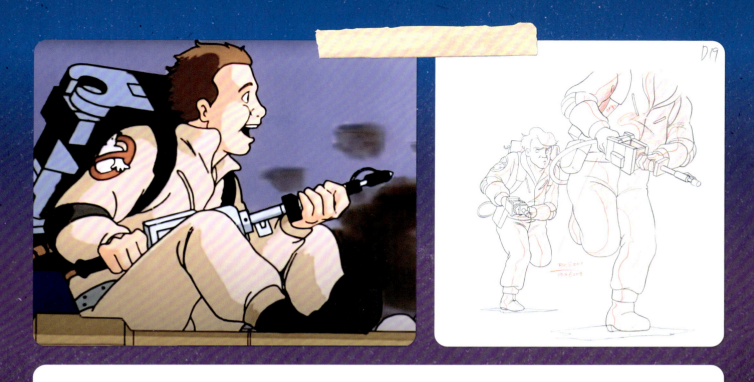

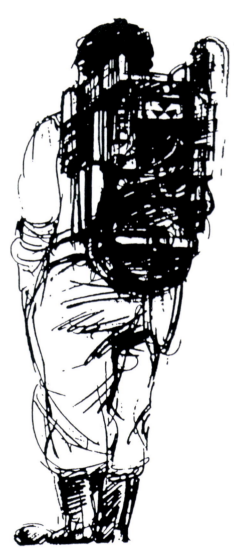

Creating a three-minute promo pilot at such a rapid pace meant all hands were on deck for character design, prop design, storyboards, and everything else that was required in detailing the world of Ghostbusters.

Chapter 1: Manifestation

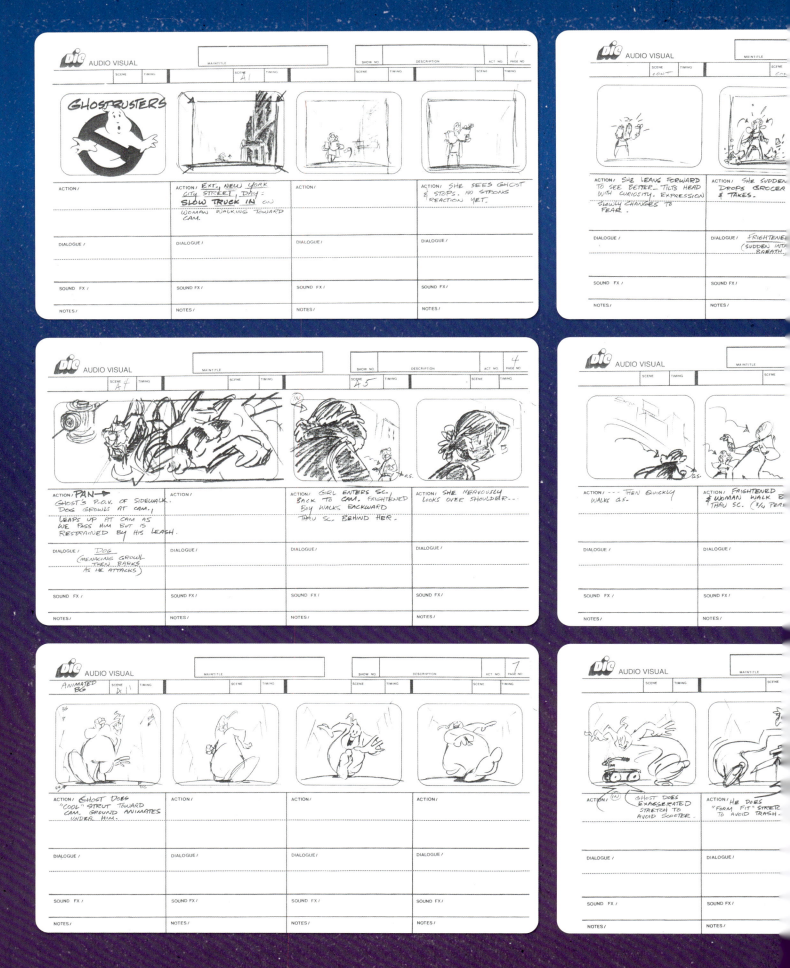

The introductory scene of the three-minute promo pilot, storyboarded by Kevin Altieri. Precisely timed to the pulsating opening notes of Ray Parker Jr.'s theme song, the first visuals had to be an immediate hook to sell the show to syndication stations and advertisers.

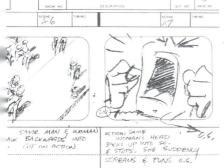

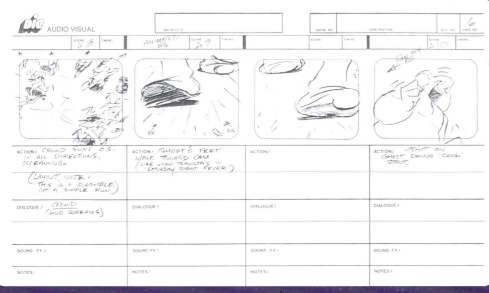

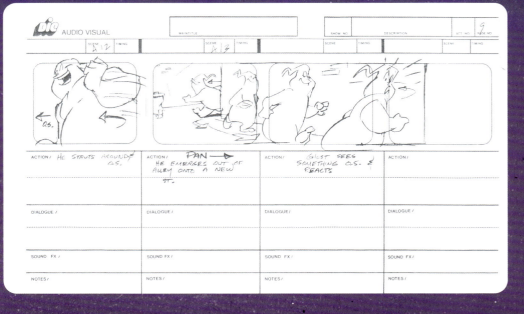

Chapter 1: Manifestation 27

as an illustration major and knew nothing about animation. My first day at work, they basically showed me my paints and told me what to get started—but didn't tell me why or what it was for. Later, I learned that I was doing background keys that were being sent to Japan as a guide for producing the show. I was just starting out and had no awareness of anything."

"We had worked on *Kidd Video* together, but mostly this was a group that had very little experience," says Richard Raynis. "When we put together our own production materials, the Japanese artists were often critical. Oftentimes, I apologized for the technical quality of the materials while defending their creative intent. Because he was Japanese American and spoke Japanese, Ken [Duer] was the mediator. He helped us navigate that relationship. I remember in those meetings when Ken would be translating, the inference was that if this were Japan, I'd never be a director. Because to be a director in Japan, you have to learn all of the technical stuff first."

"The packages we would send to Japan were just crazy for what you would expect to be done," says Bruce Zick. "It was all very low budget back then, and this work was an attempt to do something superior but within the restraints of the big production machinery that had to churn this stuff out."

"To be honest with you, none of us knew what we were doing," says Ken Duer. "James and so many artists like him came either straight out of school or had very little animation production experience. I came from film school, but I had never animated before. Nobody really knew how to efficiently operate a production, and therefore, that's why Andy Heyward and Jean Chalopin invited Japanese directors to come here: to not only work with the American team but basically teach the 101 course of animation from the Japanese side. They were key in making sure all of the elements the overseas team would need were laid out properly. Otherwise, there would be so much back-and-forth before they could animate. DIC was one of the early studios to lay that groundwork."

"I loved that pilot. I thought it was great," says Andy Heyward. "Everybody who saw it thought that it was great."

Says Joe Indelli, "I thought it was so near and dear to what you would hope for in a *Ghostbusters* show. When you hear the theme music and you're looking down the street and all of a sudden: *thump, thump, thump* comes the giant white ghost. It's so good. I told my sales team to wait until that ghost turns the corner, count to three, then turn it off. If the station buyers watching say they want to see more, we know we've got them."

The reel was an important part of the production of *The Real Ghostbusters*, but it had largely remained unseen by the general public until Time Life released their DVD set in 2008. A VHS tape of the pilot, brought by Altieri to an interview filming session for the Time Life DVD set, remains the only source of the produced sound mix—featuring the new recording of the theme song and sound effects. "Kevin Altieri turns up for his DVD interview with a big leather folder, he unzips it and asks if this tape would be of any interest," says fan and animation historian James Eatock, who also assisted in the production of the Time Life DVD bonus features. It was a lost treasure that had been hiding in plain sight. "I couldn't believe it. Dan Riba was there and said he hadn't seen that in years."

"A fan contacted me because he had found a can of film with the promo pilot on it and asked me why it didn't have any sound," says Altieri. "I had to tell him that it never had sound on it. There wasn't time for it. When we first showed the pilot, I would cue up a cassette tape and play the song from the soundtrack while people watched. The whole thing is basically an animated music video for the *Ghostbusters* theme." The fan who had found a print of the reel, Robert Barbieri, then took the reel and meticulously digitally cleaned up each frame and remastered it for release on an anniversary edition of the *Ghostbusters* films. To this day, Altieri's VHS tape remains the only known source of the reel's original audio.

"That introduction reel was pretty impressive. To pitch a series and come in and show us something like that, you go, 'Whoa,'" says Joe Medjuck. "I don't recall if Ivan had told Columbia Television that he wanted some control, or if they offered us the executive producer roles, but Ivan basically said, 'Okay, Mike and Joe, you're executive producers on this. Make it good.'"

While Reitman may have been hesitant to greenlight the *Ghostbusters* animated series initially, the three-minute promo pilot assuaged any remaining fears. With multiple projects on his slate, including the Robert Redford–starring feature film *Legal Eagles* to be released the same year as *The Real Ghostbusters*, Reitman wouldn't be able to dedicate the time and attention the series would require. "One of his great skill sets was his ability to identify what was important and what wasn't and when to weigh in and when not to," says Jason Reitman. "I think that's what made him such a unique producer-director. A director is someone who is emphatic about every detail onscreen. A producer has to know when it's important to step in, and he knew that balance well. I have to imagine on the animated series, he knew when it was important. He knew when it required his hands."

He turned to two trusted colleagues who had just finished assisting him on the original *Ghostbusters* film and who he

One Key Frame to Kick-Start the Cyclotron

SIMULTANEOUS TO the promo pilot's production, Columbia Pictures Television commissioned the artists to develop a key frame image for use in the show's preproduction. "Richard challenged all the artists to come up with a piece of artwork to present for trade magazines and promotional things, and I did this sketch of the Ghostbusters on the car chasing Slimer," says Kevin Altieri. "Then Gabi Payn cleaned it up magnificently and James Gallego painted it. You'll notice on that painting that the character designs aren't quite there yet, but it's kind of close. So we sent that out, and lo and behold, before you know it, that image is in the newspaper and on TV dinner trays, and all over the place. I did an alternate one where the Ghostbusters are facing us and there's, like, a little demon ghost in his pajamas holding a doll and behind him is this monstrous dad. Honestly that was probably one of the first pieces of art that was ever done for *The Real Ghostbusters*."

"I was in one cubicle, Gabi was in the cubicle to my right, and Kevin was on the other side to my left," says Gallego. "The two of them did the black-and-white layout of the piece, giving it structure. Gabi was really great with characters, and I think Kevin blocked in the positioning of the car and the buildings in the background. Then I did all of the cleanup and detailing of the car. This was before Google for reference; we only had a few photos from the movie to work with. I embellished from there in paint what the drawing was. It was quite a job. There was a lot of detail in it. They gave me two weeks to work on it, which was unusual.

"For background keys on shows, we usually only get a day to do one or two paintings. That painting was one of the first major things that I did in my career and I'm really proud of it. It's an iconic image. It was really gratifying it was used on so much merchandise. A friend who helped me get the job at DIC, years later, gave me the TV tray with my image on it, and I couldn't believe it."

"James did a great job painting that key art," says Richard Raynis. "I think between that key art and the promo piece, it was just one of those things that really came together really well, and everybody thought favorably of it, from the network to the filmmakers. That was great."

Chapter 1: Manifestation 29

Opening Titles and Closing Credits

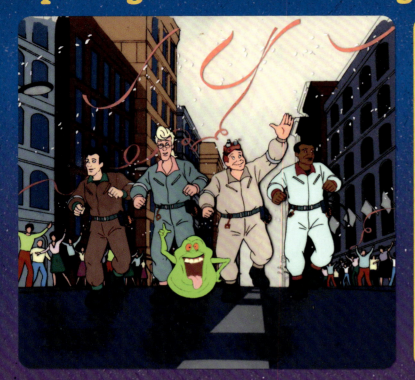

BECAUSE THE energy of the promo pilot so succinctly conveyed the show's tone, it was decided to use elements of it for the opening titles of the series itself. "A lot of the promo pilot was extrapolated into the actual cold opening of the show," says Kevin Altieri. "Nothing goes to waste."

Conversely, the closing credits were conceived independently. "I came up with the idea of a ticker tape parade where the guys are walking toward us doing the 'Keep on Truckin'," says Altieri. "And then Slimer can't control himself and knocks them all down, and then you have this sudden punch line to the joke that they chase him past the camera."

knew would be able to shepherd the project handily: Joe Medjuck and Michael C. Gross.

"They were very hands on," says Andy Heyward. "On other projects where a company is going to do an animated series based on a movie, the filmmakers kind of chip it off and don't have anything to do with it. These guys were—I have to say this with fondness looking back on it—impossible. There was not one word of one script that they didn't have something to say about. Nothing they weren't on top of. Every script, design, prop, model, color key, recording session, postproduction, sound effect, music cue. They were on top of everything from top to bottom. And to their credit, their presence made the show better."

Joe Medjuck, a cornerstone of Ivan Reitman's personal and professional life for decades, was wooed from academia in Canada to Los Angeles with the promise of a creative development job at Reitman's company. An associate producer on the original *Ghostbusters*, Medjuck had been battle tested and knew the property well. He was joined by artist and designer Michael C. Gross, who famously designed the *National Lampoon* "If You Don't Buy This Magazine, We'll Kill This Dog" cover. Gross had also just finished work on *Ghostbusters*, where he oversaw concept artists and special effects and worked with Brent Boates to design the famous No-Ghost logo. The two delighted in the idea of becoming part-time animation producers on top of their daily duties in working on Reitman's feature films. "Michael and I read all the premises and scripts and would give notes or veto ideas," says Medjuck. "We were the ones who would say, 'No, the Ghostbusters wouldn't do that.' And frequently we gave notes that certain things were aimed too young. We always said we weren't a kids' show. Mike and I loved the show and the people working on it, and we wanted to make it as good as possible. It was very strange because we basically had the mentality of 'This is fun, let's make this as good as we possibly can. And, even if nobody wants to watch it, we're gonna do it our way.'"

Admittedly, Gross knew nothing about animation at the time he worked on the film *Heavy Metal*, nor anything about the film business at the time he assisted on *Ghostbusters*. "I pretended to know animation, but I knew very little," he says. "I faked my way in. Ivan and I had history going back to the *National Lampoon* days. When Ivan did the *Ghostbusters* film, I told him that I could art direct it. I told him that I could protect the work to look right onscreen. I can draw. I went to art school. And he trusted me to guard the kind of 'animation' side of the film."

"We had a lot of great help on *Heavy Metal*," says Joe Medjuck. "Mike had worked with, like, six different animation companies, and I had flown to England to work on a

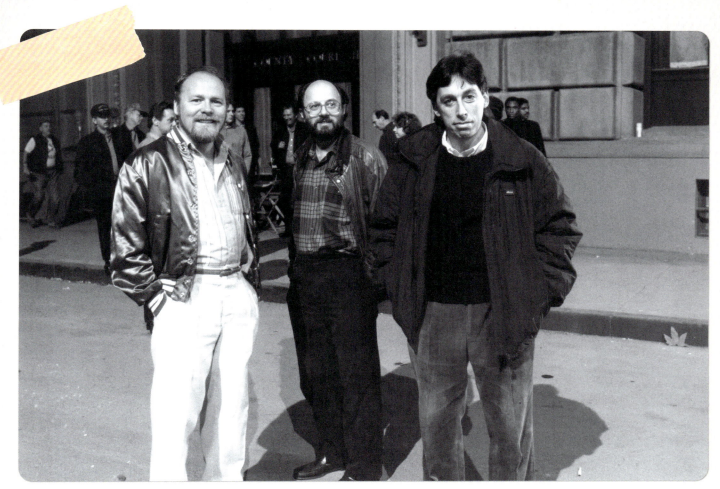

Left to right: *Michael C. Gross, Joe Medjuck, and Ivan Reitman.*

contractor's deal with animators. We learned animation through that experience. But neither of us knew TV, let alone TV animation." The two divided the supervising work: Medjuck would oversee the scripts, edits, and overall creative, while Gross would supervise character design, animation, and more of the nitty-gritty production aspects of the show. "I made a point of having no design opinions; I would leave those to Mike all the time," says Medjuck.

"I'm not a wordster, I'm not the guy who got involved with the scripts," says Gross. "It was a strange thing that they made a syndication deal simultaneous to a network deal. That had never been done before. We had to race into production and suddenly, there was a cartoon show."

An Animated Syndication Arms Race

Looking out the window of the twenty-ninth-floor presidential suite of the Westin Canal Place, Joseph Indelli knew he was sitting on a hit. The finest hotels, restaurants, and conference rooms in New Orleans had been overtaken by the power players in television for the 1986 NATPE (National Association of Television Program Executives) conference. High up, overlooking the river, Indelli, Herman Rush, Dick Woollen, and the rest of the Columbia Pictures Television team had set up their war room with one mission: to sell *The Real Ghostbusters* into syndication in as many markets and on as many networks as possible. "There was a lot of firepower behind that sale," says Andy Heyward. "Joe Indelli was a great salesman. So was Herman Rush. Michael Ovitz and Bill Haber of CAA [Creative Artists Agency], just a lot of heavyweight people involved."

With the introduction of UHF broadcast stations to major markets around the country, syndicated programming was in high demand. "Every time a UHF station went on the air, whether it was Miami, or Philadelphia, or Boise, it didn't matter. We would up our cash flow by ten times," says Indelli. "When an independent station went live into a marketplace that was dominated by usually the three major affiliates and one or two indies, they were looking for twenty-four hours of programming. The whole business was undergoing this huge sea change. If you had a product, you couldn't miss."

The Real Ghostbusters had already cemented a network broadcast deal with ABC for thirteen episodes to air on their Saturday morning lineup. And the contract with ABC had an option stipulating that, if the show's ratings performed well, an additional thirteen half-hours would be commissioned for the 1987–88 season. Once those twenty-six episodes

were completed, Columbia Pictures Television could move those episodes into syndication in the fall of 1989. "Herman had a phenomenal idea," says Rick Rosen. "We had the Saturday morning cartoon show that we sold to ABC that was a thirteen-episode order. But Herman thought the concept was so big—why stop at thirteen episodes? Why don't we do sixty-five for broadcast syndication? Nothing like that had ever been done before. It sounded incredibly ambitious, but I was a young executive. What the hell did I know?" Herman Rush, again having come from a background of selling series into syndication and knowing how lucrative it was, had another plan: to sell sixty-five *additional* episodes of the *Ghostbusters* series directly into syndication right out of the gate. That way, by 1989, the studio would have at least ninety-one half-hour shows that they could continue to renew to syndicated networks on a multirun, multiyear cash basis. "It became very obvious that this was going to be very lucrative for all the participants," says Rosen. "Plus, having those sixty-five episodes helped us with a master toy license with Kenner."

Why sixty-five episodes? On the surface, it seems to be an arbitrary number. But the episode count was very purposeful: to directly compete with *The Real Ghostbusters*' main rival, and frankly the catalyst for its existence. At the same NATPE conference, Group W Productions (owned at the time by the Westinghouse Electric Corporation) was selling sixty-five episodes of *Filmation's Ghostbusters* to the exact same networks and executives that Rush and Indelli would be wooing. *Filmation's Ghostbusters* would be on the air every day in a lot of markets, and Rush wanted their show right up against it.

Weeks prior to the January start of the conference, Filmation held a preemptive private screening for industry executives, where Lou Scheimer boasted to insiders they had 70 percent of markets already sold. Scheimer very explicitly touted their animated series as the "real" *Ghostbusters*, hoping to plant a bug in affiliates' ears and undermine Columbia's efforts. If he already claimed he had the real deal, then Columbia came up behind saying *they* were the real deal, it would make them sound like they were playing catch-up. The game was afoot. The tactics used by Columbia and Group W to try to best one another have become television and NATPE legend. How rare it was, and still is, for two shows of the same name to be directly jockeying with one another for the same territory. "Our head of marketing, Steve Aster, came up with a little pin. It was about the size of a penny and had the No-Ghost Ghostbusters logo on it," says Indelli. "We took thousands of those things to New Orleans and gave them to every cab driver, limo driver, maitre d',

> **"Nothing like that had ever been done before. It sounded incredibly ambitious."**
> —RICK ROSEN

doorman, cop, anyone who would wear them." Network representatives (and not coincidentally, the Group W and Filmation reps) couldn't go anywhere in the city without seeing the Gross and Boates–designed No-Ghost logo: it was everywhere.

The barbs traded between the two rivals weren't confined to the city of New Orleans. The entire industry had ringside seats to the knockdown-dragout war. In the weeks leading up to NATPE, and in the weeks following, Columbia Pictures Television took out large two-page-spread ads in the industry trade magazine *Broadcasting* that brashly proclaimed, "If ya want the real heroes, the real villains, the real music all based on the real movie, who ya gonna call?" Not to be outdone, Group W would also take out ads in the same trade magazine touting Filmation's pedigree in animation and the continued successful partnerships with the syndicated networks they had already been providing content for with shows like *He-Man*. Group W's ads also claimed that "millions of kids" were demanding *their* version of the Ghostbusters and weren't content with the pretenders that had been presented in the 1984 blockbuster film. "I may have written some of that copy for Filmation," says Robby London. "I had been writing a five-parter for *Filmation's Ghostbusters* that was the origin story for that series. Some of my work involved helping write copy for pitching shows to broadcasters. It's funny, because even though I was working for Filmation, I've been friends with Andy Heyward since we were fifteen years old. We were in frequent touch and, in fact, Andy was trying to hire me for years. But I had resisted. And it was fun to be competing with each other in that way."

For months, the two rivals went back and forth in the magazine, particularly as broadcasters signed on the dotted line to carry each of their shows. With each successive paid ad in the paper, Columbia and Group W would try to one-up each other on the percentage of networks and coverage they had over the United States.

Columbia succeeded in selling the series, and then some. *The Real Ghostbusters* was sold to air in syndication to 70 percent of the US in a mere three days of being on the market, and had been picked up by all six Metromedia independent stations (later purchased by Rupert Murdoch to become Fox Television networks, which participated in a group exhibition deal for future seasons of *The Real Ghostbusters* in November of 1986), along with WTAF-TV in Philadelphia, WLVI-TV in Boston, WCIX-TV in Miami,

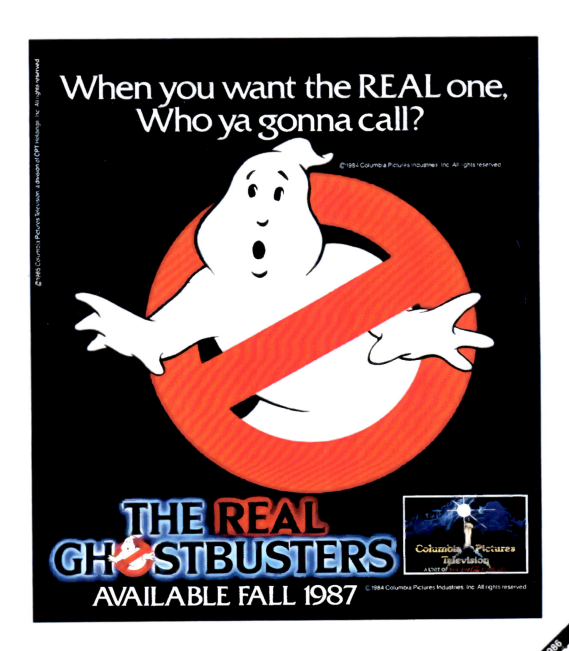

Broadcasting magazine announces The Real Ghostbusters to the industry on January 27, 1986.

Chapter 1: Manifestation 33

and the Gaylord independents in Cleveland, Milwaukee, and Seattle. "You had to have over 70 percent of US households to get an advertiser," says Joe Indelli. "That's why Tribune and Metromedia were so important. They had the gateway markets: LA, New York, Chicago. I would never sell a show if I didn't have all three together at one time."

By the end of February, over 75 stations had purchased the rights to air the show in 112 markets, covering 82 percent of the United States. "That's great coverage," says Rick Rosen. "It was a hot sale. And I'm sure by the time we were done it was in the nineties."

Says Indelli, "Every market that had an independent had *The Real Ghostbusters*. You would never get to 100 percent because there were no independents to pick it up in those remaining markets. So when we got to 80 to 85 percent, we were doing a pretty good job." Combined with the one-two punch of the ABC episodes they were readying for the fall, Columbia Pictures Television had successfully sold a series . . . that had just barely started writing scripts.

"We were doing both sixty-five episodes for syndication and thirteen episodes of a network show simultaneously," Medjuck says. "That's seventy-eight shows in one year." It was then, and still remains, unprecedented to be producing that much animated television in a single year, so a strong production partner was required. "Suddenly, I had a lot of friends in the animation business," jokes Medjuck.

According to Michael C. Gross, at one point a company came to him and said, "We've got a bag with twenty-five thousand dollars in it if we get this contract." Whether this is a joke on Gross's part or truth hiding in humor remains to be seen. The stalwart Canadian animation company Nelvana was in the running to handle the series, but, thanks to the trust and previous experience that ABC had with them, DIC (Diffusion, Information, Communications) was ultimately brought on as a production partner.

Having just finished successful runs on *Inspector Gadget* and *The Littles* for ABC, DIC had proven their mettle with the network and were a known entity. They also had an international presence and an established animation pipeline that wouldn't need to be built specifically for the show, which made them ready to start from the word go. Andy Heyward, then the CEO of DIC, saw *Ghostbusters* as a tremendous high-profile opportunity that would send his studio into the stratosphere. It helped that the network had faith in DIC as well. "Andy is an amazing salesman," says Richard Raynis. "*Ghostbusters* was a big deal. Among the

Left: *Columbia boasts of NATPE success.* Right: *ABC's license announced in* Broadcasting *magazine.*

other things that he was doing at the time, this would be the most prestigious property."

"ABC told us that this isn't like the movies, where you can just push a release date. With TV you have to deliver for every Saturday morning. They only cared about companies that delivered on time, and DIC delivered on time," Medjuck says. "So we met Andy Heyward, who was a fun and kind of weird guy, and they in turn introduced us to Marsha [Goodman] and several other crew members that became constants on the show."

Two Shows in One

"We had two great story editors in Len Janson and Chuck Menville," says Andy Heyward. "They were great storytellers and did a great job. They were absolutely essential to this series. Everybody was being guided by them and worked under them."

Len Janson and Chuck Menville were already veterans in the animation industry when *The Real Ghostbusters* was ordered to series. They met working at Disney Animation and found themselves restless with the laborious process at the storied animation studio. Shared love for stop-motion animation quickly bonded them, and for decades they had worked hand in hand as creative partners and cowriters on *Groovie Goolies*, *Fat Albert and the Cosby Kids*, *The Smurfs*, and *Star Trek: The Animated Series*, among many others. The two were hard at work producing *Kissyfur* and *Little Wizards* at DIC when the call for their help on *Real Ghostbusters* came. "Len and Chuck were very good, established, respected, high-quality Saturday morning writers. And they did not have an attitude at all," says Robby London. "Chuck was the sweetest guy that ever walked the planet. Everybody loved Chuck."

"Chuck was a real mensch," says *Real Ghostbusters* writer Pamela Hickey. Menville passed away in 1992, at the age of fifty-two. "At Chuck's funeral, Richard Mueller, Gordon Bressack, Dennys [McCoy], and I were standing after the service at Forest Lawn all remarking that we still wanted to pitch Chuck some stories. Len was like the polar opposite of Chuck. I like Len, but you didn't want to get a call from him in the afternoon, because he was usually mad about something."

"Len was particularly tough," says Richard Raynis. "Chuck was the sweet guy, and Len was the tough guy." The yin and yang of the two was a perfect combination that worked, and the pair had already built a relationship with the two vice presidents of children's programming at ABC, Squire Rushnell and Jennie Trias. ABC and DIC trusted Len and Chuck. They were tested story editors who delivered shows on time and on budget.

"They were sticklers," says Andy Heyward. "They were badasses. They did all the *Smurfs* cartoons that were so successful and so well written. Because of their success on *Smurfs*, they got this job. They understood crisis and conflict and resolution and jeopardy and stakes, all of the tools of great storytelling. These were polished and very capable writers." But even though the two were prolific veterans, seventy-eight episodes in a single year was far too many episodes for Janson and Menville to handle. The two were to focus their attention and carefully tend to the thirteen network episodes. Someone else would need to step in and help guide the sixty-five episodes for syndication.

J. Michael Straczynski, who started as a playwright and journalist in San Diego, became part of the animation industry by sheer determination to work at Filmation writing material on spec. He quickly gained a reputation for writing rich stories that could be steeped in existing mythos while laying out new groundwork for future world building. His scripts' biting and sophisticated humor was unusual in animation. He had been working at DIC when *The Real Ghostbusters* was ramping up but wasn't involved from the start. "I saw *Ghostbusters* the first week it came out and loved the hell out of it," says Straczynski. "I figured the odds of my actually getting an assignment to *Real Ghostbusters* were really small. I didn't really have any network street cred. My only hope was that they'd let me write an episode. I was working on a show for DIC that had the dumbest title in the history of dumb titles, *Jayce and the Wheeled Warriors*, when I heard Jean Chalopin wanted to see me. First thought? I'm in trouble. I went in to see him. He told me that Len and Chuck had been assigned to *Ghostbusters* because they were tight with the network. But they had not anticipated also having to do the sixty-five syndicated episodes. Jean had almost no time to find someone, and I guess I looked better with desperation. He had a very thick French accent that was almost impenetrable at times, and he said to me, 'I tell them you are the funny man. Do not make for me the liar.'"

Jean Chalopin was an original founder of DIC, a savvy French businessman who handled the international dealings of the company, while Andy Heyward focused primarily on the United States.

With Len Janson and Chuck Menville heading the network shows and J. Michael Straczynski likewise on the syndicated, it was time to build teams for each show individually. The original idea was that the network and syndicated episodes would be siloed from each other. Two separate machines creating the same show for two different outputs. But

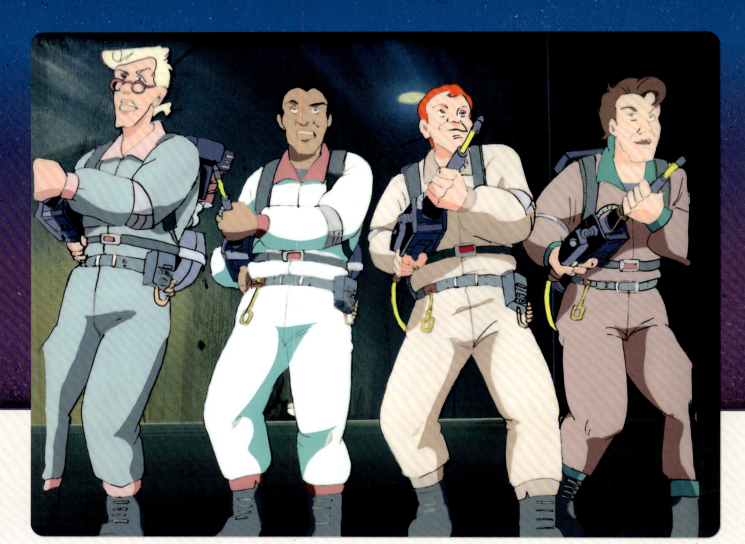

Painted cel of the revised and fully realized "Real Ghostbusters."

because the schedule was so frenetic, spillover occurred out of necessity. Luckily, a few of the artists who had worked on the three-minute promo pilot were able to jump onboard, which helped the visualization process get a head start. Though there was a "feeling out" process, with the existing team suddenly reporting to new story editors with their own ideas and visions. "Len and Chuck understood the number one rule at DIC: every Friday this show is shipping," says Kevin Altieri. "They understood animation and were pretty funny guys. They really knew how to pace a show and give it highs and lows. And thank god they had the Saturday morning network shows, because with a twenty-two-minute show, if you get a thirty-page script, you're immediately in trouble. Sometimes Straczynski's scripts would be sixty-five to seventy pages."

Menville and Janson wrote four of the thirteen episodes for the network, leaning on Straczynski to write six; Michael Reaves, Bruce Reid Schaefer, and Marc Scott Zicree wrote the remaining three episodes. Though Straczynski may have wanted to write all sixty-five episodes of the syndicated series on his own, it was clear that outsourcing to a new writing team would be necessary to get everything scripted in such a short amount of time.

Straczynski went one step further to separate the syndicated team from the network. "Len and Chuck had a bible [for the network shows], which I proceeded to ignore completely," says J. Michael Straczynski. "I wrote my own version that really pushed the show to get out there and make it really interesting. Because of that, the stories that came at me from the writers had to be good science fiction, good horror, or good fantasy. And character based. I said, look, I'm going to go after some of the best writers in town. I went after David Gerrold, Peter David, D. C. Fontana—the writers that I felt the project deserved. We didn't have time to teach new writers a shorthand in this genre. I needed people who knew how this form worked. But I knew they wouldn't work for the fee DIC offered per script. They [the higher-ups in production at DIC] fought me tooth and nail, saying that it didn't matter who was writing the scripts. I went to Joe Medjuck and Michael Gross and said that we can't do this properly unless we have the right writers. And they immediately went to DIC and got the thing done. Once that happened, we were off to the races."

"Straczynski had a vision. He was determined that the show came out the way that he wanted," says Steve Perry, writer

A revision of the character designs utilized in the promo pilot was necessary when the show went into full production, as seen in this line drawing used in production. The Venkman character went through multiple iterations until this final design, approved by Richard Raynis with an inside joke: "OK DELALA."

of long-form novels for *Aliens* and *Star Wars*. "I didn't really want to write for TV, but my buddy Michael Reaves had been doing a lot of animation and insisted it was a lot of fun and you make a lot of money. I was writing books and was not making a fortune as a book writer. Reaves kept insisting, and so finally I went to write for a show called *Centurions* kicking and screaming. And while I was working on that, he asked me if I wanted to write for *Ghostbusters*. I said, oh . . . hell yeah."

Michael Reaves, who at first wrote under the name J. Michael Reaves, was a novelist from San Francisco. He penned fantasy and sci-fi novels including *I, Alien* and *Dragonworld*, and over the course of his career was trusted to handle pop culture's most notable, including *Batman*, *Star Wars*, *Spider-Man*, *Star Trek*, *He-Man*, *Teenage Mutant Ninja Turtles*, and more. His tenure on *The Real Ghostbusters* would yield the most episodic scripts in the series, trailing counts held by Straczynski, Menville, Janson, and Richard Mueller. "I met Michael at a science fiction convention in 1978 in San Francisco. He had just had his first novel published, and he was living in an apartment complex in Silver Lake where every other person there was a writer," says Steve Perry. "These were my people. A few months later, we were moving from Louisiana to Oregon, and I got a note from Michael that said they were doing a writers' workshop in Los Angeles over the holidays and he wanted me to bring some stories to it. I spent five or six days at a Methodist youth camp in the mountains outside Los Angeles, full of black widow spiders and stuff, and Reaves and I bonded. We wrote a science fiction novel together. Reaves was a smart man, real caustic man, snarky and sharp. He would just chop you up in little pieces."

The two bonded, and thus began a long-standing creative writing partnership that spanned decades and distance. "I lived in Portland, and this was back in the days when your modem was so slow you could actually type faster than the thing could transmit," says Perry. "Reaves and I would send floppy disks back and forth to each other. Hollywood, especially at the time, was all about face time. The producers want to call you up and have you come by and talk about your scripts. I couldn't tell anybody that I lived in Oregon. I'd fly down every so often and they'd ask me in meetings where I lived and I'd say, 'Oh, up toward the Valley a ways.' Yeah. Eight hundred miles away."

Michael Reaves was diagnosed with Parkinson's in the early 2000s and had a long battle with the disease he called "the Monster." He kept a meticulous blog on his experiences until

Chapter 1: Manifestation

2013. The disease made it difficult for Reaves to write and even speak. Said Reaves in a personal blog post, "The biggest problem Parkinson's presents for me is my voice. It's the result of several different things. The more research I do, the less inclined I am to believe that one procedure—or even two or three—will provide the Hail Mary pass that's needed here. I may have to settle for a cyborg-style mechanism that'll bypass my voice completely. Because it's looking more and more like even a combination of brain surgery and reconstructive laryngeal surgery might not provide the magic bullet."

"After a while, he just stopped communicating," says Perry. "Over the course of thirty-five years we wrote books, we wrote short stories, we wrote animated shows, we wrote movie scripts. I made a big effort to try and stay connected with him, but he just kind of faded away." Reaves passed away as this book began production in 2023, more than twenty years after his fight with the Monster began.

"I had written a novel for Vernor Vinge called *Jernigan's Egg*, which was supposed to be picked up but the publisher went under five months later," says former head writer at Marvel Comics and acclaimed science fiction writer Richard Mueller. Though that project hadn't gone according to plan, Vinge offered him a consolation: "Vernor asked me if I'd like to do a novelization. His wife was supposed to write it but had signed on to write *Mad Max: Beyond Thunderdome*. And that novelization was for *Ghostbusters*. I said sure. Because when someone asks you if you want to work, you say yes."

Richard Mueller's film novelization for the 1984 film, titled *Ghostbusters: The Supernatural Spectacular*, was published and printed in August of 1985, over a year after the film was released. "Luckily I had seen the movie several times, because it was a great date movie. Every time I went, I took a different girl that I knew and it was great fun. I borrowed an

The Real Ghostbusters provided some of the greatest science fiction writers of the time an opportunity to explore a whole new world and break genres.

IBM Selectric typewriter and did the novelization, turned it in, got paid, and when the proofs came back they asked me to take all the naughty stuff out because they were aiming for a younger audience now." Even though he had to make changes, Mueller was responsible for the first iterations of background stories on all of the characters, having to expand and extrapolate a full novel's worth out of a film that ran just short of two hours. "I gave the protagonists all backstories and introduced some of their relatives. A short time later, I got a call from Joe Straczynski, who had just signed the papers to do the syndication episodes, and he knew I had done the novelization and done all these backstories and he wanted me to come write for him. I said, of course. And I was there for about seven seasons." The groundwork he'd begun in the novelization continued with episodes that introduced Peter Venkman's father Jim and Ray Stantz's aunt Lois. He also expanded upon Winston Zeddemore's air force past and gave him focal episodes where he could shine. "I had a lot of fun with it. I took stuff out of the novel, got a map of New York, and came up with ideas and had a good time."

J. Michael Straczynski also approached and convinced writers the likes of David Gerrold (*Star Trek: The Original Series*), Linda Woolverton (*The Lion King*), Larry DiTillio (*He-Man and the Masters of the Universe*), Craig Miller (a former marketing consultant and producer at Lucasfilm), Nebula Award nominee Arthur Byron Cover, John Shirley (*The Crow*), Mark Edens (*In the Heat of the Night*) and his brother Michael Edens (*X-Men: The Animated Series*), Hugo Award winner William Rotsler, cinema journalist Randy Lofficier (*Starlog* magazine), role-playing game designer Steve Perrin, and Eisner Award–winning comic writer J. M. DeMatteis, to name just a handful.

Kathryn Drennan, who worked with astronomer Carl Sagan and wrote for *Twilight Zone Magazine* and *Starlog*, says that the wheels in her mind began spinning the second she heard a *Ghostbusters*-related cartoon series was in the works. "I had written scripts for *She-Ra: Princess of Power* and *Defenders of the Earth*, so when Joe [Straczynski] became the story editor on *Real Ghostbusters*, and I heard they were going to open up the show to any writer who wanted to pitch an idea, I asked if I could pitch as well," says Drennan. "Three people all had to approve which ideas went to outline and then which went to script: Joe Straczynski, Michael Gross, and Joe Medjuck. Because I write under my own name, neither Gross or Medjuck knew I was married to Joe. In fact, I would not meet either of them until later at the actor recording sessions. And Joe the story editor was just as critical of my ideas as he was of any other writer. Proof of that is that I submitted about twenty ideas, of which only seven got past the 'basic idea' pitch. Of those seven, three were turned down after the first four-to-six-page outlines were turned in. Another one, 'The Minotaur,' went through three separate outline drafts before it was also finally turned down. I really wanted to write that script, oh well. Finally, three other outlines were approved to go to script."

Another husband-and-wife writing team, Dennys McCoy and Pamela Hickey, who were known for their razor-sharp humor and ability to create the strange, found *Ghostbusters* was directly in their wheelhouse. "The simple summation is, if you've seen a movie that's one of your favorite movies in your entire life and somebody says, 'You can keep writing that movie,' you take the job," says McCoy. He and his writing and life partner Hickey are so in tune with one another that they often finish each other's sentences. McCoy had been writing TV listings at *TV-Cable Week* when his editor asked a favor. "[Straczynski's] trying to sell me all these stories, could you take him out to lunch, buy him a meal, and have him do some listings for you?'" McCoy lunched with Straczynski, who wrote some TV listings for him, time passed, and Straczynski went on to work for Filmation on *He-Man* and eventually for DIC.

"We'd recently made the transition from standup comedy to writing comedy television. We were going to be on staff for *Barney Miller* in the ninth season, and it got canceled," says McCoy. "Our agent said DIC was looking for people to write *Heathcliff*, and we said, 'Sure! We love cartoons!' But truthfully, we needed to buy a crib and an air conditioner for the baby." As it often goes in the entertainment industry, sometimes any job is better than no job. After *Heathcliff*, the two moved on to another project with *The Get Along Gang* for Saban. Their scripts were well received, but they quickly found themselves bored. When they heard a *Ghostbusters* series was in development at DIC and Straczynski was story editing the syndicated episodes, they saw their opening. He owed them.

"We hustled Straczynski for it," says Hickey.

"DIC was right next door to Saban," says McCoy. "So I called Joe [Straczynski] and said Pam and I wanted to do *Real Ghostbusters* and we pitched him a bunch of Winston Zeddemore stories, like 'Boo-dunit,' where the Ghostbusters are trying to bust this thing while Winston's figuring out the ending of this book by Agatha Grisley."

Chapter 1: Manifestation

Bruce Zick's black-and-white background renderings.

Chapter 1: Manifestation

Everett Peck's Bigfoot design for "Camping It Up."

"Plus, Joe, you owe us," jokes Hickey, referring to the TV listings job.

"Joe called us and said, 'Dennys? . . . This is a good script.' He thought he was just repaying me a favor and that the script was going to be shit."

"Of course it's a good script," finishes Hickey.

Whether or not McCoy and Hickey were hired on the merits of their amazing and distinctive writing or as a repaid debt doesn't matter. The two went on to pitch and write some of the most beloved episodes in the first run of seventy-eight shows.

"For the syndicated episodes, Joe had to turn out three scripts a week. Pam and I came up with a joke and built a story around it," says Dennys McCoy. "We were standups and wrote jokes and sketches, so, why not?" All of the writers, including McCoy and Hickey, would start by sending in dozens, sometimes pages' worth, of log lines for episodes. These quick one-sentence elevator pitches were reviewed by Straczynski, who would then ask the writers to come up with a treatment that was no longer than a page or two for review by Medjuck and Gross.

"The writers would start by sending us premises. Which were one-page treatments where we could immediately say yes or no to a concept," says Joe Medjuck. "We turned down several of the pitches, but those that got a yes would go to scriptwriting. I don't think we canceled anything after they wrote a script. Then they would send us drafts of scripts, and we would make corrections."

"Once I got approval to go to script, I had two weeks to write it," says Kathryn Drennan. "I didn't find this to be a problem, since by the time I had finished the detailed outline I knew the story and the structure and even some of the dialogue, so it was just a matter of expanding it, filling in the details, putting it in script form, and turning in that draft."

"Once we had people who knew what they were doing and that I respect as writers, I just wanted to let them do their thing," says J. Michael Straczynski. "I tried not to note them unnecessarily and tried to give them opportunities to push it even further. We took the show to the very edges of what you could get away with. Everything I heard from writers in the years after was that they had an awful lot of fun. They could write whatever and I wouldn't mess with them."

With each round of pitches and premises, distinctive voices in the writing staff emerged. "Michael Reaves would do the scary stories or when they needed science fiction.

Richard Mueller would write the action shows. We were the ones they'd come to when they needed weird stories," says Dennys McCoy.

⸻

As the writers scrambled to come up with twenty-two-minute scripts for both network and syndication, the artists had to take what was established in the promo pilot and build it out to a full package that could be used by the United States–based production team as well as the animators overseas. Because the artists were a part of DIC, they could lean on the Japanese animation studios connected to the studio to assist with the animation process, but a heavy lift was still required. Character model sheets, backgrounds, and props all had to be detailed, a responsibility that fell to Gabi Payn, Everett Peck, Marek Buchwald, and Philip Felix. "Richard Raynis and his team of Marek Buchwald, Kevin Altieri, Dan Riba, and Brad Rader moved on to *Ghostbusters* from the get-go, right from the development stage," says Ken Duer.

"Gabi Payn designed characters. Everett Peck designed monsters. John Calmette was our background painter," says Brad Rader.

"Gabi understands animation and is an excellent animator herself," says Kevin Altieri. "When she would do a character design, even if it was a totally wacky design, they would always be the same proportions of whatever had been done on the storyboard."

Richard Raynis and Bruce Zick shared an office, with the rest of the artists right around the corner. They were a close-knit group who worked incredibly well together. "That was one of the great pleasures for me," says Zick. "As a background designer, I'm always anxious to see how my art is painted. Because it brings so much more to life than my gray-tone rendering. To see how John [Calmette] interpreted my art, he had a really unique and unusual color palette sensitivity. Nobody could do things quite like he did. It was always exciting to see what he would do to take my work to the next level."

"This team was so eclectic. I think everyone brought their own special something to everything they did," says Richard Raynis. "When I was a little kid growing up in the 1960s, I was really drawn to monster movies. I didn't collect comics, and I wasn't much of a cartoon fanatic. But I really loved B monster movies. Even the worst B movie could be redeemed if the creature was great. My thought about *Ghostbusters* was that if there was a creature in an episode, we needed to make the most of it. I wanted the designs to be original. Nothing derivative of anything else in animation or entertainment. Things that come from our subconscious that could be original and creepy. Everett Peck was so talented and did such great work. Everett and Gabi were a great team. Most of my favorite creatures in *Real Ghostbusters* came from Everett Peck. Initially, I had him doing human characters as well, but the Japanese animators pushed back, warning me that they might not fit in. Ultimately, I capitulated. Because Gabi had designed the principal characters in a more conventional style, and I saw the logic in being consistent. That being said, in some of the early episodes, you can see the human characters designed by Everett. And I don't think it was that bad. But the creatures are so great."

> "Michael Reaves would do the scary stories or when they needed science fiction. Richard Mueller would write the action shows. We were the ones they'd come to when they needed weird stories."
> —DENNYS MCCOY

"Everett's style was so particular to him in terms of his crosshatching kind of line work and modeling his figures with a line-work style. That just couldn't be done overseas," says Bruce Zick. "They would translate it into a flat outline shape. We were trying to find a way to take his approach to characters and also see that work into the actual animation, which wasn't possible."

As with the promo pilot, Richard Raynis's home became a second office where a lot of the artists could complete their work. "We did most of the work at DIC, but we would go over to Richard Raynis's house on weekends to refine things," says Gabi Payn.

"Richard is a great artist himself and is in some ways a perfectionist; he doesn't want to compromise," says Ken Duer. "I was with Richard for pretty much my entire time at DIC. His team was close knit, and his belief was that if our preproduction materials were spot on, then the animators would have an easier time animating. Which is true. In animation, you don't want to overdesign. It has to be simple. Because the more design details there are, there's more pencil mileage that the animators have to do. You really have to think about that. With a short schedule and the limited budget we had, we wanted to make sure that five hundred people down the line would have an easier time. They're up against the same schedule we are."

"I was twenty-eight years old with very little experience, but I think I did aspire for us to make good stuff. That was my mandate for this," says Richard Raynis. "The constraints of budget and schedule weren't always conducive to that, so sometimes it seemed a little like 'us against them.' Creative against production. But Andy Heyward and DIC

Chapter 1: Manifestation

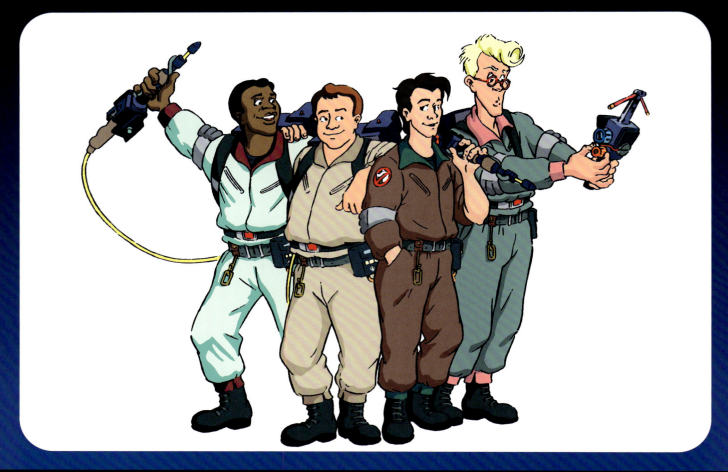

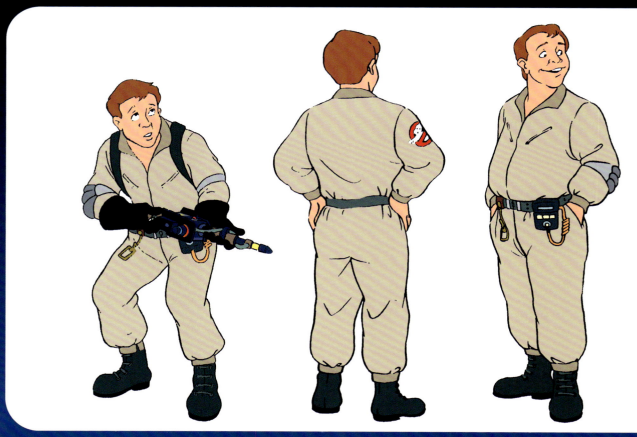

Above and opposite: Original model sheets, restored and colored by Dušan Mitrović.

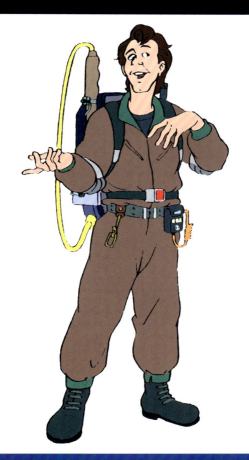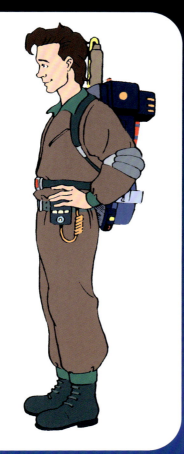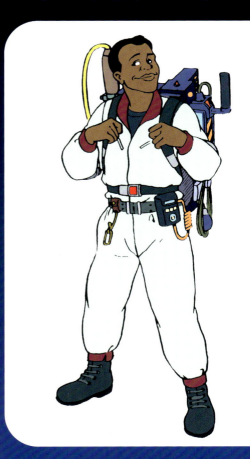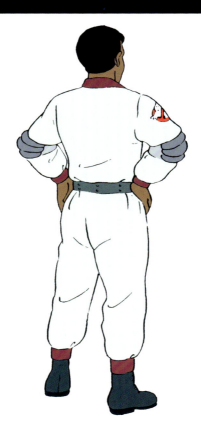

Chapter 1: Manifestation 45

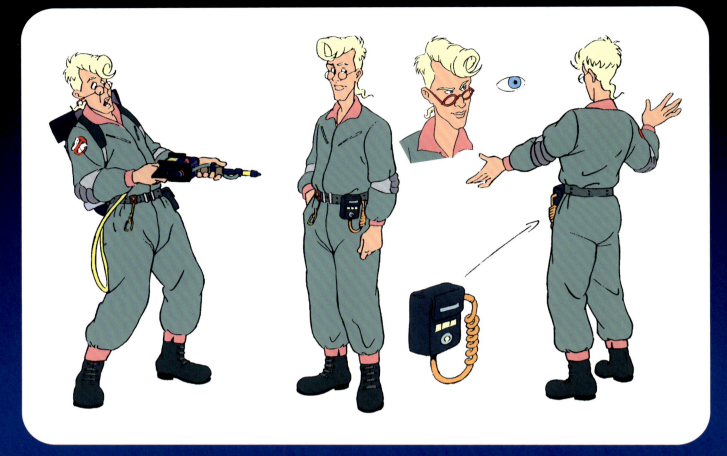

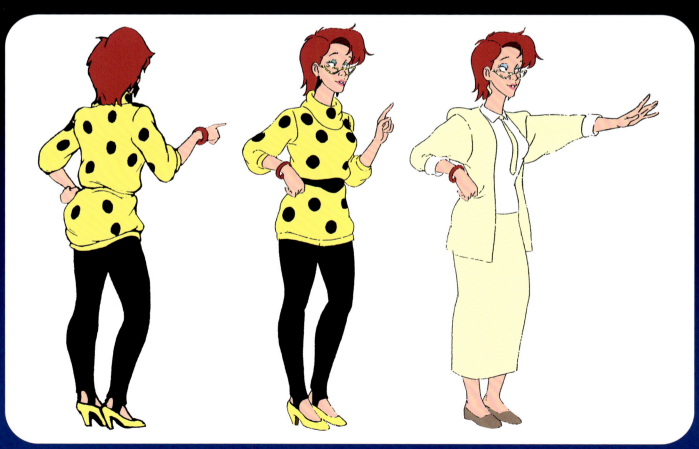

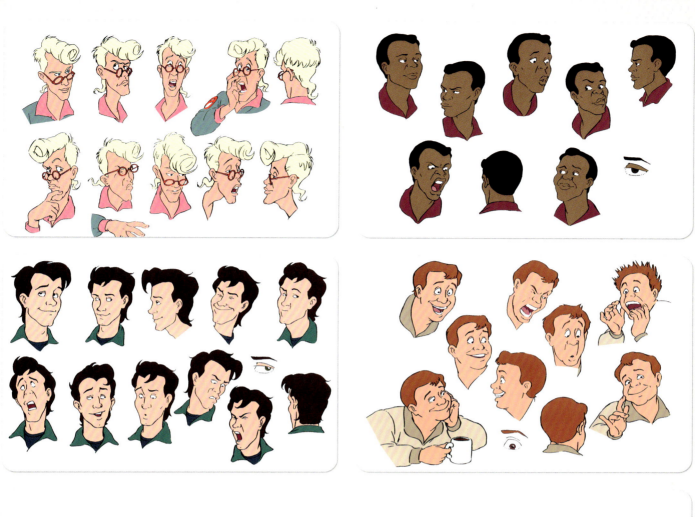
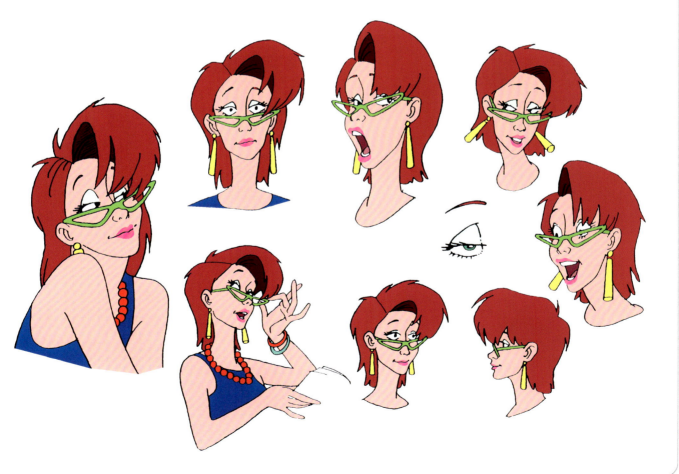

Above and opposite: *Original model sheets, restored and colored by Dušan Mitrović.*

THE REAL GHOSTBUSTERS

"WHATAYA WANT?" ECTO-1

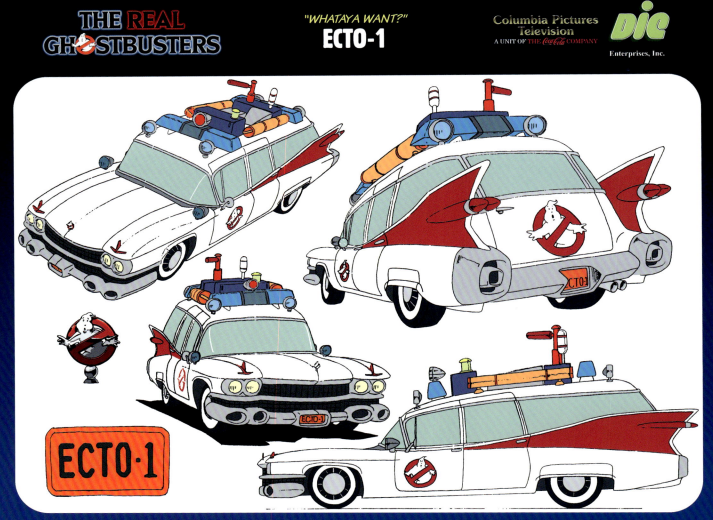

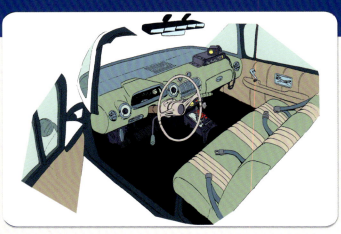

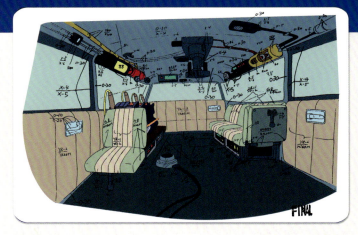

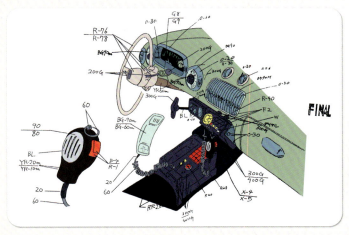

THE REAL GHOSTBUSTERS

"WHAT'S YOUR EMERGENCY?"
SLIMER

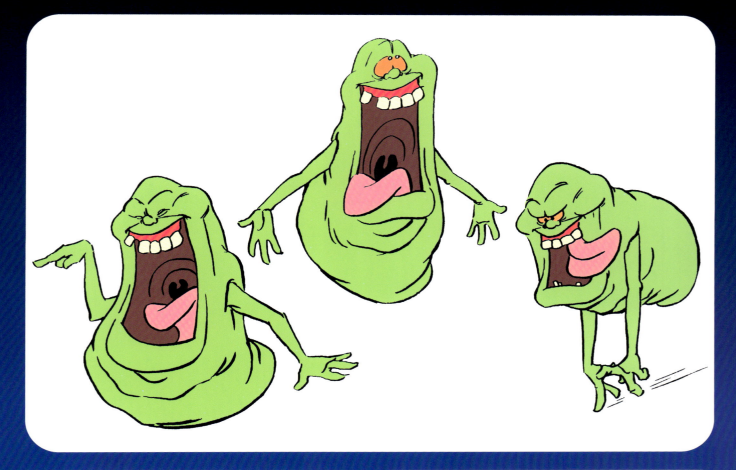

Above and opposite: *Original model sheets, restored and colored by Dušan Mitrović.*

Chapter 1: Manifestation

really benefited from the good work that we did, and we enjoyed the opportunity. So I believe in the end, it was good for everybody."

"Everybody just wanted to do so much," says Bruce Zick. "We figured if we gave the Japanese animators 150 percent, and maybe we would get 50 percent of that back—so we'd end up with 75 percent of the detail that we wanted. Which would be a pretty good compromise."

Major design changes and choices were implemented quickly. The four primary Ghostbusters sported khaki flight suits in the promo pilot just as their live-action counterparts did; however, a creative decision was made to differentiate each Ghostbuster for the main series. Venkman's suit became a deep brown, Ray's a contrasting tan, Egon's a dark blue green, and Winston's a light blue. "The uniforms all had to be different colors so that they would stand out in the long shots,"

said Michael C. Gross in the Time Life DVD set. The design intention to make the characters stand out from far away was also why Egon's hair was changed to a blond color. "But also, when we set out to design the characters for the series, all of the changes in the characters were made because of the toys. If you're going to put out four character toys, they can't all be guys in gray suits with dark hair. We took each of them and gave them a little bit of instant identification. That does help in the animation, but the different-colored suits were partly for the animation and so that we could have toys where you could identify the characters."

Visually the series was taking shape and changes were quickly implemented, but it was important that the heart of the project remain true. From the top down, the importance of tone and structure was impressed upon the writers, artists, and cast to make sure that what made the live-action film so successful and unique was still in the DNA of the animated series: horror and comedy. "We wanted the scary parts of *Ghostbusters* to be scary," says Joe Medjuck. "We didn't think of *Ghostbusters* as a movie for kids. So when *The Real Ghostbusters* came along, we took kids into consideration, but never aimed it directly at them. Obviously, we weren't going to have swearing or whatever else. At that time, I had two kids. Mike had kids, but they were older. We had a good sense of where to aim the target. We kept the scares and the humor the same as the film. We just made the show so that kids could watch it."

"*The Real Ghostbusters* didn't treat horror the way *Scooby-Doo* does," says Jason Reitman. "It wasn't afraid to have moments that were actual jump scares. It tended to lean into being scary. And introduced villains that were unusual

Above: *Abstract backgrounds like those created for the Boogieman's netherworld could be envisioned however the artists wanted.* Opposite: *Black-and-white "Boo York" background by Bruce Zick.*

50　The Real Ghostbusters: A Visual History

and made us uncomfortable as kids. It bent our sense of the universe and that's really spooky as a kid."

Kathryn Drennan points to the words of C. S. Lewis, who believed writers shouldn't write for children in the same way they would write for themselves but also shouldn't write stories adults would find boring or vapid. Lewis wrote: "We must write for children out of those elements in our imagination which we share with children."

"I think that pretty much sums up how *The Real Ghostbusters* was written and produced," says Drennan. "Everyone knew that *Real Ghostbusters* was fundamentally a kids' comedy series, but one with science fiction elements in an action-adventure format. We were, of course, constrained by certain obvious rules: no swearing, no sex, no graphic violence, and don't bore kids. But beyond that, the writers were free to write the kind of stories that we had wanted to read or see as kids and still enjoyed as adults. And to do so by combining all of those series elements into stories that we hoped were entertaining and appropriate for children but also entertaining for adults."

But standing in the show's way of a mature and challenging tone for younger viewers, particularly for the ABC Saturday morning episodes, was the ever careful and cautious Broadcast Standards and Practices: the department at the network responsible for making sure that anything going to air adheres to FCC rules and guidelines but is also "appropriate" for what the network has deemed the target audience. "With the network show, it was even just hard to refer to something as a ghost," says J. Michael Straczynski. "The show was called *Ghostbusters*, and we had to call them monsters or projections. The nervousness was that they didn't want to frighten children, and the word *ghost* would do that. That's why things like the Sandman and other monsters were introduced to the show. But in the syndicated show, we were free to say, 'These are dead things, and they're coming for you.'"

Because they were not being created specifically for the ABC Saturday morning lineup, the syndicated episodes didn't have to pass the network's stringent standards. Removing that extra layer allowed these stories to breathe and venture into territory the network episodes were unable to explore. Which was also advantageous, because the syndicated episodes had to work at three, sometimes four times the production speed of the network ones. The stories had to be good right out of the gate because there wasn't time to start over from page 1. "I find the storytelling in the syndicated episodes stronger, while the network is hit and miss," says James Eatock. "Len and Chuck were creating Saturday morning cartoons based on a popular movie. Straczynski was trying to create a TV series that directly followed the movie. The network constantly was trying to make the antagonist ghosts these big, bad, end-of-the-world Gozer types to adhere to the movie's structure. The syndicated shows utilized the ghosts for more of the human drama. 'Ragnarok and Roll' is an end-of-the-world-stakes episode, but it all comes down to a man who has been jilted by his girlfriend and he's taking it out on the world. You don't get that drama in the network episodes."

"The syndicated show just kicked ass," says Dennys McCoy. "Cheaply animated, but the best stories. People let us be as funny as we wanted to be."

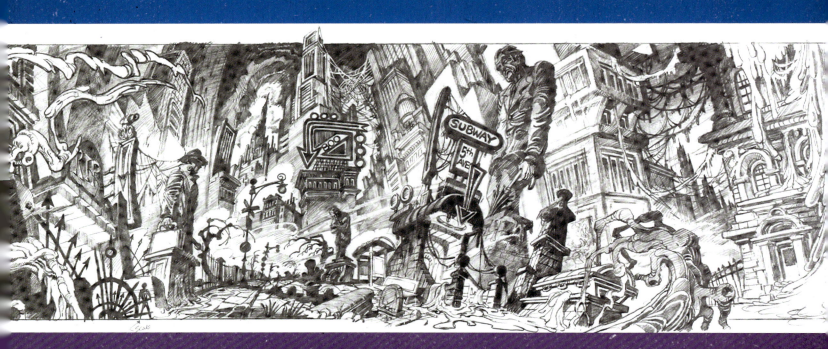

Background design by Bruce Zick.

Says Richard Mueller, "If you could write a good script and do it fast, that's all that counted. So we were able to do Lovecraft references, Greek mythology, and I even got to write a script where a living person passed into the spirit world, called 'You Can't Take It with You.' We used elements of everything that could possibly work." The syndicated writing staff also reached into the long history of literary works of all kinds and genres as inspiration or springboards from which episode concepts could originate.

This led to *The Real Ghostbusters* dipping toes into science fiction, fantasy, noir, westerns, and even taking on tropes of animation genres throughout the first season. Takes on Sam Spade, *Citizen Kane*, and kitschy 1950s alien invasions were all fair game when it came to the syndicated episodes. "It didn't matter how obscure we got, how weird we got, we were allowed to do anything we wanted to. That's such a rare opportunity in television. And to have Joe Medjuck and Michael C. Gross back us up and actually mean it, I think, is why the show holds up as well as it does. Because it's sophisticated, intelligent, and it's written incredibly well. My position with *The Real Ghostbusters* was to point to the old *Looney Tunes* cartoons, because they were written on two different levels," says J. Michael Straczynski. "Simple level for the kids to get the action of it. But if you watch as an adult, you've got more meaning, you've got more consequence. Things popped out that wouldn't have when you were much younger. I wanted to make sure that we weren't doing things that were so obtuse that kids couldn't follow it, but they also understood that there's more going on. My sense is that kids in general are smarter than television executives give them credit for. When they watch a show that isn't talking down to them, that isn't pandering to them, that sort of challenges them up to the level of the show. And I've heard from so many fans of *The Real Ghostbusters* that they liked the series because it wasn't predictable. They had to bring their A-game to figure it out. When you respect your audience, they will become very loyal to you very fast. And I think that's the whole reason why kids really reacted to the show as well as they did. Granted, we did get kind of obscure from time to time. We once referred to a [member of a] group involved in a ceremony as an Inuit minion. And you really have to parse that; like, ten people in the country probably got that. But it never got in the way of the story."

"I think that often, producers and writers think that audiences aren't particularly smart and they have to explain everything," says Steve Perry. "The truth is, you don't. With *Real Ghostbusters*, we never explained any of that stuff. 'Don't cross the streams'—the audience didn't have any trouble following that at all. I love *Star Wars*, and the opening crawl has become iconic, but that's really a no-no thing in science fiction writing. You don't need an intro or a voice-over to explain it to the people who aren't smart enough to keep up. They wouldn't be watching if they weren't smart enough."

With the show exploring subjects of the occult and paranormal, it became somewhat of an enigma for ABC's Broadcast Standards and Practices (S&P). "I still have the notes from Standards and Practices where they wouldn't give me a pass on the reference [to the Necronomicon] in 'Russian About' because they insisted it was a real occult book," says J. Michael Straczynski. Though the book had appeared in "The Collect Call of Cathulhu," when Straczynski wanted to use it in a network episode, he was told absolutely not by S&P. "I kept telling them that H. P. Lovecraft made it the fuck up. Finally, I went to [ABC's] Ame [Simon] and Jennie [Trias] with proof positive of the first references to it in Lovecraft's work. They told me that once S&P's decision is made, you can't correct them afterward. Really? That's when the Necronomicon became 'the Nameless Book,' and I declared war on S&P. Whenever I had a chance to get in a fight with them, I took it."

"[Straczynski's] rant at that table on that day still resonates in my head," Michael C. Gross said in the Time Life DVD. "I remember that very well; it was the angriest I'd ever seen him."

"The late Gordon Bressack always wanted to do an episode of *Real Ghostbusters* desperately," says Dennys McCoy. "But he and Straczynski are strong personalities and he could never get past Joe, but he finally sold one to Len and Chuck. It was 'Very Beast Friends' that was basically the God of War coming down to land. It's a great script. The weekend it was supposed to air on ABC, they pulled the episode and postponed it because of Operation Desert Storm."

"And Gordon never shut up about that," says Pamela Hickey. "He's probably in the great beyond, still yelling about it."

The network always had a hand on their shoulder, but the syndication episodes didn't have those constraints. But even they endured scrutiny of what was and was not appropriate for children. "We got flak on 'Play Them Ragtime Boos,' which was set in New Orleans," says Steve Perry. "I'm from Louisiana, I went to Mardi Gras every year and had all that background in my past to play with. Reaves and I thought we could tell a great fish-out-of-water story

> **"They would read scripts and they weren't very visual, so we would have to be like college graduates and be extremely descriptive on how we wanted everything storyboarded. We couldn't have them use their imagination, because they didn't have an imagination. They were executives."**
> —DAN RIBA

by taking the Ghostbusters out of New York and dropping them in the middle of the swamps. To this day I'm still not sure why they didn't want to do it. Straczynski never told us why. But he told me to do it anyway, because he thought I could pull it off."

"The network show was depressing. It was so conservative," says Dennys McCoy.

"The two executives were very conservative. They would have been elementary school teachers had they not been executives. We couldn't have done 'Boo-dunit' or 'The Devil to Pay' on the network," says Pamela Hickey.

"ABC had a lot of control," says Dan Riba. "They would read scripts and they weren't very visual, so we would have to be like college graduates and be extremely descriptive on how we wanted everything storyboarded. We couldn't have them use their imagination, because they didn't have an

Left: *"The Nameless Book,"* which was a point of contention between Straczynski and Broadcast Standards and Practices. Right: *Dytyllio from the episode "Ragnarok and Roll," named after the late Larry DiTillio.*

Chapter 1: Manifestation

imagination. They were executives. But I'm also floored that the network episodes were able to get away with the horror that we did, because ABC also had the tightest of broadcast standards and practices. They could be difficult to get things through on other shows. But on 'Ghosts R Us,' we had jump scares, and 'Mrs. Roger's Neighborhood,' we had her transforming in the shadows. It's horrific and really, really cool. But it's exactly the type of thing the network would worry about making kids uncomfortable with. But then I just realized they did come in and ruin everything. In the next season they had this group, Q5, that came in and really put their foot down."

What's in a Name?

Hundreds of adoring extras packed the sidewalk and street in front of the towering apartment building at 55 Central Park West, all chanting, "Ghostbusters! Ghostbusters! Ghostbusters!" Cameras rolled. Celluloid was consumed. Physical effects destroyed the street. And the four A-list lead actors heroically marched into battle. It was big, it was epic, it was expensive. At that moment, Joe Medjuck knew the title *Ghostbusters* had to be cleared by the Columbia Pictures legal department for use. None of the multiple alternatives that had been used on the production up to that point would suffice. "There was a pay phone near the set, and I had to call in to the studio during filming to tell them that I couldn't get four hundred extras to chant alternative titles in unison and they had to make a deal," Medjuck says. Blocking a quick legal clearance, of course, was Filmation and their trademarked 1975 series, *The Ghost Busters*. It is

Everett Peck's design for Wat in "Mrs. Roger's Neighborhood."

quite possible the rivalry that would see the two creative houses jockeying for position at NATPE in 1986 began on that day. But up until the 1986 rivalry, that wasn't the case. There was a cordial relationship between the two. In fact, Columbia Pictures and Filmation were proud partners.

Brokering that deal were none other than Herman Rush for Columbia and Lou Scheimer for Filmation. On January 23, 1981, two years before *Ghostbusters* went into production, *Back Stage* magazine announced Columbia Pictures Television and Filmation had agreed to a nonexclusive production and distribution arrangement whereby Filmation would produce new animated programming to be distributed by the studio. "Filmation is one of the industry's most important animation houses and Columbia is proud to be associated with them," Rush stated for the article. "We at Columbia are looking to expand our non-prime-time programming and this association is an important step in that direction."

By June 26, 1984, two weeks after *Ghostbusters* was released in theaters, the partnership had all but soured. Filmation and Columbia Pictures found themselves before a judge in the Los Angeles Superior Court, battling over the use of *Ghostbusters* for the film's title. Said *Variety* at the time, "Terms of the settlement prevented the parties from disclosing details, but it's understood Columbia was willing to pay for having used the title on its successful feature." An open door was left in the agreement for Filmation to sell the studio on a related animated series. But the relationship had fractured. That show never materialized.

Instead, Filmation began working on its own *Ghostbusters* show outside of the studio's umbrella, with a pilot script finished by July of the same year. When Columbia Television planned an animated iteration of their *Ghostbusters* property, once again the title became a major battleground. In the August 28, 1985, issue of *Variety*, John Dempsey wrote that Columbia Pictures Television was readying their animated series, saying that it would "spark a major clash," as Filmation had already announced a *Ghostbusters* series to debut in 1986. The writer surmised that Columbia's show would need to utilize a revised title, like *The New Ghostbusters* or *The Real Ghostbusters*, to avoid confusion and to honor the agreement made for the live-action film.

"We had to distinguish our show from anything else," says Joe Medjuck. "*The Real Ghostbusters* immediately stood out and said, this is the one people want to see."

> **"'Well, let's start with what we've got. We've got the real Ghostbusters—' And Woollen says, 'That's it, we'll call it *The Real Ghostbusters*.'"**
> —JOE INDELLI

Multiple people on the production have different versions of how the prefatory "The Real" in the title came to be. "When we found out that we couldn't use just *Ghostbusters* as the title, my boss at the time, Herman Rush, just came up with the idea to call it *The Real Ghostbusters*," says Rick Rosen. "The movie was such a phenomenon, and it made a distinction between the one based on the film and the preexisting one."

"I'm sitting around with a marketing guy named Dick Woollen trying to figure out how to differentiate our show from Filmation's before we go on the air," says Joe Indelli. "And I said, 'Well, let's start with what we've got. We've got the real Ghostbusters—' And Woollen says, 'That's it, we'll call it *The Real Ghostbusters*.'"

In 2012, Lou Scheimer told author Andy Mangels for his book *Lou Scheimer: Creating the Filmation Generation*, "I've often been asked why we just didn't make a deal with the studio ourselves and do a single project. I'll tell you: I tried. The guy who was running television at Columbia was Herman Rush, and he used to be an agent for Filmation. Nice guy. After the *Ghostbusters* film made it big, I went to Westinghouse and said, 'Why don't we do 65 half-hours based on our *Ghostbusters*?' And we decided to do it. And then I got a call from Herman to tell me they were thinking of doing their movie as a syndicated cartoon as well. So I talked to Ed Vane, the head guy at Westinghouse, about going down to see Herman. I said, 'We should really make a deal with them to co-produce the show. If we don't make it with them, they have every right in the world to go out and do it without us. I'm a friend of Herman's. We can make a deal to do the show, and they'll pay for half of it, we'll pay for half of it, and everybody will be happy.' But Ed said, 'No, we don't need them.'" Vane believed it would be a "headache" to deal with all the people who had worked on the movie and suggested they just create a show based on *The Ghost Busters*. "It ended up confusing the hell out of everybody."

"I remember the late, great Lou Scheimer saying that one of his biggest regrets was that Filmation should have just gotten the animation rights to make a version of *Ghostbusters* true to the 1984 film," says James Eatock. "It's so funny; there's an alternate universe where Filmation made a movie-accurate version of *Ghostbusters*. It may have been quite good. They could have reused the stock system so perfectly, with the same body for the four guys. I always wonder if Filmation hadn't done their own version of *Ghostbusters*, would they have been in a better state going forward?"

The Weight of Time

The first network episode of *The Real Ghostbusters* was scheduled to air the second week of September in 1986. That was thirteen episodes to be done in less than ten months from the start of production. A feat in itself, if that were the only challenge for the creative team. However, the syndicated episodes were slated to start their daily rollout the following fall in 1987. The same month, a new network order of ABC episodes, referred to in this book as "season 2," would also debut.

Sixty-five episodes of animation needed to be done concurrently with the first and second ABC network orders in less than two full years. Even by today's standards, with an expedited animation process thanks to a digital workflow, that volume of episodes within such a short amount of time is unheard of. It's a relentless and unyielding tidal wave of work.

"Five episodes per week, that's crazy. If you air five episodes per week, we had to put into the animation pipeline five episodes per week. It was just totally insane," says Winnie Chaffee.

Each and every person from production assistant to executive producer was up to the challenge of putting in the hours and forgoing life outside DIC in order to get things done. "We just really felt that this was an opportunity to showcase who we were as a team of artists. This was the opportunity to make a name for ourselves," says Bruce Zick. "Everybody worked extra hard and put in crazy hours. I remember at one point, Richard wanted me to work on Thanksgiving weekend. It was some side ancillary thing, so I pushed back. He said, 'We've got a deadline, it's got to be done.' Everybody was just going to do whatever it took to make this exceptional. That was the attitude, and I think a lot of that came from Richard. Richard really set the challenge to everybody."

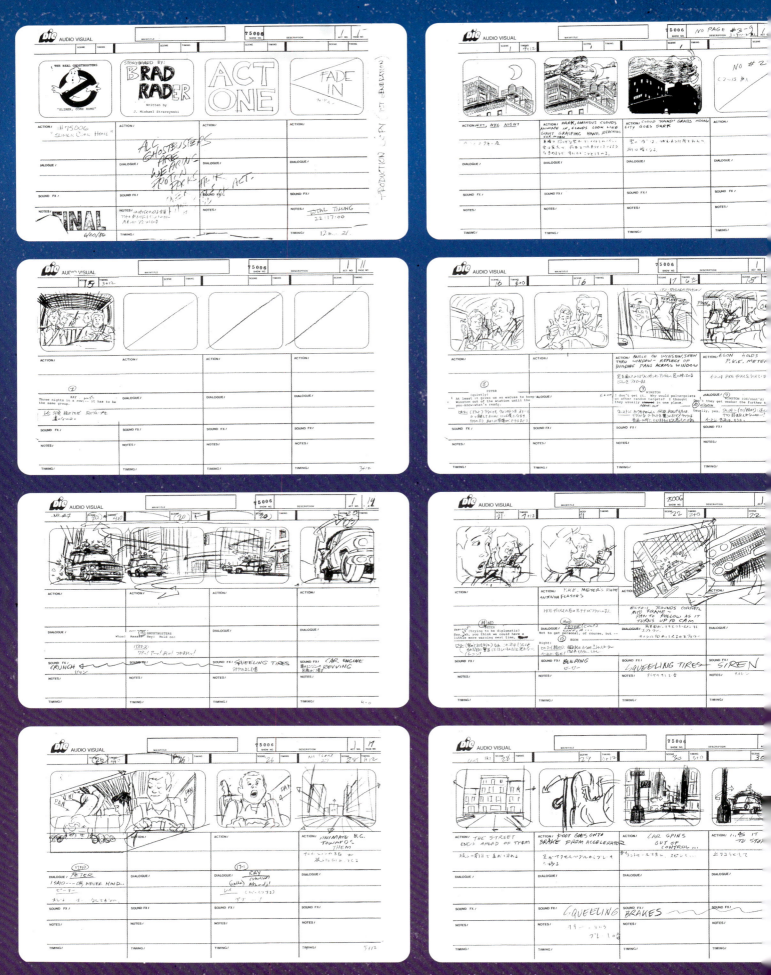

Brad Rader's storyboards for "Slimer, Come Home." Because episodes had to be produced so quickly, storyboards were among the most important production elements needed to keep the machine running.

56 The Real Ghostbusters: A Visual History

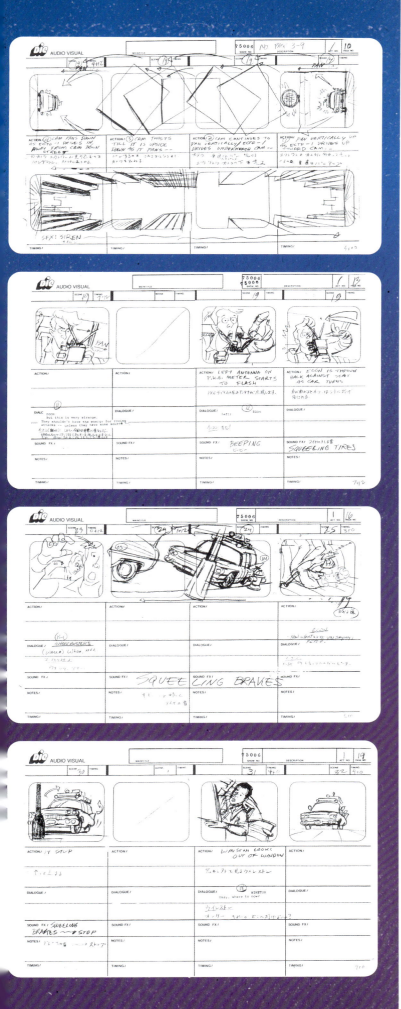

"Some people were sleeping in the studio. To tell you the truth, I would never want to do a schedule like that again. But we made it," says Gabi Payn. "Every day we were starting a new show, we were going crazy. We were working weekends, overtime, but we were having so much fun. I really loved working with Kevin, Dan, Marek, and Phil. You looked forward to work every day. But in those days, we were young and we were just doing it. I wish it could have lasted forever."

"I calculated that the average age of the production team was around twenty-five," says Chaffee. "I was the oldest one." Chaffee jokes that many of the artists blame her for taking years off their lives during *The Real Ghostbusters*.

"We worked ten to twelve hours a day, every day of the week, until the season was over," said Len Janson on the Time Life DVD set.

"We were working sixty-to-seventy-hour weeks on *Real Ghostbusters*. And I don't regret it at all," says Brad Rader. "If you think of the Beatles being in Hamburg and playing two shows a day in a GI club, that's how they got good. That's how I look at that period of time. I went from barely being a professional to working on *Batman: The Animated Series*. We were a crew. We were a team. And we all got really good."

"Richard Raynis told *Variety* for DIC's twenty-fifth anniversary that we were a cauldron of creativity of young people," says Andy Heyward. "How many young people got started at DIC in those days?"

"The thirteen network shows got written first because of the deadlines," says J. Michael Straczynski.

Says Dan Riba, "When you're done with the network shows, then it's all the syndicated shows. Because of the way the network episodes were scheduled, it was very seasonal. When my thirteen network episodes were done, they put me on designing characters for the syndicated series. The syndicated team would get about four scripts a week. There would be a crew of character designers, and some background designers would immediately start loose, rudimentary designs. Then they would send these roughs of the character designs, backgrounds, anything we had time to do, to a firm in Japan that would do the storyboards really quickly. Those would come back really quick, and the storyboard supervisor would have four entire shows on his desk to take notes, revise and fix things, and adjust on those four shows before the week ended. That was grueling. The pace the syndicated episodes were running at, it's remarkable those shows were even made, let alone that they had any quality whatsoever."

Chapter 1: Manifestation 57

"*The Real Ghostbusters* was Colette Mierlo's first job. I remember her being really bummed about the heaviness of the workload. She was thinking about quitting," says Rader. "I told her about being fired from my first job at Ruby-Spears and how difficult it was to find work after that, and told her to really stick it out."

"It was nuts. When we were still in Studio City, I remember the air conditioning didn't work in the studio," says Richard Raynis. "Then when we went into production on the series, we moved to Balboa. Which at least was a little more pleasant. But my unit was way down the hall on the other side of the building. And we didn't have a Xerox copy machine. I ended up buying one with my own money, so that my crew wouldn't have to walk across the building to the other side just to make copies."

"We were so stressed out that I got everyone together to skydive," says Chaffee. Skydiving may sound like a great release of tension and a way for the *Real Ghostbusters* crew to blow off some steam, but then think about artists under deadline placing their hands, arms, and bodies into the risky situation of falling out of the sky. It made certain people nervous. "My boss, Andy Heyward, called me the night before asking me if I was crazy, taking the whole animation team out to go skydiving. Yeah. He was a little

Despite the risk to their talented artists' hands, the DIC animators turned to skydiving to release tension.

58 The Real Ghostbusters: A Visual History

right. We were young and we didn't know any better. My assistant had multiple fractures in her legs from falling. But that adrenaline was pumping from the scariest moment of everybody's lives, and we went back to the studio and continued to work. The adrenaline lasts for two or three days, and you can't sleep."

Not only did the skydiving trip help the team bond, but it scared the hell out of them just enough to help them stay awake a couple more working days. "That was the first, and last, time that I've gone skydiving," says Dan Riba.

"In the midst of the craziness, I think we all wanted out for a few hours. Skydiving was like a good team-building thing, but we also went to a scuba diving class. Once we tried to put together a bungee jumping thing, but that got canceled because of the weather. We would work until six or seven. Then we'd go out to eat, come back at eight or nine, then leave at three in the morning. Then start all over again at nine or ten the next morning. That was quite normal back then. It was a lot of fun. And I think that's the only reason we stuck around for it," says Ken Duer.

"*The Real Ghostbusters* was this incredible incubator for talent," says Dennys McCoy.

"I think we finally got into a good groove," says Joe Medjuck. "Seventy-eight scripts is fucking insane. But we had really good writers. And the division between Joe Straczynski, Len Janson, and Chuck Menville was great. Michael Gross and I really got along with them. The first year was tough, but I also think that everyone got pretty good at it after doing seventy-eight shows in one year."

Storyboard artists would be handed scripts and were expected to have the full episode boarded no more than two weeks later. "It was grueling. What helped was that I really liked working with Gabi's character designs, Everett Peck's ghosts, and Bruce Zick's backgrounds," says Brad Rader.

"I always want to work with the best people to get the best-quality art. I loved seeing what designers like Bruce, Everett, and Marek created every week," says Richard Raynis. "I really appreciated the incredible and eclectic

Once elements were provided to the overseas animation studio KKC&D, backgrounds, layers of cels, and more had to be produced at a rapid rate by the Japanese animation studio. Seen here from "Trading Faces," a background layout and the multiple layers that had to be assembled for the final shot.

art. I thought the more great stuff we could get into the show, the better."

"The caliber of the work was so incredible that it made me have to produce up to that level. Even though financially there wasn't a lot of money working on those shows back then, seeing who you were dealing with and what the standards were, you just couldn't do any less," says Bruce Zick.

"It was fun staging, especially the firehouse," says Rader. "Everything in that location had to be connected, hooked up, and logical. You had to be aware of how one room fit into the next across two floors. One of my jobs as an uncredited storyboard supervisor was keeping track of all the freelancers' work because they wouldn't be hip to that. They didn't have the geography. It was difficult but fun in a way."

Once the episode was completely boarded, it would be provided to Michael C. Gross for approval. Every single design and every single board passed Gross's desk over the course of the entirety of the series. After his notes, the artists would have another week for revisions and cleanup. Sound recordings with the voice cast, character and background reference drawings, and painted backgrounds would then be packaged with the storyboards and sent out to the animation studios in Japan.

In some cases, the Japanese animators would also be responsible for storyboarding sequences and sometimes even entire episodes that the United States–based team were unable to handle. "At the beginning, all of the overseas animation was handled by KKC&D, which was also a part of DIC," says Winnie Chaffee. "They always really tried to make the animation a very simple style, and the models that our artists had created were very complicated for animation. KKC&D had a hard time animating the characters. It would take longer and we were always missing the schedule. I had to go to Japan so many times because they were behind."

"We bring the blueprints, we bring the specs, and they execute against that," says Andy Heyward. "They were a factory." Two to three hundred artists were involved on the Japanese side for one episode, ultimately creating and filming eleven to thirteen thousand cels per episode plus about four hundred background drawings.

"We missed some airdates because the Korean and Japanese studios were dealing with typhoons and floods;

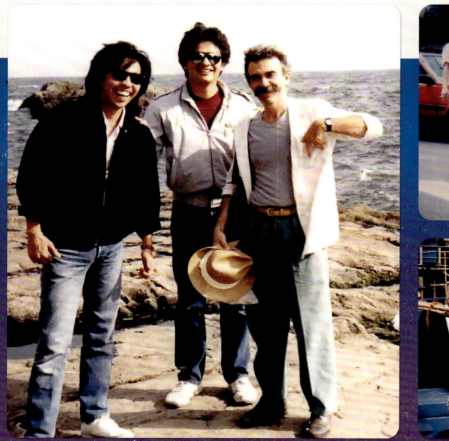

Left: *Ken Duer, Richie Chavez, and Marek Buchwald pose near the shore in Japan. The DIC artists were sent in 1986 to interface directly with the KKC&D animation team.* Top right: *The KKC&D animators responsible for* The Real Ghostbusters.

animation papers were just being washed away," says Chaffee. "There was a company that went bankrupt, and I had to run to Korea, get a few friends there that I know, and try to save our animation papers. All those things that I think back on, and it was just so crazy, so unreal."

The language barrier was difficult to overcome between the Japanese and American creative teams, even with multiple translators involved in the process. And the time difference between Pacific Time and Japan Standard Time meant that DIC animators were clocking out for the night just as the Japanese teams were pouring their morning coffee. It was more efficient for the department heads at DIC to travel to Japan to interface with the larger animation team directly, an opportunity that many of the artists enjoyed. "We had to design two syndicated shows a week," says Gabi Payn. "They sent us to Tokyo because they wanted us to be closer to where the work was being done. Tokyo is amazing. I love it."

"I started at DIC in 1984 as a translator, because I was born and raised in Japan and am bilingual," says Ken Duer, who assisted Chaffee in supervising the production as an associate producer. "Because we had KKC&D in Tokyo, they were looking for ways to lower the budget and the costs. They came up with an idea: the US side would do the scripts and the recording, but everything past that, until postproduction, would be done in Japan with the Japanese animation team and a director. Being able to speak to the Japanese directors, I was part of a small team including Marek Buchwald, Richie Chavez, Gabi Payn, and Dave Rodriguez to be stationed in Japan and work with the studios to do all the preproduction on the syndicated package."

"It seemed like the best solution to have a small creative team in Japan working with the Japanese," says Richard Raynis. "Marek would art direct and create these beautiful stylized pieces that gave creative direction, and then the Japanese animators would turn that into a really solid package."

"It ended up being more efficient in a time when we didn't have the internet or email," says Duer. "Back then, everything had to be shipped via air cargo. For example, we would put all the elements together and ship it and that alone, including the customs clearance, would take a week before the studio could pick it up and start working with it. Sometimes we would have to do a hand carry, because it was quicker to fly someone with the film back and forth. Having someone there, basically taking the materials and distributing them to smaller studios, made more sense."

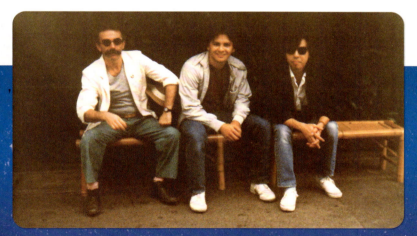

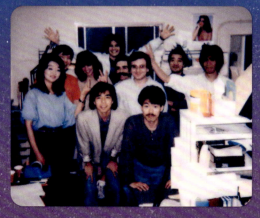
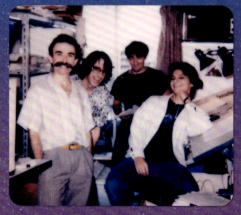

Top right: *The DIC animators' Japanese apartment building.* Bottom right: *Marek Buchwald, Gabi Payn, Christian Choquet, and Richie Chavez in a small KKC&D office.* Bottom middle: *The American, Japanese, and French DIC and KKC&D teams pose together.*

Chapter 1: Manifestation

3rd floor
2nd floor
Reception area

"Marek, who was the art director, had been sent to Japan, and that left a vacancy. I was brought in to fill his spot as art director on the show," says Bruce Zick. "When I came in, a lot of the key art had already been established; they had been working for months. I was in charge of overseeing the first episodes going into production."

"I discovered anime when I was working at DIC because everybody on the crew was hardcore into anime," says Brad Rader. "One time I asked Kevin Altieri what to do when I'm not inspired, and he told me to watch anime. So, I got a VCR and a bunch of dubs and was watching a lot of anime at the time we were working on *Real Ghostbusters*. One of the films was *Golgo 13: The Professional*, which really influenced me then. It was a super-limited animation, done with a lot of held cels, a lot of swish-pan backgrounds, and it was really educational on how to break up action and extend time. And the animation was relatively cheap. They saved money on backgrounds by doing a lot of backlighting. If a character was in a doorway, the exterior would be all bled out by light coming through the door. It was very economical and very effective. We wanted to do that. So I would sit with Kevin and ask him how they would storyboard certain shots from anime films. Figuring out how to call for shots and what we wanted in such a way that we might actually get it from the animation studios. Eddie Fitzgerald, who was also doing storyboards on *Real Ghostbusters* for a while, influenced me with his attitude toward the quality of the drawing in the boards. He said, 'No one's ever going to see this. A beautiful drawing is not the point. In fact, the less time you can put onto the drawing,

the better.' He was almost macho about it. The thinking was solid. That all changed in the second month or two when they brought in a cleanup artist who had been a comic book artist to clean up my work. Then I was just cranking like a madman but all in blue pencils. And other people were coming behind me and cleaning up the boards. But I remember we had a problem with one of the overseas Japanese directors. He was always really critical of our work and complaining—making us redo things. He was like my bête noire, who I harbored a great deal of resentment against. Later in 1988, they sent me on a hand carry to Tokyo when I was on *ALF*, because we could get the storyboards through customs faster by hand carrying them rather than shipping them. I spent five days there waiting for network changes and finally met the director. He was just some dude. He wasn't a fire-breathing dragon or anything. He was probably trying to do a good job and deflect some of the problems they were having on their end. *Real Ghostbusters* was a big show. I can't imagine having to animate those syndicated episodes that weren't written to be any more cost efficient than the network shows. They expected all the bells and whistles."

Masakazu Higuchi was the director working in Japan at KKC&D on all of the episodes being sent through the studio, and he felt the pressure from the sheer volume that his team was entrusted to handle for *The Real Ghostbusters*. "Higuchi was in charge once all of the elements were sent to Japan; everything was then in his hands," says Ken Duer. "Richard Raynis would supervise him, then he would supervise three or four other studios and the unit directors at those studios. There were a lot of moving parts. I think Richard liked how Higuchi managed things. We all really got along quite well."

"We were codirectors on those sixty-five episodes," says Richard Raynis. "But I felt that Higuchi was so talented, and with the team of DIC animators we had sent to Japan working with him, allowing the Japanese to do what they do best worked well."

"He came to LA and we met him, and he and all the directors overseas are just fantastic. They're really wonderful directors," says Chaffee. "Sometimes we didn't know how much material we had to provide to the overseas studio in order to make their production flow smoother. The studio in Tokyo always created more materials, more model views, anything that they could do on their end, because they didn't have a solid production team per se. They acted as the central company, getting material, enhancing it, translating it, whatever needed to be done, and then they subcontracted to Korea and other Japanese studios. They were like the center hub for subcontracting."

Because KKC&D had such a large volume of work, they also had to get clever with distribution and offloading of shots and scenes in order to make their deadlines. "A lot of the animation for the syndicated episodes had to be done in Korea," says Richard Raynis. "And it wasn't at the same level as the animation from Japan. The quality that comes back from Korea now is extraordinary, but back then it wasn't."

"You hoped and prayed that your episodes went to Tokyo," says Bruce Zick. "Japan could handle a lot more sophisticated animation. When Japan started subcontracting animation, when you were the artist working on the episode, you didn't know what you were going to get back." Where things really ran into issues was when those subcontractors were overloaded and they would delegate work to sub-subcontractors, removing the animation three, sometimes *four* degrees from the animators in Los Angeles. It became akin to a copy of a copy of a copy of a VHS tape, with quality deteriorating with each progression.

"What they would do was send the work out to various other studios in Japan," says Dan Riba. "They were like the clearinghouse that would delegate to places like Kuromi, Shaft, Jade, and others. Episodes that would come back from Shaft were a very mixed bag. When I was overseas, we'd get a show from Shaft and we'd say, 'Oh no.' Sometimes they were okay. Sometimes they were terrible. We were having all sorts of issues with the second season, and Will [Meugniot] came in to help with those issues and the primetime special."

"Richard would fight with the overseas animation studios every step of the way. During the process, it was really tough. But looking back, he was really fighting for the quality," says Winnie Chaffee. "That's how you get quality work. But when I would go to Japan, the overseas directors would take me to the subcontractors and show me the difficulties they were going through. Even Richard went once so that the Japanese directors could tell him that's the way things had to be. That's the way it is."

Top: *A line-art production drawing and final painted cel of Peter in a rare moment behind the driver's seat.* Middle: *The final toned-down result in "Egon's Dragon."* Bottom: *A juxtaposition of a New York City background compared to one clearly inspired by Japanese architecture.*

"When I went with the team to Tokyo, most of the artists only knew the design process. They hadn't seen what goes into the actual animation process," says Ken Duer. "Going and actually seeing rows and rows of animators doing the animation work was wowing. They had never seen that."

"Studios would take on the work, then realize they had so much going on, they would outsource to another studio," says James Eatock. "So you had outsourcing to outsourcing. It's so hard to pin down who did what. It's unfortunately one of those mysteries, where it's just gonna be a lot of guesswork to try and figure out as best as possible. Even if you look at the initial network order of thirteen shows, 'Slimer, Come Home' is clearly done by someone other than who worked on 'Mrs. Roger's Neighborhood.' I always point out one of my favorite examples of outsourcing to different studios in the episode 'Killerwatt,' where they're in the department store and there's this amazing fight sequence where Egon looks so heroic and Peter does this epic turn and fires. It's all animated beautifully. And then the next shot looks like it was drawn by a five-year-old. Because it's clearly a different studio working on the same scene."

"You wanted to get the A-team, but you didn't always get them," says Gabi Payn. "You could tell when it was the bad team. And you could tell when it was a good team. Some of the bad ones I just find hard to watch."

"The voice actors were so good that it was almost like writing for the radio that they were putting pictures to," says Steve Perry. "Because they were farming out the animation to different studios, from one they'd get a nice, sharp, clean scene. The next studio, maybe the character wouldn't be on model and they wouldn't have time to go back and fix it. When you're writing, you don't know how clear the visuals will be, or how much expression you're going to get from an animated face. We did know that the voice actors we had on the show were really great, and they could overcome all of that."

"During *Ghostbusters*, it got crazy. We would fly back on Wednesday with the film cans and have three film editors standing by, each of them cutting an act of the show," says Ken Duer. "Typically only one editor cuts an episode, and we'd edit in three or four days. But when it got tight, we would have three editors working and the director going in and out of the editing suites to give notes. At the time, we were using a postproduction house across the street from NBC called Complete Post. We would finish the one-inch videotape master at two in the morning. I would walk across the street into the NBC film library at 3 a.m. They would satellite feed the show to New York to air on the East Coast. Then it would be on a tape delay for the West Coast at 8 a.m. There was even one time we had a helicopter fly the film can from Los Angeles Airport out to Burbank. That's how crazy it got."

It wasn't just animation errors and delays from subcontractors causing problems.

Sometimes the cultural and language barriers in the pre–Google search days would lead to some odd results. "Things didn't always come back exactly the way you wanted them to," says Joe Medjuck.

Chapter 1: Manifestation

Andy Heyward
President

October 4, 1989

Mr. Michael Gross
Ivan Reitman Productions
The Burbank Studios
4000 Warner Boulevard
Producers Building 7, Room 8
Burbank, California 91523

Dear Michael:

Although I have been very, very troubled by the problems of late on THE REAL GHOSTBUSTERS, I must frankly confess to you that I was even more concerned and troubled after our discussion yesterday.

Michael, you are not only a valued client but someone whom I've come to consider a friend over the four years we've been working together. That is why I will not hesitate to be perfectly candid.

No one is more upset than I am about the current situation on the show. It is absolutely unacceptable and will not be tolerated. Unfortunately, there exists a situation overseas which is not only beyond our control, but beyond the control of every other animation studio. I am telling you as a friend that the only way this can be prevented from happening in the future is to get a pickup early enough in the production season to ensure that we will have our choice of studios. This allows us to use a studio whose system of operating allows for effective supervision by us.

Michael, you know me, and you know the people who comprise DIC -- myself, Will, Marsha, Robby, the writers and others...we care. I honestly don't believe that anyone else is as capable or as motivated when it comes to demanding the best from our suppliers. And I off[er] ... history of working together in support of this statement.

We've be[en] successf[ul] ...
anyone's ...
are bein[g] ...
next sea[son] ...
didn't e[ven] ...
having a ...

Mr. Michael Gross
October 4, 1989
page 2

honest if I didn't share with you my absolute and honest conviction that no one can do a better job than we can.

As a partner, I would ask your good faith during this temporary crisis. As a friend, please believe that you will not get a better show anywhere else.

Now, to address the specifics of what is being done to correct our current problems and ensure that they never happen again:

1. **This Week's Show**: After an extended conversation with the owner of KK C&D (the Japanese studio), I have been assured that we will get some new footage and retakes of both our half-hour show and the 14-minute episode by Thursday. I have arranged for our post-production teams to work around the clock so as not to compromise the post in any way and still deliver the show on time. (By the way, on seeing the problems with yesterday's footage, I insisted we get specific retakes before showing this program to you.)

2. **Prime Time Special**: On a positive note, we just received the first footage in of the Prime Time Special, and it looks great! This is Prime Time Emmy material! I would like you to see this today. Will and I both agree that this is both better than the best of last year's shows, and, in fact, better than anything that has ever been done on GHOSTBUSTERS. We are very proud of it, and we believe you will be, too.

3. **The Remainder of This Season**: I have dispatch[ed] ... President of Production, Winnie ... Vice President/Chief Oper[ations] ... immediat[ely] ...

Mr. Michael Gross
October 4, 1989
page 3

preliminary negotiations with them, and we have received their commitment that they will produce THE REAL GHOSTBUSTERS on our behalf next season. (As I told you, it is essential that we commit to them now, to make sure we get them for next year.) They have also assured us that the same production teams we used last year, Mr. Akehi and company, will be engaged exclusively on THE REAL GHOSTBUSTERS next year. As you may recall, we employed a system with Toei where we had a Japanese director here in Los Angeles checking materials in concert with Mr. Akehi in Japan. Will is very enthusiastic about getting them on board now, and I have authorized him to commit to two of the best board men in town, Frank Parr and Boyd Kirkland whom he feels he must engage now or risk having not having them also next season. I might also add that Will, himself, is extremely enthusiastic about getting Toei on board.

Michael, without your support, THE REAL GHOSTBUSTERS would never have come to DIC in the first place. I don't believe that over the grand scheme of things, we've given you cause to regret your judgement or faith in us. I am asking for your support once again; to bear with us through the current situation and to work with us and ABC to ensure that this never happens again. I pledge to you, your trust will not be misplaced.

Sincerely,

Andy Heyward
President
DIC Enterprises, Inc.

AH/cg

As production issues became rampant in 1989, Andy Heyward reached out to Medjuck and Gross to smooth things over.

66 The Real Ghostbusters: A Visual History

"In 'Boo-dunit,' we wrote that, at the very end, they would have pizza. None of the animators knew what a pizza was," says Dennys McCoy. "When we got the animation back, they were eating what looked like a cake."

"There was Pizza Hut there at the time. But it was kind of terrible. The cheese wasn't very good and the sauce was too sweet. And yeah, you'd think they'd see enough movies with pizza. But that kind of thing would happen all the time. For the network shows, we were able to control the background designs a lot more. But for the syndicated shows, they would have more freedom of storytelling, but only so much time for production. So in the network shows, we'd have streets that definitely looked like New York. But on the syndicated shows, New York suddenly becomes Japan. The streets are wide, then they're narrow. Things are sparsely populated in the network shows because they didn't like to animate crowds," says Dan Riba.

"There were sometimes these little glitches when you were dealing with the overseas animators," says J. Michael Straczynski. "I wrote a piece for the character that I described as 'running out of a room hauling ass.' And the storyboards came back from Japan and all the characters were holding onto their butts as they ran out of the room. Um, no. That's not what I had in mind."

"In one of the episodes, the final script came in from LA and there was a sequence where a giant taco monster runs amok in the city, and the Ghostbusters must fight it," says Ken Duer. "In Japan in the mid-'80s, no one ate Mexican food, and [they] didn't have any idea what it was like. In Japanese, *tako* means 'octopus.' So they automatically thought it was a giant octopus monster. Marek was so angry at first, thinking the Japanese director had changed it from a taco to an octopus without our approval. I had to explain to him that it got lost in translation, and it wasn't their fault. We all laughed and asked Higuchi-san to change it. Later when the studio wanted to take me out to dinner for my birthday, I told them I wanted Mexican food. They found the only Mexican restaurant in Tokyo, and that's where I showed them what a taco was. And we all had a big laugh again."

"Ashi Productions did what I consider to be the best-looking *Real Ghostbusters* episodes," says Eatock. "'Ghostbuster of the Year' and 'Egon's Dragon' are episodes that I describe as the 'heroic-looking' Ghostbusters. They look awesome. Tokyo Movie Shinsha (TMS) was arguably one of the best studios in the '80s; they did 'Cabinet of Calamari' and 'Something's Going Around,' which have moments of fantastic animation."

"Occasionally the animators went above and beyond what I called for to wonderful effect," says Kathryn Drennan.

"'Egon's Dragon' is a good example of that. In the opening scene when the Ghostbusters are battling a poltergeist, my only description in the script was 'a legless, multiarmed specter.' What the animators gave me was a legless, multi-armed specter with what looked like trumpets coming out of its mouth, and was playing a banjo with two arms, and with another arm ringing a bell, and with yet another arm clanging a cymbal on its head, another arm beating on its drum-like body, and the sixth and final arm twirling another drumstick like a baton. I loved it, especially as it set up the musical theme of the episode to come. But a few times in my scripts, I gave what I thought was very specific detail for what I wanted and didn't get it. For instance, also in 'Egon's Dragon,' I wrote in the script a sinewy, snake-like dragon the size of a 747 with large, sharp claws capable of terrorizing New York City. My thought was to set up a real contrast between how scary it looked and how it acted like an overgrown puppy around Egon. In a few scenes, we did briefly see the scary-looking dragon I wanted. In most scenes, it was Puff the Goofy Dragon. I guess the animators read how the dragon acted around Egon, and drew it to look like how it acted. I honestly don't think this mismatch between what I thought I was going to get and what I actually got hurt the episode, but it did make it feel like the most 'kid show' and the least scary of my three episodes."

The workflow completely changed after Andy Heyward, backed by Bear, Stearns & Co., purchased 85 percent of the stake in DIC in January of 1987, with the remainder of the studio continuing to be owned by Jean Chalopin and a European-based conglomerate. *Variety* estimated Heyward's purchase at $65 million at the time. Because the Los Angeles–based arm of DIC was no longer connected to DIC Paris, nor KKC&D in Japan, *The Real Ghostbusters* couldn't utilize the resources employed for the first seventy-eight shows. "We had to break our pipeline and create a new pipeline for the new company," says Winnie Chaffee. The team that was working on *Real Ghostbusters* in Los Angeles was small, but the backup that they had in the artists at KKC&D filled in the gaps. "To this point, we were providing materials to KKC&D, then they were creating materials to send to the subcontractors. Now we had to complete the entire package. And we had to find the subcontractors ourselves. The problem was at that time those subcontractors were handling a lot of shows."

There were growing pains, and they found themselves in "production hell" in the 1989–90 season. Episodes were coming in too late to make airdates. Animation that was coming back from Japan was rife with flaws. The situation was so fraught that DIC promised ABC a compilation show for free to make amends for the issues they had that year. Winnie Chaffee was once again sent to Japan immediately to supervise the animation process at KKC&D for the episodes already started, transfer the animation for future episodes over to Toei, and keep *The Real Ghostbusters* rolling. "KKC&D helped us. I don't have anything bad to say about them; they had several subcontractors established in Seoul, Korea," says Chaffee. "The transition was really smooth. After I left DIC, I went through a lot more of those types of transitions, and they were always very tedious. Contracts upon contracts. But that was smooth."

Following the production of the original seventy-eight episodes, there was a massive turnover in the staff at DIC working on *Real Ghostbusters*. "*ALF* was such a hot TV show, and they wanted to make an animated series. Paul Fusco was a very charming guy and came to DIC and won everybody's heart. Our artists were getting bored continuing to produce a very hard show, so they said, 'Hey, that's a cool show. We want to work on the new show,'" says Chaffee. "Richard Raynis left, and it was really his team. He was a leader, like Dan Riba and Kevin Altieri. After he left, the team just scattered."

Burnout, creative tensions, and a desire to start with a clean slate on a new project drove Raynis and his team to look for greener pastures. "We were young, and we were sort of rebellious, and we felt like we wanted more creative control over the stories and writing process," says Richard Raynis. "As a team we decided to leave *Ghostbusters*, and we moved on to *ALF*."

"Richard Raynis is a unique talent and attracted very strong people," says Andy Heyward. "The two story editors, Chuck and Len, were also unique talents, and the chemistry of those guys bringing the stories, Richard bringing the visuals with his team, and having Ivan Reitman's team so hands on, they were like the puppeteers. It was a very high level of creativity being brewed up." The moment any of the ingredients that made those first seventy-eight episodes so successful were removed, the broth began to sour.

"Richard Raynis left DIC, and the core team went in their own different directions," says Ken Duer.

"They really wanted me to come back and take the show over," says Kevin Altieri. "But I was working on *Starcom* with Brynne Stephens and Dan Riba at the time, which I was really enthusiastic about. *ALF* was just getting started. And I was also helping out with *Kissyfur*. I was just so damn busy that I told them all I could do was supervise storyboards done by a whole new crew. Those artists were a bunch of wacky people they hired to try to punch the comedy of the show up. In my opinion, the realistic grounding we had in the first run of shows was what made the ghosts funny. If everyone was wacky, why are the Ghostbusters scared?"

Highlight Episode: Ghosts R Us

WRITTEN BY:
Len Janson and Chuck Menville

FIRST AIRED:
September 13, 1986

PREMISE: A trio of spectral escapees from the Ecto-Containment Unit decide that the best way to get even is to discredit the Ghostbusters . . . by disguising themselves as Ghosts 'R Us, a rival ghostbusting franchise. The plan seems certain to succeed until the fake ghost hunters run up against a creature of terrible power. Only the real Ghostbusters stand a chance of defeating this new, deadly opponent.

In some ways, given the rivalry with Filmation and how The Real Ghostbusters *eventually was kicked into high gear, it was fitting that the first episode to air would be dealing with copycat ghost hunters—thinly veiled allegories for the main characters in Filmation's show—gumming up the works for our heroes. In actuality, the first episode intended to air was* "Killerwatt," *which plays as a better primer for who the characters are, their chosen profession, and the environment around them. The animators were running at a full sprint, and* "Ghosts R Us" *looked to be near the finish line first, while* "Killerwatt" *still needed time.* "It was quite common that the order of air of the episode is not necessarily the order of production," says Ken Duer. "A lot of times you start with sequential episodes, but the first episode runs into production problems and there's a huge delay. Back then, if we missed an airdate, we were penalized. We had to air. So we would swap episodes."

"We were cranking so fast on the series that Kevin Altieri and I had to tag-team 'Ghosts R Us,'" says Dan Riba. "In order to get the episode done right, we left the studio and went to Kevin's house. I would storyboard a section, and Kevin would storyboard a section. Then I'd be doing cleanup on pages that Kevin was feeding to me. Kevin is so amazing. One person can't board an entire show unless they're Kevin. We were moving so fast, and we hadn't pinned down the character designs for the three main ghosts. We just had basic shapes. Then, when Gabi turned in the character designs and we saw this weird pickle-nosed thing among them, it was like, wow. There were so many textures. Such funny designs that ended up animating well. But completely different from what we anticipated. It was just such a blast. It was really fun."

"There's a moment in the episode where Turlock is in the toy factory furnace, and I storyboarded it so that as he's yelling and we're hearing the echo, the camera is pulling further and further away from him, and it creates this big void. It was going to be this long pullout and a quick zoom. But when the animation came back, the zoom was just too slow," says Riba. "We dealt with that a lot on the series, because the timing is very much controlled by the animators. DIC didn't have sheet timers. They would do exposure sheers and then let the animators kind of vamp on stuff. It was a very different way of working than other shows."

"I was working on the sequence where the chocolate factory explodes and all the chocolate is raining down while Slimer is filling his gut," says Altieri. "That just happened to be the day that ABC came by for a visit and that board was on my desk. They were very happy."

The show's mandate to be equal parts funny and scary is very evident within "Ghosts R Us," which has comedic, almost vaudevillian slapstick guest stars and a menacing threat lurking in the darkness. "They wanted the last monster to be really scary," says Altieri. "And Gabi was just totally overwhelmed with character designs, so when the toy monster falls into the river and emerges, that's one of my designs. I wanted it to be a cross between Cthulhu and the Trollenberg Terror."

"Working with Kevin on 'Ghosts R Us' was one of the most fun boarding experiences that I'd ever had up until that point," says Riba. "When the demon is revealed as that big eyeball thing, Kevin and I worked on that at his house, and it was just like being present to see magic happen. It was just so much fun seeing it happen in real time."

Tucked between The Flintstone Kids *and* Pound Puppies, *the hotly anticipated series' debut episode was well received and, most importantly, a huge ratings success for ABC. The initial show received a 5.6 rating with a 21 share.* "They would send us the ratings every Monday," says Joe Medjuck. "And at that time, I'd never seen a ratings sheet. I didn't know if the data was good or bad. I'd make a quip like, 'Those numbers look small to me,' and the TV people would say, 'No, no! For a Saturday morning cartoon, this is great!' But every season the ratings went up and

we kept getting renewed. So I guess the ratings were good enough."

"Good enough" is an understatement: starting with "Ghosts R Us," the ratings improved and impressed. By 1989, The Real Ghostbusters was the number one animated children's series in Los Angeles, New York, and Chicago and was renewed by ABC through 1991 for ninety-nine additional episodes—thirty-four to be sent to syndication after their Saturday morning debuts. In the fall of 1989, the USA Network picked up The Real Ghostbusters as part of its venture into children's programming to attract younger viewers with their Cartoon Express block on weekdays. With Saturdays on ABC, weekdays in syndication, and a marquee spot on a bullish cable network, The Real Ghostbusters had arrived.

Background painting by John Calmette.

Chapter 1: Manifestation

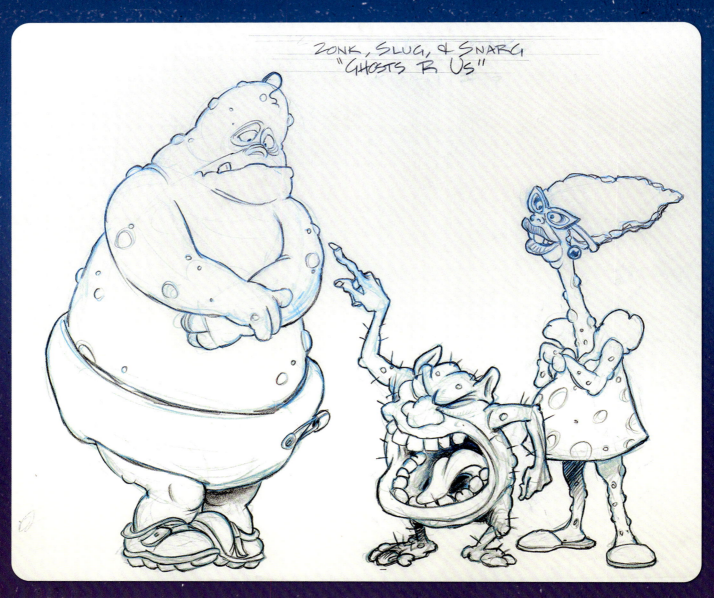

Zonk, Slug, & Snarg
"Ghosts R Us"

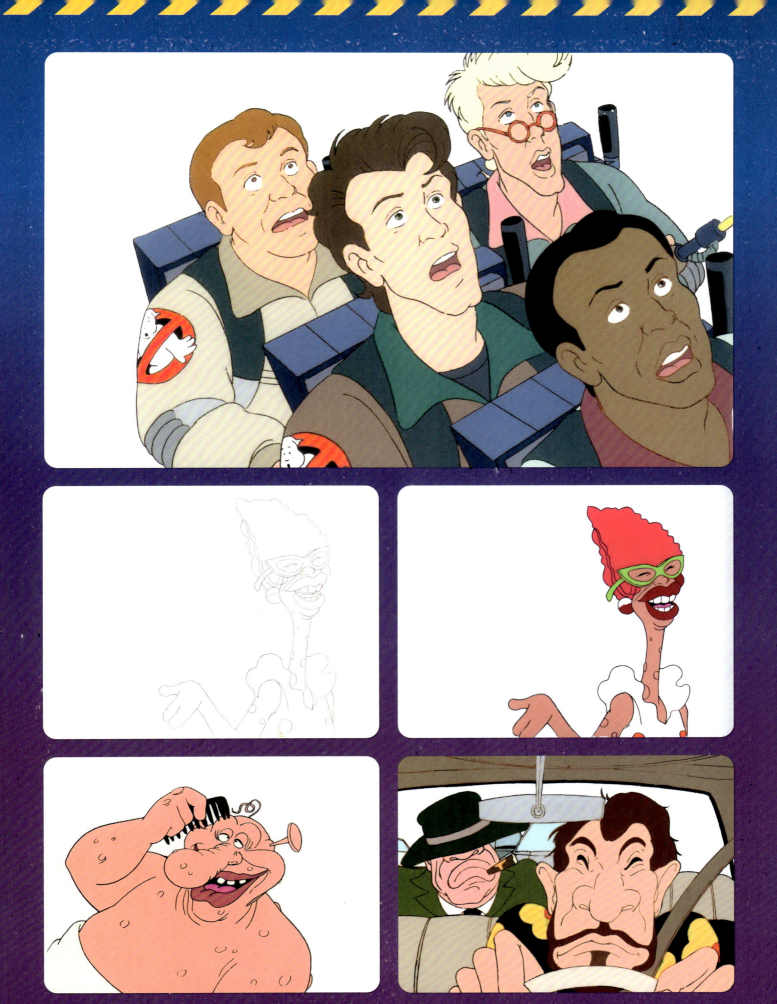

"Ghosts R Us" designs. Opposite, top: Gabi Payn's early design work for Zonk, Slug, and Snarg. Opposite, bottom left, and above, middle and bottom left: Final designs utilized in the episode. Ghosts like this really highlight the talents of Gabi Payn and Everett Peck. Bottom right: A character design of a cabbie in the episode who is a caricature of background painter John Calmette.

Chapter 1: Manifestation

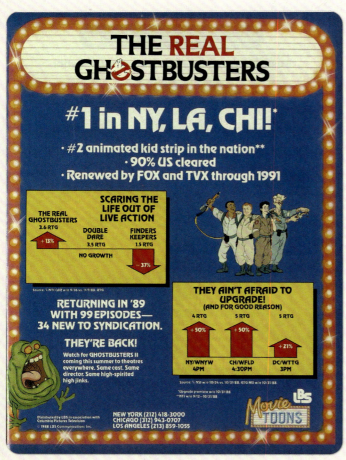

A broadcast trade magazine advertisement touting The Real Ghostbusters' *success.*

"We had pulled out of *Real Ghostbusters* and the show was going along without us . . . not so well," says Richard Raynis. "Andy came to me and said that he needed me to be involved with the show again. He asked me what I wanted, and I said that I wanted him to reimburse me for the Xerox machine I had bought with my own money." Andy Heyward has no recollection of the Xerox machine being a part of Raynis's rider.

Veteran animator and *Real Ghostbusters* storyboard artist Will Meugniot was brought in to produce and supervise episodes beginning with the 1988 season. Chaffee and the team were successful in transferring the animation to Toei. "I think that Toei was able to create a more consistent animation quality for the network show," says Riba. "While I think the earlier shows had better storytelling and more peaks and valleys, there was an even quality of everything that lifted the later seasons up a little bit. Even though the show changed dramatically in the later seasons, the animation was more consistent and better overall."

After all the changes and the turnover with the creative team, most of those involved with *The Real Ghostbusters* still look back on the first seventy-eight episodes as the finest in the series, and their finest work. "Everybody was pushing their craft to make this statement about who we were as a team. There's a lot of pride in that," says Bruce Zick. "I don't think there was anything like this group of people."

"When I look at the episodes that we did, they're just really good," says Andy Heyward. "Animation today is better, and now we have the ability to do things in CG, or use other techniques, but what was put together would be very hard to duplicate today."

The First Seventy-Eight

What follows is a guide to the first thirteen network and sixty-five syndicated episodes that were ordered and produced simultaneously, presented in production order.

NETWORK

"Killerwatt"	Production Number: 75001
"Ghosts R Us"	Production Number: 75002
"Look Homeward, Ray"	Production Number: 75003
"Mrs. Roger's Neighborhood"	Production Number: 75004
"Janine's Genie"	Production Number: 75005
"Slimer, Come Home"	Production Number: 75006
"Troll Bridge"	Production Number: 75007
"The Boogieman Cometh"	Production Number: 75008
"Mr. Sandman, Dream Me a Dream"	Production Number: 75009
"When Halloween Was Forever"	Production Number: 75010
"Take Two"	Production Number: 75011
"Citizen Ghost"	Production Number: 75012
"X-mas Marks the Spot"	Production Number: 75013

SYNDICATION

"Knock, Knock"	Production Number: 076001
"Station Identification"	Production Number: 076002
"Play Them Ragtime Boos"	Production Number: 076003
"Sea Fright"	Production Number: 076004
"The Spirit of Aunt Lois"	Production Number: 076005
"Cry Uncle"	Production Number: 076006
"Adventures in Slime and Space"	Production Number: 076007

Episode	Production Number
"Night Game"	076008
"Venkman's Ghost Repellers"	076009
"The Old College Spirit"	076010
"Ain't NASA-sarily So"	076011
"Who're You Calling Two-Dimensional"	076012
"A Fright at the Opera"	076013
"Doctor, Doctor"	076014
"Ghost Busted"	076015
"Beneath These Streets"	076016
"Boo-dunit"	076017
"Chicken, He Clucked"	076018
"Ragnarok and Roll"	076019
"Don't Forget the Motor City"	076020
"Banshee Bake a Cherry Pie"	076021
"Who's Afraid of the Big Bad Ghost?"	076022
"Hanging by a Thread"	076023
"You Can't Take It with You"	076024
"No One Comes to Lupusville"	076025
"Drool, the Dog-Faced Goblin"	076026
"The Man Who Never Reached Home"	076027
"The Collect Call of Cathulhu"	076028
"Bustman's Holiday"	076029
"The Headless Motorcyclist"	076030
"The Thing in Mrs. Faversham's Attic"	076031
"Egon on the Rampage"	076032
"Lights! Camera! Haunting!"	076033
"The Bird of Kildarby"	076034
"Janine Melnitz, Ghostbuster"	076035
"Apocalypse—What, Now?"	076036
"Lost and Foundry"	076037
"Hard Knight's Day"	076038
"Cold Cash and Hot Water"	076039
"The Scaring of the Green"	076040
"They Call Me Mister Slimer"	076041
"Last Train to Oblivion"	076042
"Masquerade"	076043
"Janine's Day Off"	076044
"The Ghostbusters in Paris"	076045
"The Devil in the Deep"	076046
"Ghost Fight at the O.K. Corral"	076047
"Ghostbuster of the Year"	076048
"Deadcon 1"	076049
"The Cabinet of Calamari"	076050
"A Ghost Grows in Brooklyn"	076051
"The Revenge of Murray the Mantis"	076052
"Roller Ghoster"	076053
"I Am the City"	076054
"Blood Brothers"	076055
"The Long, Long, Long, etc. Goodbye"	076056
"Buster the Ghost"	076057
"The Devil to Pay"	076058
"Slimer, Is That You?"	076059
"Egon's Ghost"	076060
"Captain Steel Saves the Day"	076061
"Slimer Goes for Broke"	076062
"Egon's Dragon"	076063
"Dairy Farm of the Living Dead"	076064
"The Hole in the Wall Gang"	076065

Bruce Zick's original background for "Killerwatt," the episode originally intended to be first to air.

Chapter 1: Manifestation

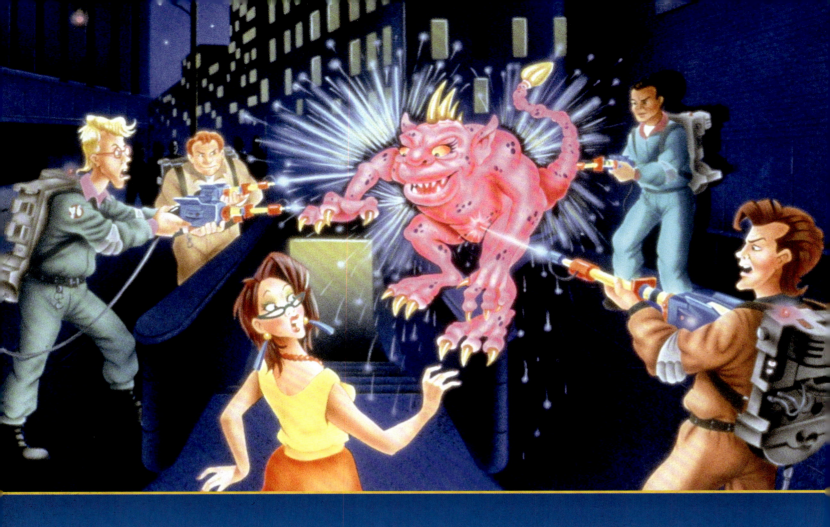

CHAPTER 2: HEROES, GHOULS, AND MARSHMALLOW MEN

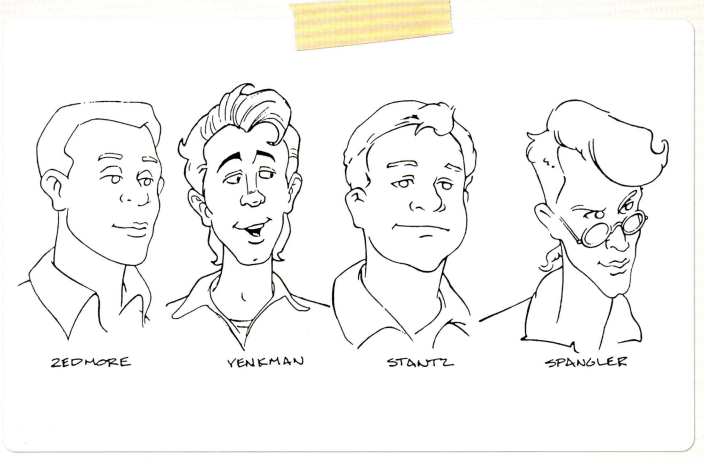

Likenesses of the Ghostbusters were heavily revised following production of the promo pilot. Peter in particular required several creative passes. Note the misspellings of Zeddemore and Spengler.

In Dan Aykroyd's initial screenplay draft of *Ghostbusters*, the main characters were all interchangeable. The Ghostbusters were working-class high-tech janitors who all spoke with the same voice and followed in step with near-identical personalities. When Second City alum Harold Ramis was brought on to the project by his friend Ivan Reitman, he and Aykroyd revised and refined the concept in their famed rewrites of the script in a basement in Martha's Vineyard in 1983. A large portion of that overhaul was the introduction of archetypes and subtleties in the characters, bringing life and definition to each of them. "We decided my character would be the brains of the Ghostbusters. Dan [Aykroyd] would be heart. And Bill [Murray] would be the mouth," Ramis said in the 1990 ITV documentary *Slimer Won't Do That!* Reitman found that having three scientists speaking technical jargon could be difficult for the audience to keep up with, and Winston was later added to the crew to represent the perspective of the "everyman." Ray, Egon, and Peter would talk to him in layman's terms, and the audience could experience the supernatural through the eyes of the new recruit. Through the performances of Bill Murray, Dan Aykroyd, Harold Ramis, and Ernie Hudson, the characters became immediately recognizable and beloved by audiences, who had much debate over who their favorite Ghostbuster was. Adults and kids alike found certain qualities of themselves in each of the characters—perhaps the wonder of Ray, the logic of Egon, the loyalty and courage of Winston, or the razor-sharp wit of Peter.

When it came time to translate those performances and those characters to animation, there was one gigantic hurdle the animators had to leap. "We couldn't use the likenesses of the actors, so we had to give each of the characters defining characteristics. But at the same time, we couldn't stray too far away from who they were," says Michael C. Gross. With roles that have become synonymous with particular actors' faces, like Harrison Ford as Indiana Jones or Bill Murray as Peter Venkman, it can be a tall order to replicate what made those characters so beloved without it feeling like a lesser facsimile. "It became more

Translating the human characters and performances to animation proved challenging.

Chapter 2: Heroes, Ghouls, and Marshmallow Men

about nailing down the characters themselves and less about re-creating the actors from the films."

"You don't look at these characters as blobs of paint. You look at them as real people," says Steve Perry. "We had the advantage that the movie was out and was a big hit; the audience already knew who these people were. Our version was just like the characters in the live-action movie. They have the same depth of personality. They had to, otherwise they wouldn't matter to the audience. And so this is a continuation of the story that we've already seen. Who are these people? What are they doing? What makes them interesting? What subtext can we put in here that the audience can realize they hadn't thought about before, but of course it should be there?"

"In the movie, the voice was so distinct and so specific that I really had no problem at all transplanting that into the show," says J. Michael Straczynski. "I must know the voice of the character before I can start writing. I used to watch the movie every week on Sunday to reload those characters' voices and then go through the week writing, then on Sunday watch it again." Crucial in replicating the voices of the live-action characters was finding voice talent with the ability to do exactly what the character designers were doing: finding the heart of the character and turning that into a physical voice, so that the audience wouldn't even have the thought they weren't hearing Murray and Aykroyd—they were just hearing Venkman and Stantz.

Enter veteran voice director Marsha Goodman, whose résumé reads like the greatest hits of childhood: *Care Bears*, *Heathcliff*, *Dennis the Menace*, *Adventures of Sonic the Hedgehog*, and *Strawberry Shortcake*, to name but a few. "The first person I ever directed was Mel Blanc," says Goodman. It's a pretty big flex to boast of giving direction to the Man of a Thousand Voices for a first gig. Goodman had started at DIC as a production assistant and had become the voice director for DIC's entire stable of shows, including *The Littles*, *Inspector Gadget*, and *Kidd Video*, by the time she got the assignment for *The Real Ghostbusters*. "I was the person at DIC in charge of all the casting and voice directing. We had so many projects in the works, and here comes *The Real Ghostbusters*, which was essentially two more shows between the network and syndicated versions."

Just as the character designers couldn't use the likenesses of the live-action actors, Goodman had been given the directive in casting to make sure that the voices didn't sound like imitations of their counterparts on film.

"When we originally cast, we were only casting for the network show," says Goodman.

"I think that the cast in the initial seventy-eight episodes is one of the finest voice casts assembled," says James Eatock. "You have this wealth of talent taking the roles without besmirching the actors who originated them."

> **"Here we are in a studio with four comics, and we were just pee-in-our-pants laughing so hard all the time. They were so funny. And because they could do all these voices, they'd be doing bits as Spartacus and Orson Welles talking to one another."**
> —MARSHA GOODMAN

"I was only doing the syndicated episodes at the start. After a couple of the episodes were recorded, they turned over both the network and syndicated shows to me because Joe and Michael wanted me to do it all," says Goodman. Les Perkins acted as the voice director on the network episodes, including "Ghosts R Us." Not that Les wasn't capable of voice directing the sessions, but a certain synergy was created with Marsha, the voice cast, and the creative team producing the show. "I think they felt that I understood the humor; we were just simpatico."

"Marsha was fabulous with the cast. And they loved her," says Michael C. Gross.

The *Real Ghostbusters* voice recording sessions were conducted at either the smaller southern studio of Wally Burr Recording at 1104 N. Hollywood Way in Burbank (now an auto shop) or just down the street at B&B Sound at 550 Hollywood Way (now a gas station). These addresses were burned into the brains of the creative team mainly because a seat in the recording sessions was always a hot commodity. Everyone wanted to be there. The sessions were usually one-night-only performances filled with improv comedy and off-mic non sequiturs that were sidesplittingly hilarious and nowhere near appropriate for children. Oh, and in between they would record dialogue for the show. "Michael and I loved going to the recording sessions," says Joe Medjuck. "They were so much fun. You basically had four comedians trying to keep up with each other. We would have to separate them

sometimes. I remember Marsha calling the sessions 90 percent fun, 10 percent work. But every now and then, she'd have to be the schoolmarm and separate them. She'd have to say, 'Okay, let's get serious, we've got a show to do!'"

Says Goodman, "Here we are in a studio with four comics, and we were just pee-in-our-pants laughing so hard all the time. They were so funny. And because they could do all these voices, they'd be doing bits as Spartacus and Orson Welles talking to one another."

"Everybody could improvise, and that was important," says Michael C. Gross. "They could just take the writing and deliver it, and every once in a while add to it. And it was just a joy to do."

"We were in a session for 'The Spirit of Aunt Lois,' and Joe Medjuck turned to me and said, 'This script isn't funny. Why did you write this unfunny script, and why am I paying you to write this unfunny script?'" says Richard Mueller. "I said, 'Wait a minute, stop the recording.' I went into the booth, and I worked with Arsenio Hall to jazz up the script right there in the session. There were great and creative people in that booth."

"That was so much fun, not only hearing such talented actors perform dialogue I had written, but also hearing the off-mic banter and the occasional on-mic ad-libs," says Kathryn Drennan. "For instance, in 'Night Game,' the final line for Peter which Joe Straczynski added to the final draft was 'From now on, I only go to Yankees games.' But in the recording session, Lorenzo Music immediately changed that to 'From now on, I only go to *Mets* games!' which was then met by overlapping ad-libs from the rest of the cast, each declaring their favorite team. Which is how we found out, by way of Maurice LaMarche, that Egon is a Blue Jays fan."

"Having a group like that was a once-in-a-lifetime thing. Now, if people even go into the studio, it's usually one at a time," says Goodman. "That group was just so rare. We were lucky."

Laura Summer, voice of Janine Melnitz, was new to voice acting at the time and leaned on the expertise of her fellow cast members. "I always liked to sit next to Frank [Welker] and ask him what I should do here and there. I'd say, 'What should I do here?' And he goes, 'Julia Child.' I knew exactly what to do," says Summer.

Lorenzo Music.

"All these guys could do standup comedy too, so they were always on," says Medjuck.

Just like putting the two class clowns at adjoining desks is a recipe for disaster, when work was to be done, some of the actors had to be separated. "You didn't want Frank Welker and Maurice LaMarche sitting next to each other," says J. Michael Straczynski.

"We'd be recording and get to Arsenio's part, and he'd be reading a *Playboy* or something and look up, surprised. 'Oh, it's my turn? Okay. Sorry,'" says Goodman. "We just had fun. Well, unless the network was there. We wouldn't rehearse, because it was always better when you read it on the first take. The cast were such professionals. But the network executive would be screaming at us to do a rehearsal. I was like, oh god. Nah. That's when Joe and Michael would have to step in and tell the network that if something is wrong, we'll pick it up."

When the network was present for recordings, Joe Medjuck and Michael C. Gross were always in attendance too; that way they could deal with any notes or changes that were being suggested directly. "When the network was there for an important episode, Joe, Michael, and I would try to be there," says Straczynski. "We would do a dog-and-pony show for two hours to distract them. If a line came up that was a little bit on the edge of what might be permissible, there was a chance they hadn't been paying attention until they heard it there for the first time. So if we distracted them with donuts and whatever else, they never heard it."

Chapter 2: Heroes, Ghouls, and Marshmallow Men **77**

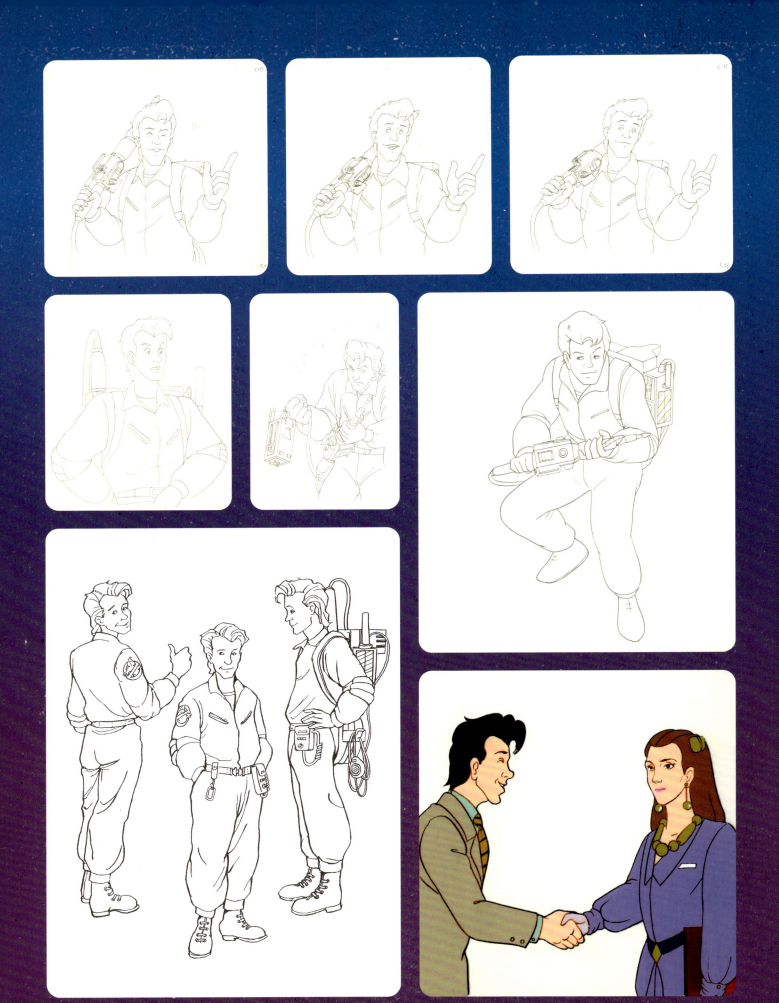

Dr. Peter Venkman was the "mouth" of the Ghostbusters. Translating his rough-around-the-edges character for Saturday morning audiences proved to be the biggest challenge the creative team faced.

"We were a part of it but we also didn't want to hold anything up," says Joe Medjuck. "We knew the most important thing was keeping the machine moving. If we didn't give notes to a script or make changes in a timely fashion, we knew it was impossible to address them."

"One week into recording, Ivan Reitman walked in. And I'm like, holy shit," says Goodman. "It made me nervous. But he said we were doing fine. So . . ."

In addition to the main voice cast, Goodman was able to bring in a who's who of voice actors and talent to do guest and supporting roles. Names like James Avery, Charlie Adler, Rose Marie, Lewis Arquette, Ed Pansullo, Walter Koenig, Adrienne Barbeau, Nancy Kulp, and June Foray played multiple roles in the show. "I could bring in anybody," says Goodman. "Because a lot of people have kids, they wanted to do cartoons. So not only could I bring in great animation voices, but I brought in some of the greatest comics of all time."

Venkman couldn't look like Bill Murray, but could be inspired by new wave musicans of the time.

Peter Venkman

Dr. Peter Venkman was the prominent voice and mouth of the Ghostbusters. In the live-action film, he was an alpha with a little black book that rivaled Sam Malone's from *Cheers*. As a researcher at Columbia University, he flirted with the coeds while zapping the guys, famously called his nemesis at the EPA "dickless," and made a house call for the beautiful client Dana Barrett because he was more interested in a date than helping her with her haunted apartment. All the while, the audience was rooting for him because he was played with a puckish charm in a way that only Bill Murray could pull off. How does one take that rough-around-the-edges character and translate him to a kid-friendly Saturday morning lineup, without losing the spark and edge that defined the character? Somewhere in the world, a representative from ABC's Broadcast Standards and Practices just had to brace themselves against a desk.

He couldn't just be a stereotypical Saturday morning sarcastic know-it-all. There were already plenty of those. He needed something more. "People think they can write for Bill Murray—it's not easy to write for Bill Murray," said Michael C. Gross in the Time Life DVD set. "Making someone sarcastic does not make them Bill Murray. You've got to keep him likable. There's a trick to that."

Also working against the very particular alchemy of Peter Venkman was the fact that the animated version couldn't *look* anything like Bill Murray His facial expressions, demeanor, posture, mannerisms, and hairstyle all had to evoke Venkman without replicating Bill Murray's one-of-a-kind personality and image.

Starting with the promo pilot, in which none of the characters could bear likeness to their live-action actors, Kevin Altieri had softened the Venkman character's look and planted seeds for how he would look in the series. As with all artists, Altieri looked to his real life for inspiration. "I was heavily into Bryan Ferry, Roxy Music, Talking Heads, David Byrne. That was my jam. I was fifth-row center for the *Stop Making Sense* tour. Richard was a huge fan of that stuff too. So I think a bit of the punk new wave crept into our character designs. Especially with Peter and Egon," says Altieri. Because the promo pilot had been done in such a hurry, Altieri's choices in the storyboards became the basis from which Gabi Payn began refining the full character model sheets for the series. "Gabi just nailed those character designs," says Altieri.

"Kevin gave Peter that Bryan Ferry haircut in the storyboards, so that's what I based that on in my design," says Gabi Payn. "But part of the reason you fall in love with Peter is the voice."

To vocalize Venkman, *The Real Ghostbusters* turned to Lorenzo Music. Music was an Emmy Award–winning comedy writer on *The Smothers Brothers Comedy Hour*. He was the story editor of the successful *Mary Tyler Moore Show*, and on that series' spinoff *Rhoda*, he took a starring role as Carlton the Doorman—though he was never seen, only heard over the apartment intercom. Whether intentional or not, Music's performance in *Rhoda* opened a door (no pun intended) that produced a long and successful voice acting career in animation and as the starring voice of the animated *Garfield*.

Left: *Venkman looking inspired by Bryan Ferry.* Right: *Excerpt from the first-season show bible explaining the Venkman character.*

"Lorenzo was such a great voice," says Marsha Goodman. "He definitely brought a great quality to Peter that helped with the issue of making the character more kid friendly." Music's sleepy voice took any edge off Venkman's dialogue and also shared many of the qualities that have made Bill Murray such a pop-culture icon. It was almost a devil-may-care attitude that immediately came through in his voice.

"Lorenzo's voice matches that perfect Garfield expression with the half-open eyes," says James Eatock. "He's not doing a Bill Murray impression, but he's bringing that Bill Murray dryness."

"I didn't realize he was doing *Garfield* when I cast him. Looking back now, if he was going to be on another Saturday morning series and essentially doing the same voice, I think that may have been a mistake," says Richard Raynis. "I had a fond memory of him doing Carlton the Doorman, and, based on the audition that really made us laugh, I thought he would really capture Bill Murray. But I think I may have been thinking of Bill Murray from *Caddyshack* and not Bill Murray from *Ghostbusters*. He has such a laid-back delivery that didn't have the same energy as Murray in the film."

"Lorenzo had a very slight delivery that just sounded right to me when I heard it," says J. Michael Straczynski. "We used to record everyone's voices together in the same room. It was like grade school, constant screwing around and misbehaving. Lorenzo had a tendency to miss his cues. We'd have to tap on the monitor to wake him up. We did this for quite a while. One day, he missed his cue and Frank Welker popped in and did the line in Lorenzo's voice. When Lorenzo realized what had just happened, he never missed a cue again."

In addition to his animation work, Music's voice became synonymous with television and radio advertising in the mid-1980s. It was challenging to turn the television on without hearing his voice-over selling Florida orange juice, Bravo pizza, or Ore-Ida potatoes; warning of the dangers of not wearing a seat belt as a crash test dummy for the Ad Council; or, yes, he was even the voice of Hostess Twinkies. "One of the big problems with Lorenzo was that he'd been around quite a bit," says Michael C. Gross. "You started to hear his voice a lot in commercials, shows, and the rest. And Bill Murray came one day and said, 'Why don't you do my voice? I can't do the show, but have someone do me.' And that's why we had to change it."

Says Marsha Goodman, "I think he also heard Maurice doing a bit of Harold and he was wondering how come Harold's voice was in the show, but not his."

"We thought, Bill Murray's watching our show? That was cool," says Pamela Hickey.

"Then we hear that Bill watched the show and made the comment that 'That guy doesn't sound like me. He sounds like Lorenzo Music,'" says Medjuck. "So, when we went into our second season, they said, 'We found a guy that can imitate Bill Murray.' It ended up being Dave Coulier, who weirdly lived across the street from me."

Standup comedian Dave Coulier was just coming off the Nickelodeon comedy news parody show *Out of Control* when he was cast as the replacement for Music. He was also about to make another debut on ABC the same year with the sitcom *Full House*. Coulier told Tara Strong (voice of Kylie Griffin on the later *Extreme Ghostbusters* animated series) on her *Ship-It Show* podcast in 2023, "I just basically did a Bill Murray impression and that was it. It was very simple. But I was filling very iconic Lorenzo Music shoes. It was something that played with my head at the time. Because I thought, his voice is so iconic, and so recognizable, and here I'm just coming in doing a schlocky Bill Murray impression."

Coulier still brought the same charm to the Venkman character and provided a wonderful performance. However, many shared Coulier's own thoughts when the change was made. The voice they associated with the animated Venkman had been changed, and now it sounded like someone just doing an impression because they couldn't get Bill Murray—essentially creating the problematic issue the series wanted to avoid from the start. "We got a lot of letters from people wondering what happened to Lorenzo," says Gross.

"To me Venkman will always sound like Lorenzo," says Straczynski. Music passed away from lung cancer in 2001 at the age of sixty-four.

Ray Stantz

Ray Stantz is the heart and soul of the Ghostbusters. From the very first glimpse of him in the promo pilot, snuggled in bed, still squeezing a stuffed Stay Puft Marshmallow Man toy tightly in his sleep—despite the giant form of that childhood icon having just recently attempted to kill him atop a rooftop temple—it's clear that it's tough to shake Ray's love of anything. The easily excitable Stantz is the most childlike character in *The Real Ghostbusters*. The paranormal, the technological innovations, even just getting his hands dirty under the hood of the Ecto-1—being a Ghostbuster is a job tailor made for Stantz. And, as it turns out, also for his creator. "Dan Aykroyd *is* Ray," says Michael C. Gross.

Dan Aykroyd has a history with the paranormal beginning with his great-grandfather Samuel Augustus Aykroyd, who was a spiritualist and often conducted séances the whole family would attend. It was that spirit of investigating the paranormal and contacting the unknown that inspired Aykroyd to write his original *Ghostbusters* script. Following the release of the film, he continued to be just as enthusiastic about the property and his character and would often watch episodes and send in notes. Aykroyd continued to be a champion of the franchise well past that point, all because of his love and connection to the characters and the premise.

"Ray is so childlike in the show," says Jason Reitman. "In the original movie, he smokes cigarettes and is seen in onscreen sexuality. The Ray that we see in the animated series is so sweet and connects with children so well. It's definitely the reason that, over the two films that Gil [Kenan] and I wrote, Ray Stantz has the same DNA of his character in the animated show. And he has such a one-on-one relationship with the kids. It's funny, because the DNA of the animated characters is a part of our understanding of who those characters are."

Stantz, the type who could still be smiling and gleefully say, "This is great!" despite being in terrifying imminent danger, was a difficult role to portray without sounding too irritating or phony. The voice needed to sell genuine excitement and not sound cynical. If anyone could handle that task, it's Frank Welker, who for years had voiced the character Fred on *Scooby-Doo* with the same infectious charm and sense of wonder. But limiting him to just that one character does him a disservice. His acting credits are a mile long, with an IMDb entry pushing a thousand acting roles that span from notable humans to barking dogs, curious monkeys, and the villain Megatron in the *Transformers* series. "Frank is so busy and so talented that he could record five shows in a day," says Marsha Goodman.

Ray Stantz, the embodiment of creator Dan Aykroyd, was the heart and soul of the Ghostbusters.

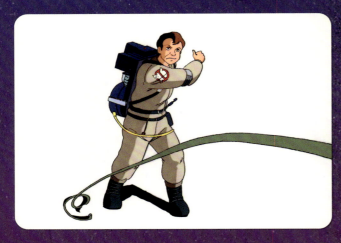

No matter what the circumstances threw at him, Ray Stantz met adversity with enthusiasm, whimsy, and gleefulness. Voice actor Frank Welker approached every role with a similar mentality: He was always excited and happy.

"If you've got Frank Welker in the room, you've also got animals and monsters and you've got kind of everything," says Kevin Altieri.

"Frank is always excited and happy; he's hardly ever sarcastic," says Goodman. "Did you know he used to do standup before he was a voice actor and opened for Elvis?" Opening for the King shows just the true capabilities of the talent's range.

Welker was always used to the full extent of his abilities, both because of his talents and because the series was working on a budget. "All the producers wanted to find people that could do multiple voices, because then they would save money," says Goodman. "The way the SAG agreement stands today, you can have an actor do two voices for the price of one. Then they can do a third voice for an additional 10 percent. And then we had everybody doing crowd and group sequences." In any given episode, Welker could be playing Stantz, the ghost Stantz is chasing, and the screeching cat in the window . . . all in the same scene.

Egon Spengler

In the screenplay for *Ghostbusters*, Harold Ramis described Egon Spengler as an "egg-headed New-Wave Spock." The type that would rather take flakes of skin samples or wave a PKE Meter over a face than shake a hand and say hello. "Egon was the chess club nerd type," says Pamela Hickey.

"Nerds really weren't cool back then," says Violet Ramis Stiel. "I felt like I wanted Egon, and in turn my dad, to get all the adoration that the other guys got. But he was in his own little nerdy corner." In the age of *Revenge of the Nerds*, socially awkward and intellectual geniuses were often considered inferior to their more charming and popular counterparts. The wisecracking Peter Venkman was often cited as kids' favorite, with scholarly Egon falling to second banana. Only in recent years has the Egon renaissance begun.

Egon is a (usually) emotionless being who values science, technology, and the study of the unknown over silly things like feelings. "The fun thing with Egon was getting him to the point where he would be angry. We wanted Egon to get really angry once, and Straczynski called us saying we couldn't do that, because he doesn't freak out," says Hickey.

Egon is arguably the most accurately translated character from live action to animation. His aloof demeanor and genius-level intellect define him in both. Cosmetically, however, Egon may be the most changed in the animated show. Two major design changes were made to Egon: his spectacles became a colorful pop of red, and his hair

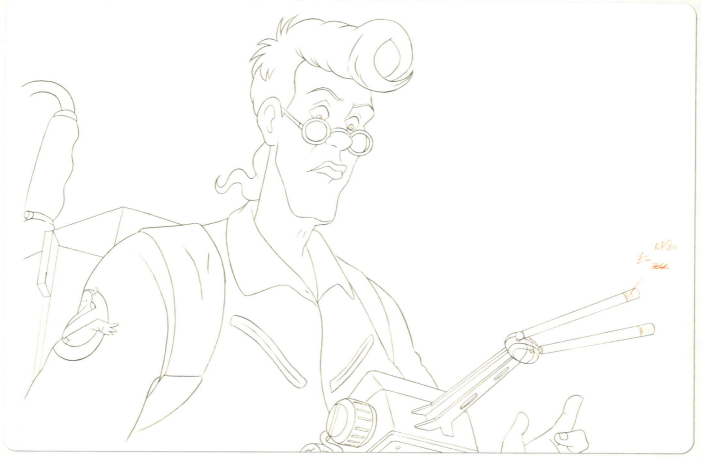

Egon Spengler, the "egg-headed New-Wave Spock."

metamorphosed into a swirly blond gravity-defying pompadour. "We were shown character sketches, and I was most shocked of all because my character came out blond," Ramis said in the ITV documentary *Slimer Won't Do That!* The gravity-defying hair was another new wave–era design choice by Gabi Payn and Kevin Altieri that added a bit of contrast to the usually buttoned-up character: a high-rising spiral of hair reminiscent of a victory roll from the 1940s. Egon's hair was a rare bit of flair in his appearance that must have taken a great deal of primping in the morning to achieve.

Voicing Egon was a young Canadian comedian named Maurice LaMarche. LaMarche was relatively new to voice acting when he got the *Real Ghostbusters* job, having only worked on another DIC production, *Inspector Gadget*. "Whenever Maurice does anything, he always credits me and says that I gave him his first cartoon job," says Marsha Goodman, who was responsible for the *Gadget* casting and voice direction in her duties at DIC.

"Maurice likes to tell the story that Michael Gross and I fought to get him the job," says Joe Medjuck. "When I was teaching in Toronto, one of my students was performing standup at a place called Yuk Yuk's, which in those days was in a church basement. Among the performers that night was Maurice LaMarche. He was great."

Unlike the new interpretations of Peter and Ray, Egon was the only character allowed to sound like their live-action counterpart. "When Michael Gross and Marsha Goodman were casting the show and giving notes to the room full of actors waiting to audition, they said, 'Stay away from impressions. Whatever you do: no impressions,'" said Maurice LaMarche on the Time Life DVD release. "My background was standup comedy as an impressionist. That's like telling me not to breathe. I couldn't see any other way of doing Egon, except for doing as close to that Ramis voice as I could." LaMarche had a feeling he wouldn't get the part if he did his impression, as it would be counter to what he was told in the waiting room. Feeling zero pressure, he entered the audition with the intention of dazzling the producers with his Harold Ramis impression, and then he'd be on his way. Instead, his impression won over the room (and Ramis himself), and he was given the job.

"In some of the first episodes recorded, you can hear LaMarche trying to do a Harold Ramis impression," says

> **"I couldn't see any other way of doing Egon, except for doing as close to that Ramis voice as I could."**
> —MAURICE LAMARCHE

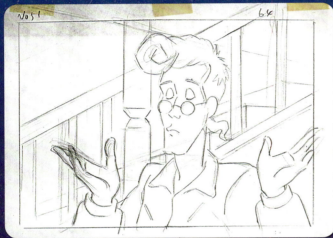

Egon Spengler had to be the scientific and logical voice of the group. It was difficult for voice actor and impressionist Maurice LaMarche to imagine any other voice for the character other than Harold Ramis himself.

James Eatock. "After a few episodes, he finds the voice and becomes more of his own version of Egon. The best way to put it is that his voice becomes more Egon Spengler and less Harold Ramis."

"I always thought, both in Ramis's Egon and mine, that there was this longingness to belong, and be one of the guys," said LaMarche on the DVD.

"Maurice was and is astonishing," says J. Michael Straczynski. "We've kept in touch over the years, but just look at the murderers' row of voice artists that we had. We had the best of the best."

"I met Maurice at a convention, and he is so wonderful. He loves *Ghostbusters* and he's so proud to represent Egon and carry that character on," says Ramis Stiel. Carry on the character he did. In addition to reprising the role in 1997's *Extreme Ghostbusters*, LaMarche also voiced Egon for promotions, including a General Mills cereal contest where a recorded Egon asked trivia questions to win a trip to the set of *Ghostbusters II*, and for the Ghostbusters Spooktacular attraction at Universal Studios Florida, where LaMarche voiced not only Egon but Peter Venkman as well.

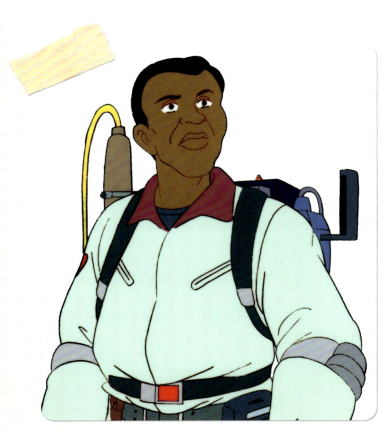

Winston Zeddemore

Winston Zeddemore was hunting for a steady paycheck when he walked through the firehouse door and became a Ghostbuster. Though he didn't show up until the third act of the live-action film, Winston was just as integral to the ghost-busting unit as the other three members, and it was clear that he would need to take on a larger role in *The Real Ghostbusters*. "The first rule in television is to service your characters. They all have to have their own stories," says J. Michael Straczynski. "I really wanted to make a point to always include Winston and to do right by the character. Winston doesn't come from the same background of the supernatural or high technology that the other characters do; he becomes the eyes and ears of the audience and a character to whom we can explain what's going on."

Acting as the eyes and ears of the audience, Zeddemore could be the character who asks all the questions and reacts in ways that perhaps the paranormal scientists might not. He could also become an aspirational representative for kids of color who may not have seen many heroes on Saturday mornings who looked like them.

"I had a lot of fun with Winston, because I felt like he was sorely underutilized in the film," says Richard Mueller. "In 'The Brooklyn Triangle,' we meet Winston's father, who runs a construction company and breaks into another dimension pouring the foundation for a building. Coincidentally, that's also an episode where I got to put in a character loosely inspired by Harlan Ellison called the Collector. And then in 'Elementary My Dear Winston,' where the Ghostbusters have accidentally trapped Watson, and Winston is forced to become [Sherlock Holmes's] sidekick. I was in Len Janson and Chuck Menville's office one day when they got a call from Dan Aykroyd, who wanted to tell them how much he liked that script, particularly how we dealt with the concept of belief made manifest."

"We're a diverse culture, and we need to represent people," says Steve Perry. "If you grew up when I did in the '50s and '60s, I saw a lot of cis white guys as the heroes. Whereas if you were a Black kid, you didn't have that representation. There were a lot of stereotypes like the laughing Irish cop, because that was typically what the police were. With Winston, we wanted Black kids to look at him and think, I could be this guy. This is somebody I could emulate. This is somebody who's as good as anybody else. We had a Black character who needed to be as smart and as funny and as realistic as all the other people."

In the Time Life DVD set, Maurice LaMarche said that after his audition, he had been chatting outside with Arsenio Hall, who was waiting for his turn, when Ernie Hudson walked out of the studio. "Arsenio turned to me and mouthed, 'Why am I here?'" said LaMarche. The job was given to Arsenio Hall and, though Hudson may not have voiced the character of Winston, the character's portrayal on the series expanded

Chapter 2: Heroes, Ghouls, and Marshmallow Men

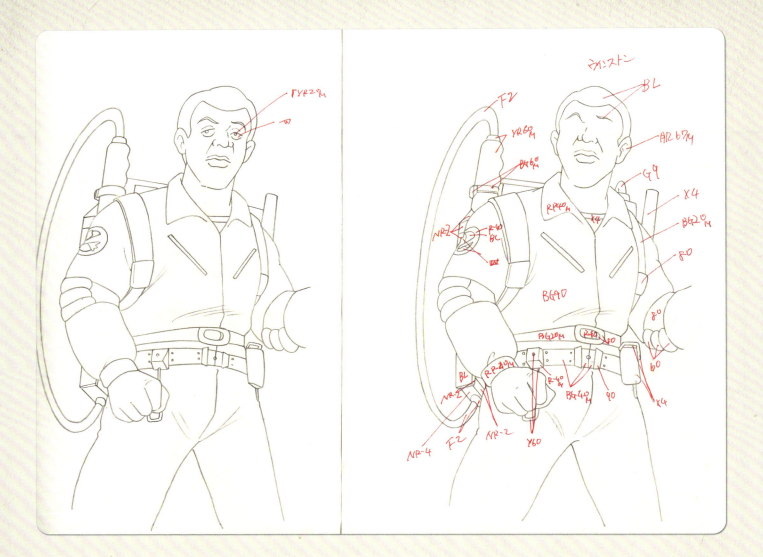

his role and importance and solidified him as a fan favorite. Hall also brought his infectious energy and enthusiasm to the character.

"Arsenio told me after he did *The Real Ghostbusters* that I helped him buy his first Jaguar," says Marsha Goodman. Hall's guest-hosting stint on Joan Rivers's late-night show and his scene-stealing role in Eddie Murphy's *Coming to America* in 1988 caused his star to skyrocket, and many more luxury cars were in his future. After *The Arsenio Hall Show* debuted on January 3, 1989, on Fox, Arsenio became a household name.

"Arsenio was doing the animated show when he got the Fox deal," says Michael C. Gross. "He was on Fox for two weeks before he had to drop the animated show, because he couldn't do it."

With Hall's departure, Buster Jones took over the role. Jones had a smooth radio announcer DJ's voice and had a long career in journalism and commercial work in addition to his character voice work on *Transformers*, *G.I. Joe*, and the *Super Friends* series. He reprised the role in the 1997 *Extreme Ghostbusters* series. Buster Jones passed away in 2014.

Janine Melnitz

Janine Melnitz was far more than just the receptionist. The brash, no-nonsense Janine kept the ship running. Plus, she wasn't afraid to grab a proton pack when the situation demanded. "I'm very fond of strong female characters. Janine is like Princess Leia; she's not cowering in the corner. Why would she?" says Steve Perry.

In the live-action film, Annie Potts played the character with trademark New Yorker attitude, a disgruntled and underpaid employee who wasn't afraid to take out her frustrations on the other end of a phone conversation. For the animated series, Janine's character went through a metamorphosis to continue to bring the sass but also give her a chic and fashionable 1980s look that would make her seem too good to be an administrative assistant for these ghost janitors. "Janine is a wonderful design," says Kevin Altieri. "What really helped with this show was that all the characters were just so much fun to draw."

Heading the design process for Janine was Gabi Payn, who imprinted very personal traits onto the character. "I made Janine really sexy," says Payn. Credited in the series as Gary

Highlight Episode: Knock, Knock

WRITTEN BY:
J. Michael Straczynski

FIRST AIRED:
November 6, 1987

PREMISE (FROM THE ORIGINAL *REAL GHOSTBUSTERS* WRITERS PACKET): Subway workmen accidentally open a door marked DO NOT OPEN UNTIL DOOMSDAY—and in so doing open the door to the Underworld, to Hades, which begins to fill first the subway tunnels, and then parts of New York with all the creatures from the Underworld. If the Ghostbusters don't stop it, Doomsday will come quite a bit early.

"Janine's Day Off" had the distinction of airing as the first syndicated episode in September of 1987, but that episode wasn't intended to kick off the run. "'Knock, Knock' was the pilot for syndication, where 'Ghosts R Us' was the pilot for the network's Saturday morning lineup," says Kevin Altieri. Due to the syndicated episode production schedule becoming so fluid, the order originally intended to air would fluctuate constantly. It's easy to see why the creative team behind the syndicated episodes wanted "Knock, Knock" to be the first episode: it had a much darker tone than many of the network episodes, including a truly terrifying sequence on a subway train and an epic conclusion in which the Ghostbusters put their own lives on the line to save the day. Says Altieri, "I actually storyboarded the whole first act myself. Then the Japanese director storyboarded the rest. Having graffiti come to life was always something that I wanted to do."

The issue of "Knock, Knock" not being the first episode that audiences saw was remedied when it came time to release episodes on VHS for rental and purchase. "Knock, Knock" was released under RCA / Columbia Pictures Home Video's Magic Window label in 1986 as volume 1, ensuring it would be viewed first by the home market.

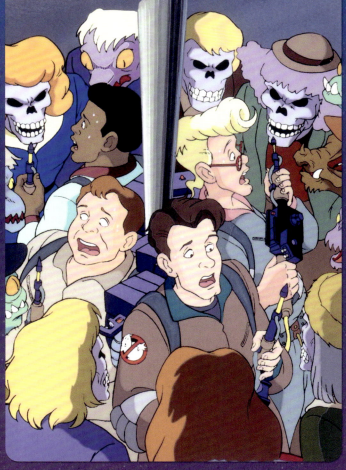

"Knock, Knock" allowed character designer Everett Peck to play around with otherworldly beings, including variations on a bowling alley ghost and denizens of a haunted subway train.

Chapter 2: Heroes, Ghouls, and Marshmallow Men

The Real Ghostbusters *allowed the Winston Zeddemore character a moment in the spotlight, particularly in episodes like "Elementary My Dear Winston."*

Payn, Gabi was in the process of transitioning and envisioned the idealized image of herself through the Janine character.

"If you look at photos of Gabi back then, she had that same sort of hair coming down," says James Eatock. "Obviously that's what went on to become Janine's initial look."

Laura Summer had recently relocated to Los Angeles from New York and was searching for work when a friend of hers suggested she read for a part in an animated *Ghostbusters* series. The catch was that Summer hadn't seen the film and had no familiarity with the character of Janine at all. "I went to some place in Burbank, and I remember that I was just like, 'Hello, Ghostbusters. How can I help you?' I didn't do a New York accent; they really didn't ask for it," says Summer.

When she left the audition, Summer didn't have any indication that she had the part. She continued the path of all new-in-town aspiring actors: working a full-time job and taking acting classes on weekends. After acting class, she returned home to find a message on her answering machine telling her she'd gotten the role of Janine. "When I got the job, they mailed my audition tape to me so I could match it. It's kind of unusual. The very first day was a really long day. I remember Lorenzo saying to me, 'It's usually not like this.' At some point during recording, they asked me if I could do a New York accent," says Summer. Her audition had been great, but they were finding it was missing something. The next words out of her mouth were what became Janine Melnitz. "I wasn't cast with a New York accent. But I'm from Queens. I was just cast sort of sweet and in my own voice. It was just very natural for me. Janine was a lot like me. She was sassy. She didn't really have a filter. I didn't set out to create a character that was so beloved in pop culture."

"When you hear Laura's regular speaking voice, it's not blatantly the same as Janine but you can hear that she

Character model for Janine Melnitz, restored and colored by Dušan Mitrović.

grew up in New York," says James Eatock. "That tone is always there. Annie Potts in the movies is incredible, but the script kept her limited to what she could do. Laura had to come in and use those few lines of dialogue from Annie Potts's performance to create a character, and she does such a great job."

"Just like Frank Welker, Laura can do multiple voices too," says Goodman. "Our cast was just so versatile. They could do so many different voices that were unique and original."

On the very first day of recording, Summer was asked to voice Snarg, the pink ghost who schemes to undermine the Ghostbusters in "Ghosts R Us." Says Summer, "I thought, this is kind of demanding of me because I was new and didn't know what I was doing. I knew I had to sound different, but I wasn't really trained, so I just made her really high."

With changes implemented in 1987 for the show by the network and Q5 (more on this in chapter 6), Laura Summer was replaced by veteran voice actor Kath Soucie. "I had heard the character in the movie and was surprised they were going in this different direction," said Kath Soucie on the Time Life DVD release. "Our job as an actor is to deliver as close as possible to what the production crew is asking for. So that's what I did. They wanted perky, cute, enthusiastic, fun; they wanted a more smooth kind of feel. The thing about Janine is that it's really close to my own voice."

"That came from the network and whatever focus group testing they had done," says Goodman. "I love Kath and Laura, they're both fabulous. But it was really bullshit. The focus group testing had said Janine's voice was 'too New York.' They wanted everything rounded out and homogenized."

"A wonderful actress followed me. We all work hard. We're all lifers. I think it's really important to be respectful and kind. I'm glad that the artwork changed when they changed the voice," says Summer. Time has healed wounds, and Summer reflects on her time spent on the show fondly. "I'm very proud of my work, and I'm grateful for getting to play Janine and being part of the *Ghostbusters* fandom and franchise. I'm very appreciative of that."

Chapter 2: Heroes, Ghouls, and Marshmallow Men

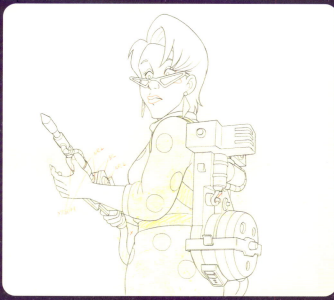
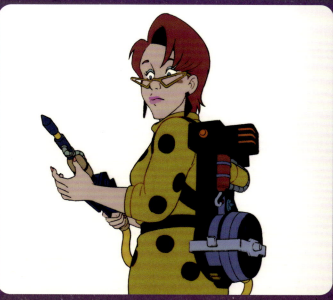

Top: *Marek Buchwald's early design for Janine Melnitz.*

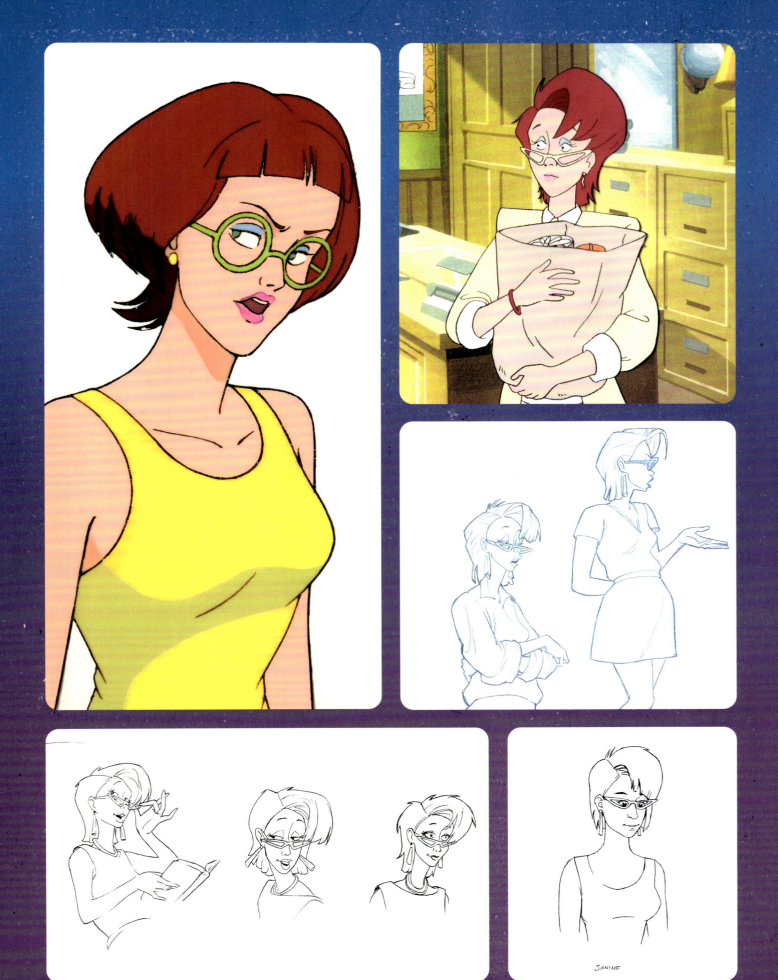

Janine Melnitz was the character who underwent the most revision throughout the course of the series. Originally designed by Gabi Payn as the idealized version of herself, the character was toned down and softened by the network.

Chapter 2: Heroes, Ghouls, and Marshmallow Men

Louis Tully

Easily flustered accountant Louis Tully wasn't part of *The Real Ghostbusters* until the 1989 fall season, following the summer release of *Ghostbusters II*. Tully's appearance (as well as another design change to Janine to make her appear more like Annie Potts's character in the second film) was intended as connective tissue to the live-action iteration. However, because *The Real Ghostbusters* had been running for three-plus years by this point, the break in continuity created some initial confusion.

Filling the shoes of Rick Moranis in the role was veteran voice actor Rodger Bumpass, who had worked with Medjuck and Gross on *Heavy Metal* and is now best known for his role of Squidward on *SpongeBob SquarePants*.

Slimer

Known only as "the Onionhead" during development and production of the original *Ghostbusters* film, the gluttonous green blob with a craving for room service carts became a key in *Ghostbusters*' success. Aykroyd viewed the green ghost—a literal remnant of someone who enjoyed life—as the shadow of John Belushi and his character, Bluto Blutarsky, in *Animal House*, both of whom had large appetites. "There's no way that, when I wrote that initial scene of him haunting a guesthouse in Upstate New York, that I ever thought the character would be anything more than that," Aykroyd said in the ITV documentary *Slimer Won't Do That!* Audiences loved the character. Venkman's proclamation of "He slimed me" became part of the pop-culture vernacular.

"It was a cartoon show, and we needed a lovable sidekick," says Michael C. Gross. "It seemed like part of the animation formula for Saturday mornings." It became clear that the ghost character from the film would fit that bill and the character would live on. The character would receive a reworking and reimagining in the series to become "Slimer," a name that stuck and became as globally recognizable as the No-Ghost logo itself.

"Slimer from the get-go was everybody's favorite. Even in the movie, which he was only in for a small amount of time," said Len Janson in the Time Life DVD set. "He got everybody's attention. We knew if he was going to be one of the stars, we needed to make him more of a complete character. Not just an eater, which we kept because it was funny. We decided to make him like a five-year-old kid. He was annoying. He was in people's way. He was chattering all the time and wouldn't shut his mouth. He was so different from the human characters that he just took off."

Though a centerpiece to the live-action films, the Louis Tully character didn't appear until the 1989 season.

To provide connective tissue to the live-action sequel, Rick Moranis's character, Louis Tully, was adapted for the series.

Gone immediately in the process was "Onionhead," and we all now take for granted the name "Slimer." But one of the great mysteries is who was responsible for first coining the character's name. Unfortunately, this book will not be able to provide that answer. To this day, nobody on the production team will take full responsibility. "I'd like to say it was me," jokes Joe Medjuck. "But I doubt it. I can't remember who finally came up with the name Slimer or decided that he would become their mascot, but we all certainly agreed with it."

"I think the first time I remember hearing the name Slimer was from Michael Gross," says J. Michael Straczynski. "I'm not saying that's who originated the name, but that's who I always figured had done it."

"None of us are fessing up to naming Slimer," said Gross in the Time Life DVD set, countering Straczynski's claim.

The first appearance of the name is in Len Janson and Chuck Menville's first-season bible, dated 12/5/86, but early concept drawings by Gabi Payn and Kevin Altieri name the character as Slimer. Could one of the artists have picked up on an offhand remark by Dan Aykroyd's Ray Stantz as he showed Winston how to empty a Trap into the Containment Unit, saying, "This is where we store all the vapors and entities and slimers that we trap," and incorporated it into one of their drawings? All of the above may be possible, as the humble creative team doesn't want any one person to take all the credit.

"The film production had sent us a drawing that they gave us," says Gabi Payn. "That was basically what I started with. I tended to make him more cartoony." In order for Slimer to be the comedic sidekick, he evolved into the firehouse's version of a ghost-busting Dalmatian, a big lovable goofball who wanted to greet his human companions at the door with slobbery kisses.

"We liked drawing Slimer. We got it, we knew that kids would like Slimer," says Dan Riba. "The network shows were

Chapter 2: Heroes, Ghouls, and Marshmallow Men

Highlight Episode: Citizen Ghost

WRITTEN BY:
J. Michael Straczynski

FIRST AIRED:
November 22, 1986

PREMISE (FROM THE ORIGINAL *REAL GHOSTBUSTERS* WRITERS PACKET): When a reporter asks why the Ghostbusters have a resident ghost, a flashback story reveals how the Ghostbusters teamed up with Slimer. The story begins with their return to the demolished firehall after disposing of Gozer, only to find the ghost that slimed Peter still hanging around. For a while it's a cautious game of cat and mouse; Egon wants Slimer for scientific research, Ray wants a pet, Peter wants to fry his little green tuchis right on the spot and Winston would rather not get involved. Matters are further complicated when the residual spectral power left over from the Gozer encounter gathers for an assault on the Ghostbusters—and in the final confrontation, only Slimer can decide which side will win.

"Citizen Ghost" is a direct continuation of the events seen in the 1984 film, acts as a flashback origin story to explain Slimer's presence, and introduces ectoplasmic spectral mirror-universe antagonists for the Ghostbusters. With all of those elements combined, it's easy to see why this particular episode became a fast fan favorite and is often mentioned in top-ten episode lists for the series.

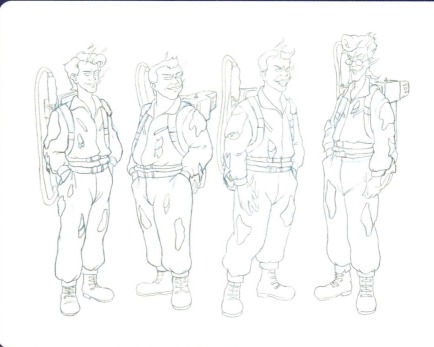

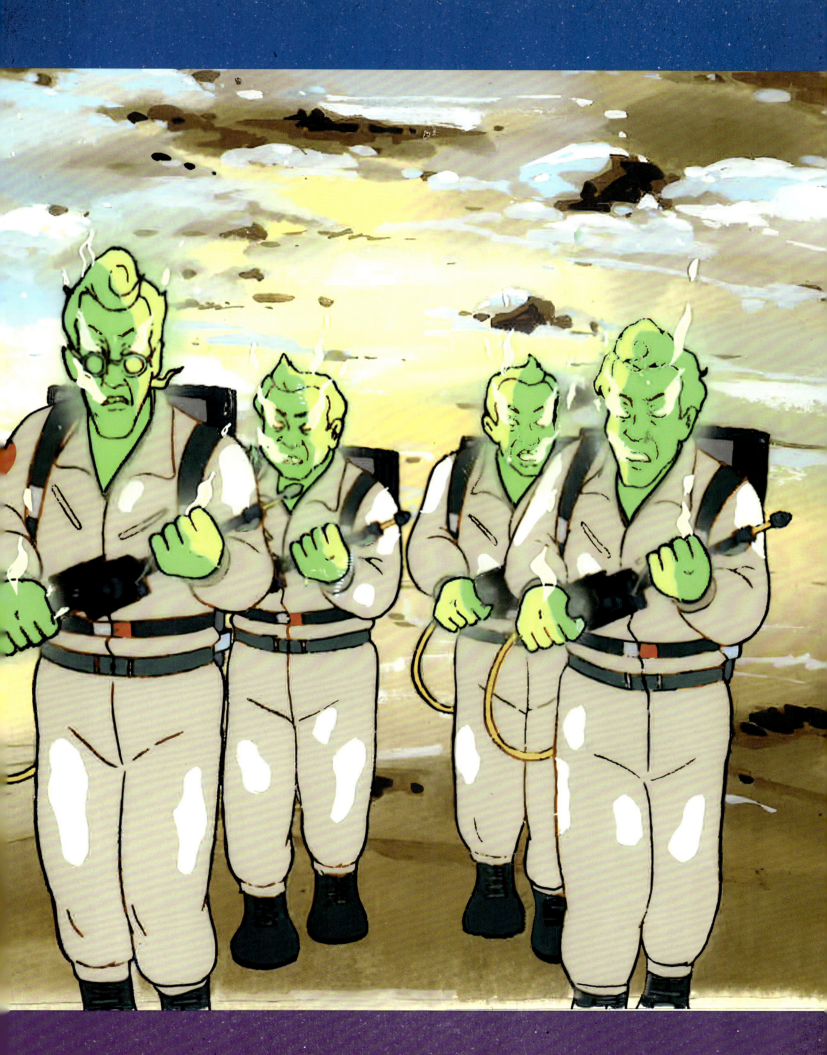

Early concept illustrations for "Citizen Ghost" by Dan Riba. Initially the spectral Ghostbusters were to experience varied states of grotesque disfiguration throughout the episode.

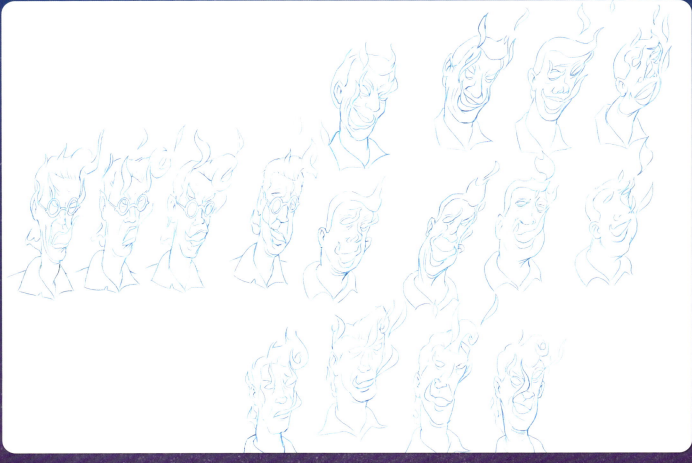

Chapter 2: Heroes, Ghouls, and Marshmallow Men

Slimer, while a lot of fun for the animators, proved a tricky character to balance.

very Slimercentric because we all got that the character would be important. But I totally also get others' takes on why this little spud gets in the way and his shtick gets old."

"I had a lot of fun with Slimer," says Brad Rader. "He was a great character to animate because you could give him great takes and allow him to do more overexaggerated acting. And that played well off the naturalistic acting of the human characters."

"The idea was that Slimer was like a six-year-old kid," says Dennys McCoy. "We wrote an episode called 'Kitty-Cornered,' and Pam had just lured a stray cat into our house for our daughter."

"I just held bologna at the top of the stairs," says Pamela Hickey.

Continues McCoy, "Slimer wanted a kitty and brought it up, but what the Ghostbusters didn't realize until too late was that this was a witch's familiar. Slimer, being a supernatural creature, had these dreams that the cat manifested as reality. We got a note back from Jennie Trias at ABC that just said, 'No notes. We love this episode.'"

"The networks kept pushing me to use more Slimer," says Straczynski. "I always said that a little Slimer goes a long way. With a character like that, the more you use it, the more you risk overusing it. I tended to agree with Peter. Slimer was there to be stomped on and dissected. I come from the background of the Marx Brothers, who would always make fun of their guest stars, and I wanted to play in that kind of way where the Ghostbusters were just constantly giving their guests a hard time. He's only interesting as a subset of the Ghostbusters, not as a character of his own self because he doesn't have a background. You know? He is a spud. He doesn't have a history. So you really can't do [anything] with him as a character. And if you try to do that, you're going to run into a wall because there's nothing to work with."

In the original *Ghostbusters* film, sound designers combined stock audio of raging gorillas and other creatures to make the Onionhead vocalize. For the animated series, the creative team turned to genius creature performer Frank Welker to find a way to voice Slimer. Since Welker did Ray mainly in his normal speaking voice, he accepted the challenge of pulling double duty on the show and finding the right guttural gibberish for Slimer.

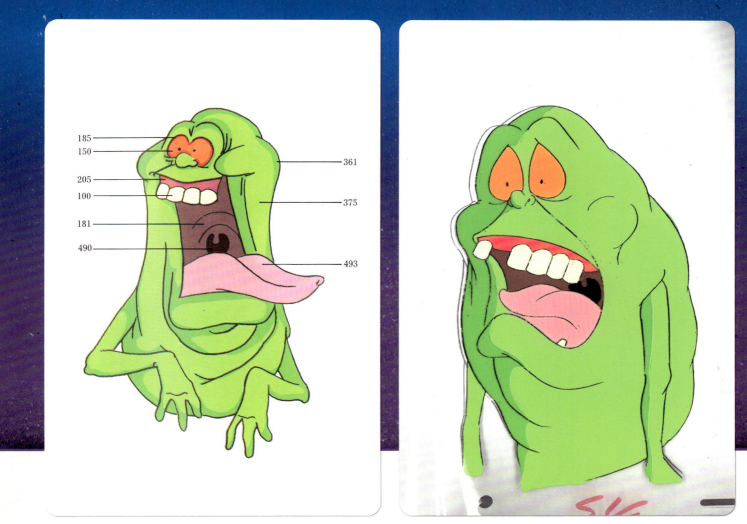

Left: *A branding style-guide reference for Slimer.* Right: *The character as he appeared in a final painted cel.*

"Frank Welker can do extraordinary things with his voice," says Medjuck.

"In the beginning, he didn't really articulate," says Marsha Goodman. "Halfway through, we started having him say one or two words."

Welker said in Daniel Wallace's *Ghostbusters: The Ultimate Visual History* that he was often asked to ad-lib the Slimer scenes. He was usually successful but often received notes that what he'd done was far too lengthy. "Frank Welker as Slimer was in a league of his own when it came to ad-libbing," says Kathryn Drennan. "Although I sometimes wrote specific dialogue for Slimer, such as 'the gibberish equivalent of *of course not*,' I often just indicated general sounds appropriate to the scene along with the emotion Slimer was feeling. Or the intent Slimer had. 'A shriek' or 'angry gibberish' or 'puzzled sounds'. And then Frank Welker created magic, pouring out torrents of words, sounds, and gibberish that perfectly fit the scene and clearly communicated what Slimer meant."

"And he almost made Slimer like one of the voices he does for *Gremlins*," says Michael C. Gross. "We had to pull him off *Gremlins* all the time."

The Stay Puft Marshmallow Man

As a child, Ray Stantz used to roast Stay Puft marshmallows by the fire at Camp Waconda. Ever the child at heart, when asked to visualize the form of his own destroyer, Ray couldn't help but evoke those memories of the soft and plushy marshmallow spokesman. Even though the Stay Puft Marshmallow Man was merely the manifestation of Gozer that incinerated into goo when the portal atop 550 Central Park West was closed by the Ghostbusters crossing the streams, *The Real Ghostbusters* somehow had to work "the big guy" into the series from time to time. He's as recognizable as Slimer or the Ecto-1, and therefore marketable and merchandisable.

Just as Kevin Altieri and the team placed Slimer into the original promo pilot as a pivotal link from the film to the animation, so too did Stay Puft get a starring role. A Stay Puft Marshmallows truck is also ransacked in the pilot by a ravenous Slimer. Stay Puft acting as the final boss for the Ghostbusters to face at the end of the three minutes was such a fulfilling and exhilarating conclusion to the promo pilot that it was replicated for the main title sequence in the series proper. So technically, the fifty-foot marshmallow

MEMORANDUM

Date: March 2, 1990

To: Every human being in every city in every country in the world working on "The Real Ghostbusters" and "Slimer" Show.

From: Michael C. Gross

I do <u>not</u> want to see another drawing, story board, model sheet or animation that portrays slimer with a tail.

If you have any questions, direct them to Will Meunigot at DIC.

After 3 years, I trust this will be the last word on the subject.

Mailed to Lori Crawford

GB PRODUCTIONS
The Burbank Studios - Producers Bldg. 7 - 4000 Warner Blvd. - Burbank, CA 91522
818 / 954-4276 - Fax 818 / 954-2747

Just after the production of Ghostbusters II, Michael C. Gross found it necessary to remind everyone that Slimer should never include one particular physical trait.

A common sequence in the show: Venkman being slimed.

STAY PUFT

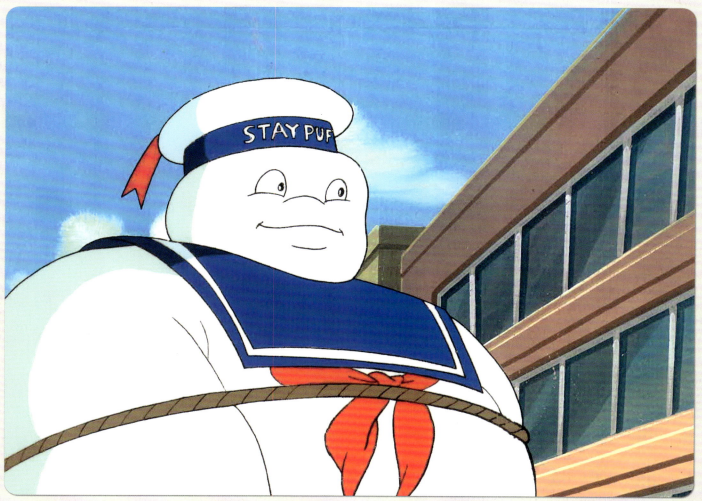

Technically, Stay Puft appeared in every episode of the series, since he was present in the opening title sequence.

102 The Real Ghostbusters: A Visual History

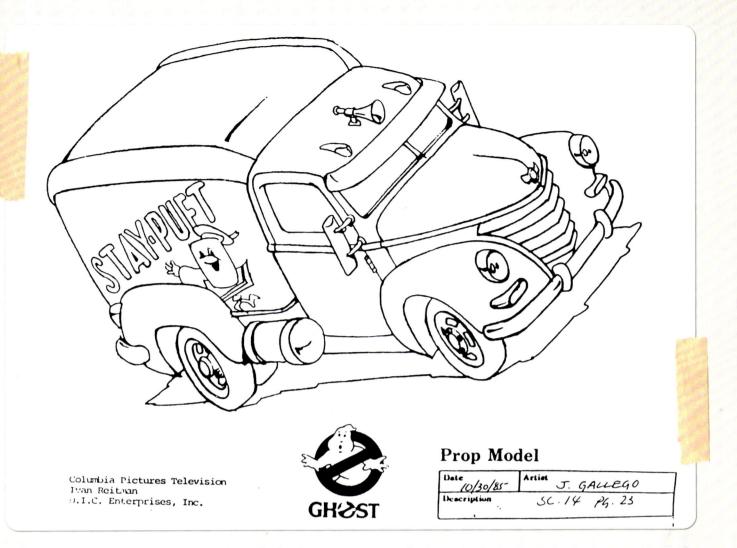

Columbia Pictures Television
Ivan Reitman
D.I.C. Enterprises, Inc.

Prop Model

Date	Artist
10/30/85	J. GALLEGO
Description	
SC. 14 PG. 23	

Columbia Pictures Television
Ivan Reitman Productions
DIC Enterprises, Inc.

Prop Model

Date	Artist
11/12/85	G. PAYN
Description	
STAY PUFT MARSHMALLOW PACKAGE SC. 15 PG 24	

Stay Puft Easter egg branding continued to be present in the animated series.

Chapter 2: Heroes, Ghouls, and Marshmallow Men

Highlight Episode: The Revenge of Murray the Mantis

WRITTEN BY:
Richard Mueller

FIRST AIRED:
November 2, 1987

PREMISE (FROM THE ORIGINAL *REAL GHOSTBUSTERS* WRITERS PACKET): The huge, inflatable balloon of Murray the Mantis—a popular Saturday morning cartoon character—becomes possessed during the balloon's appearance in a prominent New York parade. The only way to stop something this big is to release the Stay Puft Marshmallow Man from the containment unit, controlling him just enough to use him to attack Murray. The two battle it out over the streets of New York.

Just as it was important to find a way to bring Slimer into the series, finding excuses to integrate the Stay Puft Marshmallow Man proved tricky. The character is so large and so imposing; there had to be a good reason for him to be in a story aside from total destruction. And would he be a friend or a foe? The writers decided to play up their own trepidation concerning the character onscreen. When the Ghostbusters conjure him out of the Containment Unit (technically also a break from the continuity of the film) to combat a Thanksgiving Day parade balloon gone awry, will he help them? Or will he turn on them and join the giant bug? "There was just a lot of fun in that episode," says Richard Mueller. "The first act, you introduce a hero. The second act, you throw rocks at them and chase them up a tree. Then in the third act, they have to come down. If Stay Puft can act as a plus character, great. Use anything."

Also appearing in "The Revenge of Murray the Mantis" was Lieutenant Frump. In the absence of Walter Peck (who wouldn't appear until much later in the series' run), Frump acted as a bureaucratic foil to the Ghostbusters, believing them to be criminal-element wolves in sheep's clothing. Frump appeared in three of the original order of seventy-eight episodes and was intended to have a more major role but was ultimately left behind after changes were made to the series.

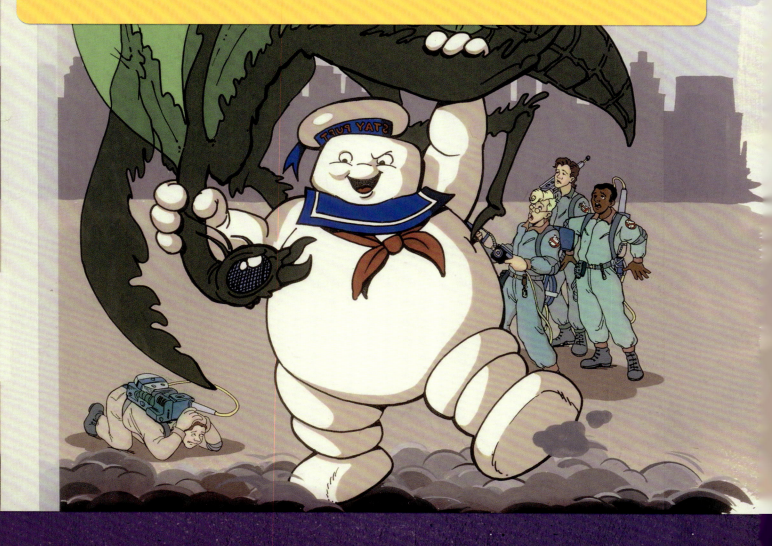

Chapter 2: Heroes, Ghouls, and Marshmallow Men

man was seen in every episode of the series. However, he only made a small handful of appearances in the plots themselves.

Samhain

The physical embodiment of a dark Celtic pagan celebration that begins on Halloween, *The Real Ghostbusters*' Samhain was a formidable enemy with a menacing jack-o'-lantern head atop a wraith-like body and the ability to command the undead as his own drone army. The character only appeared in two episodes (with a couple of additional cameos), but fans latched on to him as one of *Ghostbusters*' greatest villains. Samhain has gone on to appear in comic books, video games, board games, and more. The character also appeared in the opening credits of the 1997 *Extreme Ghostbusters* but never appeared in an actual episode. Although he had such a small part in *The Real Ghostbusters*, the reason the character has resonated so much could be because of his menacing silhouette. "The design of the character is really strong," says Jason Reitman. "I had an animator once tell me that you can judge the success of a character by whether or not you can identify them by their silhouette. Stay Puft, Slimer, a Terror Dog, you can recognize them all by their silhouette. I definitely feel that way about the Boogieman. But maybe there's a little bit of that to Samhain."

Samhain made a brief but memorable mark on The Real Ghostbusters.

Highlight Episode: Mrs. Roger's Neighborhood

WRITTEN BY:
Len Janson and Chuck Menville

FIRST AIRED:
September 27, 1986

PREMISE (FROM THE ORIGINAL *REAL GHOSTBUSTERS* WRITERS PACKET): The Ghostbusters are called to rid sweet old Mrs. Rogers' Victorian house of ghosts. Mrs. Rogers stays with Janine while they go to work and then realize the house is a trap for them, while Mrs. Rogers is the dreaded demon Wat whose goal is to invade and conquer the living world. After escaping the house, the Ghostbusters return to the firehouse to rescue Janine. Wat takes over Peter's body to use his fingerprints to release the safety catch on the Containment Unit. Peter's life is in the balance as he must withstand the energy of the throwers to free him from Wat and foil the demon's plans.

Chapter 2: Heroes, Ghouls, and Marshmallow Men

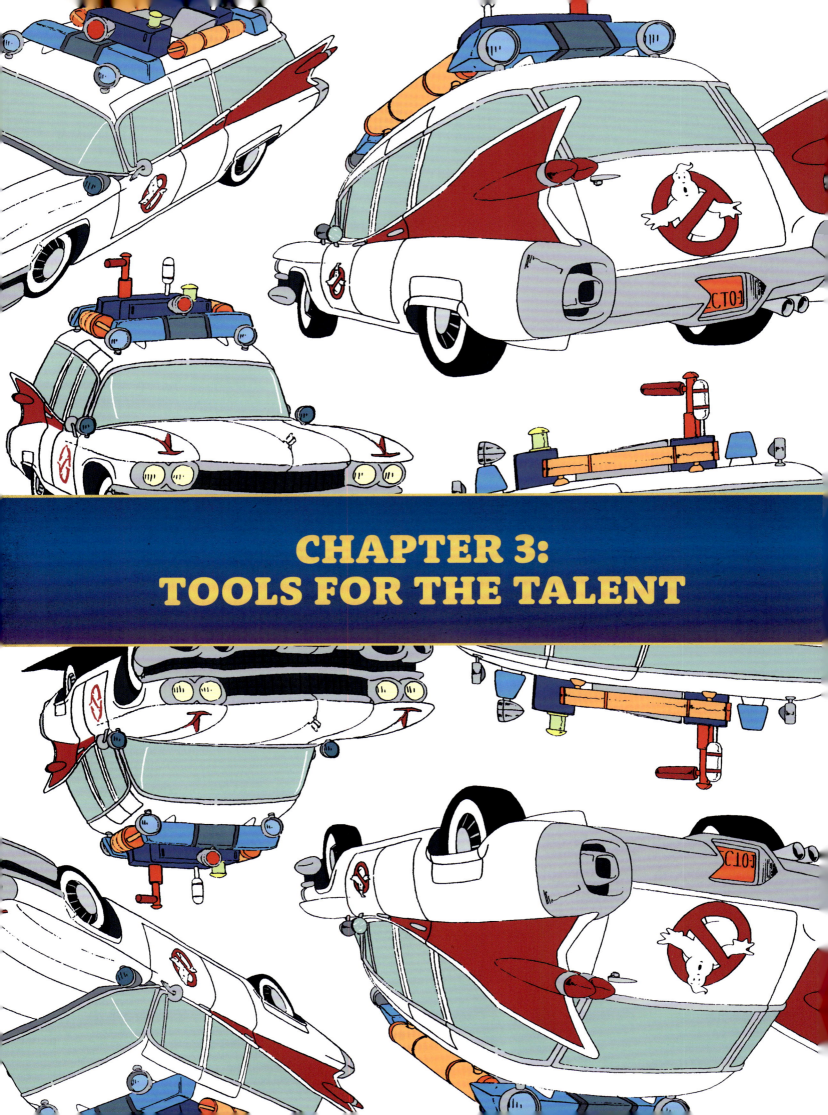

CHAPTER 3: TOOLS FOR THE TALENT

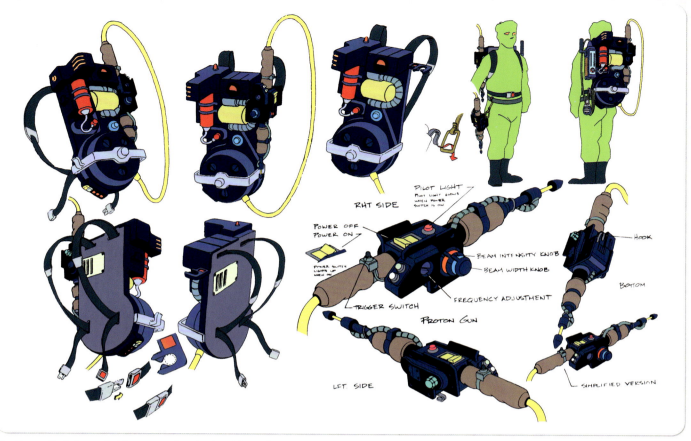

The Proton Pack from all sides, restored and colored by Dušan Mitrović.

A craftsman is only as capable as their tools. Luckily the Ghostbusters have a myriad of high-tech and fantastical gadgets at their disposal. *The Real Ghostbusters* took the concepts of Proton Packs, Ghost Traps, and PKE Meters from the live-action film and amplified them to eleven. The medium allowed the technology to go in directions that only animation is capable of depicting. Joining the gear seen in the films were new vehicles, like a two-seater gyrocopter, new ghost-catching equipment, a souped-up Ecto-Containment Unit, robots, portals to other dimensions, and any other gadget or gizmo that the story required Egon Spengler to invent in the nick of time. New gadgets were often the catalyst for the story. In episodes like "Adventures in Slime and Space," a Spengler invention splits Slimer into multiples who terrorize New York City. In "Egon on the Rampage," his own invention sucks Egon's spirit into another realm and replaces it with a maniacal and malevolent demon. At one point, business is so slow that Egon and the team reconfigure all of their ghost-catching gear to become crime-stopping "Crimebusters." If the story needed something to incite a problem, or a deus ex machina to save the day, the perfect piece of Ghostbusters technology was there to fit the bill.

One of the most notable changes to the Ghostbusters' gear in its translation to the animated series was a decision to uniformly change everything that was a flat black in live action to a shade of blue. Proton Packs, Traps, the PKE Meter—all were given blue makeovers. The common conception is that this was done primarily for the Kenner toys, to make sure that any role-playing items were made in accordance with new laws passed to make toy weapons bright colors to be totally distinguishable from real weapons. That's partially the case. The decision was also made to make the gear blue to help the hero characters stand out against dark and often completely black backgrounds, so as not to have their gear completely fall off into the void. Even going back to the ink and paint done for the promo pilot's animation, the Proton Packs and Ghost Trap were given an almost silvery blue chrome-like highlight to help the gear pop from the darkened backgrounds, a quick solution to make sure that the Ghostbusters' trademark gear was identifiable and stood out among all the details.

Proton Pack

The 1984 *Ghostbusters* film introduced a very DIY aesthetic to its technology, as if Ray and Egon had raided dumpsters at jet propulsion labs to find all of the equipment needed to create Proton Packs, Traps and more. The Proton Pack and the Ghost Trap are the two essential pieces of paranormal-removal technology, acting as both the fishing rod and the cooler to keep 'em in after you've caught them. A heavy backpack and a tethered Thrower that blasted a wild, property-destroying plasma stream were the two

Chapter 3: Tools for the Talent **109**

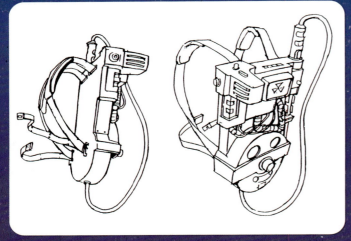
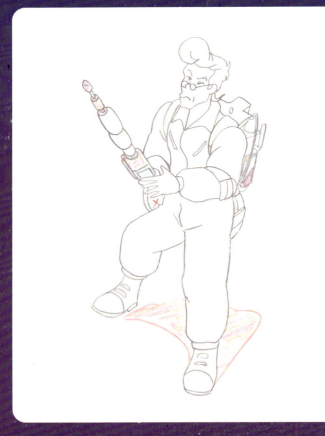
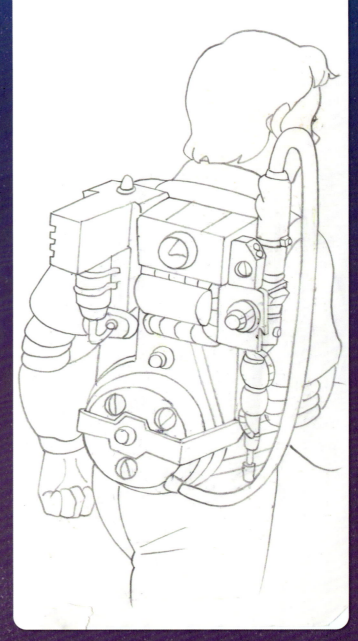

The Proton Pack was a highly detailed prop that proved difficult to re-create in successive animation frames. Above: The initial design of the backpack and Thrower included several details that were refined as the series went on.

main components of the Proton Pack. The blinking lights, Clippard valves, banjo knobs, and all sorts of greeblies peppering the designs to provide detail on the Proton Pack and the Particle Thrower presented a design challenge to the animation pipeline, where just a second of footage would require drawing that detail at least twenty-four times. *Real Ghostbusters* prop designers Marek Buchwald and Richie Chavez worked tirelessly to simplify the technology, especially the Proton Pack, down to basic forms that would still give the familiar silhouette but would also keep artists' hands from cramping upon repeat sketching.

Unfortunately, even that simplified prop design led to issues. "The Proton Packs and the Ghostbusters' costumes were still really detailed," says Dan Riba. "There were so many buckles and pockets and stuff. The animators would get the designs and be like, 'Are you out of your minds?' There was a revolt. The animators refused to do it. It was Richard's idea to work with the animators and come up with a solution."

"I would just say to just extract from it the creative inspiration, because I knew that [was] our contribution. The Japanese artists were so talented, and so technical; I knew they were going to make this all look good," says Richard Raynis.

"So, what was done was really clever," says Riba. "They did three sets of model designs. One was for close-ups, showing the exact level of detail that we wanted to see in the animation. Especially for the network show. Then for the wide shots, we allowed them to erase some of the lines and simplify the Proton Packs a bit. Then in the really long shots, there was a cipher. The shapes were simplified even more."

"That's an anime thing," says Raynis. "We were just very naive. Even when it came to filmmaking choices, things like choosing shots and economizing the way you design the animation. Part of anime is that they're very good at that. The Japanese artists were always aware of the cel count. We'd always hear how many cels it would take to do something. They definitely guided us."

"What's funny is, for the network shows, we got those close-ups. For the syndicated package, they never did that," says Riba. "They would just go between the details in the middle and the widest shot. There was no way they were going to be able to animate that level of detail and shadow for the syndicated package."

Ghost Trap

When a ghost is worn down and ready to be reeled in, there's nothing more satisfying than throwing out the Ghost Trap and slamming that foot pedal to open and shut the laser containment grid. Essentially a box at the end of a long cable with a triggering device at the other end, the Ghost Trap acts as a definitive conclusion to the ghost-catching process (and often slamming the door shut on the story as the bad guy is caught at the end of an episode). For this reason, the design of the Trap was key and was a tricky one for the designers to lock down.

In the promo pilot, the Trap was very simple: just a box dangled at the end of a string, with a chromed metallic finish that would be easy to animate. Given how quickly that pilot had to be produced, many of the pieces of gear, like the Proton Pack and Trap, were highly simplified down to their essential elements. When it came time to accentuate and redesign the Trap for the main series, detail was added back in—including details that weren't on the live-action prop that could also be

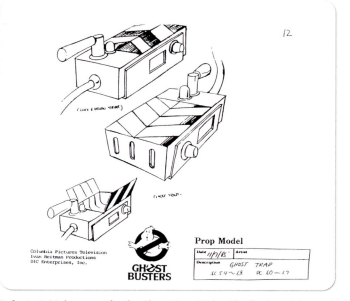

Left: *An initial concept for the Ghost Trap.* Right: *The final model, seen in a production drawing.*

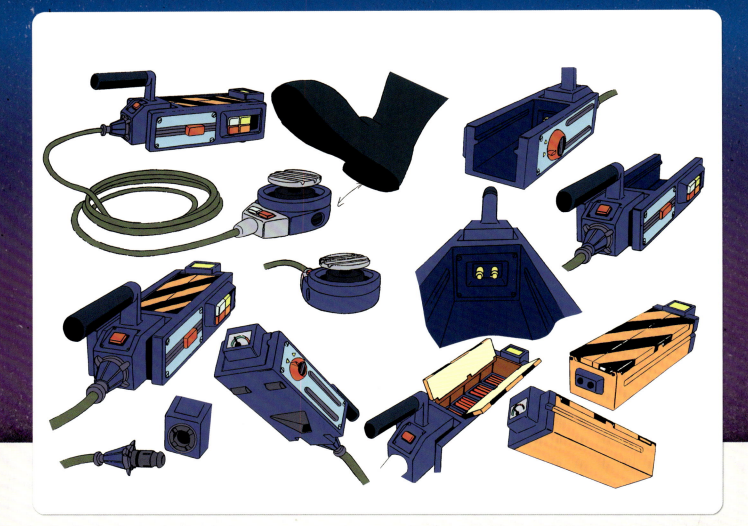

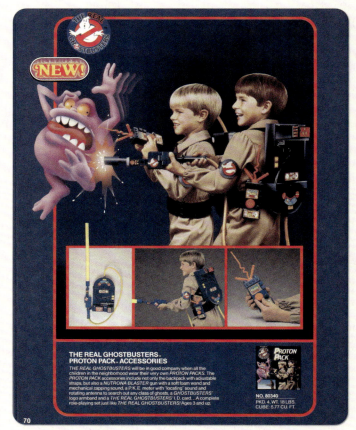

Top: *The final model for the Ghost Trap, restored and colored by Dušan Mitrović.* Bottom: *The PKE Meter originally deviated from how it appeared in the film and was rendered to look like a multimeter. Initial toy concepts from Kenner reflected that design, and the wings of the prop made it onto the final released toy.*

112 **The Real Ghostbusters: A Visual History**

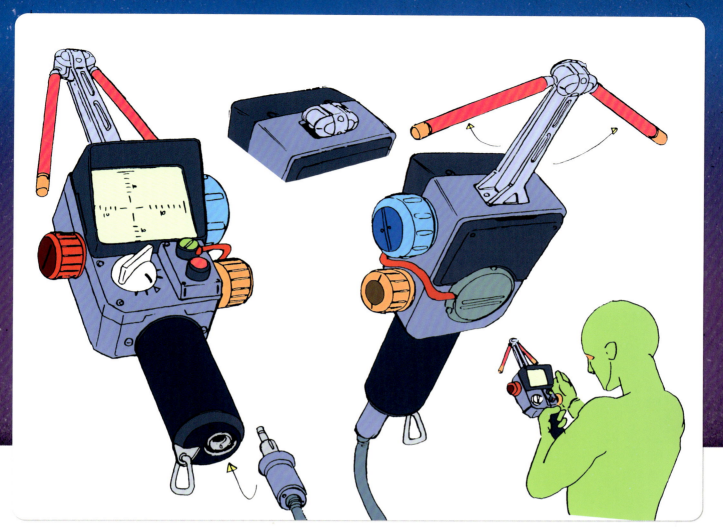

PKE Meter model sheet, restored and colored by Dušan Mitrović.

incorporated into the storytelling. Large buttons, dials, and blinking lights were added to the corners of the Trap to make it look like a futuristic and highly complicated piece of hardware. That prop model stuck around long enough for the Columbia Pictures Television sales team to create a vacuum-formed plastic version of the Ghost Trap that Herman Rush and his sales staff could send out to prospective syndicators, advertisers, and licensees with marketing material contained within the trapdoors.

As the series progressed, a decision was made to pull the design of the animated Trap back to something closer to what was seen in the live-action film: a narrower design with only a few knobs and indicator lights. Not only would this provide some continuity between the film and the series, but it would also mean less detail work for the animators, who were already sweating having to draw four Proton Packs in single shots.

PKE Meter

Just as Spock wouldn't leave home without his tricorder, Egon Spengler is never far from his trademark ghost-divining rod, the PKE Meter. In the original live-action film, the PKE Meter was kludged together using a brush-shaped Iona shoe polisher, outfitted with a light-up screen and two wings that protruded from the sides, which would indicate the proximity and intensity of a ghost. In the three-minute promo pilot, the PKE Meter was designed in a vastly different silhouette: appearing like a rectangular box with a dial dead center and a spinning antenna at the top, this PKE Meter design looked more like a multimeter used by an electrician or a tuning device utilized by musicians. Once again, in Kenner's role-playing toys, the PKE Meter design was a hybrid, combining the final version of the Meter seen in the show with the spinning antenna seen in the promo pilot. Because of the lead time in toy production, the mechanism and concept that kids could spin the antenna as part of the toy's playability had already been designed and finalized, and it was faster and more cost efficient to only redesign the body. Early promotions and prototypes of the Kenner role-playing toy resembling the Meter designed for the promo can be seen in Toy Fair guides and sales merchandise.

When it came time to refine and redesign the PKE Meter for the series, the bottom handle returned and the antenna

Highlight Episode: Troll Bridge

WRITTEN BY:
Bruce Reid Schaefer

FIRST AIRED:
October 11, 1986

PREMISE (FROM THE ORIGINAL *REAL GHOSTBUSTERS* WRITERS PACKET): Trolls have taken over the Brooklyn Bridge, and threaten to devastate New York unless another troll, who—tired of living under bridges—ran away to the Big City in search of good times [*sic*]. The Ghostbusters make a deal: give them twenty-four hours and they'll deliver the troll themselves. They find the troll, but by then 1) the 24 hours are up, and 2) the Ghostbusters find they kinda like the little guy. Keeping the troll free and keeping New York intact requires some quick thinking and a little fancy footwork.

Top: *Designer Everett Peck's initial designs for the troll characters in the episode.* Bottom: *The trolls as they appeared in the final episode.*

114 The Real Ghostbusters: A Visual History

became something that could be extended or retracted into the body of the unit, with the indicator wings attached. This added a more dynamic movement, as the motion to activate and use it was more deliberate than pushing a button or turning a knob.

Ecto-1

Batman has his Batmobile. James Bond has a garage full of Aston Martins and BMWs. The Ghostbusters have their tried-and-true Ecto-1: a 1959 Cadillac Miller-Meteor with a distinctive silhouette and a personality all its own. Just as it was in the original three-minute promo pilot, the Ecto-1 was as integral a character of *The Real Ghostbusters* as any of the named heroes who utilized the car. It was their preferred mode of transportation, could give chase to the most mobile of ghosts, and acted as a remote headquarters away from the firehouse—but above all else, it was just really cool. "I still get excited seeing the car every day I walk up to work," says Jason Reitman. The original Ecto-1 used in the first film as well as the refurbished Ecto-1 seen in *Ghostbusters: Afterlife* and *Ghostbusters: Frozen Empire* sit parked outside the Ghost Corps offices on the Sony Pictures back lot, ever ready to jump into duty. "There's something so unique about the choice of vehicle on the part of Aykroyd, and the design from the film that makes it so cool forty years later."

To make sure the Ecto-1 continued to have all of the appeal and charm that it had in live action, James Gallego kept the silhouette of the car, embellishing only the front end to give it more of a "face" (which would also come in handy for the few times the car was possessed or animated by a supernatural entity in the series). As with the Proton Packs, the amount of detail on the car proved challenging for the overseas animators, particularly in the intense chase sequences or wider shots that showed the vehicle from a distance, so

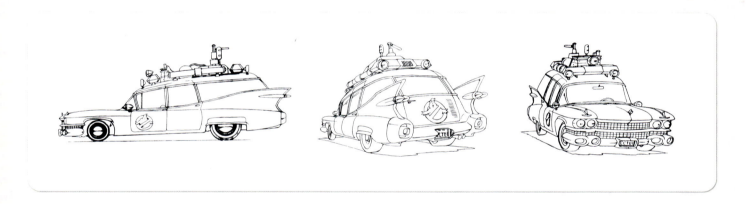

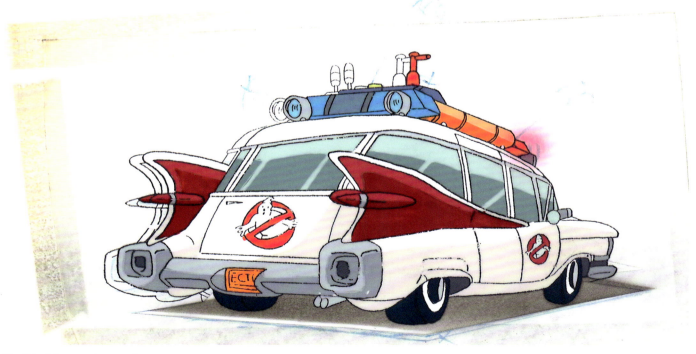

The Ecto-1 from various angles.

Chapter 3: Tools for the Talent 115

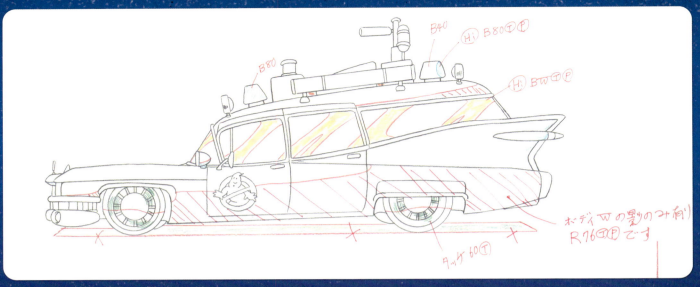

Top: *A production callout of the Ecto-1 in profile.* Middle left: *A painted background interior of the Ecto-1 by Kevin Altieri and James Gallego.* Bottom: *The Ecto-1 literally becomes a character when possessed by a malicious being.*

varying levels of detail had to be employed depending on the situation.

"I distinctly remember designing the Ecto-1. Looking back at it after so many years, I think I did a pretty good job," says James Gallego. Though Gallego was primarily a key background painter for the series, he was given the task of designing the Ecto-1 for one simple reason. "I've always been into drawing cars. I grew up drawing cars all the time, and I wanted to be a car designer when I was going to school. I may have mentioned that I love drawing cars and that's why I got the assignment. With some input from the producers and directors, I took the original car and simplified it while just trying to keep the look of what it's supposed to be, staying faithful to what the car was in the film. But keep in mind that I had only been in the industry for a year. Maybe not even that. I just sort of designed what I thought would work."

All of the writers wanted to write elaborate stunts, gags, and even entire plots for the Ecto-1. "I'm a character guy. Many of the various writers who came in had ideas of things to do with the technology within Ecto-1," says J. Michael Straczynski. "And if it made sense, I said sure. But when you're running the creative side of things, you have to stay focused on the characters. The rest is just what orbits around that."

Ecto-2

When the situation was grim and it was necessary for the Ghostbusters to split up, the rear cargo door of the Ecto-1 would fly open and out would emerge the Ecto-2: the two-seater gyrocopter that was a wholly original creation for *The Real Ghostbusters*. In fact, Ecto-2 was the only element in *The Real Ghostbusters* that was specifically designed with a toy in mind. "Kenner was talking about wanting to add a smaller vehicle as a toy," says Kevin Altieri. "And because I was in love with *Macross* and *Robotech* at the time, I pitched this autogyro that would sit in the back of Ecto-1 that would slide out and unfold. I really wish we didn't have to destroy it in that bridge sequence at the end of 'Ghosts R Us.'"

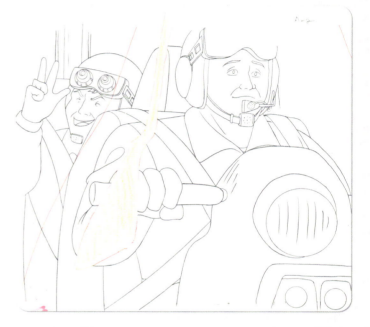

"We destroyed it in the very first episode. What were we thinking?" jokes Dan Riba. "It was the coolest thing in the world, so luckily it came back. And I'm glad it did. It was one of the few things we designed for the show with the toy line in mind. But it was totally natural. It wasn't that Kenner came to us with the idea; we saw 'Ecto-2' in the script and we all thought it would be a kick-ass toy. So we designed the model with that in mind."

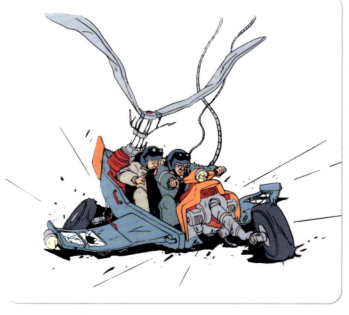

The two-seater Ecto-2 was a favorite among the animators and the toy designers.

Chapter 3: Tools for the Talent **117**

Highlight Episode: The Boogieman Cometh

WRITTEN BY:
Michael Reaves

FIRST AIRED:
October 18, 1986

PREMISE (FROM THE ORIGINAL *REAL GHOSTBUSTERS* WRITERS PACKET): As most kids suspected anyway, the Bogeyman [*sic*] is real, and lives in the In-Between place, where the walls, ceilings and floors consist entirely of doors . . . and every door leads to a different kids' bedroom closet. When two of these kids come to the Ghostbusters with a plea for help, Egon—who has a longstanding grudge against the Bogeyman—volunteers the Ghostbusters' assistance. The mission takes them to bedroom closets throughout New York, and finally into the twisted world of the Bogeyman himself for the final confrontation.

For centuries, tales of the Boogieman (or Boogeyman or Bogeyman; seemingly all variations of the spelling were used in various production documents for The Real Ghostbusters) have been told by parents to their children. A mythical creature who hides under a bed or inside of the closet, the unseen nightmare that hides in the shadows was given a name and a face (and defeated) in The Real Ghostbusters.

This version of the Boogieman is truly terrifying. Spiked blue hair cascades down the angular and strangely shaped back of the character, who also sports the ears and legs of a goat and razor-sharp teeth. The grotesque, pale being has an eerie blend of anthropomorphic features—a colossal head resting upon a smaller torso and legs. The Boogieman's powers are fueled by the fears of children from all around the world, including those of a young Egon Spengler, making the creature's debut episode a more personally terrifying journey for the normally stoic and reserved brains of the operation. Finding the right blend of scary, mischievous, and surreal was a challenge for the Real Ghostbusters character designers, and multiple iterations were explored by Everett Peck and Gabi Payn. Payn's final design for the villain was so grotesque, so larger than life, that the animators had difficulty figuring out how the being would walk or even get through the doors of the closets he intended to haunt.

Voice actor Frank Welker gave the Boogieman a guttural voice that seemingly came from the back of the throat, for a result that sounded both otherworldly and terrifying. At the time, neither Welker nor any of the other voice actors had any idea what the Boogieman character would look

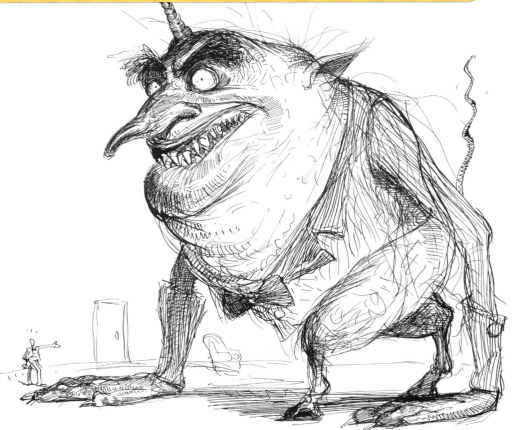

like; they only had his description on the page. The animation team was, as always, working around the clock to storyboard and complete the episode. "The Boogieman episode was one where we had to farm out the storyboards initially, and when they came back, Dan Riba and I totally had to reboard it," says Kevin Altieri. "We kept bits and pieces, like this drawing or that background, and saved what we could from the initial storyboard, but that was a bit of a fire drill. That episode came out pretty well, I thought."

Says Maurice LaMarche, "We were making scary sounds, but I had no idea how scary the visuals would be until the show came on. Any one of these episodes could have been used for Ghostbusters II; they wanted them to be sequelworthy. So they demanded that level of quality for each concept."

"The Boogieman Cometh" became one of executive producer Michael C. Gross's favorites. "It was frightening," says Gross. "The design, the writing, the concept was scary. And we were very proud of it because, for us, it helped defuse the boogieman for children. We gave them an answer to it. The Ghostbusters can take care of it. The network was very nervous about it. They were scared of this episode."

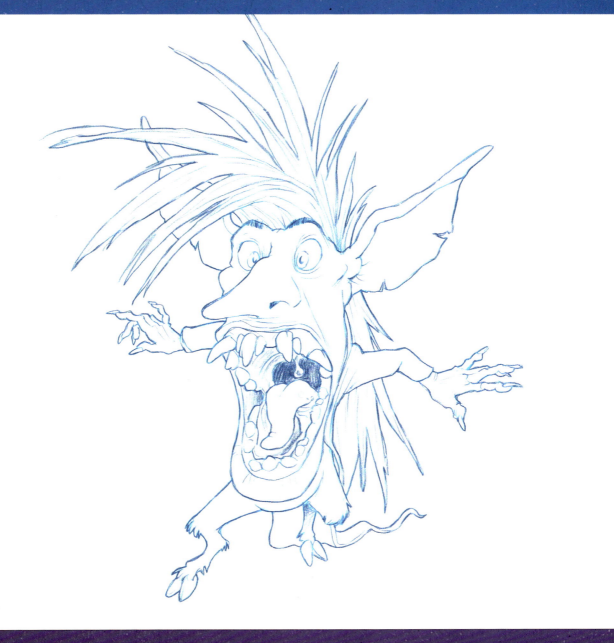

Opposite: *Everett Peck's original concept for the Boogieman put him on a massive and intimidating scale.* Above: *Gabi Payn's final concept for the Boogieman character as it would appear in the series.*

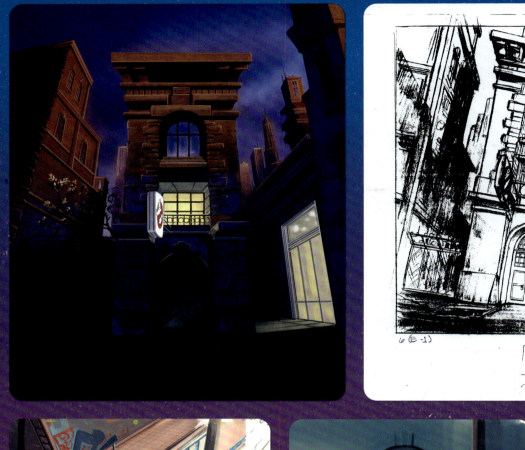
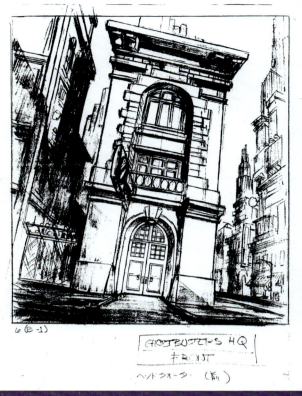

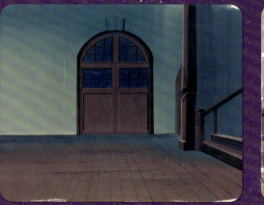

Top left: *A rendering of the firehouse created by Emiliano Santalucia for the Time Life DVD release.* Top right: *A final model sheet for the firehouse, used by the animation crew for reference.* Bottom: *Final background paintings of the iconic location.*

The Firehouse

A vacant fire hall in Lower Manhattan becoming the Ghostbusters' main headquarters was one of the boldest and most memorable choices for the 1984 *Ghostbusters* film. It was quirky, it was cool, and it was strange enough to be congruous with the Ghostbusters' 1959 Cadillac transport, their air force flight suits, and their dangerous and precarious-looking nuclear-powered gear. In fact, the firehouse was perhaps another feather in *Ghostbusters*' cap with its appeal to a younger audience who dreamed of someday inhabiting their own firehouse and sliding down the fire pole to a waiting Ectomobile. From the promo pilot on, it was clear that the firehouse would act as home base, a retreat from the action, and the monolith that helped make the Ghostbusters into icons of the city. "The *Real Ghostbusters* firehouse was an excellent reproduction of what we used in the films," says Joe Medjuck. "The exterior of the firehouse was a practical location in New York City. In Los Angeles there was exactly the same style firehouse that was basically abandoned that matched the interior in New York. And, in the series, the firehouse looks pretty much like the real deal."

"So much work had to be done. Looking back at designs, I'm amazed at how much Marek did," says Richard Raynis. "A lot of Marek's background work was used as inspiration, particularly for the firehouse, usually cleaned up by artists like Richie Chavez."

Top: *In a stunning cel setup provided by collector Beau Obremski, it's clearly evident how the same background of the firehouse pole was utilized for multiple shots of the characters descending into the garage bay below.* Bottom: *A model for the firehouse interior as rendered by Richie Chavez.*

Chapter 3: Tools for the Talent

The Ecto-Containment Unit

"I designed the Containment Unit, which was really cool. And it was important that it looked really cool," says Richard Raynis. "I just had this idea of what I thought it should look like and, using my experience in creating backgrounds, I just did this master shot. Then Richie Chavez created some of the angled shots on the unit and John Calmette did the painting on it."

"I had come into the series with a different artistic direction. I had been trained in background design and art direction to rely a lot on shading and lighting to make my renderings theatrical. Hugh Ferriss was somebody who I really admired, and that was the direction that I tried to bring to my artwork," says Bruce Zick. "What was the habit of Richard Raynis's team was to create more of the line work—the skeletal, almost architectural, design work information. It was very amazing and precise, but mechanical. Then the background painter would be the one that would add the theatrics: the tonalities, lighting, and the shading."

"We were just following on the heels of the first movie. But we made it bigger. We made it more impressive. We had to look at it like the greatest amassed, tightly packed group of ghosts and demons that wanted to conquer the world were in there. If you look at the design of the Containment Unit that we designed for the cartoon, I found ours to be more interesting. It was a space where dramatic things could happen. 'Mrs. Roger's Neighborhood,' the whole point of the story was that she wanted to get to the Containment Unit to let all the ghosts and demons free. That became an ongoing situation that happened more than once in the series," says Brad Rader.

"They took something from the film and built it bigger and better and then explained why," says James Eatock. "It doesn't make much sense that the basement of the firehouse is so much bigger, but I love all that."

"I liked my Containment Unit better," jokes Raynis.

Top: Original three-quarter background design of the Containment Unit and its surroundings by Richard Raynis. Bottom left: A painting of the Containment Unit created for the Time Life DVD set by Emiliano Santalucia. Bottom right: Egon Spengler venturing into the Unit's inner dimension. Opposite: Richie Chavez's detailed view.

Chapter 3: Tools for the Talent 123

Highlight Episode:
Mr. Sandman, Dream Me a Dream

WRITTEN BY:
J. Michael Straczynski

FIRST AIRED:
October 25, 1987

PREMISE (FROM THE ORIGINAL *REAL GHOSTBUSTERS* WRITERS PACKET): A Sandman—one of hundreds normally assigned to help ease people into sleep—goes renegade. He decides that humanity might stop its warring and fighting if it had a nice, long nap . . . say, five hundred years. The sleep dust he uses for this special job is so strong that it brings the sleeper's dreams to life, causing havoc for the Ghostbusters, who must stop him before the entire world goes beddy-bye. But they are picked off one by one by the Sandman. And if that weren't bad enough, there's just one other complication: the Sandman has the ability to turn the loosed dreams into nightmares, and turn them against the Ghostbusters.

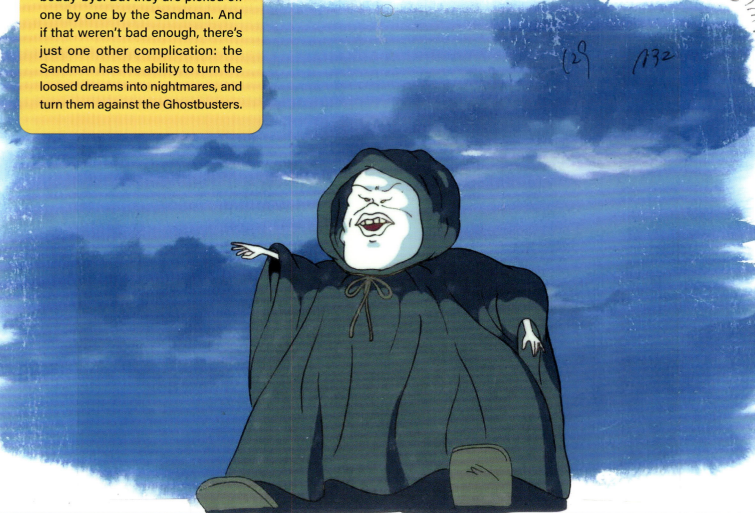

"Mr. Sandman, Dream Me a Dream" was character designer Everett Peck's dream come true, as seen in these conceptual images for surreal, dream-like creations.

Chapter 3: Tools for the Talent

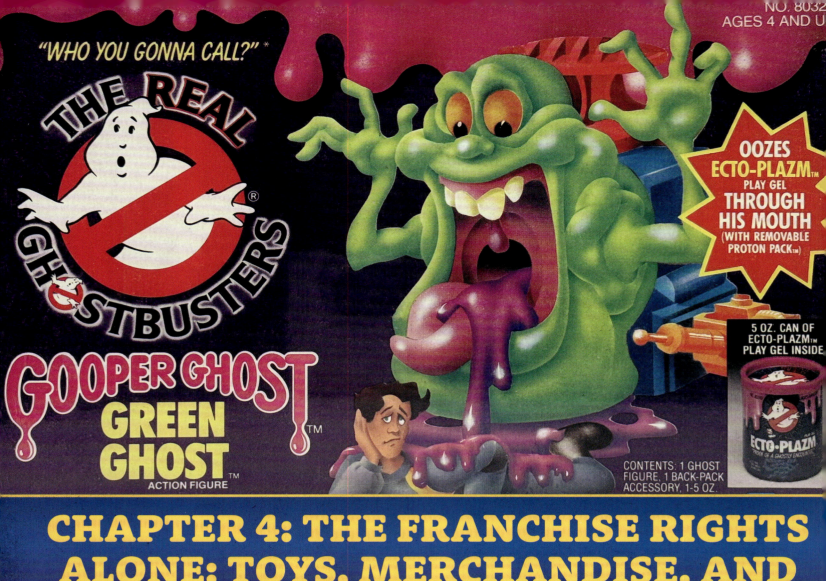

CHAPTER 4: THE FRANCHISE RIGHTS ALONE: TOYS, MERCHANDISE, AND THE RISE OF ECTO COOLER

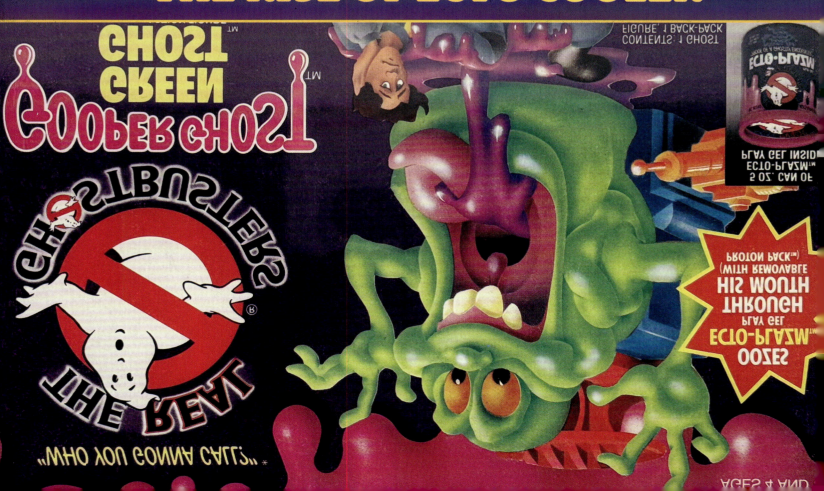

Ghostbusters *was a massive hit, but getting toys to shelves took time.*

"*Ghostbusters* was a big hit. But there was hardly any merchandising," says Joe Medjuck. Licensed products and merchandise sales were a crucial part of a film franchise's financial success and longevity in the 1980s. Aside from a skyrocketing soundtrack album, nothing was on the shelves for *Ghostbusters*' launch in 1984. The film had been produced so quickly, there wasn't time to ramp up production on any merchandise or secure any licensing deals. The general public demanded anything with a Ghostbusters logo on it, and kids who wanted to bring the experience of the film home through toys were unable to do so. Supply was all but nonexistent. "Part of the problem was that Toy Fair in New York was in February, and we were still shooting the film in February for a June release," says Medjuck. Early buzz on the feature film had been positive, but it wasn't until the film's release in June that the studio had taken note of its resonance with children. Starting the process of toys and products aimed toward children at that point meant making it to the shelves in fall of 1985 at the earliest. "There was no lead time for the toy companies to work with the movie. Plus, we didn't know about the word 'toyetic' at that point, so we weren't really thinking about it at the time."

Eric Reich, who works alongside Sony Pictures Consumer Products while overseeing the licensing and consumer products for the *Ghostbusters* brand as the senior vice president, brand management, of Ghost Corps, says that not much has changed since the early 1980s. Creating movie tie-in products is not dissimilar to projecting a trajectory to the moon, since many variables and factors in the production pipeline can cause the products to land early or late. "Developing a product line can take over a year, usually," Reich says. "That's what's hard with movies. To get something realistically on the shelf the day the movie comes out is incredibly difficult with the timelines."

"By the time the movie comes out and is a hit, you can't tool up a two-year production schedule for toys," said Michael C. Gross on the Time Life DVD. "By that time, the movie would be history. That's why there were no toys for the movie." With animation, particularly Saturday morning programming, enjoying a boom in the mid-1980s, there were a lot of eyes on the Ghostbusters-themed animated series. Having a lot of consumer product tie-ins to *The Real Ghostbusters* was a surefire way to keep the energy and momentum of the franchise moving by putting little reminders of *Ghostbusters* throughout all facets of everyday life. The hope was that kids would beg their parents for toys in brick-and-mortar toy aisles, clamor for *Ghostbusters*-themed Happy Meals, and have household *Ghostbusters* products like bubble bath, toothpaste, and bed sheets. Morning, noon, and night, awareness for *Ghostbusters* would never fade. The crown jewel in the consumer products lineup would be a large toy line deal with Kenner Products, which would be hot holiday gift

items for children around the world. "We were a little reluctant at one point," said Gross. "Between the animated show and the toys, were we selling ourselves out? And we said we can only do this if we maintain integrity."

Robby London, who had come from Filmation and worked on a primarily toy-driven show with *He-Man and the Masters of the Universe*, had a frontline perspective on what toys could do to the animation process. Contrary to a popular trend at that time, he believed it was possible to combine the merchandising with smart and intelligent storytelling. "In the 1960s and '70s networks would basically pay a license fee that would cover the costs of the show. The producer could get their costs covered simply with the US network license fee, and any other revenues that could be generated on their show was gravy," said London to *Animation World Magazine* in 1997. "The international licensing, merchandising, all those things were just profits to the studios. It was a very good business because there was basically no risk. That changed radically in the 1980s. In many cases, the domestic licensing fees are a relatively small part of the cost of a production. International, licensing, and merchandising are far more critical to getting a show financed."

"Some of the shows I worked on were twenty-two-minute commercials for the toys. With *Centurions*, they came up with the toys first, and they did a cattle call for writers sitting around playing with them. And I'm thinking, I can't laugh. If I laugh, I'm not going to get this job. With Chuck Norris's *Karate Kommandos*, we had all those things spelled with *k*'s, like the Karate Kommando Corvette. And we had to write that all in," says Steve Perry. "I didn't get that from *Real Ghostbusters*. Straczynski never once said to us that we had to feature such and such toys."

This was also a time that Action for Children's Television argued before the courts that animated shows were blurring the lines between entertainment and commercial intent to sell products to children. Their efforts would eventually lead to the Children's Television Act. (More on how that affected *The Real Ghostbusters* in chapter 6.)

"The real key is to be a storyteller first," said London in the *Animation World Magazine* interview. "Certainly speaking for DIC, we value storytelling more than anything else. We also value merchandise, and I think it's very organic and natural for certain kinds of stories to make kids want to play

> **"Certainly speaking for DIC, we value storytelling more than anything else. We also value merchandise, and I think it's very organic and natural for certain kinds of stories to make kids want to play with those toys."**
> —ROBBY LONDON

with those toys. Kids have a right to play with toys, just as we have a right to enjoy stories."

"Cartoons are very different from a movie release, because they're released daily or weekly," says Reich. Reich looks back on the release of *The Real Ghostbusters* compared to the licensing and merchandising of the modern era as something that was very of its time and difficult to replicate in the present day. "The cartoon lasted for so long—they had so many opportunities to create so many tie-in products. It really was a different time. Now with the way that content is consumed, there isn't as consistent of a flow of new characters and new vehicles. Content is dropping like movies, all at once. There are a lot of conversations now about how streamers and networks can parse out more content over a longer period of time. So that they can build an audience awareness, and create some longevity so that the products can last longer. I think that's our goal. We always talk about a 365 content plan where there's *Ghostbusters* stuff happening throughout the year, every year. You can really only achieve that with a series like *The Real Ghostbusters*."

"When I'd see kids playing with the *Ghostbusters* toys, it just made me so happy," says Dan Riba. "When I was a kid, you couldn't buy a *Space Ghost* toy. *Star Trek* didn't get decent toys until years after it was canceled. I may have been a little jealous."

Kenner, The Crown-Jewel Licensee

Christmas 1987. High above Vine Street in Cincinnati, the twelfth floor of the Kroger Building was still. The calm after the preholiday chaos. Just a mere week before, the twelfth floor's monolithic reception desk was swamped with incoming phone calls, employees rushing to finish their year's work, and parents desperately pleading for a chance to get their hands on a last-minute gift for their children. But now? Silence. On either side of the quiet reception desk, watching over the lobby, were two trophy cases. Elegantly lit and decorated for the holidays, the protective cases weren't housing accolades and awards, as many businesses would proudly display. Instead, they were populated with museum-quality iterations of the most famous and successful toys of all time: the Easy-Bake Oven, Play-Doh, Care Bears, the Star Wars Millennium Falcon play set, Spirograph, Baby Alive, the Six Million Dollar Man, and for the first Christmas ever—the central attraction: the Real Ghostbusters Proton Pack. Is this heaven? No, it's Kenner. While all may be calm and the scene may feel like a slice

The Social Corner
by Maryann Campbell

In October, Tom Osborne resurrected the annual PUMPKIN CONTEST. For those of you who have lost their cultural balloon schedule, the Pumpkin Contest used to be THE event of the year. It was forgotten in more recent years, but 1987 saw its return with vigor. With 23 entries in materials ranging from embroidery to human flesh, the Pumpkin Contest exercised the creative spirit of participants and viewers alike. Judged by our President, David Mauer, prizes of pumpkin pies were awarded in the following categories:

 Most Tasteless: "O'Lantern Family" - Drafting
 Best Carved: "Punk" Pumpkin - Donna Weaver
 Best Group Entry: "New Product Pumpkin Heads" - NPC (incorporating the actual heads of Tom Riddle, Mindy Corcoran, Steve Trammel, Kathy Riordan & Joel Roadruck)
 Best of Show: "Lez' Eat" - Larry Elig

A bigger and better Pumpkin Contest for 1988 is being planned and we are hoping for more entries to compete for bigger prizes in more categories! So plan now to participate!!!

Amid poinsettias and the gentle sounds of harp music, this year's CHRISTMAS DINNER DANCE was held on Saturday, December 5th in the Grand Ballroom of the Clarion Hotel. A complimentary drink and hors d'oeuvre hour began the festivities with dinner, dancing and door prizes following. There was a special appearance by Kenner's own "K-102's" (Tom Osborne, Ed Busam, Mike Brann, Tim Conroy, Paul Van Risseghem), the "Markettes" (Ginger Kent, Lisa Christensen, Liz Kalodner), and "MacDonna" (yours truly), plus the "Editions" had everyone dancing the night away. It was a lovely, entertaining way to begin the holiday season. Congratulations to the dance committee for making it a truly enjoyable evening.

Kenner internal newsletter showing the winners of the jack-o'-lantern carving contest created by Tom Osborne.

of heaven, it was one hell of a journey for that Proton Pack to be readied for this moment.

Founded in 1947, Kenner was named by Albert, Philip, and Joseph Steiner after the bustling street where they had previously owned a soap shop, their first business. They opened their toy company with a single product: the Bubbl-Matic Gun. By the time the Steiners sold Kenner to General Mills, it had metamorphosed into a powerhouse. The cereal giant brought Kenner the infrastructure for manufacturing and distributing toys in massive quantities—a supply chain that was key in the company's success when, in 1977, Kenner revolutionized the toy business with their Star Wars line. The decision to scale down the action figures, vehicles, and play sets to a world-building-friendly 3¾ inches allowed Kenner to sell more than three hundred

THE REAL GHOSTBUSTERS

NEW!

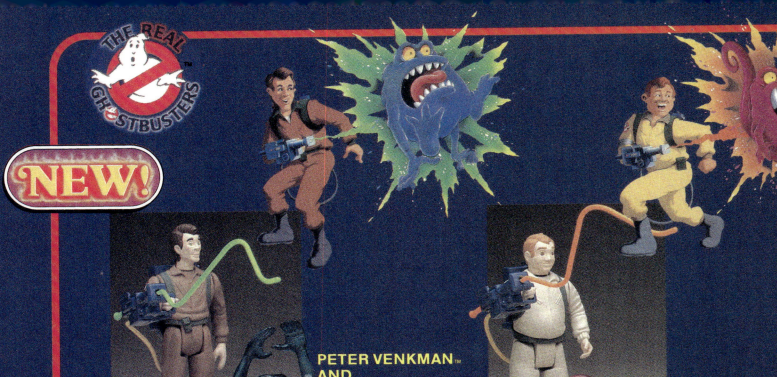

PETER VENKMAN AND GRABBER GHOST
The fast-talking natural leader of the group who wants to become a national ghost-hunting hero.

RAY STANTZ AND WRAPPER GHOST
The energetic enthus[iast] who can't get enough [of] blasting ghosts.

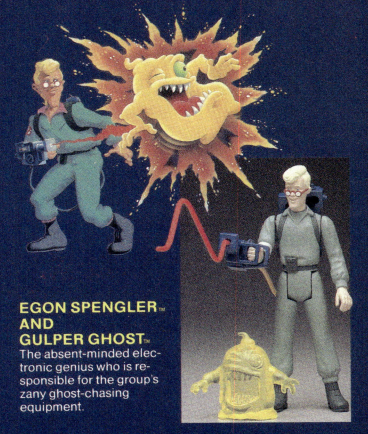

EGON SPENGLER AND GULPER GHOST
The absent-minded electronic genius who is responsible for the group's zany ghost-chasing equipment.

WINSTON ZEDDMORE AND CHOMPER GHOST
The practical, common sense member of the group who tries to keep THE REAL GHOSTBUSTERS from getting completely out of hand.

GHOSTBUSTERS HERO FIGURES

Meet THE REAL GHOSTBUSTERS... wiseguy PETER VENKMAN, practical RAY STANTZ, science-minded EGON SPENGLER and the ever-helpful WINSTON ZEDDMORE. Standing 5¼" tall, they are articulated at head, arms and legs. Each figure comes with a clip-on PROTON PACK and NUTRONA BLASTER with spinning "laser" action. Each hero also comes with a different ghost companion, which can attach directly onto the figure, for a complete haunt-and-bust play situation.

NO. 80000 ASST.
PKD. 16, WT. 3 LBS.
CUBE: 1.26 CU. FT.

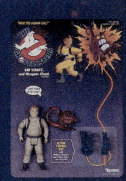

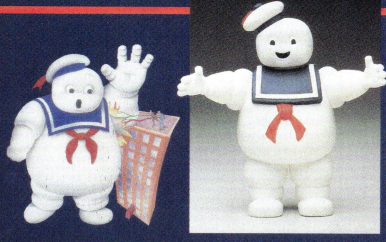

THE STAY-PUFT MARSHMALLOW MAN™
The largest and wildest of all ghosts, he represents *THE REAL GHOSTBUSTERS'* biggest challenge.

BAD-TO-THE-BONE™ GHOST
The cagiest of all ghosts. He loves to close in on *THE REAL GHOSTBUSTERS*.

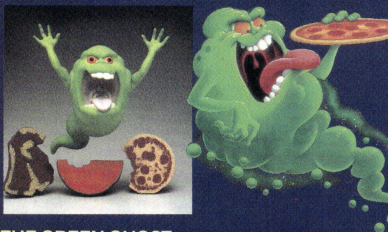

THE GREEN GHOST™
The hungriest of all ghosts, he is now on the side of *THE REAL GHOSTBUSTERS*. No pizza or donut is safe when he's around!

H₂GHOST™
This is the ghost with the split personality. He'll drown out any of *THE REAL GHOSTBUSTERS* if he has the chance…split-splash style.

BUG-EYE™ GHOST
The most far-sighted of all ghosts. With his 20-20-20 vision, he keeps his eye(s) on *THE REAL GHOSTBUSTERS*.

THE REAL GHOSTBUSTERS™ ACTION GHOSTS

Oh no! They're heading this way…the wildest, weirdest assortment of ghosts you've ever seen—or sold! With all kinds of ways to trap and attack our heroes.

THE STAY-PUFT MARSHMALLOW MAN may be smiling, but he's 6" of ghostly nastiness (larger than hero figures), articulated at the head and arms.

GREEN GHOST is always hungry—his mouth can be opened and closed, and he even comes with his own pizza, watermelon and T-bone steak. He's articulated at the arms and tail.

BUG-EYE shoots a unique weapon: his blood-shot eye, which pops right out of its socket! Thanks to articulated arms, he can also hold his eyeball right in the palm of his hand, so he can see what's behind him.

BAD-TO-THE-BONE has a rib cage that opens and closes to trap a hero figure inside. When his skull fits over the hero's head, his eyes pop out and his jaw drops. His head is also removable!

H₂ GHOST is really two complete ghosts that combine to form a single creature. Each of these split personalities squirts a stream of water. Ages 4 and up.

NO. 80100 ASST.
PKD. 16, WT. 3½ LBS.
CUBE: 2.30 CU. FT.

million units between 1978 and 1985. Kenner's Star Wars became a format and model every company replicated for decades. Not to overstate their importance, but during this time, Kenner ruled the industry. Everyone wanted to either be in business with them or actually *be* them.

The *Star Wars* sequels *The Empire Strikes Back* and *Return of the Jedi* seemingly fueled Kenner's future. But the imminent end of the *Star Wars* film series and increasingly competitive toy rivals loomed on the horizon. In 1982, Hasbro successfully relaunched G.I. Joe, following Kenner's strategy by shrinking the action figure series from 12 inches to the 3¾-inch scale. Across the country in California, Mattel struck gold with their new animated series and accompanying action figure line, *He-Man and the Masters of the Universe*. The two competitors were making huge bounds and gaining ground on Kenner.

Tim Effler, an industrial designer who started his career with Kenner right out of college, remembers the stiff competition being a motivator for the product design team. "We were looking at the other guys all the time. Not just to one-up them, but lauding them for some of the amazing stuff they were doing at the same time," says Effler.

Kenner admired creativity and inspiration, even from the competition. It was as if the Cincinnati-based company fed on unparalleled creative energy. Somewhere between a frat house and a cutting-edge engineering lab, Kenner was full of young and hungry industrial design graduates from the nearby University of Cincinnati. One of those former Bearcats was designer Tom Osborne. Osborne dreamed of designing cars. But after working multiple co-op semesters at Kenner during college, he had learned that Kenner was the place to be. It was so desirable, even veterans working at other companies were knocking on the door. "We had a lot of transfers from Mattel at that time. Bernie Loomis, who was the president of the company, came from Mattel. I worked for Drew Holland, who was also from Mattel," says Osborne. Osborne was interviewed for his permanent position by the senior vice president of product concepts and design, David Okada. Okada was a designer who was in part responsible for Star Wars' incredible success and the decision to create the action figure line in the 3¾-inch scale. "Dave hired me as a designer in the preliminary group. After a stint there, they asked me to go down to the production group. They were trying to set up the prelim group creating the new first-year product. Then my group, the production group, would be doing second- and third-year products. We were responsible for the final way toys looked, how they played, and the graphics that were on them." Osborne's run in the production group was

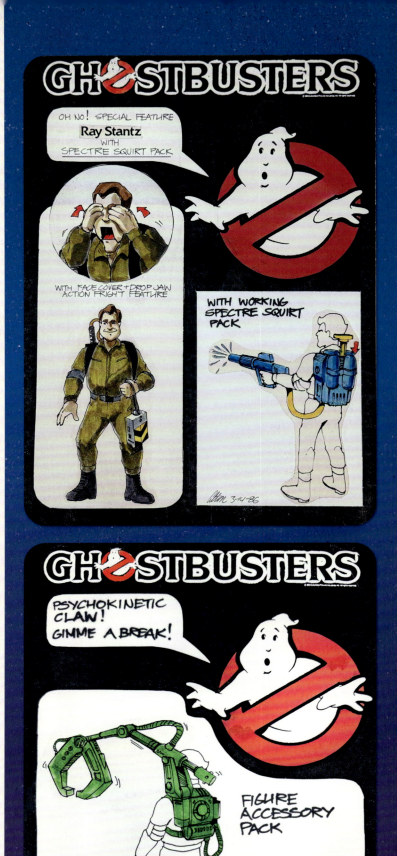

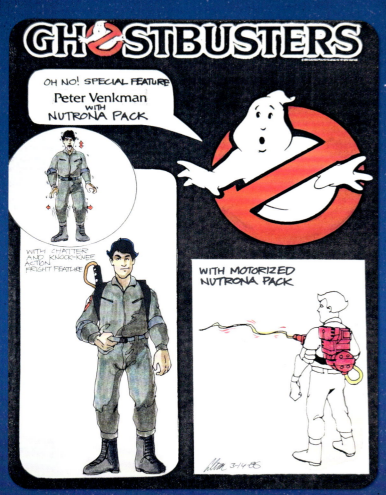
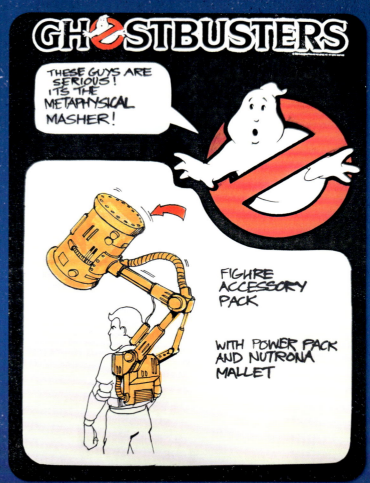
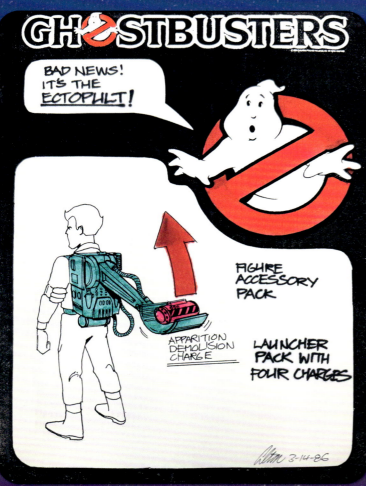

Prior to Kenner having the full creative reference for the animated series (including the "Real Ghostbusters" title), these pitches were created.

Chapter 4: The Franchise Rights Alone: Toys, Merchandise, and the Rise of Ecto Cooler

Unrealized concepts for wind-up Ghostbusters toys.

successful, and he was promoted to director of all design at the company. "They wanted to get the designers out from being under engineering. That way they would have more say in the product. That's what we did."

Osborne loved the irreverent atmosphere and tone that permeated the halls at Kenner. Every day was new and different. Employees raced die-cast cars along tracks that lined their office walls. One employee famously took their day's frustrations out on a Star Wars AT-AT vehicle under the guise of "stress testing." Making toys was fun work, and the Kenner team never lost sight of that mantra. "It wasn't just a job. We had this rubber band material that we would stretch from a door down the hallway, about thirty feet, and let it go," says Osborne. "We'd see who could get the nearest photograph of it flying before it hit the wall. One time engineering was having a meeting in one of the conference rooms and I lit up some theatrical smoke and slid it under the door. I got in a little trouble for that one. We worked very hard, but it was great fun." Kenner's sense of play in their work led to a team that not only worked together but remains close to this day. Osborne recalls the team gathered at the bottom-floor farmers' market of the Kroger Building every other Thursday for Salad Thursdays. "Everybody that worked there just thinks that it was the best time in their life. And it was. We had a jack-o'-lantern

contest that developed such that we had entries that were doing every—and I mean every—every bodily function."

Social events at the company were frequent. A monthly internal newsletter acted as the town crier of the company, featuring articles, photos, birth and marriage announcements, and classifieds written by the staff to bring the employee community together. "It was an amazing experience. We all grew up together," says designer Marian Ihlenfeldt. "We had a huge social group. We had intramural volleyball, basketball, golf. We had Christmas balls. We spent way too much time at work together, but we liked each other. So it was good."

Kenner's talented designers turned dreams (and inappropriate pumpkin carvings) into reality and fostered an extraordinary bond. "It was collaborative across disciplines. I had worked at other companies, and they were scary, backstabbing places," says Tim Effler. "I never worried or feared that at Kenner. It felt like you knew everybody at the company, which I thought was important."

"It was really family. I know you hear that a lot, but it really was," says Osborne. "It was great. It was the high point of my life. And it was over at thirty-nine."

Says Ihlenfeldt, "We still get together once or twice a year."

Jerry Perez, an MBA who began his career in the Quaker Oats marketing department in Chicago, had tired of the buttoned-up corporate life and found kinship with Kenner. "If you're in toys, you have to have a sense of humor," Perez says with a smile. "Kenner was a very fun place to work for, and we had very talented designers. Incredible and imaginative artists who came up with so many exciting ideas. It was a fun place." Headhunted by a recruiter, Perez landed at Kenner and first worked on Centurions, the short-lived futuristic sci-fi series which has since grown into a cult classic but at the time failed to make the impact the Kenner team had hoped for. "Centurions never really kind of took off in a big, big way or never met the expectations that were assigned to it," says Perez.

Similarly, DC Super Powers is also beloved by modern collectors but struggled to create the kind of sales needed to stay competitive with Mattel and Hasbro. "Super Powers didn't do as well as I think we had hoped it would," says Kenner marketing manager Ed Zobrist. "We did a whole bunch of mediocre male action figure lines we considered flops." Kenner hadn't quite recaptured the magic of Star Wars, which had fueled the company for nearly ten years, and needed a jolt of whimsy, and success, to get them back on track in the action figure market.

Following that string of fizzled lines, Perez found himself in a funk and searching for a project to reignite his passion. When he caught wind that Kenner was attempting to acquire the *Real Ghostbusters* license, Perez saw his opportunity. Perez was a fan of the 1984 live-action film and knew that it had the perfect tone and subject matter for Kenner's strengths. Not wasting any time, Perez went straight to Jim Block's office. It was a bold move, considering the corporate structure, as Block, then a vice president and brand and product manager at Kenner, hadn't interacted directly with Perez to that point. Perez implored Block to assign him to the *Ghostbusters* project, using his previous marketing experience as the ace up his sleeve. "'My knowledge of *Ghostbusters* is excellent. At Quaker, we made a granola bar sales promotional film with a *Ghostbusters* theme.' I sold him all this kind of stuff," says Perez. The plea worked. Perez was assigned to become the first product manager on Kenner's The Real Ghostbusters. There was one catch: Kenner hadn't yet officially been awarded the license by Columbia Pictures' consumer products department.

To do so, Kenner had to woo Columbia Pictures Merchandising's vice president and general manager, Lester Borden. Borden began his oversight of studio licensing and merchandising in 1975, spearheading successful product tie-in runs for *Close Encounters of the Third Kind*, *Annie*, and *The Karate Kid*. Borden was among a handful of pioneers in the industry in the 1980s who saw product merchandising as a profitable secondary revenue stream for the studio that also acted as a new form of marketing and promotion outside of the usual print and advertising. T-shirts with the *Ghostbusters* logo on them were walking billboards for Columbia's film that the consumer was paying the studio to wear. It was a win-win business model. Borden told the *Sarasota Herald-Tribune* in 1989 as *Ghostbusters II* was hitting theaters, "There's a hook, a logo, a popular film. People want to see the film. They have an enthusiasm for it. They want to relive the experience by buying merchandise for it." Most importantly, Borden knew when a property he held was "toyetic"—that is, when certain elements within a motion picture or a television series naturally lend themselves to creation of toys that will sell. By 1986, Borden and the department had developed an alchemy at Columbia Pictures. They were consulted heavily and regularly by film and television executives on what projects they believed would support a successful licensing campaign. Borden's team even went as far as evaluating screenplays prior to the studio greenlighting them to advise on how well, or how poorly, they could fuel consumer products. On the flip side of that, it then fell to Borden's team to negotiate and broker the deals with licensees looking to use Columbia's intellectual properties. Talking to the *New York Times* in 1982, Borden said he looked for three key advantages for his studio in any proposal: what visibility and impact the packaging would have, the quality and memorability of the product, and what

Columbia Pictures Merchandising
A division of Columbia Pictures Industries, Inc.

LESTER J. BORDEN
Vice President and General Manager

711 Fifth Avenue
New York, New York 10022
212-751-4400
Cable: COLPIXMERC NYK
Telex: 224175

March 10, 1986

Jim Black
KENNER PRODUCTS
1014 Vine Street
Cincinnati, OH 45202

Dear Jim:

Enclosed please find the GHOSTBUSTERS character sketches. Please be advised that the Venkman character is being revised, and we will get it to you as soon as possible.

If you have any questions, please do not hesitate to call.

Yours truly,

Lester Borden

Enclosure
LB/vf/v1/v

6 FOOT THE REAL GHOSTBUSTERS™ PLAN-O-GRAM CONTAINS:

Qty	Type	Code
2	cases	81700
1	case	81540
1	case	81200
1	case	81760
2	cases	81800
1	case	81800
2	cases	80840
1	case	81390
1	case	80240
1	case	81250
2	cases	81430
2	cases	81610
2	cases	81440
1	case	81470
1	case	81450
2	cases	81620
2	case	80230
1	case	80340
1	case	80580

Top left: *A memo to Jim Black from Lester Borden at Columbia, detailing initial character sketches for The Real Ghostbusters.* Top right: *Concept artist Alton Takeyasu.* Bottom: *Kenner's final "plan-o-gram" from 1991 showing the last items to hit shelves.*

promotional opportunities the licensee could afford. Though by all accounts, Borden was an easy collaborator, he was very particular about whom he was licensing Columbia's properties to and how. (Borden was contacted for an interview for this book but passed away during its writing in January of 2024.)

Despite the license not officially being in hand, the Kenner creative team moved full speed ahead. They were confident a deal could be made. By that time, the rivalry between Filmation's and Columbia's *Ghostbusters* was well known, even within the toy industry. During the R&D phase on Real Ghostbusters, Kenner learned competitor Schaper

> **"There's a hook, a logo, a popular film. People want to see the film. They have an enthusiasm for it. They want to relive the experience by buying merchandise for it."**
> —LESTER BORDEN

Toys was producing licensed tie-in toys for *Filmation's Ghostbusters*. As with everything Filmation was plotting with their iteration, Schaper wanted to be first to market and was expediting their product at every turn. Because of this, Schaper Toys had sample products readily available to view in their corporate show room and was more than happy to show them off. "Everyone at that time gave people tours of their show room," says Jerry Perez. Perez and the Kenner team took a tour by the very proud Schaper Toys that included the full product lineup for *Filmation's Ghostbusters*. Kenner wasn't going to tell the competitor what they were working on, and those at Schaper never asked. "They didn't know we were, like, *this* close to getting The Real Ghostbusters." Unimpressed with what they saw at Schaper, Perez and Co. were motivated to move fast.

In April of 1986, staff designer Alton Takeyasu had just completed his work on the Centurions toy line and was tasked with developing very early iterations of Ghostbusters figures. What might a line of figures look like? What could the basic style lines of the packaging look like? Now a chief designer of the Hot Wheels brand at Mattel, at the time Takeyasu had just started his nearly forty-year career in toy design and was hungry to prove his mettle. A line based upon *Ghostbusters* played into his strengths, particularly his love of cars and vehicles. Takeyasu's earliest designs mimicked the theatrical advertising design: primarily black backgrounds with red highlights to evoke the feeling of the No-Ghost logo. Not having reference for the animated series, Takeyasu designed characters and costumes to mirror what was seen in the live-action films; therefore, there was a lot of khaki. The design and color configuration of the figures would be revised once the designers had reference from the animated series in hand, which wouldn't happen for about another month. Takeyasu also toyed around with potential gimmicks for the Fright Features line and a series of wind-up toys that were ultimately abandoned.

The deal between Columbia and Kenner was closed and official. Kenner's Jim Block had successfully presented to Lester Borden the three key pillars of what the toy company could do as a licensee. "Jim Block was our contact with the entertainment industry, our licensing guy," says Perez. "Jim had great success. He was kind of unassuming but was just so good at developing relationships with people. He always made sure that we were always at the front door if there was a Hollywood property that needed an action figure line." To adhere to Borden's standards, Block put together a package that showed Kenner was capable of creating memorable packaging that would stand out on a shelf and toys that would be unique, memorable, and of high quality—and that Kenner's marketing department was ready to paint the town with No-Ghost logos in print and television ads to make sure the whole world knew.

In total, Block and Borden carved out room for Kenner to produce *(1) articulated and nonarticulated action figures in all sizes, including dolls with accessories; (2) stuffed plush and cloth toys; (3) hand and finger puppets; (4) vehicles, excluding ride-ons, bicycles, and tricycles; (5) play sets; (6) target sets, excluding Velcro target sets; (7) toy weapons; (8) role-playing toys; (9) radio-controlled and remote-controlled toys; (10) visual toys utilizing audio and visual techniques, excluding View-Master-type viewers and accessories; (11) modeling compounds; (12) gel compounds and related accessories; (13) light-activated toys; (14) electronic toys, excluding video and interactive VCR games, radios, and record, tape, and disk players; and (15) inflatable toys.* As if that weren't enough, Kenner also had the ability to create and sell picture frames, flashlights, clothes hangers, and wastepaper baskets in the United States only.

Perez's team was off to the races to get merchandise on–shelves as quickly as possible. Pitch meetings immediately commenced with the studio. Kenner laid out their blue-sky plans in front of Columbia Pictures, DIC, and Joe Medjuck and Michael Gross. It was immediately clear Kenner dreamed big. Concepts for innovative and elaborate Fright Features figures were among the first ideas the company created and presented. But with very little time to get the figures to market, those complex toys were put on the back burner, giving way for a more basic figure that would be quicker to produce and might feasibly make shelves by the holidays.

LOW PRICE GOOPER "BRAINSTORM"

SOFT VINYL ROTOCAST

SQUEEZE CHARACTER'S BRAIN TO CAUSE GOOP TO OOZE OUT LEGS AND NOSE

Alton 7-10-86

HOOVER GOOPER

SQUEEZE BELLOWS TO START GOOP FLOWING THRU TUBES AND OUT NOSE

Alton 8-18-86

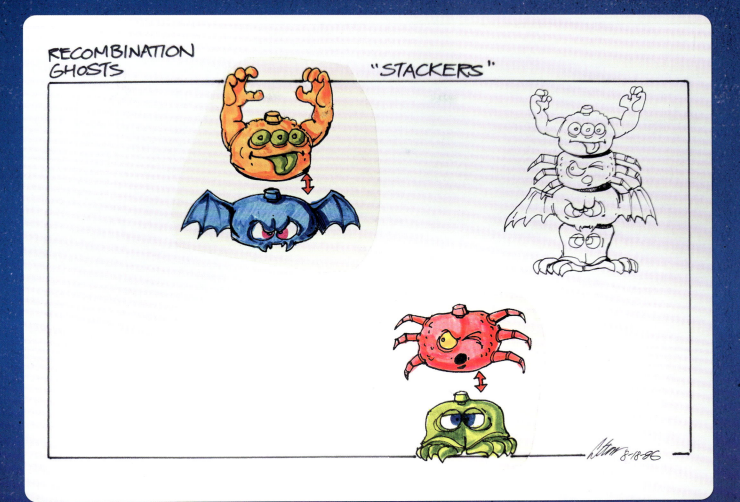
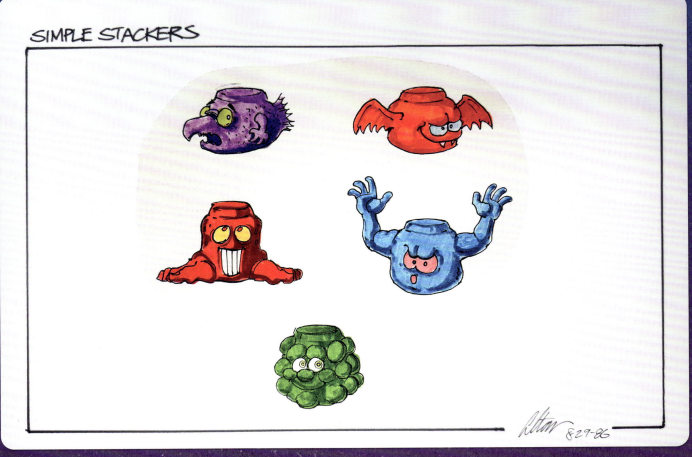

Unrealized concepts for stackable mini ghosts.

Chapter 4: The Franchise Rights Alone: Toys, Merchandise, and the Rise of Ecto Cooler

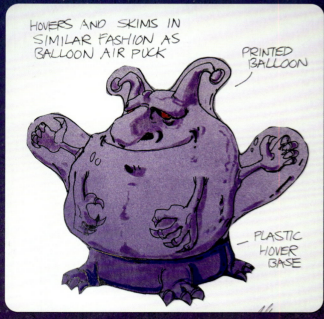

Unused concepts for potential ghost action gimmicks.

As concepts were visualized and planned, marketing research was moving at a fast clip. Kenner had a powerhouse of an internal marketing research department that worked tirelessly to poll parents and kids alike and guided the product team with priorities and potential pitfalls. For The Real Ghostbusters, Kenner extensively interviewed six hundred boys between the ages of five and ten in Cincinnati. They were shown product demonstrations, videos, and illustrations of potential figures and toys in the upcoming line. Interestingly, Kenner determined that the Real Ghostbusters toys skewed younger, with the five- to seven-year-olds expressing the most enthusiasm, while the older focus group kids trailed off in interest starting around age eight. Four different combinations of basic action figure sets were shown to the focus group: the original four hero figures with companion ghosts, another group without those pack-ins, the first run of Fright Features figures with their ghost guns, and another group without the accessories.

Unsurprisingly Kenner's high-concept Fright Features figures tested well, as did the basic hero figures. The kids were far more interested in both sets of figures when they included an accessory, like the companion ghost or ghost gun. Kenner found that including a ghost with a Ghostbuster appealed to younger kids because it both contained something "gross" and also provided what the toy company called a "complete play pattern," meaning a kid could buy one toy and have a hero and a villain ready to play right out of the box. Surprisingly, all of the toys tested well among kids who hadn't even seen the original movie or the animated series. This would be Kenner's first indicator that the toy line was able to stand on its own and would sell based on the concept alone.

Among the other items shown to the focus group were concept renders of potential low-cost ghosts in the line. The focus group results showed an early popularity for Bad-To-The-Bone, the Green Slime Ghost (Slimer), and the Stay-Puft Marshmallow Man. Other ghosts that were tested but never released were Terror Riser, Poppin' Poltergeist, Fright Bite, and Eat and Run.

The extensive marketing tests confirmed Perez's intuition: *The Real Ghostbusters* was a completely unique concept unlike anything held by competitors. And it just so happened that the outside-of-the-box concept was perfectly suited to Kenner's humorous and whimsical sensibilities. The research encouraged Kenner to be Kenner. "Don't try to be G.I. Joe or Transformers or anything like that. Just be this unique property that was funny and silly. And play that up," says Jerry Perez. Columbia Pictures had given Kenner complete freedom and a clean slate from which they could create and conceptualize their own figures. Whatever their designers could dream up would be considered. All

Left: A cover sheet for an internal Kenner marketing report. Right: At the approval stage, Michael C. Gross expresses concern about a head-worn projectile role-playing toy.

> **“We never once said, 'Let's do this in the show, it'll sell.' We never wanted to force a story point into the show for the only reason that it would make a great toy.”**
>
> —JOE MEDJUCK

Columbia asked in return was Ivan Reitman Productions' approval at every step to ensure that the *Ghostbusters* brand was upheld from conception to the final product on the shelf. "There was very little friction in the overall approval process," says Perez. "DIC played no role at all. Lester Borden went with whatever Michael Gross wanted. I don't remember Michael and Lester being difficult at all. They trusted Kenner's expertise. Most approvals sailed through."

"They came from *National Lampoon*, so they were pretty irreverent too," says Tom Osborne.

"Kenner would come into our offices and ran everything by us," says Joe Medjuck. "Michael approved everything, from the sketches to photographs to the instruction books. It was around this time that it dawned on us that it was a time period where people basically did animated shows to only sell merchandise. We never once said, 'Let's do this in the show, it'll sell.' We never wanted to force a story point into the show for the only reason that it would make a great toy." This mindset allowed Kenner's The Real Ghostbusters line to flourish as its own companion universe to the animated series. It also freed the toy designers to let their imaginations run wild and not be constrained by the same Broadcast Standards and Practices "appropriateness" that the animated series had to face.

"The toilet ghost was great," says Dennys McCoy of the unforgettable Fearsome Flush figure. "We couldn't have done the toilet ghost in the show. But they did it. And the Fire House—funny thing, we lived in Santa Monica, and one morning we woke up, and somebody had left a Fire House on our lawn. No idea who left it, just left a Fire House on our front lawn."

"We were totally flattered," says Pamela Hickey.

"The toy line was fabulous," says Andy Heyward. "I remember Ivan Reitman had a collection of all the toys in a trophy case. He loved it."

The Line Debuts

In the fall of 1986, Kenner conducted sales presentations to a very select few of their most trusted buyers. The pre-

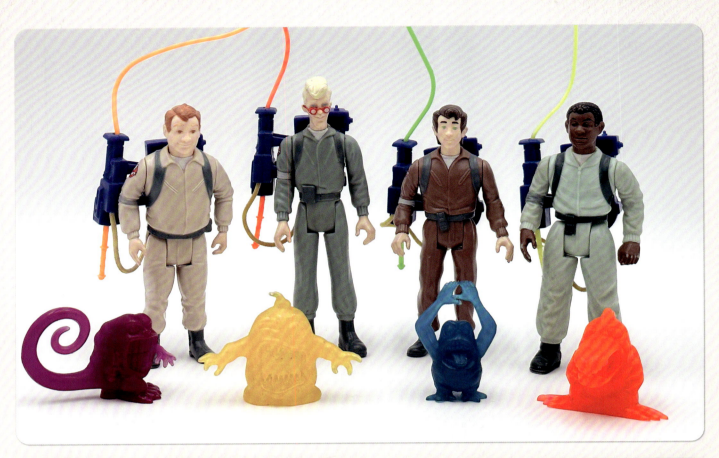

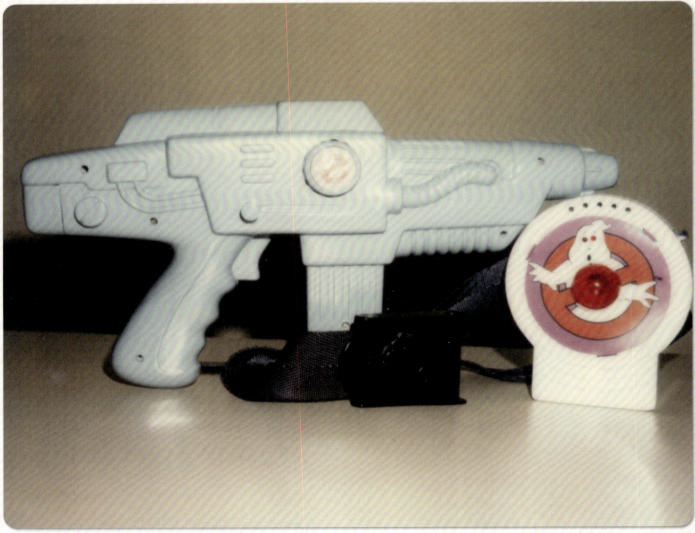

Top: *The original wave of heroes and their companion ghosts.* Bottom: *A Nutrona Blaster laser tag set was prototyped but ultimately unrealized.*

sentations were intended as a sneak preview to whet the appetites of purchasing agents prior to a more public official announcement of the Real Ghostbusters toys at Toy Fair, scheduled a few months later in February of 1987. Buyers and potential partners poured into a hotel suite in New York City, where Kenner conducted sit-down product demonstrations of everything related to The Real Ghostbusters they had to offer. Just as the marketing research among the kids had shown overwhelming enthusiasm, so too did the buyers and retailers who would be stocking Ghostbusters products on their shelves. Though the two plush toys in the line would not be nearly as successful as the action figures, the Green Ghost puppet made a huge splash during these initial sales meetings. Sellers used the puppet to demonstrate the wide range of emotions and facial expressions that kids would be able to convey themselves. This tactic worked and helped drive early retail partners to the brand who quickly recognized that Kenner's The Real Ghostbusters was going to be huge. That intuition was confirmed when Kenner revealed their lineup at the New York Toy Fair in 1987. At the annual industry conference that brings together toy manufacturers, store purchasing executives, media, and fans from all over the world, the response was through the roof.

The Real Ghostbusters toy line was ready for sale in January of 1987, just four months after the first Saturday morning episode of the series aired on ABC. The first wave of products included basic action figures of the four main Ghostbusters, the Stay-Puft Marshmallow Man, Green Ghost (Slimer), two plush toys, and the GhostZapper: a role-playing gun that combined the technology of Kenner's Give-A-Show toy projectors with picture disks similar to those used with the View-Master to project images of

With projected sales of $127 million in 1987 alone, Kenner found themselves in the early stages of a bona fide toy phenomenon.

spectral entities onto household walls and entice kids into becoming Ghostbusters. The GhostZapper was a repurposed and retooled role-playing toy from earlier in Kenner's history, a quick stopgap to make sure that a role-playing toy was on shelves from day one, since a true Proton Pack was still in early development stages. (As an aside, in a demonstration of what a small world the entertainment industry is, the TV commercial for the GhostZapper featured Rick Moranis's costar from *Honey, I Shrunk the Kids*, Robert Oliveri.)

Though Kenner had missed the 1986 holiday sales rush by mere weeks, that didn't stop consumers. *Real Ghostbusters* products flew off shelves. Sales showed that demand matched the prerelease hype that Kenner was feeling during Toy Fair. With projected sales of $127 million in 1987 alone, Kenner found themselves in the early stages of a bona fide toy phenomenon. "I just remember being impressed when we went over $100 million, which at the time was considered big," recalls Ed Zobrist. Kenner was still looking to repeat the success of Star Wars, and The Real Ghostbusters' launch had the promise of just exactly that. To ensure continued sales success, the line must continue. Luckily Kenner knew that they still held that ace up their sleeves: the Fright Features figures they had yet to reveal to the public but had teased to retailers. This was merely the beginning.

The Real Ghostbusters Heroes

First to make it to store shelves were the four main Ghostbusters: Peter, Ray, Egon, and Winston. The facial designs and trademark features from the show, like Egon's spectacles, Peter's hair, and the four uniquely colored flight suits, translated perfectly to toy sculpts. The instantly recognizable figures served as a mere first course for what would become a buffet of Kenner offerings. The figures had a basic five points of articulation: arms, legs, and head. Though Kenner knew the potential popularity of the more complex Fright Features figures, there was an advantage to releasing these more basic iterations first. Having four

An original Fright Features pitch prior to Kenner having creative direction on the series.

Chapter 4: The Franchise Rights Alone: Toys, Merchandise, and the Rise of Ecto Cooler

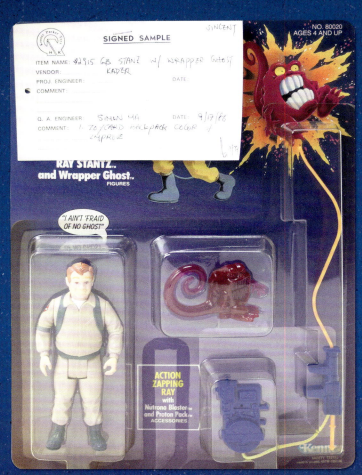
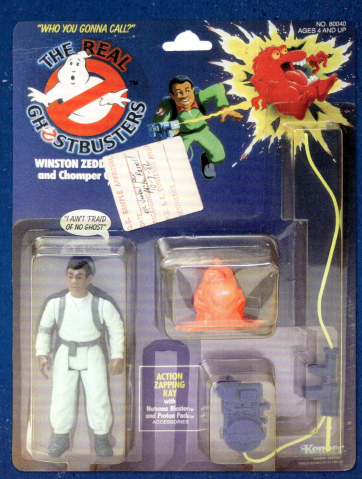
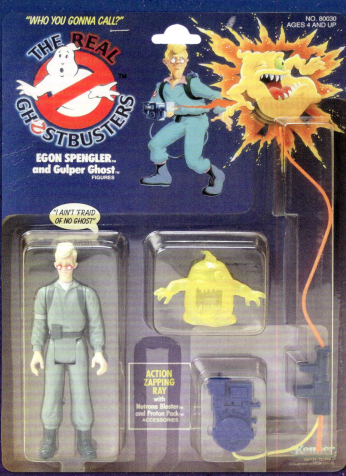
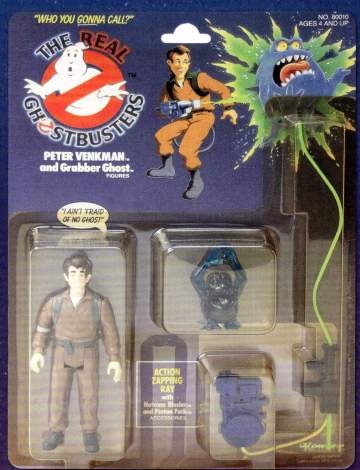

Final Kenner samples, signed and marked as approved for production.

toys that distinctly resembled the characters as seen in the show allowed kids to adapt what they saw on the screen to their everyday play. Kenner also knew from their market testing that what the figures lacked in a gimmick they made up for with the additional value of two accessories: a Proton Pack and a pack-in companion ghost.

"Each character was 5¼ inches high. That was a fresh thing for me," said lead designer Mark Boudreaux in 2019. "Coming from the Star Wars line that was 3¾, these taller characters gave us an opportunity to do things we couldn't on a smaller scale." In preproduction, the first wave of heroes were designed in "two-up" scale: approximately 10 inches tall, twice the size of the final figures that would be sold on shelves. This was a common practice in toy design at the time and allowed for more intricate details to be sculpted into the figures. The larger prototype sculpts also made approvals more fluid and efficient. Stakeholders could see details clearly on the larger models, allowing for specific notes that cut out a lot of back-and-forth with designers. Once they were approved for production, master molds of the smaller figures were created, and the manufacturing process would begin.

Each figure had a Proton Pack that snapped onto the back of the figure via a simple peg. A Neutrona Wand was connected to the backpack via a yellow string. Taking a cue from the popularity of the lightsaber designs used for Star Wars, Kenner designed the Neutrona Wand accessory with a thin extension of plastic that ran through the weapon and spun with the flick of a thumb and forefinger to mimic a "proton stream" emerging from the blaster. Keen eyes will also notice that the bodies of the first-wave Proton Packs look more like those seen in the three-minute animated promo pilot, rather than the final prop models used for the series. This was due to the lead time necessary for the hero figures to be out on the shelves. By the time the animation team had refined and revised the design for the Proton Pack for the show, the accessory had already been tooled. Each figure also came with a small semitranslucent ghost with a memorable name that described their appearance and personality: Grabber Ghost, Gulper Ghost, Chomper Ghost, and Wrapper Ghost.

Packaged in a square plastic bubble affixed to the blister card, the Real Ghostbusters figures popped out to prospective buyers from their pegs. Using purple as the main color for the packaging design was a gamble at the time. On one hand, it would separate the toys from the usually subdued color palette of boys' toys. On the other hand, the color came with preconceived subconscious notions that could have inhibited purchases. "I worked with the design agency Lipson and Associates, who created the line look and all of the packaging for the toys, from the color of the boxes to the artwork," said senior art director for Kenner Jim O'Brien in an interview for the website The Art of RGB. "The individual illustrators and designers at the agency would do the art for the packaging based on our direction. What I remember most was the background color of the packaging. It was a color that I chose, and had to fight for. It was almost refused by upper management at Kenner because some marketer said, 'Purple is a girl's color.' But I convinced them otherwise."

"It ended up being a very dark purple. Some people didn't like that. They thought it was too dark," says Jerry Perez. Marketing and package designers favor bright and vibrant colors, with identifiers that can be spotted from far away to entice buyers. But the purple was an intentional and necessary design choice, intended to contrast with the vibrant and colorful painted character art that would be on every package. "We felt like you could take these really colorful illustrations and pop them off with a darker background," says Perez. "We chose illustration over actual art from the show because we wanted to make sure that we were depicting the exact fantasy that kids were seeing in their minds with these toys." Over-the-top and gross or "gotcha" moments were chosen for the packaging illustrations to really highlight the fun and zaniness of the line. It was a tone that kids would respond to based on Kenner's marketing research.

> "It was almost refused by upper management at Kenner because some marketer said, 'Purple is a girl's color.' But I convinced them otherwise."
> —JIM O'BRIEN

On the back of the blister card, Kenner employed a tried-and-true method that had proven successful with Star Wars: "cross-selling" additional toys with photography of other items in the series acting as a marketing and promotions catalog and as a visual checklist kids could use to add every single Real Ghostbusters item currently available and coming in the future to their wish lists.

An upside for the Real Ghostbusters line was the broad appeal of all four core characters equally. Unlike some toy lines, where there would be one or two "peg warmers" left unsold on shelves, each of the four characters inspired an identical amount of interest. It helped that onscreen, the Ghostbusters were a team and had to work together to get the job done. Kenner found that kids enjoyed playing with a solo character but desired the set of all four Ghostbusters to play the complete story. With the suggested retail price on the individual figures around $4.99, spending twenty dollars to have all four Ghostbusters wasn't too much of a strain on 1987 wallets. And for every figure sold, retailers paid Kenner around $2.00. It was a significant profit for the retailer and for Kenner, who made a return on their investment with every unit sold.

Illustrations of the animated characters were initially used on the packaging for the line, but Kenner wanted to jump on the opportunity to cross-promote the Real Ghostbusters figures with the release of *Ghostbusters II*. The company explored adding trading cards with photography from the new film into the key action figure, vehicle, and role-playing packages. Ultimately, because this directly associated the animated iterations of the characters with the live-action talent that portrayed them, it became a legal issue. Kenner explored alternatives for *Ghostbusters II* tie-in packaging, including nonhuman characters or group shots, but ultimately the idea was abandoned.

Mark Boudreaux conceptualized several ghost characters and gimmicks that never made it into production, including this handful with memorable names.

Approaching the First Wave of Ghosts

Kenner's team of designers worked tirelessly to ensure there were plenty of ghouls and goblins to choose from in the toy line, each with unique movements and actions to make them distinctive. A creative decision from the higher-ups that the ghosts in the line wouldn't be based on anything seen in the animated series meant that the Kenner designers had a blank canvas they could explore without being tied to anything previously existing. That is, within reason. The only constraint was keeping the ghost figures just as affordable as the four human figures that were flying off shelves. "These were designed to be lower-cost offerings with simple features," said Mark Boudreaux in 2019. "The fact that the series was animated gave us designers an extra level of coolness. It really lets us do things we normally wouldn't do for live action. We were fortunate enough to be given a lot of creative latitude. It really let us do toys."

Boudreaux spent over forty years at Kenner and, through his work there, was a key figure in the most famous toy lines of the twentieth century. Like many who worked for Kenner, Boudreaux also studied industrial design at the University of Cincinnati. His talent for design extended to architecture, carpentry, and mechanical engineering. As a self-proclaimed "master of design," he loved solving a

> **"Toys embody all of the fantasy that kids love to engage in. The toys then allow the kids to bring that fantasy to life every day."**
> —MARK BOUDREAUX

good problem. He was the lead designer on the immensely successful Star Wars line, considering his greatest achievement the design of the original Millennium Falcon play set. Boudreaux retired from Kenner in 2020 and passed away in 2023, just prior to the production of this book.

With The Real Ghostbusters, Boudreaux had a new and exciting opportunity to design something fresh. He could instill his love of toys into the ghosts, and that excited him greatly. "I love toys," Boudreaux told *Bloomberg*. "Toys embody all of the fantasy that kids love to engage in. The toys then allow the kids to bring that fantasy to life every day."

At the Ghostbusters Fan Fest, an event on the Sony Pictures studio lot in 2019, Boudreaux appeared at a lengthy panel where he was able to show off his designs to fans from around the world. It was there he publicly shared for the very first time his original concept sketches for the first wave of ghosts. This included Green Glutton (which became Green Ghost, and is more commonly known now as Slimer), Bad-To-The-Bone, and two colorful pudgy twin demons called Vapor-Izor. The latter offering was eventually combined into one ghost during development and renamed H2 Ghost. This wasn't an uncommon practice at Kenner; if something wasn't ready for the shelves and needed more time to "cook," it would be reevaluated and revised. "There's always an evolution when we're doing a product for the very first time. It's an evolutionary process," said Boudreaux at the panel.

Green Ghost (Slimer)

The highest priority for Kenner was to get two evergreen and hugely popular characters onto shelves as quickly as possible: Green Ghost (Slimer) and the Stay-Puft Marshmallow Man. Kenner's marketing tests earlier in the year showed that kids gravitated toward these two characters—and for good reason. Their memorable stint in the live-action feature film was so impressive and made such an impact that they had become icons in the animated series as well. They were synonymous with the brand, having become de facto mascots, and were just as popular as the human characters. Kenner wanted to translate that success to the toy line, knowing these two characters would be a hot commodity. They were the first two larger ghosts to make their way to store shelves and were both immediate hits. The marketing tests from earlier in the year proved that kids really gravitated to these two specifically.

"With Stay-Puft and Slimer, we said, 'What's the fastest way that we can do these?'" says Jerry Perez. "We did them with no real mechanisms, no punches, no actions. We worked to get those out as fast as possible." Both Green Ghost and Stay-Puft were hollow and rotomolded. As opposed to traditional injection molding, rotomolding is a process that is ideal for larger, hollow products that need to be strong and durable. Injection molding is best for small and complex

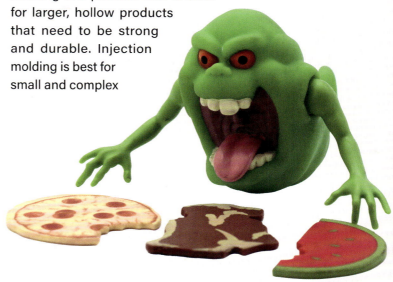

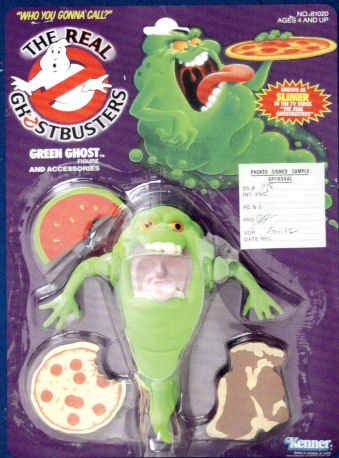
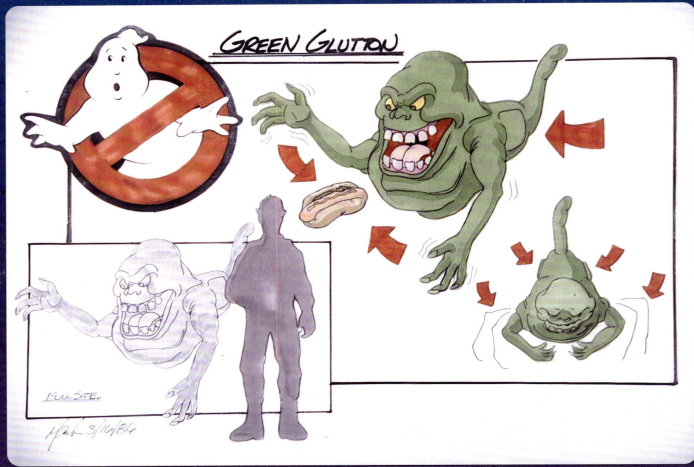

Top left: Created by Kenner sculptor Joan Amorati, this large-scale "Green Ghost" Slimer, currently on display at the Cincy Toy Museum & Buying Center, is believed to be an unreleased concept or a rough character study created prior to the original figure's release. Bottom: Mark Boudreaux's original sketch for the Green Glutton.

products that require precise dimensional accuracy and high-quality finish. This led to a shorter production time and gave Kenner the ability to get both onto shelves quickly.

The Stay-Puft Marshmallow Man

The "fifty-foot marshmallow man" known as Stay-Puft underwent a transformation for his toy iteration, shortened to a mere 6 inches. The figure's scale was intended to reduce both production and retail costs, and this also allowed the iconic character to be packaged and hung on a peg next to Slimer and the heroes. With a surprised smile adorning his soft plastic body, Stay-Puft became a pivotal and recognizable element in the Real Ghostbusters toy phenomenon. Statuesque figures like Stay-Puft sold well, even to those who may not have collected the whole line. It wasn't uncommon for some households to have a Stay-Puft and no other Ghostbusters toys. Because of the tremendous sales and popularity of this single figure, the original Stay-Puft figure boasted several packaging variations through multiple years of production. Among the most sought-after variants is one known as "Kroger Stay-Puft," which is directly linked to Kenner's roots in Cincinnati. This exclusive figure featured Kroger-branded packaging artwork and was available only at select Kroger grocery store locations, making it a rare gem for collectors and enthusiasts alike.

Bug-Eye Ghost, H2 Ghost, Bad-To-The-Bone

With the priority ghosts Slimer and Stay-Puft locked up, all eyes (or perhaps eye) were turned to the wholly original ghosts that would be released next. Kenner had to have something striking, something iconic, to really start the line off on the right foot. "We used well-known phrases like 'bad to the bone' and 'bug eye' to help with our development process," said Mark Boudreaux. Boudreaux pointed to Venkman's line in which he calls Janine "bug eye" as inspiring; something about it clicked and eventually manifested into a physical toy for the line. The resulting Bug-Eye Ghost remained one of Boudreaux's favorites.

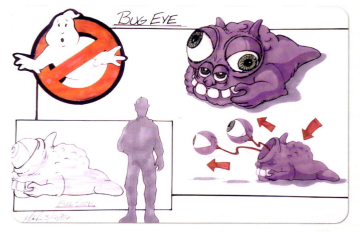

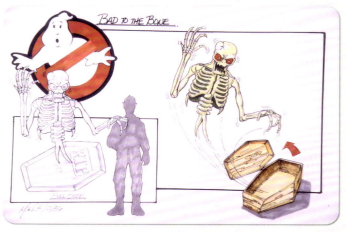

Left: *Packaging from the rare Kroger Stay-Puft release.* Right: *Mark Boudreaux's original concepts for Bug-Eye and Bad-To-The-Bone.*

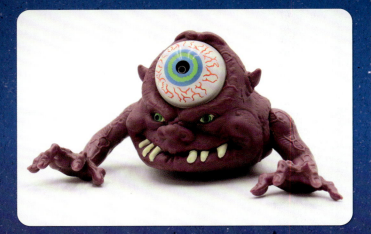
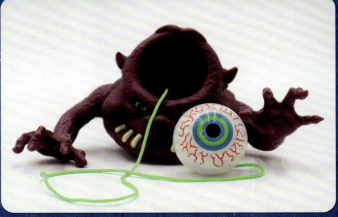

After several revisions to simplify the concepts, the final Bug-Eye, Bad-To-The-Bone, and H2 Ghosts are pictured above.

"Bug-Eye was this purple blob. It was originally supposed to have two eyes that would come out," says Terry Healy, an assistant product manager at Kenner. As was and still is the process at Kenner, the two-eyed Bug-Eye was sketched and designed, then put in front of the marketing team, including Jerry Perez. At that point, it was agreed that two eyes would be expensive to manufacture and would also increase the recommended sales price to retailers, which the team was working to avoid.

To keep the cost of production and cost of purchase lower, revisions were made, an eye was removed, and Bug-Eye became a Cyclopean monstrosity. "I loved the two eyes," says Healy. "Jerry explained to me it was all about the cost. If this is going to be so much more expensive, does it give you that much more value? That was a great lesson." The financial decision ended up paying off. The toy became so popular that the character went on to appear in *Ghostbusters* video games and comics, and it even had a cameo in the 2021 live-action *Ghostbusters: Afterlife*.

Rounding out the remaining first wave of ghosts were H2 Ghost and Bad-To-The-Bone. H2 Ghost was the revised iteration of Mark Boudreaux's original vision of "two ghosts for the price of one," a variation on the old Russian nesting doll. Bad-To-The-Bone, originally intended to pop out of a coffin that would act as the figure's housing, was revised to become a capture device. When activated, the skeletal ghost's eyes would bulge and the skull would bounce. Hinge mechanisms on the skeleton's rib cage would open the chest cavity and then shut to trap a smaller figure within its confines. H2 Ghost may not have had the same popular culture impact as Bad-To-The-Bone, which went on to become a favorite ghost figure in the line and even cameoed in the IDW comic books.

Ecto-1

Recognizing the car's status as one of the most famous pieces of iconography in the growing *Ghostbusters* lore, Kenner seized the opportunity to bring the Ecto-1 to life.

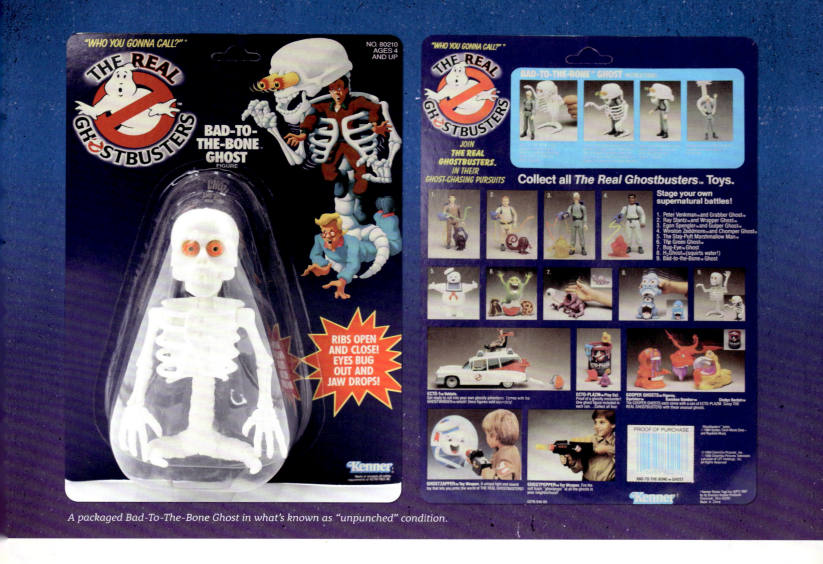

A packaged Bad-To-The-Bone Ghost in what's known as "unpunched" condition.

But getting the product onto the shelves at the same time as the first wave of heroes was quite a daunting task. "You know the famous story of selling an empty box of Star Wars figures? That didn't happen with Real Ghostbusters," says Tom Osborne. "We were always under the gun to get stuff done because of the timing. The worst thing you can have is a toy that's on shelves December twenty-sixth. With the Ecto-1, the prelim group had to build a model of it. It could be just slab sided to define some of the features and help the marketing group make sure it fits in a price point. Then it was turned over to us in the production group. Our challenge was to make it work and do everything prelim said it could do at the price point marketing set for it. A lot of times, prelim would have it packed with more features than we could really afford. Often, we'd change things and redesign things to make them fit the profit margins. We usually had ten to twelve months to do this from the time a toy was turned over to us." With Christmas of 1986 completely infeasible, Christmas of 1987 was the new target, but that was still a shorter timeline than a complicated vehicle like the Ecto-1 would usually require.

"I think we did a really great job on the Ecto-1," says Tim Effler. "There was some back-and-forth on the proportions of the vehicle. We would push designs to make them a little more comic and not a spot-on model, like making the fins a little bigger, or whacking stuff out proportionally to fit a 3¾-inch figure. We always took that into consideration to see how small we could make it to fit the price point and packaging size, while still have it appear to be in scale with the figures."

"One of the easiest things we did to save money was to reduce the paint operations," says Tom Osborne. Reducing the paint operations and adding decals helped bring the Ecto-1 within margins.

Original prelim concepts for the Ecto-1 included elaborate mechanics, like a projector that would cast the light of a ghost onto the wall from the roof of the car. But in the interest of time, and to keep the price point within the limits marketing had set, the ghost-grabbing winch and the gunner seat for the roof were the settled-upon play features. "The seat on the roof was an especially cheap play feature. We could just make it pivot and have a strap for a figure," says Tim Effler. "That kind of thing is important to tell a story because it's very visual."

Chapter 4: The Franchise Rights Alone: Toys, Merchandise, and the Rise of Ecto Cooler

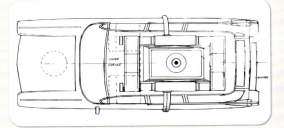
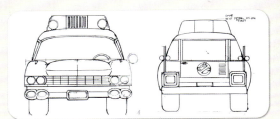

Left: "Control sketches" created by the engineering team conceptualizing the functionality of the Ecto-1 vehicle. Right: The front and back of the Ecto-1 packaging showing the final features for the vehicle that made it to consumers.

Highlight Episode: Take Two

WRITTEN BY:
J. Michael Straczynski

FIRST AIRED:
November 15, 1986

PREMISE (FROM THE ORIGINAL *REAL GHOSTBUSTERS* WRITERS PACKET): The Ghostbusters are famous. So famous, in fact, that a movie of their story is going to be made. They're flown out to Hollywood, to a place that looks suspiciously like Columbia Studios, and are shown around the lot, where a replica of the firehall and all their equipment has been constructed. But when a ghost in search of some peace and quiet is accidentally awakened from a long slumber, the Ghostbusters are called into action. Which would be far easier to accomplish if they had only taken the real Proton Packs, and not the props, by mistake.

An episode that established that the protagonists of the animated series were indeed "real" and their exploits had resulted in a live-action film sounds like a fun and engaging concept on paper. But the strict mandate that The Real Ghostbusters *not feature the likenesses of Bill Murray, Dan Aykroyd, Harold Ramis, and Ernie Hudson—and comparisons of those actors to their animated counterparts must be avoided at all costs—created a challenge in how to show the 1984 film in the animated world. As the "real" Ghostbusters sit at the film premiere and the opening moments from the live-action film unfold before them, Bill Murray's voice couldn't be used. Enter multi-talented impressionist Maurice LaMarche, who stepped in to do a Murray impression and recorded the first lines of dialogue from the film. Always critical of himself, LaMarche didn't think he quite nailed the voice. But he did use it as a primer for when he later had to voice Peter Venkman at the Universal Studios Florida attraction Ghostbusters Spooktacular.*

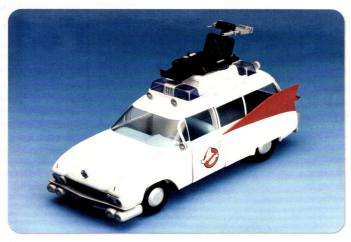

A "studio shot" prototype of the Ecto-1 created as proof of concept for development.

Proton Pack

Kids didn't just want to play with Ghostbusters—they wanted to *be* Ghostbusters. It was Kenner's goal to make kids feel like that was achievable. Crucial in that goal were role-playing toys that would be impressive enough to evoke imagery from the series, have playability features that made them interesting and fun, and have a price point that was premium but still fairly affordable. The Proton Pack was an essential component in the role-play line.

And even with a hollowed-out plastic backpack and a Neutrona Wand that had a trigger mechanism that created a mechanical sound effect, it was a struggle to keep the retail price any lower than twenty dollars. "Everybody thought we were crazy," remembers Jerry Perez. "Because role-play typically had been very cheap, usually under $9.99. There shouldn't be anything close to $19.99. That was kind of unheard of in role-play. But we knew that, to really get the size and the mass of the thing that would make it feel like a real thing for kids, we were going to be up in those price points."

The Proton Pack came equipped with a Neutrona Wand and PKE Meter that could both be attached to the backpack. Also in the box were a plastic Ghostbusters-logo armband and the official Real Ghostbusters ID Card, a credit card–sized badge that could be filled in with the name of its holder.

The Proton Pack tapped into the thrill kids had from becoming part of the team. Kids could bust ghosts at home, and Kenner found an innovative (and cost-effective) way to mimic the proton stream being thrown from the Neutrona Wand with a cylindrical piece of yellow foam. The foam was cheap to produce, could be shoved into the packaging

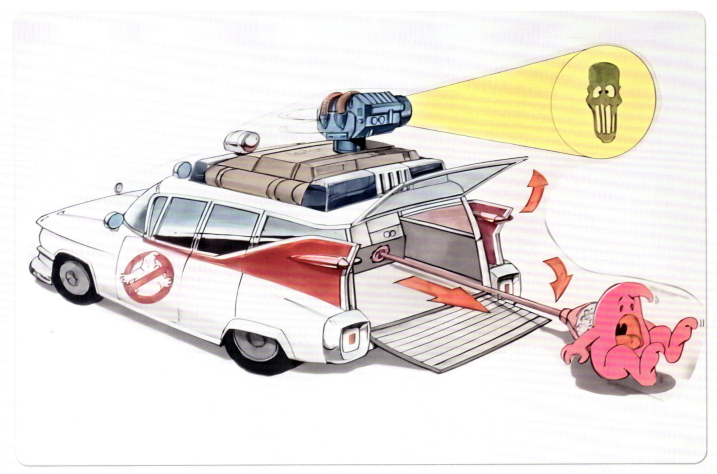

Prior to budgetary limitations, the Ecto-1 was imagined with a ghost-projection light.

Chapter 4: The Franchise Rights Alone: Toys, Merchandise, and the Rise of Ecto Cooler

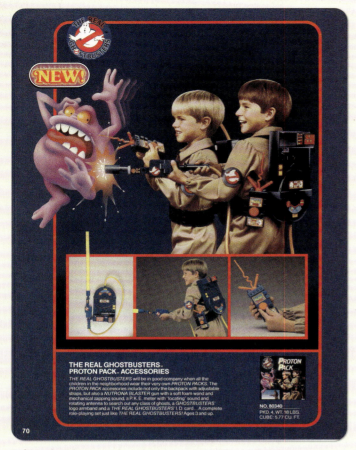
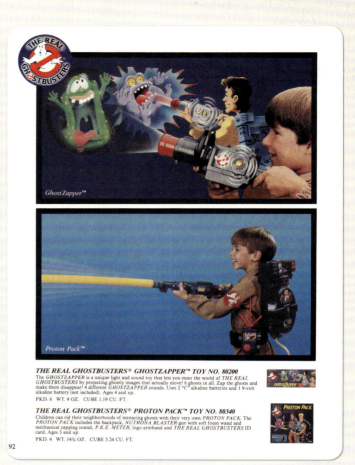

Left: *Early Kenner mockup showing a very different design for the Proton Pack and PKE Meter.* Right: *Kenner 1988 Toy Fair catalog.*

without increasing the size of the box, and when removed would easily bounce back to a length that resembled a blast from the particle accelerator. "We found that we could spread that into the box in a way that would fit," says Perez. But upon pulling the foam piece out of the box, some consumers found they were unable to straighten it out. Perez chuckles at the mention of a bent proton stream. "That was the big controversy. They could stretch it out, and it was fine. It just took a little time."

The Proton Pack outsold even Kenner's wildest projections. The holiday rush of Real Ghostbusters products flying off the shelves that Kenner had wanted in 1986 had come, just a year later than expected. Parents scrambled to get a Proton Pack under the tree for Christmas, lining up overnight to greet Toys"R"Us delivery trucks at four in the morning. Ed Zobrist recalls receiving a frantic call from Columbia the week before Christmas of 1987. "Dan Aykroyd needed a Ghost-busters backpack as a gift to someone," says Zobrist. There was only one problem, since the Proton Pack was one of the hottest holiday gift items that year. Warehouses had been empty for months. Kenner had nothing to offer him. "They're not in the stores, and it's not like we have some special warehouse where we're holding stuff back that we didn't want to sell." The studio was insistent. Dan Aykroyd wouldn't take no for an answer. With the majority of the office out for the holiday break, Zobrist alone was Aykroyd's only hope. Completely out of options, Zobrist called it quits for the day. He walked through the empty lobby and past the reception desk. Zobrist was inspired: the display case! "In there was a box of the Proton Pack, and it was the actual product, not just the box! That was the very last one that existed inside the company." Zobrist removed the Proton Pack from its secure enclosure, overnighted it to Los Angeles, and saved the day for an actual Ghostbuster.

Ecto-Plazm

It's difficult to evoke imagery from *Ghostbusters* without the horribly disgusting and viscous slime that is the bane of Peter Venkman's existence. The needle on popular culture bumped the moment Venkman was attacked in a hotel hallway by Slimer and muttered, "He slimed me." *Slime* as a verb was burned into our common vernacular, and suddenly slime

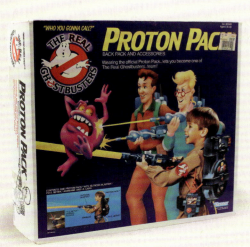

154 The Real Ghostbusters: A Visual History

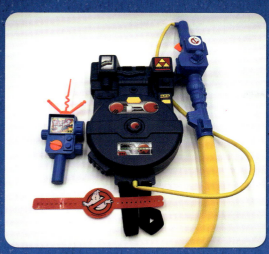
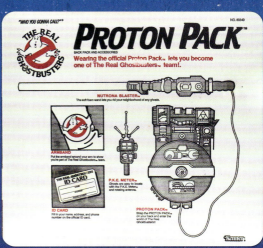
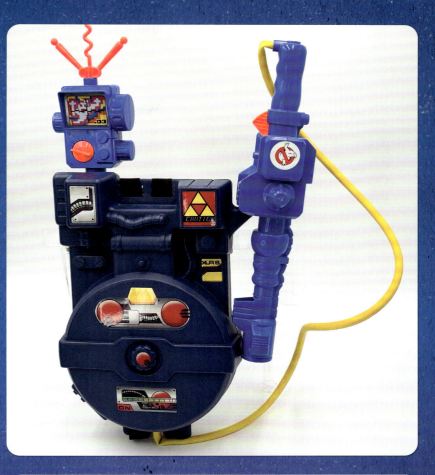

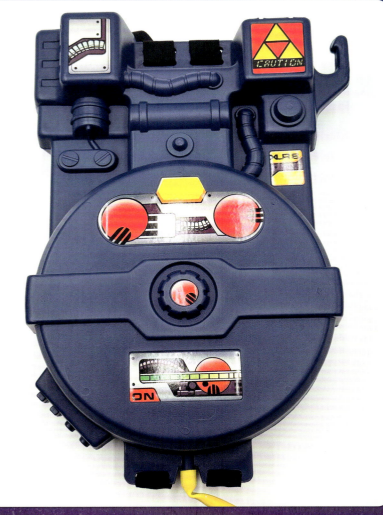

The final Proton Pack role-play toy and all pack-in materials, including the instruction booklet. Top left: The foam "proton stream" had to be folded to fit in the packaging. Shown here is a "bent stream," the ire of many consumers.

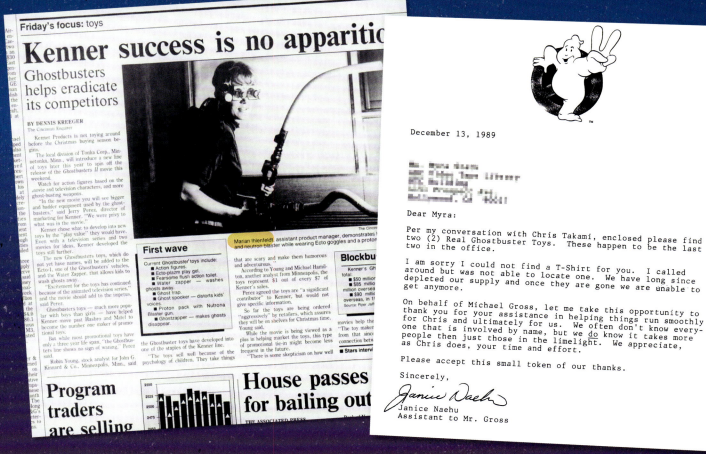

Left: *Photo of Kenner designer Marian Ihlenfeldt wearing a Proton Pack and Ecto-Goggles in* The Cincinnati Enquirer. Right: *Memo from Christmas of 1989, when Michael Gross sent out the last two Real Ghostbusters toys in the office as gifts.*

was everywhere. In fact, it was arguably the foundation upon which Nickelodeon was built. Slimer and Venkman's slobbering, slime-laden rivalry continued into *The Real Ghostbusters*, and Kenner saw a tremendous opportunity to bring slime from the screen into the homes (and carpets) of kids. Ecto-Plazm was available to purchase as a single can, and kids could collect one of four mystery ghosts included inside.

Marian Ihlenfeldt started in the design group as a product engineer and designer at Kenner in 1982. Recruited straight from Stanford University, Ihlenfeldt broke ground in what then was primarily a boys' club. "I was only the second female engineer they had at Kenner. It took me about a year and a half to earn their respect. My very first project was Strawberry Shortcake, then I worked on the Care Bears Cloud Car. After I worked on the Rose Petal line from Hallmark, they made me the 'Fragrance Queen' of Kenner. Here I went to Stanford and got an engineering degree. Suddenly, I'm Kenner's Fragrance Queen." Responsible for project managing and engineering the various scents that were utilized by toy lines, particularly Strawberry Shortcake, Ihlenfeldt grew restless and eventually worked her way onto The Real Ghostbusters, first overseeing Ecto-Plazm in the chem lab, and then later the creation of the Highway Haunter in the engineering department. "The projects really were creative because the entertainment industry was learning how to merchandise at the same time we were doing it. This was all newfound money for them. So they gave us a lot of creative freedom," says Ihlenfeldt. Her position allowed her to see projects through from start to finish. She explains the pipeline of Kenner products as follows: "We had a preliminary design group. When we brainstormed toy concepts, they would do what we call kit bashes, where they would find similar toys or products and put them together like a Frankenstein model. After that, it would pass over to an industrial designer, a sculptor, a model maker, and (if you were lucky enough) a draftsman to do a layout. But most of us did our own layouts. We were like our own design draftsmen. Then the project would go to packaging structures, line tooling design, and finally collaborating with the manufacturing and the injection mold people, because we didn't have time to design and then design for manufacture. We did it as quickly as we could. So it was always a collaboration. And I think that's why the Kenner

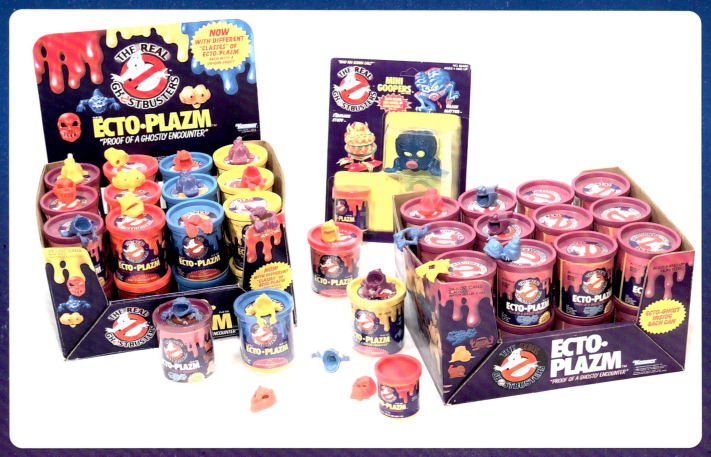

Coveted by kids and scorned by parents, Ecto-Plazm was widely available with displays that made for great impulse buys at point-of-sale counters.

people are always so excited to talk about Kenner—because we couldn't have done it without each other. We became very close."

Heading up the Ecto-Plazm project was a chemist who had been working on Play-Doh for nearly twenty years, Carol Guthrie. Guthrie passed away in 2019 after moving from her toy career into teaching high school chemistry in Cincinnati. "Carol ran our chem lab. She is no longer with us, but she was absolutely amazing. She had mentored under a Chinese immigrant named Dexter Liu who had come to the United States right before the Communist revolution and could never return. He wound up being the head of our chem lab and taught Carol everything she knew," says Marian Ihlenfeldt. "I was essentially the project leader working on coordinating the packaging and all the collateral materials that went with Ecto-Plazm."

Kids may have questioned why the slime wasn't a disgusting green as it was in the movie, but a competitor had beaten Kenner to the punch: Mattel had just introduced a green goop for their popular He-Man and the Masters of the Universe line, and Kenner wanted to differentiate theirs. "Mattel beat us to the market with slime, which was bright

green," says Ihlenfeldt. "Our quality-control folks were steering us towards a more translucent, pale purple so that it wouldn't stain as badly."

As Guthrie and the chemists worked on the formula for Ecto-Plazm, they made sure it was a purple that would stand out and be completely different from other offerings. "We'd go out and test different formulas, and it would be like, 'Oh my gosh. I can't get this off of my hands,'" says Terry Healy. "I never had an issue with it sticking to my

Chapter 4: The Franchise Rights Alone: Toys, Merchandise, and the Rise of Ecto Cooler **157**

hands, so I was not allowed to test the different products."

"Carol knew a lot about shelf life and preserving the contents of the goo," says Ihlenfeldt. "That was the biggest challenge. It took quite a bit of research and trial and error to make sure it was wet, gooey, and nasty feeling, without staining and all the things that make parents go nuts."

The Ecto-Plazm also provided a unique, memorable, and dynamic gimmick that could be used in television and print advertising. It was an ad maker's dream. Nearly every original commercial for The Real Ghostbusters included a figure being slimed to demonstrate how fun and gross the toys could become. This was in large part a response to the market testing Kenner had done, where kids reacted strongly to seeing the Ecto-Plazm in action. "You didn't sell a whole ton of slime, because parents didn't really like it that much. But you had to put it in the commercials. As soon as you showed those Ghostbusters slimed, it just went through the roof. Kids absolutely loved it," says Duncan Billing, a Kenner product manager who joined the team Ghostbusters brand in 1987.

Parents' resistance to purchasing the goop, which they envisioned creating a horrible mess and destroying their furniture (or again, carpets), may have also added to the appeal of Ecto-Plazm. "We didn't want it to be very sticky, but it also had to have a viscosity that would flow," says Tom Osborne. "That was a fine line. I think it did stick to stuff a little bit."

Parents hated it, which in a punk rock kind of way made the viscous substance more appealing. "So, although their parents wouldn't really let them play that way, they really wanted to play that way. It was pretty cool," says Billing.

The original iteration was a pink-hued purple; eventually, the Ecto-Plazm offerings expanded into more colors, in-

Top: *Original concept art for the Gooper Ghost line.* Bottom: *Slimer makes his Gooper Ghost debut with a new sculpt that looks more accurate to the character's depiction in the show.*

cluding red, yellow, and blue. Kids loved those little cans of Ecto-Plazm, but parents absolutely detested it. Market testing and consumer polling revealed that it was a source of frustration for mothers and potentially contributed to a declining interest in the line. Letters were received by the bagful from parents upset that the Ecto-Plazm had ruined furniture and carpets. Eventually, the outcry convinced Kenner that by removing Ecto-Plazm from the line completely, they had a better shot in winning over parents on The Real Ghostbusters. By 1988, Kenner shifted its focus away from creating new products centered around the gooey substance, and Ecto-Plazm slimed no more.

Gooper Ghosts

Before the complaints of parents won the battle, Ecto-Plazm was a necessity and was even included with some of the toys throughout the line. Most famously Ecto-Plazm was a key ingredient in making the Gooper Ghosts both cool and also very gross. Squisher, Sludge Bucket, and Banshee Bomber were the three figures that made up the Gooper

Letters were received by the bagful from parents upset that the Ecto-Plazm had ruined furniture and carpets.

Ghost offerings. Each figure had a unique play feature that ended up with Ecto-Plazm everywhere. "We really tried to make this as cool and as gross and as fun as possible, taking as much advantage of the slime," said Boudreaux. "With the slime it was a must, having to incorporate [it] into the product, so our goal was . . . how do we take these oversized ghosts and have them be very interactive with our figures?"

Squisher was a large-jawed creature who could collapse his maxilla to enclose one of the action figure heroes, all the while oozing Ecto-Plazm from his nose and mouth onto the poor entrapped figure. Banshee Bomber was a flying ghost that "bombed" figures (and again, carpets) with slime. Then there was Sludge Bucket, whose gaping mouth and air-pumping tail jailed a hero and

Left: *Gooper Ghost Sludge Bucket and Banshee Bomber.* Right: *Gooper Ghost Squisher in the development process, including a kit-bashed Ghostbusters figure.*

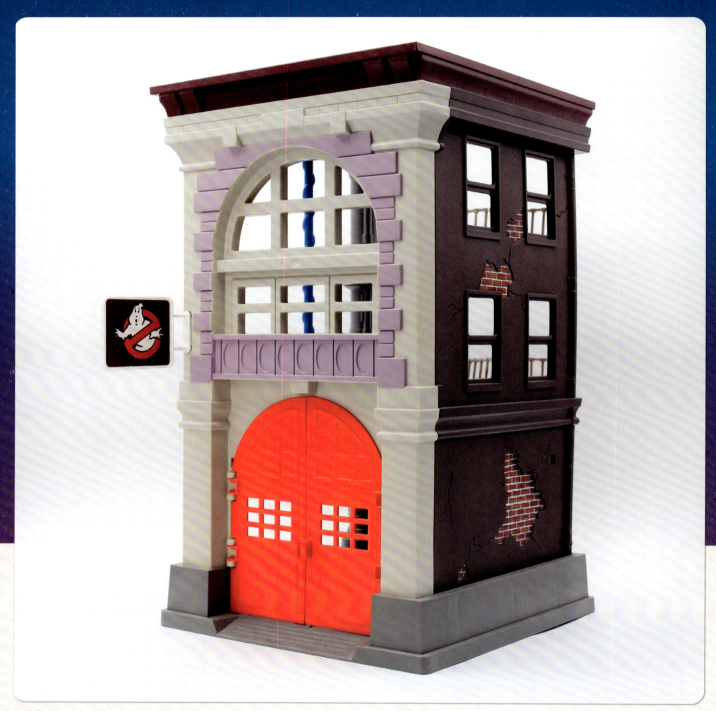

Standing over two feet tall, the Fire House Headquarters was a mammoth undertaking for Kenner.

blew a slime bubble around him. Sludge Bucket was featured in one of the first Real Ghostbusters television commercials and immediately got a huge reaction from kids and parents. "Moms had an issue when we did the Gooper Ghosts," remembers Terry Healy. "But I thought they were just so much fun." The figure originally was to include a catapult-like throwing arm that could hurl slime through the air, but the feature was abandoned due to cost reductions.

In 1988, a fourth Gooper Ghost was added, featuring a brand-new Slimer sculpt whose likeness was closer to what was seen on the animated series.

The Fire House Headquarters

Major toy lines of the 1980s were known for their play sets, which featured incredibly detailed sculpts and engaging play features, like trapdoors, jail cells, and missile launchers—all features that would immediately snag potential buyers in the advertising. Usually sitting at a higher price point than the rest of the line, the play set was the ultimate centerpiece of a kid's collection and the envy of their friends. He-Man and the Masters of the Universe had Castle Grayskull, the Teenage Mutant Ninja Turtles had a subterranean Sewer Lair, and The Real Ghostbusters had the Fire House Headquarters, which

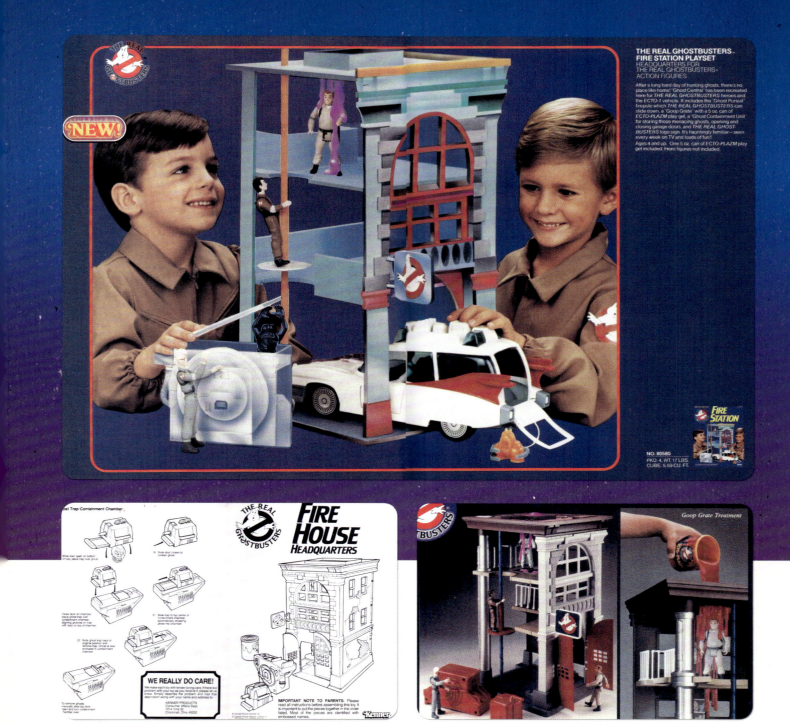

Top: *As a prototype build of the Fire House was unavailable for Toy Fair solicitations, a foam core model was photographed with child actors for Kenner's sales materials.*

has stood the test of time as one of the most beloved play sets in toy history.

Standing at over two feet tall and featuring three levels of play, the Fire House play set was the first and only large-scale set released in the line. Acting as home and headquarters, the Fire House had a garage bay for the Ecto-1 vehicle on the ground floor, living and sleeping quarters on the floor above, a rooftop on which the Ecto-2 could land, and a space for the Ecto-Containment Unit, which in the films and TV series was in an underground basement but was offered in the play set as a floating two-piece accessory that could be placed wherever the play took it. Designed by Mark Boudreaux, the Fire House play set began its life as a foam core model of the building, which ended up being used in the original photography featured in Kenner's marketing pamphlets and brochures. "Foam core was really easy for us to test things and to make changes," recalled Boudreaux. "That happened from time to time and this was one of those cases where we just didn't have anything else [to photograph]."

As mentioned, action items in play sets were absolutely key and essential in their success and profitability. The Fire House had two marquee play features that could adorn the box and be used in the television marketing. The first was

Chapter 4: The Franchise Rights Alone: Toys, Merchandise, and the Rise of Ecto Cooler **161**

Highlight Episode: Night Game

WRITTEN BY:
K. M. Drennan

FIRST AIRED:
September 22, 1987

PREMISE (FROM THE ORIGINAL *REAL GHOSTBUSTERS* WRITERS PACKET): The Ghostbusters have big decisions to make when Winston is drafted to play on the side of Good in a baseball game played between good and evil. The prize? Winston's soul.

"My handwritten notes for this episode initially had Ray as the central character," says writer Kathryn Drennan (credited in the episode as K. M. Drennan). "But immediately after finishing the notes, I went back and scratched out his name and wrote in Winston. Now I can't imagine anybody but Winston being the central character in this episode. I loved being able to shine a light on his character as someone who knows what he saw and wasn't going to let the others make him doubt himself. And more importantly, as someone dedicated to fair play and doing the right thing. And being loyal to who and what he loves, in spite of their defects, all of which he discusses with—Slimer? That happened because in the original outline, Slimer was all but absent. This was very early on in the development of the show, and it was my first *Real Ghostbusters* script, so I hadn't yet realized how much fun Slimer was to write for. Happily, the only major note I got back before going to script was: couldn't I find a way to sneak Slimer in? So off to the ballpark with Winston went Slimer, giving Winston somebody to talk to in dialogue that sets up his character as the perfect person to play in the upcoming good vs. evil ball game."

Though baseball had always been the central attraction of the episode in Drennan's mind, because of the inherent drama and mythic qualities the sport has naturally, there was an instant the episode could have been far different. "I was not at all prepared for the initial character sketches and rough storyboards that came back from the animation department—they had decided on their own, without consulting me or story editor Joe Straczynski, that football would be more visually interesting than baseball, and so they had altered my script completely to make it a football game instead of a baseball game. It had to be baseball and no

other sport. Baseball is one of only a handful of sports that, under the rules, could extend into infinity. Any baseball game could, theoretically, last forever. Baseball is simultaneously a team sport and a dual sport. At the center of every game is the one-on-one battle between pitcher and batter. And finally, there is no other sports official to compare to the home plate umpire. He is the very symbol of the intimidating but neutral judge, calling balls and strikes impartially as he sees them, upholding the rules of fair play." Straczynski and Drennan obviously successfully argued their case, and the football element was reversed back to the original intent.

The back-and-forth creative tug o' war on "Night Game" wasn't the only time the writers and animators disagreed on expanding upon the written page. "When we were working on Kidd Video, we took a lot of liberty with the scripts [in animation]," says Richard Raynis. "We didn't do that as much with The Real Ghostbusters, but I do remember on the storyboard for 'Ghosts R Us,' I thought Eddie Fitzgerald could do some cool sequences with the ghosts. He did a lot of comedy stuff with the ghosts, but I worried that we were taking too many liberties with the script, so I wanted to show it to Michael Gross first, to get his reaction. I went out to his house and showed him the storyboard. He looked through it and said that we did just the right amount of plusing. A day or two later, the storyboard came back from the writers filled with red ink and expletives. I found myself in a tribunal with the writers and Michael Gross, who just turned to me and said, 'Sorry, I had to side with the writers on this one.'"

"When the dust eventually settled, it was firmly established that all scripts would be finalized by Joe [Straczynski] and the producers, and that the animation department would not rewrite them in any way but put their creative talents into bringing to visual life the words on the page as written. Which they did wonderfully. I was very pleased with the animation on all three of my episodes," says Drennan.

"I think in the end, everybody appreciated what we were doing, and we all appreciated the scripts," says Raynis.

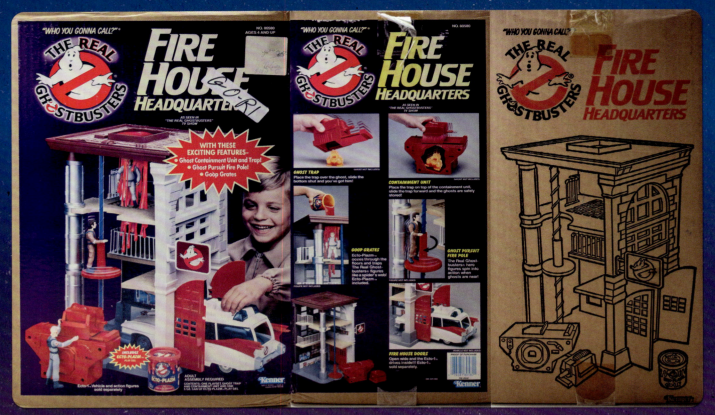

A flattened final package for the Fire House Headquarters, showcasing the "exciting features" intended to help make a TV commercial.

atop the play set's roof, which also featured a "goop grate." This waffle-shaped cutout at the top of the roof allowed kids to pour Ecto-Plazm down onto unsuspecting Ghostbusters below. Though the chemists at Kenner worked tirelessly to make sure Ecto-Plazm wouldn't stick or stain, Fire House play sets that saw regular goopings through the grate would be covered in a crusty white byproduct, which has become the bane of vintage toy collectors looking for mint-condition offerings.

But just as it was for Ray Stantz in the original film, the main selling point of the Fire House was the fire pole. Running from the top of the play set down to the ground floor, which housed the Ecto-1, the fire pole allowed pegged figures to stand on a circular base and quickly descend from top to bottom, all the while spinning around the pole's axis. The spinning move was a very deliberate design and engineering choice by Boudreaux. "We didn't want to just have figures come crashing down to the garage floor," he said. "So I put a spiral on the central post, and that created a spinning action. It was a very simple, but very elegant, way of giving the play set a little bit more action."

"The marketers could destroy the fun of the toy by taking a feature out of it or the packaging to save a fraction of a penny," said Jim O'Brien to the Art of RGB website. "One marketer told me, 'If it doesn't help a TV commercial, it's not worth it.' And those kinds of decisions after months and months of hard work are hard to deal with."

"You want play sets to come alive for the commercials," says Jerry Perez. "The slime dripping through the grates we knew would play visually. But when we did commercial testing that showed the spinning fire-pole feature, it blew off the charts." A hard sell through an engaging commercial was key to overcoming the Fire House's retail price of $39.99, which was quite a sum at the time. "We threw caution to the wind because forty bucks was astronomical," says Perez. "But we knew it was iconic. It was an environment that fit into the lore of the line. Every kid was going to want this. Somebody wanted us to shrink into a $29.99 price point, and we just said no. We really wanted to deliver the play experience. So we distilled it down to the basic structure, with the three levels and just the two or three cool features that would help us bring a commercial to life. It worked. We sold out. I'll never forget the day I got a call from Dan Aykroyd asking if I was the guy to talk to to get a Fire House. They couldn't be found anywhere."

Unveiling the Fright Features

Though they weren't quite ready for the initial rollout of products, when completed, the ace up Kenner's sleeve

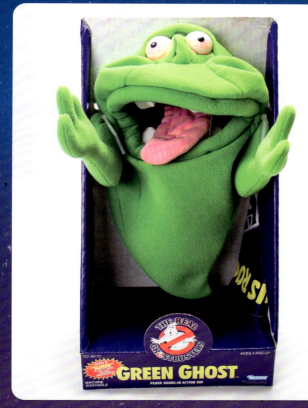
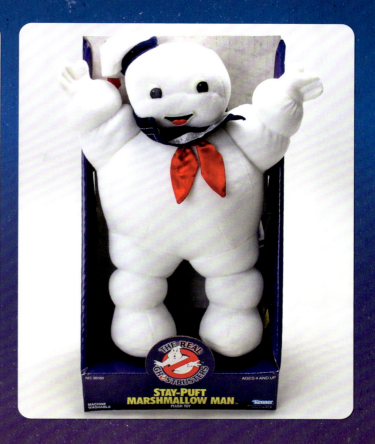

Packaged samples of Kenner's only two plush offerings.

> **"The engineering was phenomenal. It was like clockwork going into an action figure. It was a major tent pole for Kenner at the time."**
> —TIM EFFLER

was an instantaneous hit. "Fright Features came out and the Real Ghostbusters line exploded," says Jerry Perez. "I remember Tim Effler and Alton Takeyasu showing me the Fright Features figures in a conference room on the R&D floor, and I was shaking. They were so right on to the concept. They were so fun. So unique. I thought it nailed the essence of what made The Real Ghostbusters so unique. It was action-adventure but also humorous. Everything else was so serious."

"Ghostbusters was a line that was much more fun than Star Wars to work on in a lot of ways," says Tom Osborne. "Because we had imagination and we could infuse them with a little more craziness. You could do really, really weird things." With the Fright Features line, Kenner introduced new iterations of the four main Ghostbusters heroes with gimmicks that went far beyond the old action figure cliché of "kung fu grip." Kenner had tried that previously with their Super Powers line, in which figures like Superman would "punch" with a squeeze of their legs. Though dynamic and obviously playable, that line wasn't as successful as intended.

"Our engineering and sophistication was evolving with a lot of the lines. Kenner was really good at getting the mechanisms down into the smallest envelope so that you could put a body around them. We gained a lot of experience on all of that to move into doing Real Ghostbusters," says Perez. Developing the mechanisms for the failed Super Powers line served as an iterative experience for Kenner's R&D. The actions in those mechanics acted as prototypes for what would be implemented in the Real Ghostbusters Fright Features toys. Just as with Super Powers, kids "activated" the figure with a simple movement: a push of an arm or a squeeze of the legs. But instead of a dud of an arm movement, the figure would come to life, striking a frightening and grotesque pose! From Venkman's bulging eyes to Spengler's famed flip-up necktie, the before-and-after poses of the figures have become iconic. Each figure was equipped with a ghost gun accessory and companion ghost for added playability. Janine Melnitz was also introduced in toy form for the first time through the Fright Features lineup.

"Our goal was to develop really cutting-edge mechanisms that would give us unexpected results. And I think we were really successful," said Mark Boudreaux on the Hasbro PulseCon live stream in 2020. "We also wanted to make sure that each one of those features played up the personalities of our heroes."

From a consumer perspective, the toys were surprising and whimsical. From a design and engineering perspective,

these figures were innovative in a way that the toy industry had never attempted. The result was an instant notoriety and popularity, with over $100 million in sales. The line was also a physical and tangible representation of what Kenner was at the time: a fun and free-spirited bunch of toy makers. "To me, Real Ghostbusters represented the apex of action figure features with the Fright Features," says Tim Effler. "The engineering was phenomenal. It was like clockwork going into an action figure. It was a major tent pole for Kenner at the time."

Each Sold Separately

Since the advent of television, and with it programming directly geared toward children, advertisers and consumer products companies have seen kids as a major market. Cross promotions from television programs to breakfast cereals to toys and Happy Meals and sugary treats have been a lucrative business strategy. Constant bombardment of consumerism toward children comes with a moral conundrum: just how much can and should be sold to young and impressionable minds? In 1980, shortly after being elected president, Ronald Reagan deregulated legislation that had been created to limit how marketing was directed at children. Rolling back these regulations allowed advertisers to market directly and more freely to children during commercial breaks of cartoons. It also allowed companies to develop entire children's shows merely to fuel toy sales. A result of this relaxed new world was *He-Man and the Masters of the Universe*, which had been developed as a new major toy line at Mattel. The animated series was created as a secondary project to support sales of the toys. Each episode was produced with the sole purpose of being a twenty-two-minute commercial for Mattel. Sure enough, even during the commercial breaks, there were ads for even more Mattel-owned products.

That was the stigma that both the creators of the animated series and Kenner wanted to avoid. *The Real Ghostbusters*, while clearly still a moneymaking endeavor, was viewed as more than just an expensive television commercial. The show didn't exist with the sole intent of selling toys—even though an impressive and successful toy line was a direct byproduct of the show's popularity. "TV advertising was the second primary strategy in selling Ghostbusters toys," said Jerry Perez in an archival interview with Joe O'Brien of the Art of RGB website.

In 1987, after the first Kenner Real Ghostbusters products hit shelves, Kenner launched an extensive marketing campaign including television commercials. Grey Advertising, an advertising agency founded in 1917, was responsible for some of the most memorable ads from Block Drug, Greyhound Bus, Kraft Foods, Dannon Yogurt, and Stove Top Stuffing. Kenner knew them as the go-to agency that conceptualized and produced the commercials for their Star Wars line to great effect. When it came to creating television spots that would capture the fun, grossness, and innovativeness of the Real Ghostbusters toys in thirty seconds or less, Grey was the clear one to call.

"Grey did a very nice job on Real Ghostbusters. We were demanding clients, but they always found ways to meet or exceed our expectations. Lots of good creative thinking on their part," says Jerry Perez. Perez worked closely with the agency to make sure the commercials were being produced with each and every finding Kenner had discovered in their extensive market research of three- to five-year-olds. "The tone was faux scary. Punctuated by lots of humor and silly action. The formula that worked from the very beginning: introduce the scary villain right upfront ('Oh, no, it's Bad-To-The-Bone!'), show the Ghostbusters surveying and using their arsenal of ghost-busting equipment, then end with the Ghostbusters victorious, even if the ghost came back for one last funny scare."

"The one thing that we could do that other action figure lines, boys' action lines, couldn't do was we could show the Ghostbusters killing those ghosts because ghosts were dead already," says Tom Osborne. "There was no law, there's no regulation that would stop us doing that. So, our advertising and marketing could do that really effectively versus Star Wars and stuff where you had to be super careful."

Unlike most toy lines directly tied to an animated series, the Kenner team opted to not use animation from the *Real Ghostbusters* show in any of the commercials. Striking a balance of funny and goofy with the perceived threat of real ghosts, the ads mainly featured realistic movie-style clips and elaborate diorama cityscapes where the ghost-busting action took place. "The buildings in which the kids played with their action figures were made to look 'kid designed,' but were extremely elaborate and created by adult craftspeople. This gave kids a sense that they could immerse themselves into an entire world of play if they so desired. And many did," says Perez.

The toys used in the commercials were not examples of the final product, but rather prototypes built specifically for testing and advertising. "Our policy was to have a minimum of three working prototypes on set in case one or two conked out on the day of production," says Perez. "The worst case of which (none worked) could result in

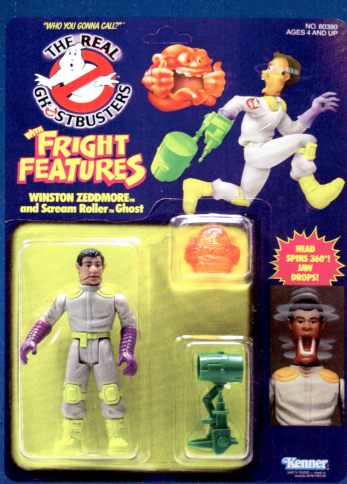
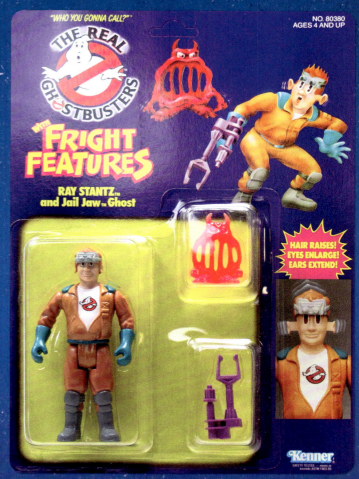
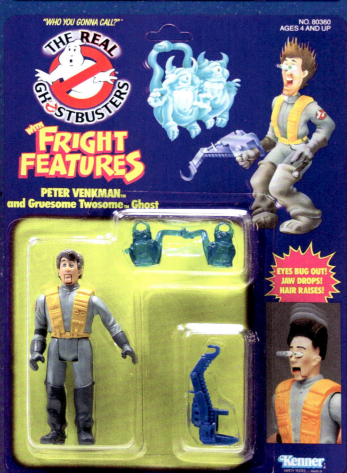
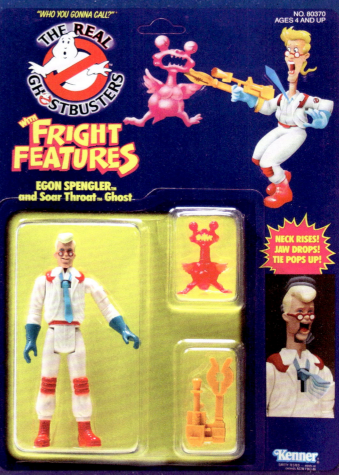

Initially slated for release in early 1987, the figures required complex mechanisms and advanced engineering that needed more time to be refined. When the line debuted, the unique and visceral actions they were all capable of made them an instant success.

Chapter 4: The Franchise Rights Alone: Toys, Merchandise, and the Rise of Ecto Cooler

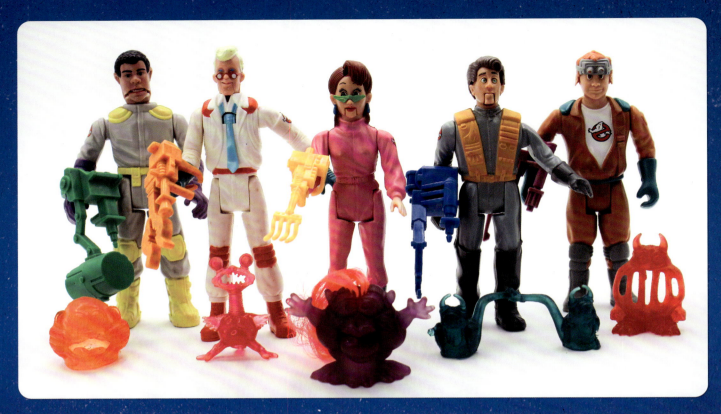

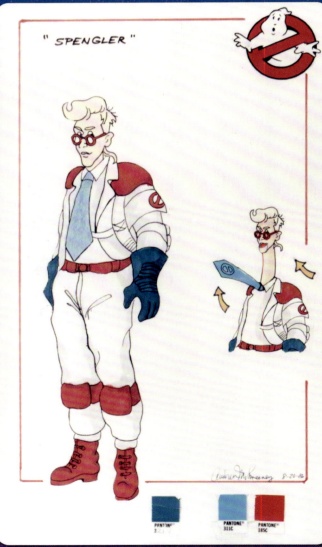

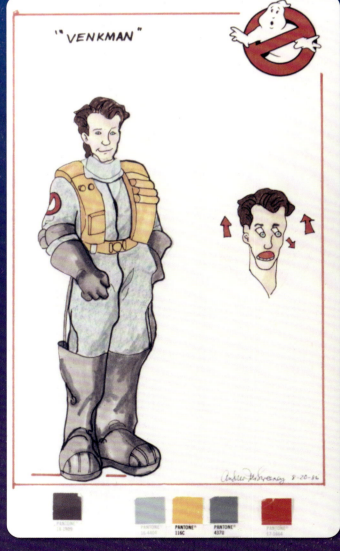

Top: *The entirety of the first wave of Fright Features figures. Snap-on accessories replaced mechanical Proton Packs, giving the Ghostbusters all-new gadgets to combat the supernatural.* Bottom: *Designer Andrea McSweeney's final renderings of Fright Features Egon and Peter.*

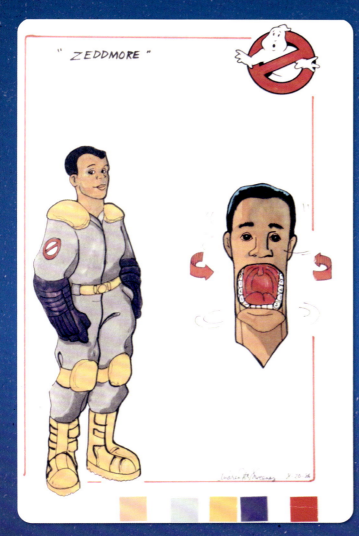
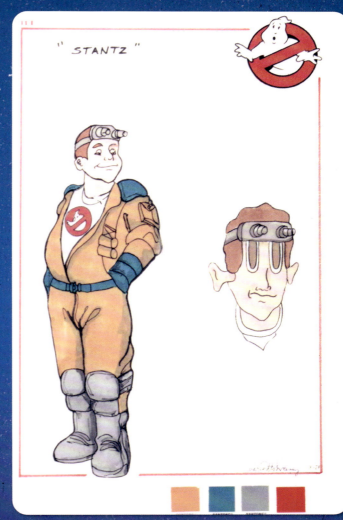
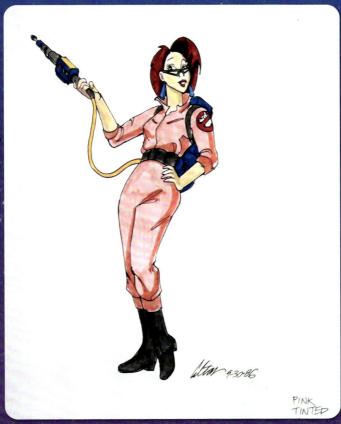

Top: *In-house industrial designer Andrea McSweeney created these final hero color call-out images of Fright Features Winston and Ray.* Bottom: *Alton Takeyasu's initial design for Fright Features Janine and an international sales poster for the new line.*

Chapter 4: The Franchise Rights Alone: Toys, Merchandise, and the Rise of Ecto Cooler

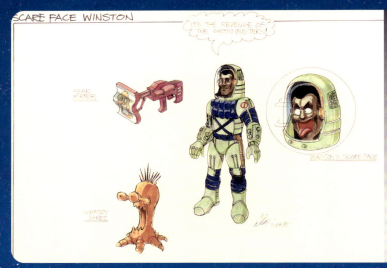
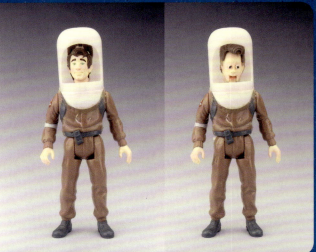
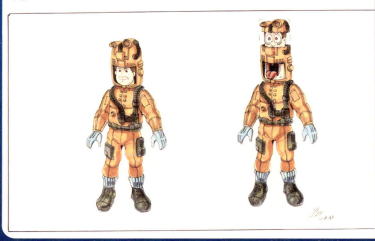
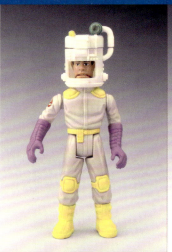
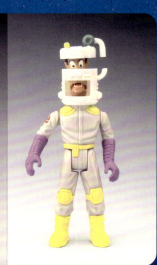
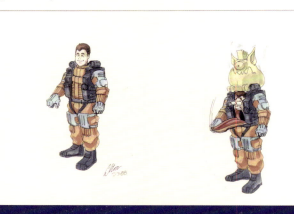
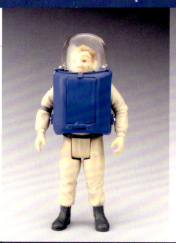
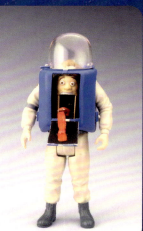

Concept art taking the Real Ghostbusters figures into "the next dimension" was the starting point for developing these complex figures. Next, the engineers created mockups with functioning mechanics to show how the toy might function (and how complex manufacturing might prove). Note that the functions assigned to the title characters were shuffled from concept to prototype to the final released items.

The Real Ghostbusters: A Visual History

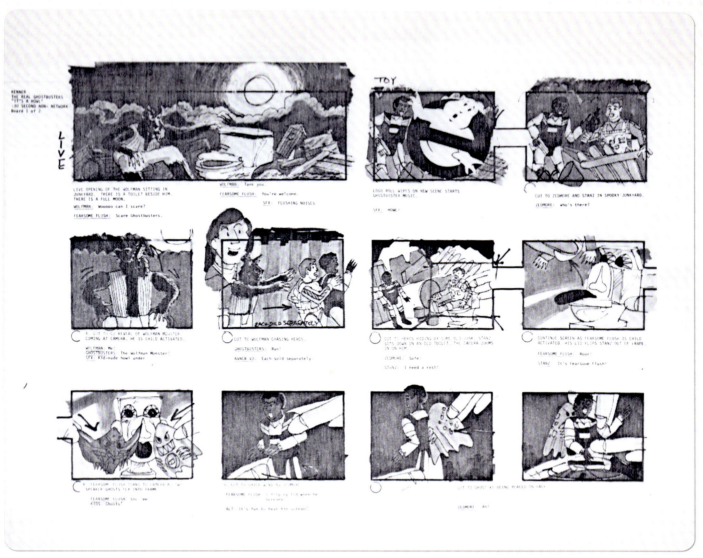

Grey Advertising commercial storyboard presentation.

thousands of dollars of loss in production time. Commercial production was very expensive, with a single commercial often costing $100,000 or more. We also required that a 'toy doctor,' a technician from the sample department, be on the set to fix any last-minute problems."

The formula worked. Grey's memorable ads helped propel the line forward for the next five years. "Ghostbusters connected with young boys because most kids are afraid of the dark, the monster under the bed, in the closet, things that go bump in the night," says Perez. "Ghostbusters gave young boys a 'fantasy of mastery' over all those things and made it fun in a way that no other property had done."

The Line Continues

If 1987 was Kenner's proof to the world that The Real Ghostbusters was a toy line to be reckoned with, the company's follow-ups in 1988 and 1989 had to be bigger, bolder, and slimier. The 1988 New York Toy Fair would be the world's first glimpse of Kenner's next round of offerings. It would also be the first opportunity for the toy company to initiate any course corrections based upon lessons from the first wave—both in how they were marketing the toy line and the variety and diversity of the products they were putting on shelves.

Hoping to crack the code of customers who had yet to make their first purchase from the line, Kenner conducted extensive internal testing to compare owners of Real Ghostbusters toys with those who didn't own a single item from their lineup. Unsurprisingly, Kenner found that those who already owned Real Ghostbusters toys would enthusiastically be repeat buyers. But an interesting pattern from that research also emerged. Kids who were viewing the animated series tended to be older, roughly ages eight through ten. But that demographic wasn't purchasing the toys that Kenner was offering. Sales among the eight- through ten-year-olds were lower compared to kids seven and under. Kenner theorized that the role-play toys and more juvenile-feeling toys they offered in 1987 might have

been contributing to a lack of eight- to ten-year-old interest. Kenner would have to find a way to add a little bit of edge to bring the older kids in. Enter more macabre offerings like the Haunted Humans and role-play items that might appeal to an older demographic.

Haunted Humans

Looking to add edge to the line and bring in the older crowd, Kenner developed the Haunted Humans wave. These figures were everyday folks—a mailman, a police officer, a trash collector, a football linebacker, and a sweet old grandmother—but they were concealing a dark secret: with one action, each of them would transmogrify with frightening poses and terrifying expressions. "It's always a balancing act between aesthetics and engineering. The animation styling gave us a lot of flexibility and let us change proportions of the characters, especially the Haunted Humans," said Mark Boudreaux. Cheating proportions and the silhouettes of these figures that were intended to appear realistic was key in hiding the mechanical and design elements that would be required for their transformation. "It was always a contest among us designers: how much could we pack into any given volume of material? It really does take some ingenuity to get all of this mechanism

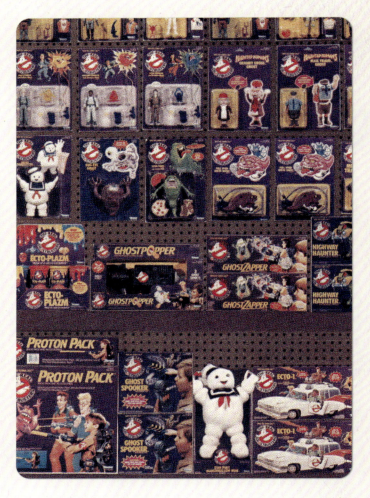

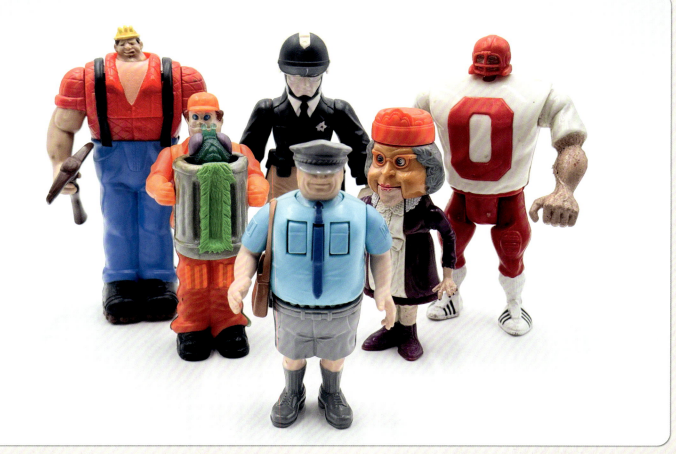

Top right: *Every* Ghostbusters *fan's dream: shelves stocked with* Ghostbusters *toys.* Bottom: *Haunted Humans—an original lineup of hometown heroes gone ghastly, ready for the Real Ghostbusters to bust.*

172 The Real Ghostbusters: A Visual History

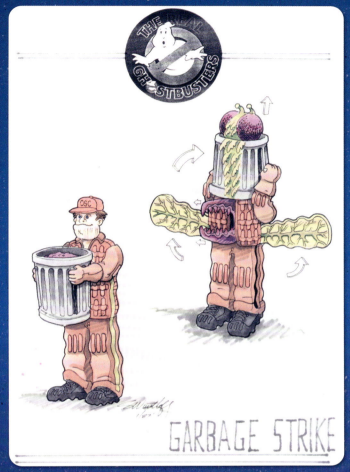
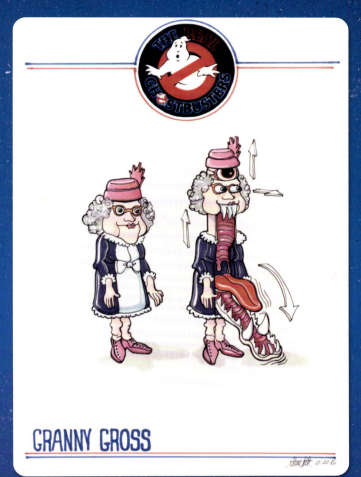
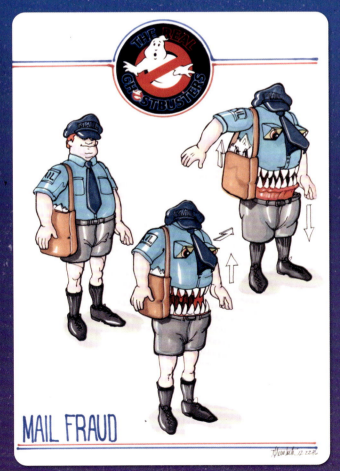

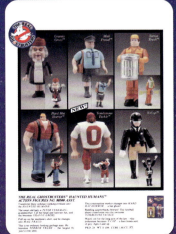

The Haunted Humans line was immensely popular, even among those not interested in Ghostbusters. Pictured here are Alton Takeyasu's original designs for the wave, as well as a Kenner employee dressed as Granny Gross for an internal presentation.

Chapter 4: The Franchise Rights Alone: Toys, Merchandise, and the Rise of Ecto Cooler

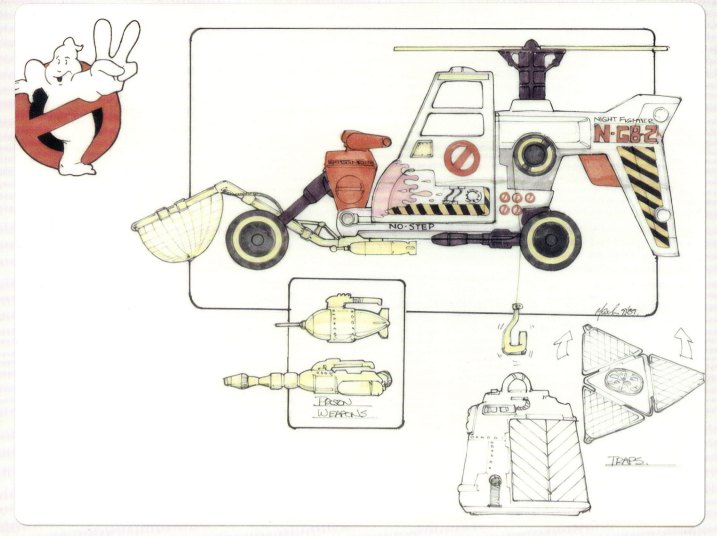

Above: *Mark Boudreaux's sketch for an unreleased "Ecto-2A" that would have been a rerelease of the vehicle for a* Ghostbusters II *tie-in.* Right: *Mockups for the vehicle.*

EVENTS AND contests are always huge drivers for advertising and promotion. Throughout the years, Kenner experimented with various promotions, including a proof-of-purchase mail-away campaign for a haunted wristwatch and 1989's Find the Ghost program. Tasked with helping the animated version of Peter Venkman locate the Scoleri Brothers, kids could enter for the chance to win their own official Ghostbusters uniform. In conjunction with the release of 1989's *Ghostbusters II*, Kenner plotted an elaborate scavenger hunt akin to finding the Golden Ticket in a Wonka Bar. Gigameter decoders and ghost maps were to be placed in one million specially marked packages of Kenner's 1989 The Real Ghostbusters toys. Kenner hoped a star from the film could act as the face of the promotion and originally conceived the game as "Find the Ray," with hopes to involve Dan Aykroyd. In March of 1989, Kenner submitted a formal request to Michael Gross and Columbia to use Dan Aykroyd's likeness on the ghost map as well as in stores at the point of sale. Kenner also petitioned for Aykroyd's participation in promotional photography and an appearance in a thirty-second commercial spot. Aykroyd politely declined.

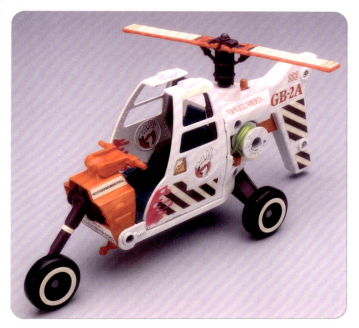

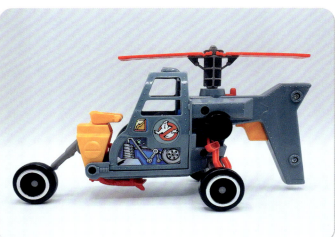

into tight spaces. It's amazing what a spring, a little bit of plastic, and a lot of imagination can do."

"Essentially, it's like taking a refrigerator and sticking that inside of a human and trying to make it look organic," said Kenner sculptor David Vennemeyer in 2020. Sculpting complex figures like the Fright Features or Haunted Humans took a lot of three-dimensional thinking. "You would have to take the features and what those entailed into mind, and think about the manufacturing and how a figure would be translated into plastic ultimately."

The result was a popular line that sparked with the older demographic, even kids who weren't collectors of Real Ghostbusters figures. Tombstone Tackle became a figure that every kid on the block owned, regardless of whether they were *Ghostbusters* fans or not. The burly football player could be set into a hiking position, which revealed an alligator-like apparition emanating from the back of his neck, with bulging eyes popping out of his shoulder blades and his lower back rising from his torso. The grotesque change was enough to catch the attention of any boy, girl, or even football-loving parent who was amused by the fantastically engineered gimmick.

Ecto-2

As was expected when it was introduced in the animated series, the Ecto-2 made one hell of a toy. Having appeared in the debut episode of *The Real Ghostbusters*, "Ghosts

R Us," the Ecto-2 was a one-seater gyrocopter featuring moving chopper blades, a grappling hook, and foldaway doors that doubled as wings. Though on the show, the Ecto-2 could neatly fold itself and be tucked away in the rear hatch of the Ecto-1, there would be no such luck for kids attempting to cram the new vehicle into the back of the Kenner version. "They talked about it," says Marian Ihlenfeldt. "But they thought it was more important to have the figures fit inside the vehicle." Ecto-2, though diminutive in stature, was a monumental challenge for Ihlenfeldt and the Kenner engineering team. "It was the first time as an engineer I worked on a gear mechanism that triggered the blades to spin. It also had a little winch that hoisted up a figure. Luckily, there was a whole group of engineers working on it. I had to go to Mexico, where we had sent the tools for manufacturing the vehicle. They needed my help as an expert to debug the parts for the product. There were issues, and usually, if things aren't fit to print, you don't tell the manufacturer to fix it. You look for what you can change the fastest to make the parts work. We had to redesign as fast as we could. Because as an engineer you can never cause harm to a child, and you can't move Christmas."

Highway Haunter

Sending shivers down the spines of interstates was the Highway Haunter. Modeled after a classic yellow Volkswagen Beetle, the vehicle transformed in one movement into a praying mantis that towered over the basic figures. Packaged with its own companion, a spirit-possessed motor ghost, the Highway Haunter never appeared in *The Real Ghostbusters* but did have a striking resemblance to Janine Melnitz's car. Engineering the vehicle fell on the shoulders of Marian Ihlenfeldt. "We had taken over space in the subbasement, where we had started a huge model shop that did patternmaking and protomolding," says Marian Ihlenfeldt. "One of our patternmakers carved the vehicle contours out of wood. Beautiful shapes carved in wood. Then we had a sculptor who created the monster inside. My job was to make sure that whatever the patternmaker did for the exterior of the vehicle allowed the sculpt of the monster inside to live." In a perfect world, the car exterior would have been finished and the monster inside would be built around that, but the production timeline on the Highway Haunter was so tight, that wasn't possible. "Everything happened at once. The only thing that had been turned over to us had been a rendering, a basic drawing of what they wanted. I worked with an industrial designer to figure it out from there and tried to make it all fit together so that it would move."

"The coolest thing for me was to see when our designs were turned into fully functioning models," said Mark Boudreaux. "A sketch is great, but there's nothing better than a model."

Brain Blaster and Pull Speed Ahead

Continuing to find engineering answers to memorable ghost figures, Kenner introduced two mechanically complex premium ghosts in Brain Blaster and Pull Speed Ahead. Brain Blaster, a grinning ghoul with a colossal head, shot one of four torpedo-shaped mini ghosts into the air when his mechanics were triggered. Pull Speed Ahead was a ripcord-and-rail-based ghost sporting a Mohawk and sneakers, evoking an edgy demeanor that cried speed. When the ripcord was pulled, the ghost spewed sparks from its mouth and rocketed at top speed across a kitchen floor. The sparks were created using a mechanism similar to a simple lighter, rubbing pieces of flint in the gear works together. This type of technology was employed by toy companies to great effect for several years until an incident in 1993 where a Rollerblade "flicker 'n flash" Barbie that employed a similar mechanism caused a household fire, at which point it fell out of fashion due to risk of liability.

Mini Ghosts

Brain Blaster and Pull Speed Ahead carried a suggested retail price of $13.99, which was a bit steep compared to earlier offerings in the line. To make sure there was a range of affordable ghosts still on the shelves, Kenner created what they called "Mini Ghosts." These included Mini Traps, Mini Goopers, Mini Shooters, and haunted vehicles like

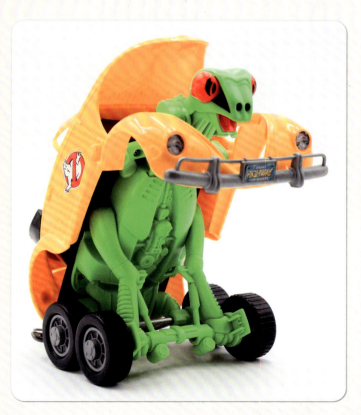

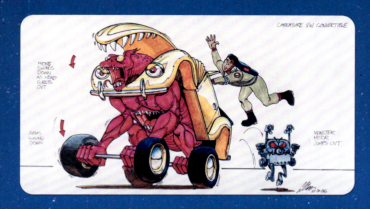
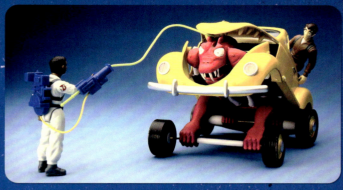
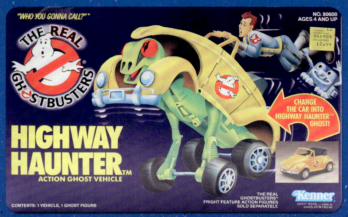
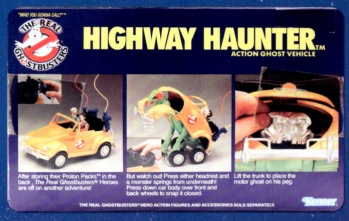

The Highway Haunter vehicle was a deceptively complex mechanism that required quite a bit of planning to accomplish. Bottom: Marian Ihlenfeldt's final engineering schematics utilized for the production of the intricate vehicle.

Chapter 4: The Franchise Rights Alone: Toys, Merchandise, and the Rise of Ecto Cooler

Wicked Wheelie and Air Sickness. The figures and haunted vehicles were kept simple to keep the price points lower, but the cost-effective approach tended to score low in the marketing department's desirability testing. The Mini Traps gained a particularly painful reputation for snapping kids' fingers. "That was all Mr. Woodhouse," said Mark Boudreaux of Hampton Woodhouse, who designed the simple mousetrap-like ghosts. "He was British and he had that sort of sense of humor. I think that was his way of getting back at us somehow."

Expecting the lower-cost options to sell in greater quantities, Kenner produced massive numbers of the Mini Ghosts and Haunted Vehicles. They went largely unsold. For this reason, collectors now find carded or boxed examples of these items with greater ease than some of the more popular items from the line.

Role-Play, Round Two

Even though role-play toys had failed to resonate with the eight- to ten-year-old consumers, the response from younger kids to the first wave of Ghostbusters role-playing offerings was resoundingly positive. "Real Ghostbusters was one of the first boys' brands that really deployed role-play as a concept in a major way," says Duncan Billing. "Kids wanted to dress up and be Ghostbusters and actually play that fantasy out themselves." This alone separated Kenner from the pack and was a key differentiator in the toy aisle when comparing Ghostbusters to other popular brands like G.I. Joe, where role-playing items were limited or nearly nonexistent. But once a kid has a Proton Pack strapped to their back, which already included a PKE Meter to help track down the ghosts to hunt, what more could they need at their hip when the goopers got sticky? As it turned out, Kenner had a virtually limitless supply of concepts for role-play toys that they were ready to offer.

GhostPopper

The GhostPopper was among the first supplementary role-play toys Kenner released. It was a popular seller, possibly purely because it was a precursor to the $350 million venture that Nerf guns have become today. Parker Brothers (which was a sister company to Kenner after General Mills had separated the two holdings into their own entity) was readying their Nerf Sports line for 1988, which included their first foray into weapons with Nerf fencing sabers. The first Nerf gun was still at least a year out. But the Real Ghostbusters team saw the Nerf-like foam inserts included with the Proton Pack as an opportunity for a projectile-based ghost-busting weapon. "You needed something that could neutralize a ghost at a distance, and the GhostPopper was the answer," said Mark Boudreaux.

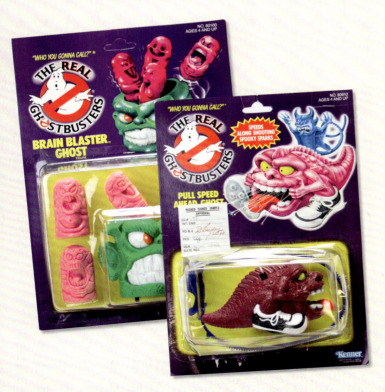

The GhostPopper utilized a forced-air launching system that projected small foam darts that had previously been manufactured by Kenner as Finger Pops. If firing at a lineup of Kenner figures wasn't feasible, Slimer and Stay-Puft Marshmallow Man targets were part of the toy's packaging and could be cut out for use. "We actually used packing foam as our darts," said Boudreaux.

"The one core memory I have of the Real Ghostbusters toys was the taste of the foam poppers," jokes Eric Reich. "I don't know why. I don't know if anyone else ever did this. But it's the one thing I can specifically remember [from] playing with that toy. Seared in my mind is the taste of those little cylindrical poppers."

Ghost Trap

Kids who were lucky enough to have a Proton Pack under their Christmas tree in 1987 very quickly noticed that a key component in ghost catching was missing: the Ghost Trap. Kenner received countless letters inquiring when an accompanying Trap would be available, and the Kenner team had been working tirelessly behind the scenes on the role-play toy. But what seemed like a fairly simple mechanic had been particularly challenging for the engineering team. "The Proton Pack had done so well, we were trying to figure out how best to do the Ghost Trap," says Ed Zobrist.

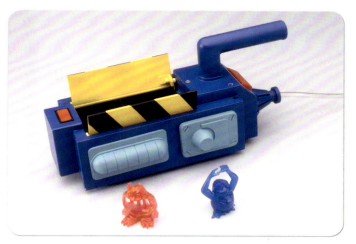 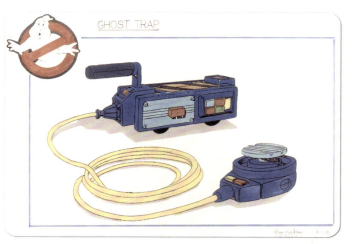

A latecomer to the role-playing lineup, the Ghost Trap required the expertise (and focused attention) of Ham Woodhouse to finally be brought to shelves.

Highlight Episode: Chicken, He Clucked

WRITTEN BY:
J. Michael Straczynski

FIRST AIRED:
October 19, 1987

PREMISE (FROM THE ORIGINAL *REAL GHOSTBUSTERS* WRITERS PACKET): Cubby Maltese lives behind a 24-hour-a-day chicken restaurant. Gradually driven mad by the constant smell of chickens—in his clothes, his sleep, his life—he makes a deal with a demon to get rid of all the chickens in the world. The Ghostbusters must intercede on the behalf of the world and one very chagrined demon.

"Very early on, Joe Medjuck and Michael Gross trusted me enough to know that I wasn't going to screw them. When there were problems, we'd get in touch as needed," says J. Michael Straczynski. "When I turned in the script for 'Chicken, He Clucked,' Joe called me and asked if everything was okay at home. I said, 'Why do you ask?' He says, 'Well, we read the script and either you're deeply disturbed or you're funnier than we thought you were.' After that, I think the guy trusted me more. Here's the backstory on that episode: the DIC offices were just off to the side from Amber's Chicken Kitchen at the corner of Balboa and Burbank. I don't drive. Every morning I'd walk past Amber's Chicken Kitchen to get to the office. At that time of the morning, the smell of cooking chicken is just appalling. You want to kill yourself and the person next to you. It was so thick that every day, my clothes would smell like chicken. One day I was stuck on what to write for an episode, and my shirt smelled. I thought, hang on. Let's just work out our anger with this now."

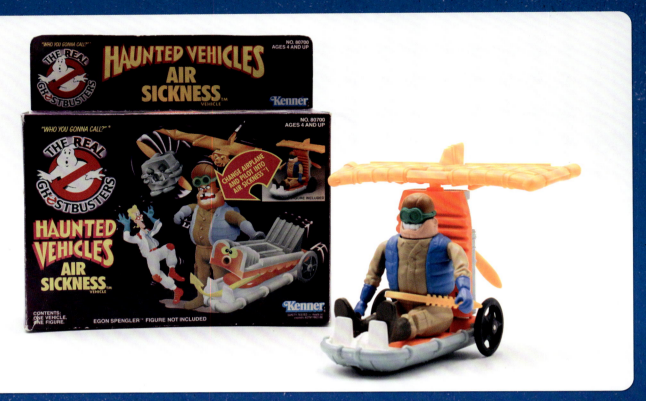
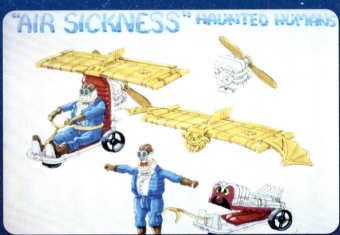
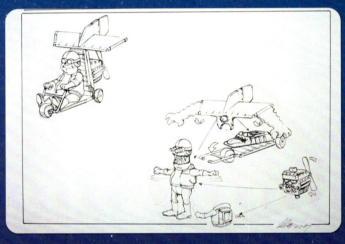

Cost-effective solutions with fun playable actions were the sole driver to later introductions in the line, including the Mini Ghosts and Haunted Vehicles. Bottom: Concept art showing how simple mechanisms like those modeled after mousetraps could interact with the figures (and snap on kids' poor fingers).

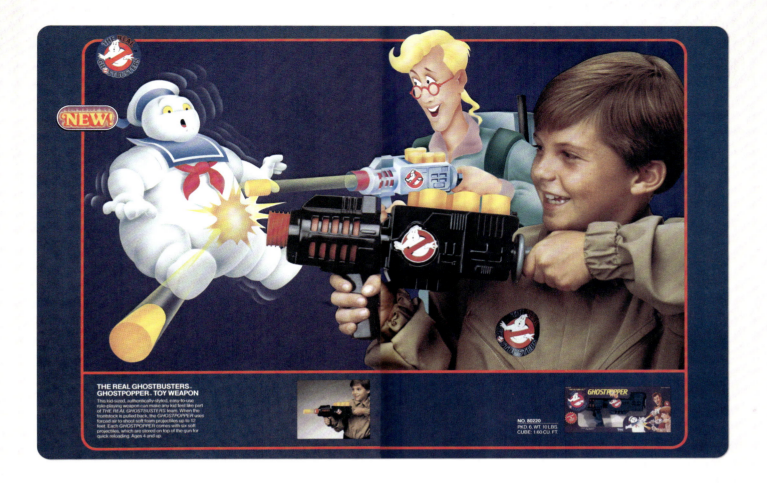

Hampton "Ham" Woodhouse spent nearly thirty years as a principal designer for Kenner and Hasbro. As the self-proclaimed "guru" of role-playing for the company, he still holds the patent for a very particular "toy sword" that replicates the functionality and appearance of *Star Wars*' lightsabers. "He was responsible for most of, if not all of, the role-play for Real Ghostbusters," said Mark Boudreaux in 2019. The British-born tinkerer was tasked with finding a way to design the Ghost Trap for the Real Ghostbusters line. It was a must that the toy had the same mechanical action seen in the animated series: a trapdoor mechanism triggered by a foot pedal. It's a deceptively simple concept that quickly could have become complicated and expensive, but Ham and his fellow Kenner designers approached the doors using the KISS (keep it simple, stupid) principle. "Ham used a simple air pump to activate the opening doors for the Ghost Trap," said Boudreaux. "Sometimes there's a tendency to complicate designs, but he knew that simple was always better. . . . You can *always* make something really complicated and expensive. It's a real master who can simplify things and still deliver the content but make it something that's fun and functional and also elegant."

Spenglerizing the Lineup

The creators of the animated series recognized that fitting a portable nuclear accelerator on a kid's back to fight ghosts was something entirely unique to Ghostbusters, and Kenner also quickly made the same realization. The second a kid threw on a Kenner Proton Pack, there was a boldness and a confidence that exuded from them. "Hey, if I've got this stuff on, I ain't afraid of no ghosts," says Duncan Billing. Beyond the standard-issue ghost-busting items like the Proton Pack and Ghost Trap, Kenner found expanding the role-playing line into all sorts of gizmos and gadgets with different action items (and varied price points), like the GhostPopper and GhostZapper, would lead to popular top sellers, even if they were never utilized in the series by the heroes themselves. Seemingly, as the gadgets that Egon Spengler invented for the Ghostbusters to save the day were limitless, so too were the creations of Kenner's marketing and engineering teams. Nearly a dozen role-play toys were part of the Real Ghostbusters line and were always a vital part of the sales strategy throughout the line's lifespan. Walkie-talkies, extendable claw arms, water guns, laser-tag sets, and every imaginable variation of foam-projectile shooter—if any traditional play concept could remotely be justified as suitable for ghost capture and detainment (which Kenner referred to internally as "Spenglerizing"), the company was at the ready.

"We were just inventing shit by that time," says Jerry Perez. "I have to hand it to the designers. They were so creative. We were coming up with things that we just thought would be fun." Through their development and engineering, the

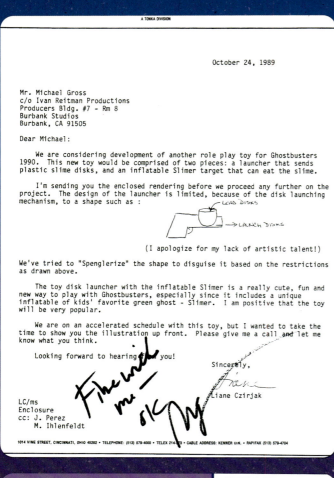
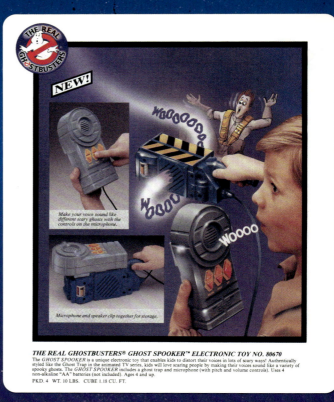
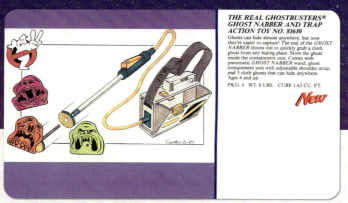

As the role-play line continued to evolve, Kenner creatives began taking successful concepts from elsewhere and finding ways to "Spenglerize" them. This included voice modulators, suction cup grabbers, water guns, and more.

Kenner team created a variety of items: The Ghost Spooker, a voice-changing device that looked like the Ghost Trap. The Ghost Grab-A-Meter, a rifle-shaped claw that could fire a projectile and ensnare a ghost in its clutches. The Water Zapper, a squirt gun that resembled the animated Neutrona Wand. And the Ghost Nabber and Trap, a close cousin to Peter Venkman's Bacharach Sniffer, which he used in the film to take readings in Dana Barrett's apartment.

Despite the endless variety of role-play options on the market, the Proton Pack always remained the mainstay bestseller. A frequent request from young consumers was for Kenner to create an accurate flight suit to accompany their role-playing, but it was one item that the toy company never produced. "I was begging management to let us make a jumpsuit. Just a brown jumpsuit and a *Ghostbusters* logo on it. I'm telling you, kids would go crazy," says Ed Zobrist. "I was relatively young. My bosses said it was too much of a hassle. We would have to deal with sizes, which meant lots of fabric. It wasn't our specialty figuring out how to do costumes, and there's a whole category of people who are experts who can do Halloween costumes if they want. So we never did it . . . although I still think it would have worked."

Higher and Higher

In 1988, The Real Ghostbusters had successfully demonstrated its staying power. But with fresh competition on the horizon from Nintendo and Sega's video game consoles,

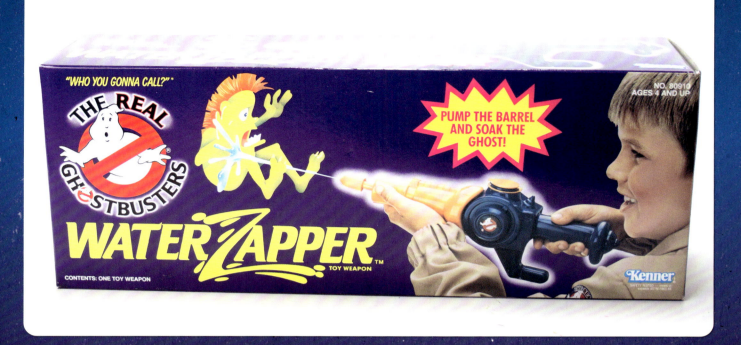

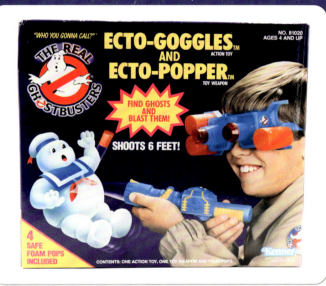
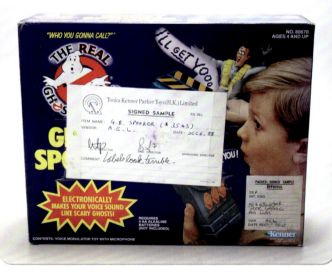

Final packaging for more role-play toys offered in the line. Bottom right: A rare "signed sample" from the Kenner archives with a particularly critical comment from the quality-control inspector.

and the continued popularity of G.I. Joe, Batman, and Teenage Mutant Ninja Turtles, Kenner recognized the need to continually innovate to maintain interest in the line. "You really want to step on the gas right after the first year. Usually second and third years are really, really big. Then they'll start to decline after that," says Duncan Billing.

Standing in their way from pushing the pedal to the metal: parents. While a focused effort had been made to add edge to the line to appeal to older kids, continued internal marketing testing reported that moms found the Real Ghostbusters toys to be "too expensive, too gross, and too messy." Some parents told Kenner that the reason their kids didn't have Real Ghostbusters toys was that the parents themselves found them to be "faddish." To these parents, running around and zapping remnants of the undead was gross and inappropriate. As a result, Kenner took a more humorous approach in its advertising to combat these negative connotations.

Nineteen eighty-nine held the promise to be a banner year for Kenner. With *Ghostbusters II* in production, the company knew that the toys would enjoy a huge bump in popularity and sales. Priority one for the coming year was to replenish supplies at retailers of the popular "carryforwards." These were the mainstay Real Ghostbusters toys that continued to sell, including the four main heroes, Ecto-1 vehicle, and Fire House play set. All of the basic ingredients for a successful play story would once again be highly sought after, and Kenner wanted to make sure every shelf had them available.

Chapter 4: The Franchise Rights Alone: Toys, Merchandise, and the Rise of Ecto Cooler

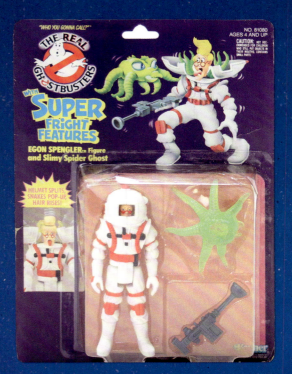
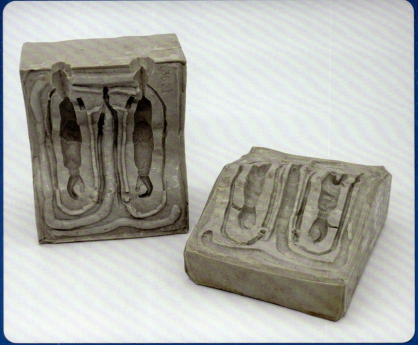
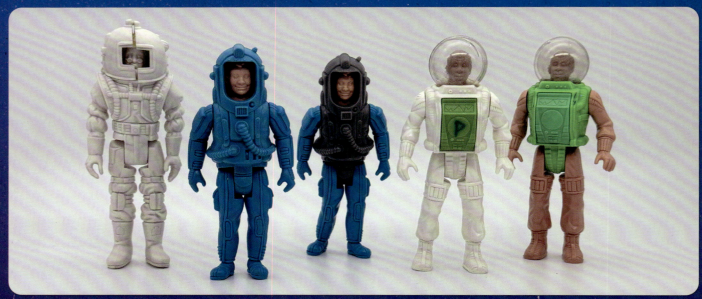
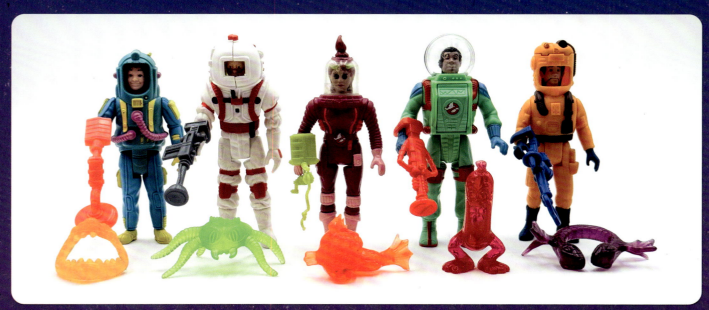

Top right and middle: *Super Fright Features test-shot prototypes and original factory leg molds.* Bottom: *The Real Ghostbusters Super Fright Features.*

Marketing testing never ceased for the line, and testing was conducted to see how Real Ghostbusters stacked up against two of the leading competitors' brands: Hasbro's G.I. Joe and Tyco's Dino-Riders. Kenner's internal research found that interest in Real Ghostbusters remained high, especially among five- to seven-year-olds. In total, 204 boys between the ages of five and ten were shown and asked to respond to all of Kenner's Real Ghostbusters product lineup for 1989 alongside the Hasbro and Tyco competition. Each child was allocated tokens to select which toys appealed to them based on a series of questions, videos, and demonstrations given by the marketing team. Fifty-seven percent of the participants selected The Real Ghostbusters as their first-choice purchase. Eight out of every ten kids made a selection from the Ghostbusters line. The Ghost Trap tested through the roof, Ham's simple mechanism satisfying everything the role-playing Ghostbusters had been seeking. And the new hero figure rollouts for both Super Fright Features and Screaming Heroes looked like they were going to be winners. Sure enough, The Real Ghostbusters remained a top seller through 1989, reaching $130 million in sales that year alone.

Super Fright Features

First on the docket for 1989: a complete refresh of the four main hero Ghostbusters with a total redesign that Kenner called Super Fright Features. The line expansion was intended to take what Kenner had begun with the popular Fright Features line and go bigger and bolder—to push the boundaries even further beyond the original mechanics the toy company had been able to house within a five-inch action figure. Early concepts showed a push-button mechanism on the back that would expand, drop, or distort each character's face. Some of the preliminary designs would be switched around during production. With Super Fright Features, the original design for Scare Face Winston ended up as Ray, and two different mockups of Heads Up Ray were eventually used for Winston and Peter.

Screaming Heroes

The Screaming Heroes figure assortment was a logical successor to Fright Features. Each hero was built with an internal wind-up mechanism, usually powered by spinning

Kenner distributed tens of thousands of mini product catalogs packed with vehicles, deluxe ghosts, and role-playing toys. These Action Toy Guides became a staple in Kenner's marketing strategy and are just as iconic as the toys themselves. "The Kenner universe was so large and had so many different properties—our kids could certainly find the specific line they'd bought into but also find others they might be interested in too," says Jerry Perez. The hope from Kenner marketing was that, by refreshing these guides about once a year, kids who loved and collected the Real Ghostbusters line might be interested in RoboCop, Swamp Thing, Police Academy, Beetlejuice, or Bill and Ted, all of which were also Kenner's properties.

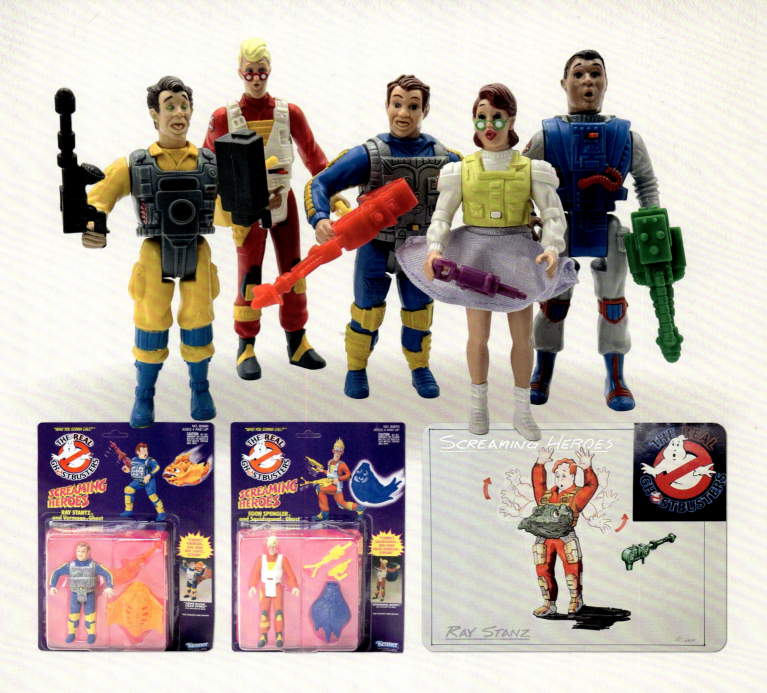

the figure's torso or head. The release of tension was triggered by an attachable companion ghost. Kids who had wanted necessary accessories for their action figures, like a PKE Meter and Ghost Trap, were rewarded for their patience, as Egon was equipped with a PKE Meter and Peter with a Ghost Trap in this line. Janine, perhaps ahead of her time, was packaged with her very own cellphone.

Fearsome Flush

"I think the most terrifying ghost we ever created was Fearsome Flush," said Mark Boudreaux. "The bottom line was to always remember to look before you sit." A monstrous possessed toilet was perfectly in line with what the Real Ghostbusters line was known for. As Fearsome Flush rolled along the floor, the seat opened, revealing a nasty tongue and yellow teeth, and bulging, bloodshot eyes popped out of the top lid.

"I remember getting a letter from a mom that was very angry because she was trying to toilet train her son," recalls Terry Healy. "He would not use the toilet because of Fearsome Flush. He was panicked. And she thought it was a terrible disservice to all moms trying to potty train their kids!"

"The letter was scathing. Saying we crossed the line, and asking us how we dared make this thing," says Tom Osborne. "But it was funny, so we ended up passing it all around the place."

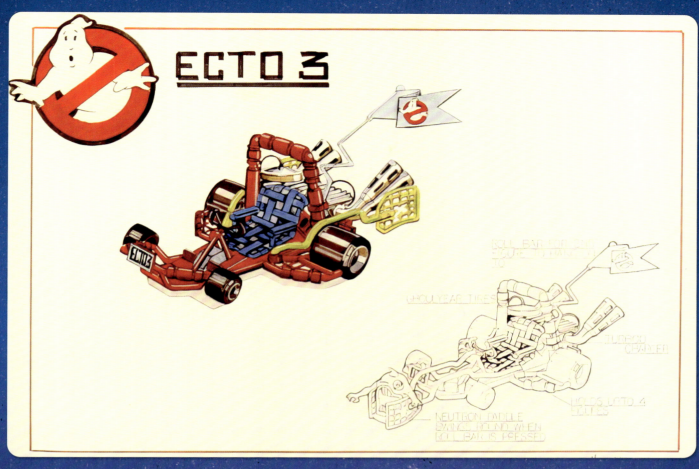

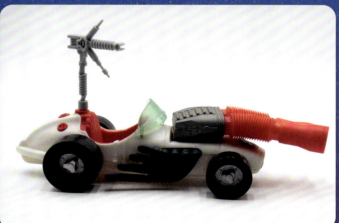
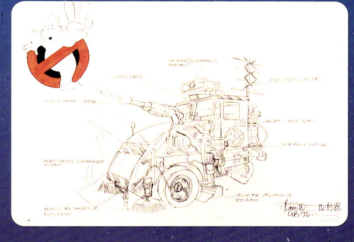

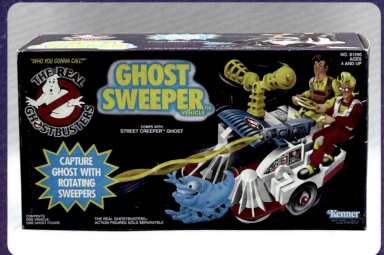
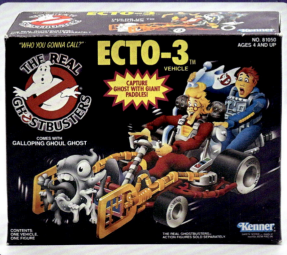

The Ecto-3, Ghost Sweeper, and Ecto-500 were smaller vehicles with a reduced price point that revolved around one key "ghost capturing" hook.

Chapter 4: The Franchise Rights Alone: Toys, Merchandise, and the Rise of Ecto Cooler **187**

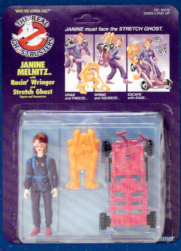
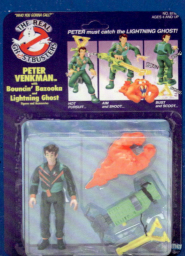
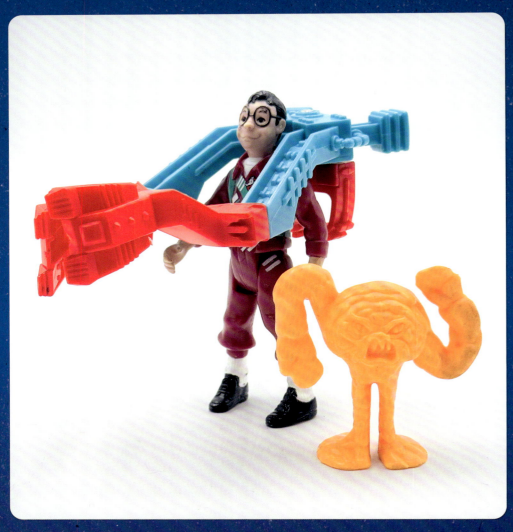
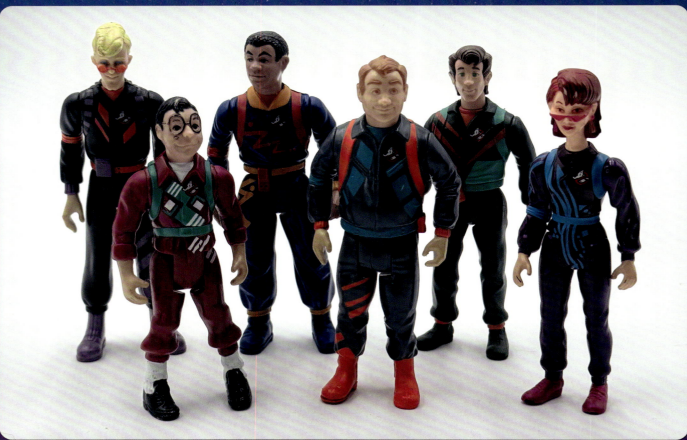

The Power Pack Heroes afforded Kenner the chance to rerelease the original molds of the first four heroes and introduce Janine and Louis Tully to the line.

Ecto-3, Ghost Sweeper, and Ecto-500

Throughout the final years of The Real Ghostbusters, a variety of additional vehicles joined the lineup. Though none had any counterpart in the animated series, each resembled a real-world vehicle retrofitted with a ghost-catching gimmick that would add to the vehicle's playability.

Among these new arrivals was the Ecto-3, a go-cart equipped with sizable fly swatter–like paddles designed to ensnare its packed-in spectral companion, the Galloping Ghoul.

The Ghost Sweeper resembled a cross between a New York City street sweeper and a Zamboni, with two spinning brushes that would consume a ghost figure into its body.

Lastly, the Ecto-500 was a sleek, low-to-the-ground 1950s speedster with accordion-like red ghost catchers extending from the engine. "Instead of using a high-tech Indy car, we used a 1950s–'60s version," said Mark Boudreaux. "We liked that vintage retro look to the elements that we designed for Ghostbusters."

Power Pack Heroes

The Power Pack Heroes wave reused the original molds of the first wave of hero figures from 1987 but showcased updated flight-suit colors with vibrant new patterns. This time around, the four hero Ghostbusters were joined by Louis Tully, who made another memorable appearance in Ghostbusters II and had become a regular player in the Slimer! And the Real Ghostbusters series. Outside of the cosmetic changes, to differentiate the figures from their previous releases, each figure was equipped with a modular Proton Pack that also served as a single-person vehicle.

Monsters

Another effort to bring an edge to the next year's offerings ironically took The Real Ghostbusters back to another era of the horror genre. Drawing inspiration from the classic Universal Studios monsters, Kenner released the Monsters line: Dracula, Wolfman, Frankenstein, Quasimodo, Mummy, and Zombie. Much like the Haunted Humans, the hope with the line was that it would appeal to consumers who recognized the monsters themselves and the Ghostbusters brand. This way, fans of the classic horror films and characters might be apt to purchase the figures regardless of whether they were fans of Real Ghostbusters or not.

These figures included subtle action features: the Wolfman's head reared back with an opening and closing jaw, Dracula bared his fangs, and the Mummy shed his wrappings to dangle at his side. The Monsters were heavily featured in Kenner's marketing campaign, particularly around the release of Ghostbusters II. One commercial featured a live-action actor as the Wolfman having a conversation with a puppeteered Fearsome Flush. Another featured live-action actors as Dracula and Frankenstein's Monster, crank calling the Ghostbusters, with Laura Summer's voice as Janine answering on the other end.

Action Ghosts

The Finger Pop Fiends utilized the same foam pellets as the GhostPopper (and the 1970s-era Finger Pops, from which the ghosts also pulled their name). "They were just packing peanuts that we put in a blister and sold," joked Mark Boudreaux. The foam darts were dyed in three colors: orange, pink, and green. Plastic ring-like overlays with eyes and teeth could slide over the darts and surround the foam. The foam cylinders made the figures soft to the touch but also surprisingly durable. It was also a cost-effective item

A more accurate representation of Slimer was released wearing a Proton Pack offered in both red and blue.

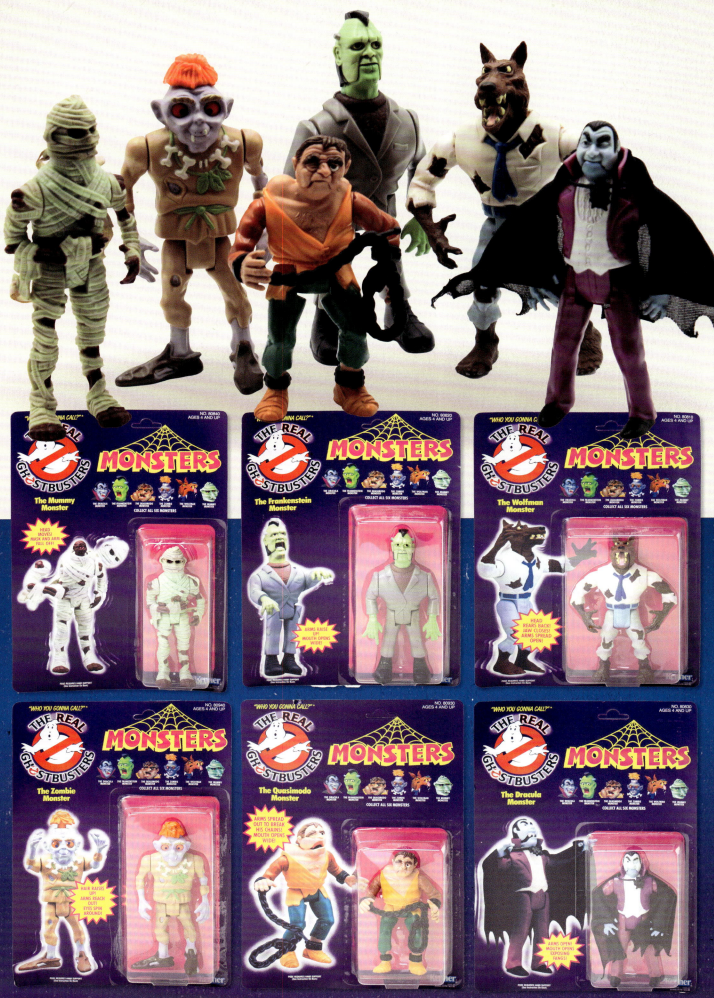

Inspired by the iconic Universal monsters, Kenner reenergized the lineup of villains by introducing fresh interpretations of beloved classics.

to bring to market: taking the old Finger Pops, adding a ghostly element and new packaging, and releasing them under the Real Ghostbusters banner.

Released under the Action Ghosts wave was the third and final Slimer figure: Green Ghost with Proton Pack. Slimer featured bug-out eyes, a dropping jaw, and articulation to allow him to wield a Neutrona Wand. This variation of Slimer was one of a few Real Ghostbusters figures with a true color-variant accessory, as the Proton Pack was offered in both blue and red. Green Ghost with Proton Pack was primarily available in Canada, with French- and English-language packaging. English-only American-packaged Green Ghost with Proton Pack sets are exceptionally rare, with very few examples showing up in even the most elite Real Ghostbusters collections.

Ecto-1A and Ecto-Charger Pack

Though Kenner wasn't able to overtly exploit the second *Ghostbusters* live-action film for a full line of characters and vehicles, two *Ghostbusters II*–specific items sporting the revised No-Ghost logo were available in the Real Ghostbusters lineup.

The Ecto-1A, which in the film was a revamped and redecorated version of the Ecto-1 vehicle seen in the first film, was the only action figure–specific release from Kenner. The company took the original Ecto-1 toy release and gave it a redecoration with fresh *Ghostbusters II* logo decals, pink slime splatters, and caution stripes. Essentially a repaint, it was a cost-effective way to get a *Ghostbusters II* product to the shelves with minimal development cost and without having to tool and sculpt a vehicle from scratch.

The other sequel-specific item released from Kenner was a role-play toy with the hope of replicating the lightning captured in a bottle with the Proton Pack. In *Ghostbusters II*, Ray and Winston sport "slime blowers" for the climax of the film: backpack-worn tanks filled with pink psychomagnotheric slime that emitted from a handheld nozzle. Kenner engineers wanted to find a way to create a spray mechanism, but unfortunately, because the timeline between February of 1989, when the Ecto-Charger project commenced, and getting the product to shelves was so expedited, a simple mechanic had to be employed. To keep the cost of the toy to a minimum, decals and paint applications were sparse. The majority of costs on the unit were dedicated to a blow-molded tank shaped like the prop seen in the film. The attached nozzle hid a "pink slime" insert that could be extended with a hinged trigger.

Even with all of the cost-saving reductions on the Ecto-Charger, a retail price of $24.99 made it comparable to the Proton Pack in cost but with far fewer features. It was a rare misfire, and many of the units went unsold. However, the role-play toy has since developed a cult following, particularly as the opinion of *Ghostbusters II* has become more favorable over the years.

Terrible Teeth, Nasty Neck, and *Terror Tongue*—the Gobblin' Goblins.

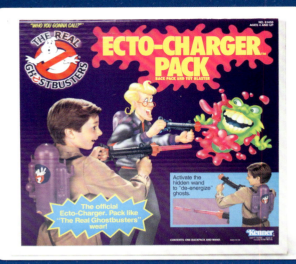

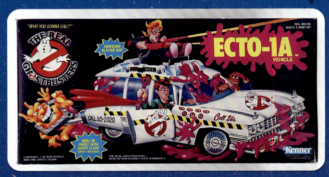

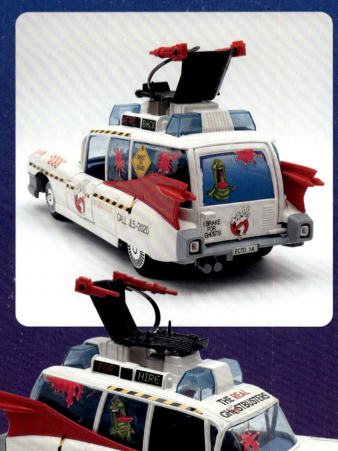

Two of the only tie-ins to the Ghostbusters II feature film.

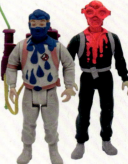

Slimed Heroes

The closest thing to *Ghostbusters II*–themed action figures came with the Slimed Heroes wave. These figures utilized the same molds from the original 1987 line and added the Louis Tully from the Power Pack Heroes collection. A special chromatic paint application that remained invisible at room temperature was used in the creation of the figures; when exposed to water, it revealed a colorful "slime" effect.

This color-changing feature became a focal point of Kenner's marketing efforts in 1989, showcased prominently in commercials and advertisements. It was a way to show the figures being "slimed" as they were in the original run, without all of the mess to clean up—hopefully making both parents and kids happy. The Slimed Heroes received a television commercial that looked like a scene lifted from the *Ghostbusters II* film, with ghosts attacking the Statue of Liberty and drenching the heroes in slime-inducing water. For the parents, the commercial placed heavy emphasis on the word "clean," which was utilized and underlined multiple times in the short thirty-second advertisement.

Requiring nothing more than cold water for the gimmick, each Slimed Hero figure came with a ghost companion squirt toy, so that the ghost could "attack" and activate the color-changing feature. Along with the companion ghost, each figure included a Proton Pack and either a mask or goggles, which could mask the figure against the water spray and give the illusion of protection from slime.

Ecto-Bomber

The Ecto-Bomber, released late in the line and one of the final vehicles to make it into production, was a vintage-style open-cockpit fighter plane, featuring "ecto-bombs" to drop below onto unsuspecting ghosts. "I was especially happy that we could preserve the vintage open-cockpit look," said Mark Boudreaux in 2020. "We didn't want this to be a sleek, brand-new fighter jet. The vintage look kept more in line with what we were doing in general for the toys."

The Ecto-Bomber was one of Michael C. Gross's favorite vehicles from the line, so much so that he held on to the product photography and his original approval of the Gee Bee racing fighter.

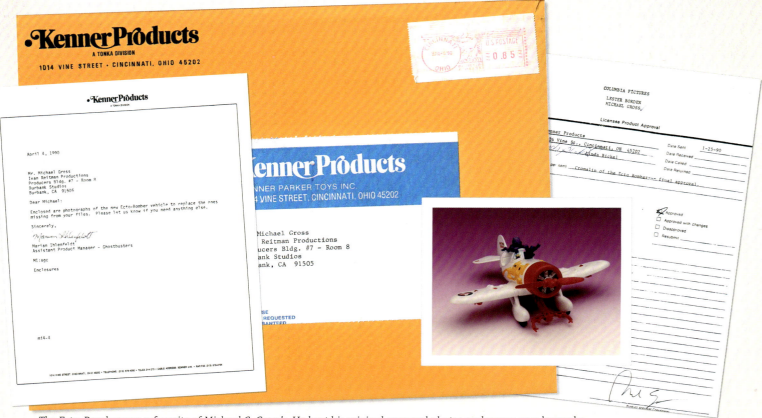
The Ecto-Bomber was a favorite of Michael C. Gross's. He kept his original approval photos and memo as a keepsake.

Gobblin' Goblins

The alliteration continued to be strong with the naming of the Real Ghostbusters ghosts with the trio of Nasty Neck, Terror Tongue, and Terrible Teeth representing the Gobblin' Goblins wave. The last deluxe ghosts to be released by Kenner, the Gobblin' Goblins were intended to look cute and harmless in their initial state. But one switch, like the extension of an accordion neck or the opening of a gaping maw, would turn them into hideous creatures.

The Luminous Ecto-Glow Dims

In 1989, the highly anticipated sequel *Ghostbusters II* was in the rearview mirror with no apparent plans for a third installment. The animated series was ending development and production of new episodes. The core Real Ghostbusters market of five- to seven-year-olds were approaching their teenage years. And on top of it all, the new kids in town, the Teenage Mutant Ninja Turtles, were a dominant force in children's entertainment and toy aisles. All of these ingredients foretold a bleak future for the Real Ghostbusters toys, which faced an inevitable demise before the year's end. Popularity of the brand was waning. "When the second movie came out, *Batman* came out a week later. The whole summer was all about *Batman*," says Jerry Perez. "I think the brand just lost steam. And they made a lot of changes with the animated show. They started gearing it way more towards kids, and there was a quality drop in the show itself. Obviously, in theory, once the show went away, there wasn't going to be a toy line." As enthusiasm among consumers fell, so did the Real Ghostbusters creative spark at Kenner. Fright Features had been so popular, they were a tough act to follow. Other gimmicks seemed to fall short.

A weak holiday season across all toy brands in 1990 threw the entire industry into turmoil. Nintendo's acclaim had skyrocketed, and video games outsold Tonka's popular Parker Brothers board games tenfold. Kenner's parent company, Tonka, had fallen into debt, reporting major losses in 1990. They needed security and change to steel the company for the future. And while Kenner held popular bargaining chips in licensing deals with *Batman*, *Ghostbusters*, and others, they found it was generational product names, like Play-Doh and Nerf, that were enticing to larger companies looking to bolster their portfolios with items proven to survive the test of time, unlike "flash in the pan" licensed properties that could be subject to short-term popularity with a tremendous downswing.

Budgets and resources were reduced, which meant that Kenner had to get creative. A plan to reverse the line's original conceit of being in a smaller scale and release 12-inch action figures was explored but ultimately abandoned because of the prohibitive cost. Hoping to get two toys on the shelf for the development price of one, Kenner also paired the development of new Real Ghostbusters items with other

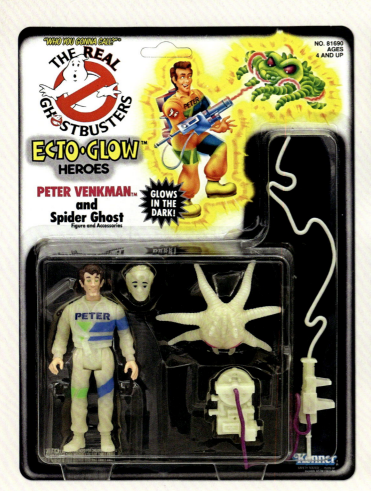

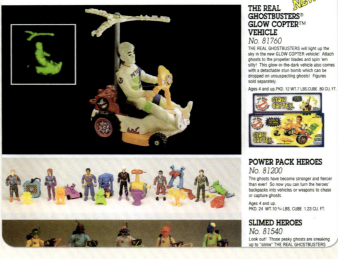
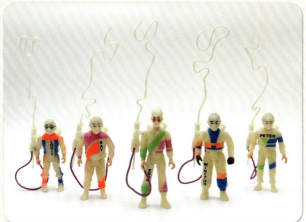
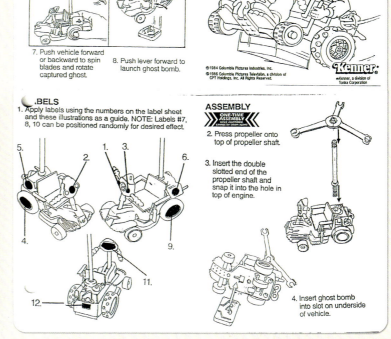
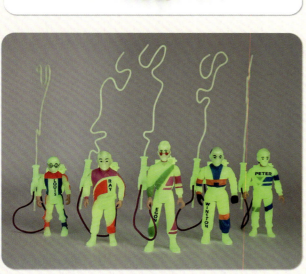

The future that never was, Kenner's Ecto-Glow series was intended to breathe fresh air into the line, but instead marked the end of the run.

lines they were producing, like the *Police Academy* tie-in. The hope was to approach new properties using the same irreverence, mechanical ingenuity, and marketing test data that had made The Real Ghostbusters so popular, just with an all-new cast of characters in new locales. Unfortunately, these successors to The Real Ghostbusters failed to generate the excitement or the sales of Kenner's flagship brand.

It was a tough time for Kenner and for the Real Ghostbusters line. For some the writing was already on the wall. Employees who had been at Kenner since before The Real Ghostbusters were either polishing up their résumés or had already left. "During that time, they lost a lot of people. They lost the entire marketing department. Jerry Perez left for Fisher-Price. The only reason that I left is because the company was heading toward Chapter 11," says Marian Ihlenfeldt. "Kenner merged with Tonka and financed it backwards. They had Tonka, the smaller company, buy Kenner. So that the Kenner shareholders could make their fortune. That saddled Kenner-Tonka with an enormous amount of debt." Poachers at larger companies like Johnson & Johnson saw their opportunity and began luring engineers, including Ihlenfeldt, over to the medical industry. With reduced resources and high attrition, the Real Ghostbusters toys faced insurmountable odds.

Ecto-Glow Heroes

The 1991 Toy Fair marketing brochure marked the final attempt by Kenner to keep the Real Ghostbusters line thriving. Unfortunately, the newest offering in the catalog, a wave of action figures with a name that conveyed its gimmick, Ecto-Glow, would ironically be the last light of the Real Ghostbusters flame.

Mark Boudreaux noted the concept of Ecto-Glow, while clearly Kenner's first foray into the glow-in-the-dark fad, was to explore how our intrepid heroes could actually enter the spirit world. Heroes that emitted an eerie green glow could have been a strong visual for Kenner's trademark television commercials, which never came to pass. "We molded the figures, the gear, and the ghosts in phosphorescent pigment," said Boudreaux. "Since green actually holds the light charge the longest, green it was. And it really made a lot of sense. Slimer comes to mind. Green was part and parcel to what we thought Ghostbusters was all about." The figures were also the first in the Kenner lineup to come with removable heads, allowing the entirety of the figure to glow in the dark from top to bottom.

The Ecto-Glow packaging color scheme was also a departure for the brand. Card art moved away from the

Highlight Episode: Venkman's Ghost Repellers

WRITTEN BY:
Richard Mueller

FIRST AIRED:
October 20, 1987

PREMISE (FROM THE ORIGINAL *REAL GHOSTBUSTERS* WRITERS PACKET): Peter's father shows up peddling phony ghost-repellent ponchos. No one is hurt by this till an expedition goes off to investigate the New Jersey Parallelogram. Wracked with guilt, Old Mr. Venkman goes off to save them. But at the end, it is he who needs saving—by the Ghostbusters.

A perfect example of the apple not falling far from the tree, Peter Venkman's father, Jim, was always working an angle to make a quick buck—particularly now that he could cash in on the newfound fame of his ghost-busting son. "Jim was a total con man," says Richard Mueller, who introduced the character in the episode "Venkman's Ghost Repellers." Through Jim, one could easily see how Peter Venkman's charm and cunning could have been used for far more malicious purposes. In order to provide consistency from the elder Venkman to his son, he was portrayed in a gravelly voice by both Lorenzo Music and Dave Coulier throughout the series.

classic purple to a primarily white design with fluorescent yellow and dark blue accents. Jerry Perez theorized that a radical reversal in design scheme with a bright and vibrant, eye-catching color palette would breathe new life into the line. The figures themselves would glow, and the bright packaging hanging on a peg would be a beam of light demanding attention on store shelves.

Unfortunately, production of the Ecto-Glow Heroes wave was cut short. The plug was pulled on the release mid production stream, and the majority of shipments never made it to primary retail. Those that did languished at liquidators and discount stores. The wave became so difficult to find in the pre-internet age that there was a common misconception they had never been released in stores at all.

Because of that scarcity, Ecto-Glow figures, particularly those still in pristine mint-condition packaging, are rare and very valuable on the secondary market. So few figures exist that they are Holy Grail–like treasures sought after by collectors, with only a lucky handful able to claim ownership.

Unreleased Figures, Vehicles, Play Sets, and Role-Play

Ecto-Glow was one of the only lines that Kenner showed off at 1991's Toy Fair that actually made it to market. The toy giant's presentation that year showcased quite a few unreleased figures, vehicles, and role-play items.

Backpack Heroes, featuring the four main Ghostbusters, were equipped with an oversized backpack-worn Containment Unit and a companion ghost. The Backpack Heroes wave was photographed in prototype form and promoted to buyers but never reached shelves. The Glow Copter, a glow-in-the-dark one-seater helicopter intended to complement the Ecto-Glow figures, met the same fate and was canceled. The Glow Copter progressed further into production than some of the other unreleased items. Instruction booklets for the vehicle were designed and approved, and multiple prototypes and packaging samples have found their way into collectors' hands. In a cost-reducing effort, this vehicle shared a mold with a toy from Kenner's Police Academy line, the Crime Mulcher. The two would have been nearly identical, with only a slightly modified propeller and decal alterations differentiating them. The Crime Mulcher was also never released.

In the early '90s, the Argentinian toy company Jocsa produced their own line of Real Ghostbusters toys using original Kenner molds. As they were not beholden to Kenner's infrastructure and quality-control methods, Jocsa's releases were inconsistent with the quality and design of the original Kenner figures. Jocsa produced figures for other Kenner lines as well, including Police Academy, famously releasing Kenner's never-produced Copper Corner play set for the line. This led to rumors that other unreleased Kenner concepts, such as the Real Ghostbusters Glow Copter, actually made it into production in Argentina. Chalk it up to the Mandela Effect, a false memory that lies somewhere between recollection and reality.

Another unreleased vehicle, the Fire Frighter, was a fusion of a fire truck and a Containment Unit. The truck was equipped with a claw arm in place of a traditional ladder to ensnare ghosts. Ham Woodhouse originally designed a highly elaborate airport fire truck vehicle that would have been a premium vehicle with a lot more functionality. It was designed with a companion garbage truck Ghost Removal System that theoretically could be released at the same time.

"The original designs were a bit too large and complicated, and therefore a bit too costly," said Mark Boudreaux. "We reduced the size and complexity, but were able to keep a lot of the interactive features. We had the fire truck and the garbage truck, and everybody loved both. But we only had room for one. So we put both concepts into a blender, and out poured a little red fire truck that combined all the great attributes of both and combined them into one."

Like most Kenner releases, the vehicle was sketched, kit bashed, and subject to numerous variations before reaching the final production prototype stage. That was where the vehicle's lifespan ended; it was never produced. As with the Glow Copter, a few complete samples have fallen into private collections, commanding thousands of dollars in online auctions because of its scarcity. Also as with the Glow Copter, Kenner was trying to find efficiencies in production, and the Fire Frighter was intended to share molds and tooling with the Police Academy Jail Jalopy vehicle, which would have replaced the claw arm with a confinement cage for ne'er-do-wells. "If you can use a tool and save a little bit of money, that's not a bad thing," said Mark Boudreaux. In 1991, Kenner had also used Star Wars tools and sculpts in their Robin Hood: Prince of Thieves line in an effort to boost the offerings of a new brand. "And if it works out to be appropriate to the given line, and can deliver what the new brand is looking for, that's not a bad thing." The Police Academy vehicle was similarly never released.

Two unreleased role-play toys were among the 1991 Toy Fair lineup. The Ghost Blaster was an orange rapid-fire zapper that fired ten No-Ghost disks. The Slimerizer was a pump-handle slime shooter, advertised with packaging mirroring the Ecto-Glow aesthetic. When the Slimerizer came across the approval desk of Michael Gross, it was

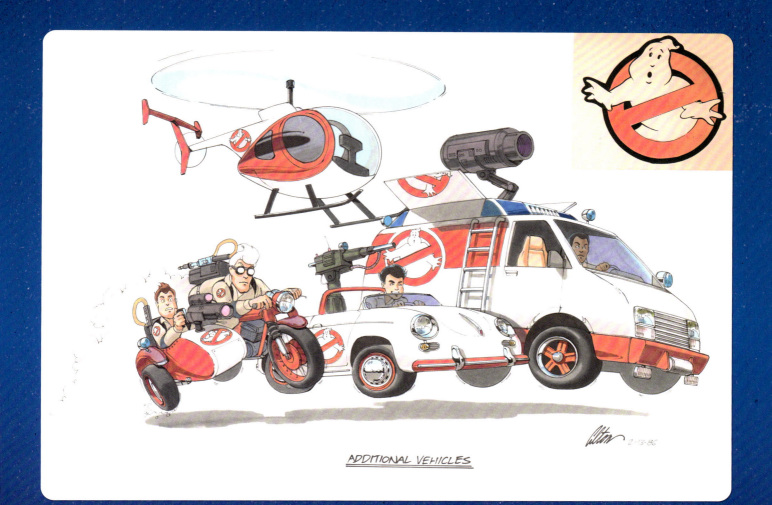

Unrealized concepts including vehicles, Haunted Humans, and ghosts.

Chapter 4: The Franchise Rights Alone: Toys, Merchandise, and the Rise of Ecto Cooler **197**

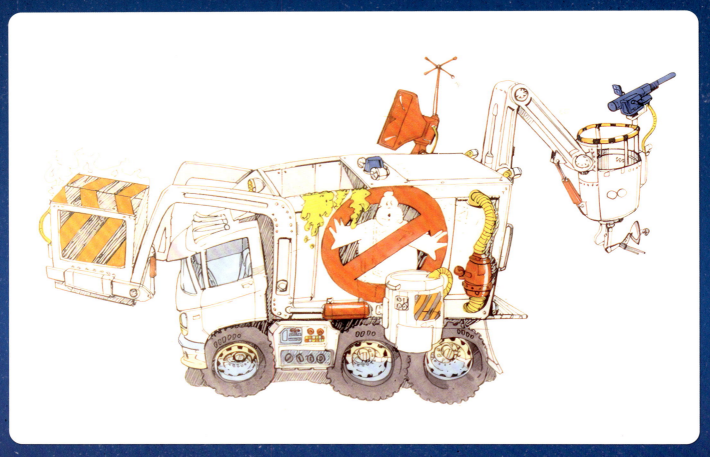
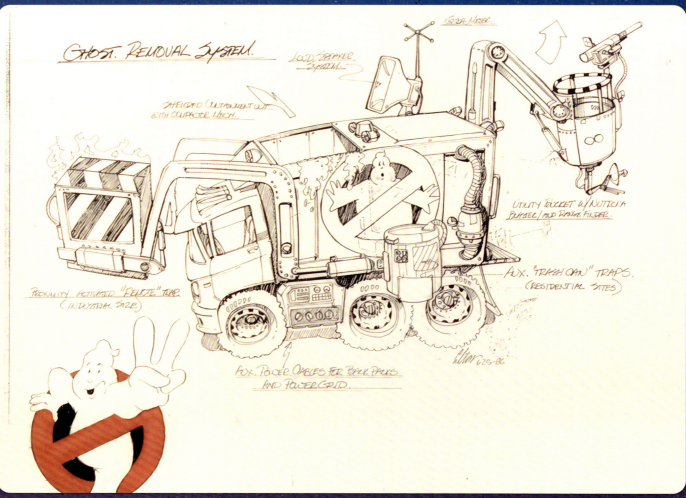

A complex ghost-busting garbage truck, much like a similar fire truck concept, went through several iterations in the preproduction phase but never came to pass.

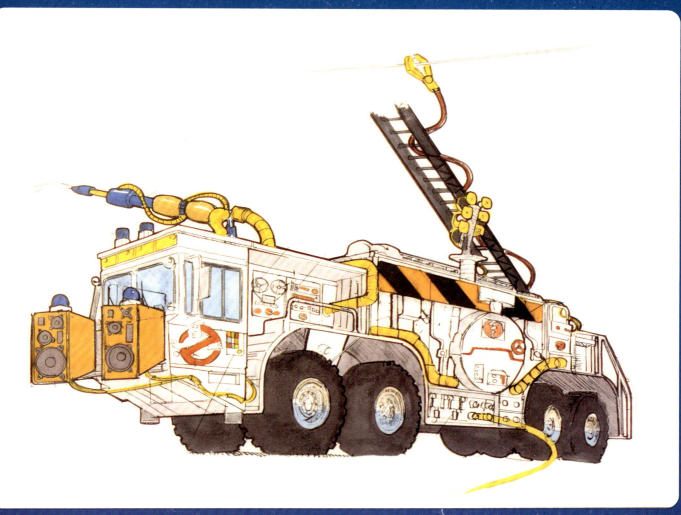
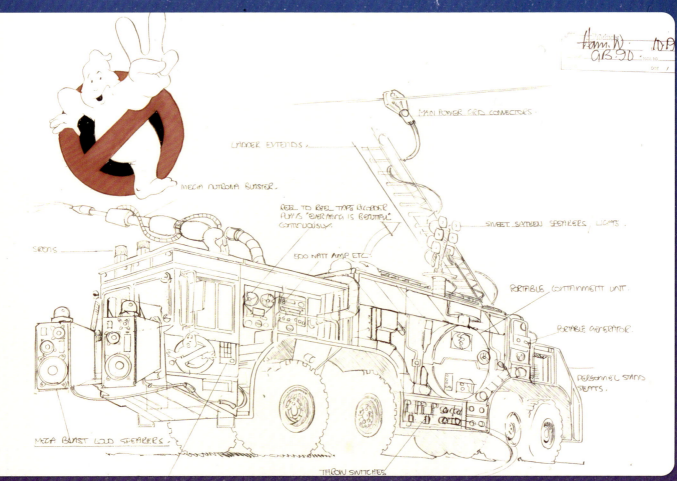

Chapter 4: The Franchise Rights Alone: Toys, Merchandise, and the Rise of Ecto Cooler

Glimpses of what might have been. Additional mini vehicles, "Mini Squirts," and other action-based ghost concepts.

A role-play-scale Bigger, Badder Bad-To-The-Bone would have launched ghost accessories, while a haunted house concept would have launched smaller-scale play sets.

Chapter 4: The Franchise Rights Alone: Toys, Merchandise, and the Rise of Ecto Cooler

labeled as "Boozooka." Gross declined approval, noting that a gun reference shouldn't be part of the toy's name.

A variety of other items were in stages of development at Kenner but weren't ready for prime time in the Toy Fair solicitation. Additional Haunted Humans, including Fire Fright and Momma Trauma, only exist as concept artwork. Kenner looked to introduce role-play adversaries with a giant-sized Bigger, Badder, Bad-To-The-Bone. This was a large, wearable version of the original Bad-To-The-Bone figure that entrapped a Proton Pack–sporting junior Ghostbuster behind the rib cage of the skeletal ghoul.

The company also explored incorporating complex mechanisms inspired by the Fright Features figures into play sets. Among the concepts explored was a Haunted House set, which had elaborate play gimmicks, like a secret bookcase door, a haunted chair, and a jaw-dropping moose head.

Egon's Lab

Last, but certainly not least, is arguably the most legendary of unreleased Real Ghostbusters toys: Egon's Lab. The play set, which was initially intended to be the second released after the Fire House, was in a constant state of flux over the course of the toy line's run. Through its multiple concepts and iterations, the concept was always a diagnostics bed in which a figure could be examined, probed, and studied in ways only Egon would, with an end result in the ghost or subject matter being placed into a Containment Unit. The Egon's Lab project was originally envisioned by Mike Katauskas and managed by David Griffin, a member of Kenner's product concepts department.

Josh Blake, a collector and archivist of *Real Ghostbusters* prototypes and unreleased relics, was one of the first to obtain a physical prototype of the play set and is considered to be the keeper of all Egon's Lab knowledge. The fun and marketable concept of the play set was a favorite of the designers, but despite their enthusiasm, it never made it past the next steps into production. "It was continually passed over by management every time the designers brought the concept to them," says Blake.

After years of development, refinement, and tinkering, a final prototype of Egon's Lab was photographed and advertised at the 1991 New York Toy Fair. But the play set's string of horrible luck had not come to an end. As the Real Ghostbusters line ran out of steam, it never made

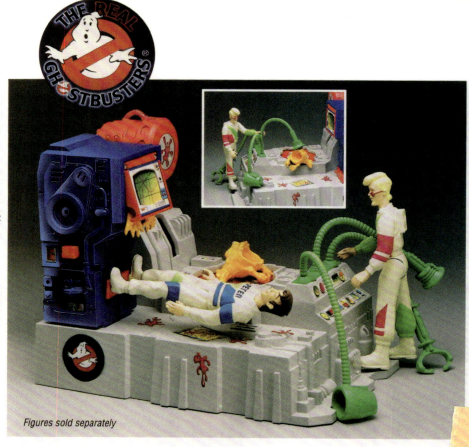

it to production or to market. Among all of the toys that Kenner solicited but never released, Egon's Lab was the most mysterious. Not much was known about the set, nor how advertised features like "captured ghosts can haunt the equipment and cause The Real Ghostbusters Heroes to rise into the air" would function. The play set remained an enigma for two decades, until collectors like Blake shared their knowledge of the set and collector communities pooled resources on internet message boards.

Two mockups of the play set were created for presentations, and three fully working hand-built models were created for demonstration purposes. Two variations of these iterations and prototypes are displayed in Sean and Ryan Lehmkuhl's Cincy Toy Museum & Buying Center in Cincinnati, Ohio, just a few miles north of Kenner's original downtown headquarters.

One Door Opens, Kenner's Doors Close

In February of 1991, Tonka was acquired by the toy giant Hasbro for $516 million. Bringing in Tonka's holdings, including Kenner and Parker Brothers, immediately made Hasbro the nation's largest toy company. Though Hasbro had good intentions of keeping the spirit of Kenner alive, the combined toy powerhouses were forced to reevaluate structures, workflows, and redundancies. Milton Bradley and Parker Brothers became one and the same. Teams were dissolved, absorbed into other departments, and there was quite a bit of turnover at the company following the acquisition. "Hasbro bought Kenner, and a couple people who I really respected called me and told me to come back, so I did," says Marian Ihlenfeldt. "Hasbro was not the same thing as Kenner anymore. Two of the three people who talked me into coming back left."

Though Kenner had a couple of years of independence, it became clear that the nation's largest toy company couldn't have headquarters in both Ohio and Rhode Island. The Kroger Building had become obsolete. When the doors to the main Cincinnati office of Kenner were officially shuttered in 2000, it was a physical and symbolic representation of the end of an era. "It was very sad when we had to close Kenner. It was here for forty years. It was the first place I worked in the United States," says Duncan Billing. "It wasn't just work. We were young. Most of us were single. We all socialized together. We'd go out and party and have fun, then go back to work the next day. That builds trust. It builds relationships really well. It was just a good time. Just really, really a good time."

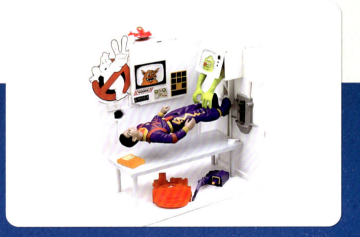

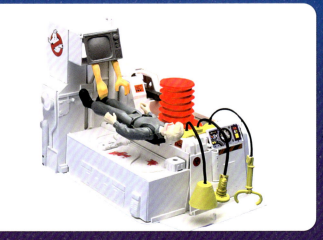

In a state of seemingly perpetual development, Egon's Lab was a concept that Michael C. Gross and team loved but could never bring to fruition.

Chapter 4: The Franchise Rights Alone: Toys, Merchandise, and the Rise of Ecto Cooler 203

Highlight Episode: The Collect Call of Cathulhu

WRITTEN BY:
Michael Reaves and Steve Perry

FIRST AIRED:
October 27, 1987

PREMISE (FROM THE ORIGINAL *REAL GHOSTBUSTERS* WRITERS PACKET): What was the green creature that stole the Necronomicon from a local museum? Why do the Ghostbusters venture up to the Miskatonic University at Arkham to meet Alice Derleth? And what will happen when the elder god Cthulhu [*sic*] finally breaks into this world to conquer and destroy? Only the Ghostbusters—and an old copy of Weird Tales—can solve the riddle.

Yes, that's "Cathulhu" in the episode title, not H. P. Lovecraft's spelling of "Cthulhu"—which is how it was spelled on the original draft and all production documents for the series. "I thought the misspelling was just a typo when I saw it on air, but Reaves told me he thought Lovecraft's work may have still been under copyright," says Steve Perry. "I joked it might have been to make sure the actors could pronounce it." This episode has everything kids love: Lovecraftian mythology, Illuminati underground cults, you name it. "I can't take any credit for this episode. It was all Michael," says Perry. "We collaborated on references and Easter eggs (though we didn't call those that back then). Lovecraft, Clark Ashton Smith, T. E. D. Klein, Robert E. Howard, Wagner's magic shop: there are a lot of in-jokes there."

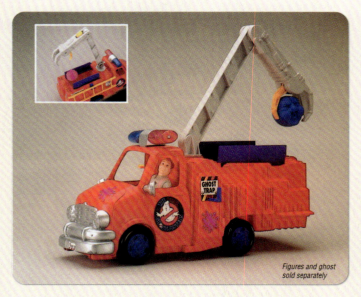

The Fire Frighter was designed by Ham Woodhouse to be more complex and share molds and tooling with Kenner's Police Academy line.

The conclusion of Kenner's Real Ghostbusters line and the Hasbro acquisition closing the company may have a felt like a definitive ending to the story. But Kenner and The Real Ghostbusters had done something special. They had captured a feeling, an aesthetic, and most importantly, the imaginations of an entire generation that would have fond memories they treasured. Besides, as any good Ghostbuster would forewarn: the dead never stay that way. *Ghostbusters*, and even the Kenner-branded toys that accompanied it, would return in time.

Over the years, there were multiple starts and stops to reinfuse the *Ghostbusters* franchise and the consumer products machine it carried with life and energy. New comic books, animated series, and video games mark the time between 1991 and 2016 for the *Ghostbusters*

property. A short-lived animated reboot, *Extreme Ghostbusters*, debuted in September of 1997 and was supported by a small line of action figures and accessories made by Trendmasters. The show and the toy line are fondly remembered by collectors but didn't make much of an impact at the time. Perhaps the timing wasn't quite right on the show, as nostalgia for the 1980s had not yet hit a peak, and the kids who originally grew out of their love of *Ghostbusters* weren't old enough yet to be looking backward to the days of their youth nor to pass their love on to their kids.

Ghostbusters celebrated twenty-five successful years in 2009. With it, the large-budget *Ghostbusters: The Video Game* for major consoles was released, and rumors of a third *Ghostbusters* feature film reached their loudest din. With the promise of the property surging back to new heights, Mattel secured the master toy license for the brand. The toy line solely focused on the live-action movies, though Mattel did release a small wave of 8-inch Mego-inspired *Real Ghostbusters* figures. A third *Ghostbusters* film failed to manifest itself, and the Mattel toy line ran its course in 2016.

Everything Old Is New Again

In 2019, *Ghostbusters* returned to where it all began. The master toy license was once again awarded back to Hasbro. It was like a homecoming for the property, returning to the company where it thrived in the 1980s. A new and invigorated creative team at the toy company was eager to bring new ideas to the table for the films *Ghostbusters: Afterlife* and *Ghostbusters: Frozen Empire* while saving room in the plans to revisit familiar friends from the past. The Real Ghostbusters once again took center stage at the 2020 Toy Fair. Hasbro introduced the first wave of Kenner Classics, featuring updated artwork illustrations and retro Kenner-inspired packaging. Collectors new and old would get a chance to acquire Kenner's The Real Ghostbusters with reissues of the first-wave heroes Egon, Peter, Winston, and Ray, alongside reissues of the Green Ghost (Slimer) and Stay-Puft. "I think the biggest challenge but a fun challenge for the retro rereleases was having an artist re-create the art for the packaging," says Eric Reich. "That's always the most fun for me . . . to see how they redo the packaging and the art." Rereleasing the Real Ghostbusters figures in a modern environment meant having to re-create the packaging so that it was virtually indistinguishable from the original. It also meant adhering to new standards in print quality, consumer safety regulations, copyright and legal concerns, and modern techniques employed by toy companies, without these alterations making the new release feel too different.

It's a thankless job, because if done right, the consumer will never know how much time and artistry went into it, thinking it was a 100 percent authentic replication of what came off the 1986 assembly line. If done wrong, and even the smallest detail distracted from the experience, it would mean the line wouldn't sell. Enter the packaging artist Harry Moore, responsible for more than five hundred individual design projects for Hasbro. Moore has a track record of breathing new life into nostalgic designs, having successfully resurrected designs from the original '90s Toy Biz Spider-Man packaging art for Hasbro's Marvel Legends, among others. Moore was tasked with re-creating the original illustrations used on the Kenner card art. "They sent me some photos and told me to do the best that I could to make it look like it was the 1986-era piece," says Moore. In addition to re-creating the packaging for the carded action futures, Moore re-created artwork for further Real Ghostbusters retro releases, including the reissued Ecto-1 vehicle.

Using a jeweler's loupe, Moore meticulously studied the original artwork, looking to re-create the hand-drawn imperfections of the original Ghostbusters artwork completely. The slight imperfections would only add to the authenticity of the re-creation. "I think the charm of these is they're not perfect. They're done by hand. They were done traditionally. There's a real nice quality to that," says Moore.

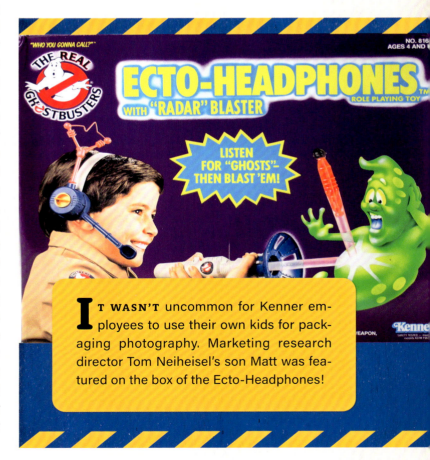

It wasn't uncommon for Kenner employees to use their own kids for packaging photography. Marketing research director Tom Neiheisel's son Matt was featured on the box of the Ecto-Headphones!

For the retro rerelease, the original package artwork was meticulously re-created.

Moore, a collector himself, studied several of the original packages, keeping an eye on technique and materials to make sure what he was using would ring true. "It looked like a really bright opaque paint may have been used for highlights, and a little bit of overspray on the airbrush," says Moore. Moore loved the challenge of re-creating the original art, leaning heavily into the exaggerated styles of the Kenner illustrations, as opposed to the more straightforward cel-shaded animation that appeared on the show. "The best compliment that I've gotten is when fans, or even former Kenner employees, think that was the old art."

Hitting the target for the Real Ghostbusters trademark purple color was a trial-and-error process for Moore, who again leaned on his own personal collection of figures for reference. "When I was a kid, the family next door had three boys, all spread apart in age," says Moore. "This house had toys that ranged from the combat-grip G.I. Joe to Mego and Super Powers. Their mother would keep all the toy packaging. When they would get a toy for Christmas, she would keep the box, fold it up, and write their name and date on it. There was a whole drawer full of these things. I would go over and sit in their basement and pore over those boxes. That's where I got the bug. I've kept almost all of the cards of my figures. During COVID, while everything was locked down, I was able to put my Pantone book up to some old card samples and help guide Hasbro to make the correct color choices."

Another color-matching challenge was presented by the action figures themselves. Matching the colors of the original figures released in 1987 using modern paint applications and all the tools available to designers today proved a greater feat than expected. "The colors on the figures tend to fade. It was a challenge to figure out the skin tones and color tones for the four original-release uniforms," says Eric Reich. "We went back and forth on a lot of the retro characters for coloring, because we see different images online with different levels of fade on them. And there were variations in the releases even back in the '80s."

The initial wave of Kenner Classics proved successful, and Hasbro continued to release retro Kenner The Real Ghostbusters figures through the next few years, bringing back bestsellers like the role-play GhostPopper, Bug-Eye Ghost, and Fearsome Flush.

In 2019, as Columbia Pictures looked to restart the *Ghostbusters* franchise once again with a series of new live-action films, the influence and impact of The Real Ghostbusters was taken into careful consideration in plans for the future. "When we were developing products for *Ghostbusters: Afterlife*, we made a conscious choice to make all of the role-playing toys blue as a nod to *The Real Ghostbusters*," says Eric Reich. "We wanted it to feel nostalgic because we know a lot of the parents, who are now buying the toys for their kids, grew up on the show." To coincide with the launch of *Ghostbusters: Afterlife*, Hasbro unveiled a comprehensive range of action figures aimed at kids, dubbed Fright Features as a wink and a nod to the past. Though these figures didn't rely upon the same advanced engineering as their '80s predecessors, the retro moniker instilled a sense of fun and whimsy that communicated the line was geared specifically toward children instead of adult collectors, now one of the main consumers of toys.

For that generation of discerning consumers, Hasbro also rolled out a new offering: the Ghostbusters Plasma Series, a new line of action figures specifically aimed at adult collectors. Following in the footsteps of their successful Marvel Legends and Star Wars: The Black Series lines, the Ghostbusters Plasma Series focused on classic and new movie characters from the franchise. The toys had a focus on finer details, including likeness accuracy and statuesque poses, with less of an emphasis on playability. Adults also weren't left out of the role-play this time around. With the release of *Ghostbusters: Afterlife*, Hasbro developed a one-to-one-scale Neutrona Wand based on the actual prop seen in the film and, later, a full-sized Proton Pack, Ghost Trap, and PKE Meter. All were accurate to the live-action films and crowdfunded through their Hasbro HasLab program. Nearly forty years after role-play toys helped drive Kenner toward record-breaking sales with

The Real Ghostbusters, the children of yesteryear, now fully grown adults with disposable income, invested in the Ghostbusters gear that their five-year-old selves could only dream of.

As this book goes to press, Hasbro continues to embrace the original spirit of Kenner, infusing it and the era in which it produced The Real Ghostbusters into their everyday work. The original outsiders who loved to make toys, carve jack-o'-lanterns, and experiment on various concoctions to create the perfect Ecto-Plazm still live and breathe in the next generation of toy designers, engineers, and marketing executives. That energy can be felt in the company's live streams, which highlight their employees and their love of the toys and the brands, including Ghostbusters. Hasbro is poised to expand their offerings of Real Ghostbusters toys through 2025 and beyond. Four decades after making waves at 1987's Toy Fair, Kenner's The Real Ghostbusters remains a beloved cornerstone of popular and toy culture and a pioneer in toy history with no signs of stopping.

Partnerships

While the 1984 film may have had a lackluster product rollout, Columbia Pictures Television granted licenses for *The Real Ghostbusters* to every major consumer-product category possible. In addition to Kenner's popular toy offerings, Ecto Cooler juice boxes from Hi-C, bubble baths, candies, balloons, Data East arcade game cabinets, and Happy Meals from McDonald's added to the legs of the animated series.

Over 130 companies were given licenses to *The Real Ghostbusters*, ensuring that it would literally be everywhere. Antioch Publishing provided bookmarks, doorknob hangers, textbook covers, and sticker storybooks to book fairs around the United States. The unmistakable smell of *Real Ghostbusters* Colorforms and Shrinky Dinks populated kitchens. The Bibb Company created sleeping bags that would be the envy of sleepovers. Ben Cooper Inc. took Ed Zobrist's challenge and created Halloween costumes. Shortly before the Hasbro-Kenner merger, Milton Bradley created board games, jigsaw puzzles, and inserts for their popular Lite-Brite toys. Thermos made sure that lunchboxes and insulated beverage bottles were available for school lunchtime, while Perio Products made sure anticavity fluoride rinse and toothpaste were ready when they got home. Simon & Schuster released children's books, coloring books, and pop-up books. Hallmark created party goods, including plates, napkins, and table covers, for the countless *Real Ghostbusters*–themed birthday parties. Coleco could create *Real Ghostbusters* iterations of their popular Power Cycle three-wheeled plastic vehicles. J. P. Stevens & Company

Licensing pamphlet created by the studio consumer products team.

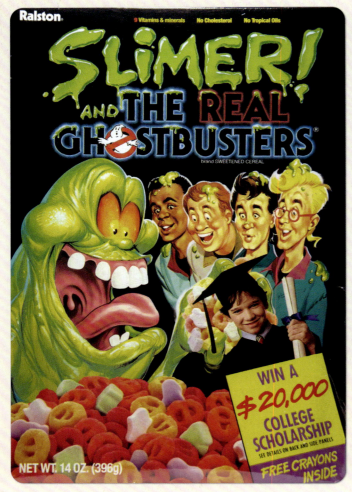
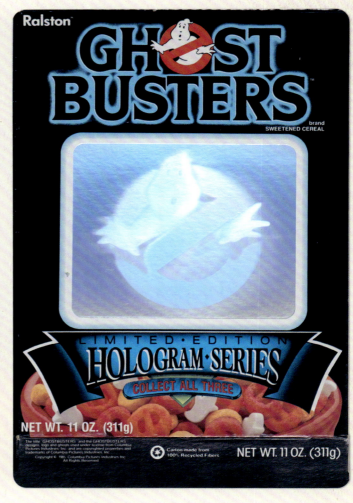

Box art from Ralston Purina cereal releases.

made bed sheets, pillowcases, comforters, bedspreads, and other textiles to completely theme a *Real Ghostbusters* room. NOW Comics could create tie-in comic books in the United States, while Marvel could do the same in the UK and Ireland. Image Watches offered wristwatches. Merritt Foods could make popsicles. And a little company called Emecege (owned by Michael C. Gross) held the rights to produce T-shirts and sweatshirts in adult sizes depicting Slimer. No stone was left unturned.

A Ghostbusters cereal from Ralston Purina was released in the United States, Puerto Rico, and the Caribbean.

Canadian Happy Meals featuring bike toys unavailable in the United States.

The cereal featured holographic imagery on the box. Just prior to the 1989 release of *Ghostbusters II*, the cereal had a pack-in playable record where Maurice LaMarche's Egon Spengler asked kids trivia questions with the prize of a once-in-a-lifetime trip to visit the set of *Ghostbusters II*.

McDonald's was given a window of four weeks from September through October of 1987 for a premium promotion in their Happy Meals. However, because of the very specific licensing rules and rights that were carved out between Columbia Pictures and Kenner, toys couldn't be included with the meal. Instead, the United States received a batch of school supplies, including erasers, pencils, pencil cases, and rulers, while Canada received bicycle accessories. This was also an issue when *Ghostbusters II* was released.

"Because we were the master toy licensee, we controlled all toy rights to *Ghostbusters*, and, if someone else wanted to do a toy, they would have to get our approval," says Jerry Perez. "While Kenner wanted the extra marketing of a fast-food promotion around the property, we didn't want whatever toys they offered to compete with whatever we were selling. As a result, we let them do these electronic

The Real Ghostbusters: A Visual History

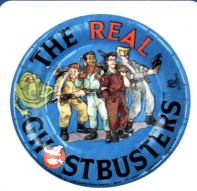

The Real Ghostbusters *products were released in a wide variety of applications.* Top: *Original art for* Real Ghostbusters *paperback young adult novels.* Bottom: *Michael C. Gross acted as his own licensee for Slimer T-shirts and explored illustrations of his own design for products.*

Chapter 4: The Franchise Rights Alone: Toys, Merchandise, and the Rise of Ecto Cooler

noisemakers, which didn't compete with anything we were doing. To get exposure for our toys, we gave them some free sets of our toys for sweepstakes giveaways, on the condition that they would feature our toys in their marketing literature in-store and in a mini brochure that came with their premium. It worked for everybody."

Ecto Cooler

Columbia Pictures' parent company, Coca-Cola, saw a tremendous opportunity in *Real Ghostbusters*. Pack-in beverages for kids and little packets of sugary juice mix were all the rage in the 1980s, and at the top of the food chain was Coca-Cola's Hi-C. Born in 1989 at the height of *The Real Ghostbusters* and in anticipation of *Ghostbusters II*, Ecto Cooler became the juice box to have in a school lunch. For this rebranded version of Hi-C's Citrus Cooler drink, the box art featured the *Real Ghostbusters*–designed Slimer. Conceived as a promotional tie-in that would normally have a minimal shelf life, Ecto Cooler was a top seller and remained in stores until 1997, well beyond the end of the animated series' run and nearly ten years after *Ghostbusters II*'s release. The beverage essentially was the only *Ghostbusters*-branded consumer product keeping the franchise alive.

The citrusy taste of Ecto Cooler remains a core memory for fans of *The Real Ghostbusters*, right up there with the show and the Kenner toys. To this day, a loyalty to the drink remains strong among the die-hard fans, with campaigns to resurrect Ecto Cooler frequently popping up online. In 2016, in anticipation of the new *Ghostbusters: Answer the Call* movie, Sony partnered with Coca-Cola for a limited-time rerelease of the drink, sending fans and collectors into a frenzy. It was the first official Ecto Cooler on shelves in decades. *The Real Ghostbusters*' Slimer was no longer featured on the packaging, a result of new legislation and regulations for using cartoon characters to market soft drinks to children. Ecto Cooler made another brief reemergence during the promotion of the 2021 film *Ghostbusters: Afterlife*. The drink wasn't made available in stores. Instead it was only shipped to lucky fans and social media influencers and given as a gift at the world premiere in New York City. Because the drink wasn't available for retail sale, Slimer returned to the packaging for a victory lap.

A tie-in lunch bag.

NOW Comics and Marvel UK Magazines

In 1985, independent publisher Tony Caputo hung out his NOW Comics shingle and immediately captured what he thought were hot licenses: *Terminator*, *Fright Night*, *Green Hornet*, *Speed Racer*, and *The Real Ghostbusters*. Caputo's gamble on licensed comic properties paid off, and his issues could be found on grocery and drugstore spinner racks across the country. The *Real Ghostbusters* book included a pinup poster every month and published letters and fan drawings, both of which were popular among the target audience. In fact, Caputo once claimed that a Draw a Slimer contest elicited about twenty thousand submissions (including one from this book's coauthor Craig Goldberg himself).

Writers for the comic included James Van Hise, who wrote most of the issues, and *Milk and Cheese* and *Bill & Ted*'s Evan Dorkin. "I had interviewed Tony Caputo for a magazine called *Comics Feature* about NOW Comics, and one day he called me up and asked me if I wanted to do a tryout story for a *Ghostbusters* comic," says Van Hise. "I hadn't seen *The Real Ghostbusters* up until that time. I grabbed videotapes to see the approach, and I thought it was interesting." Van Hise went on to write twenty-eight issues of the comic, introducing his own characters, vehicles, and gear and telling story arcs that were completely unique to the comics. Writers from the television series even jumped over to write a few comic scripts for NOW, including Dennys McCoy and Pamela Hickey, who wrote issues of the *Slimer!* comics series, which was launched and spun off at the same time the television series became *Slimer! And the Real Ghostbusters*. Having the book be at essentially an independent publisher and without the oversight of Broadcast Standards and Practices meant that it could explore darker, scarier stories that the series was unable to. For example, at one point, Venkman befriends the son of the devil, who is looking to escape hell. "I was basically given carte blanche. They let me do whatever I wanted to as long as nobody used dirty words. I was never given any restrictions," says Van Hise. "The only thing we weren't able to do, which the animated series was, was

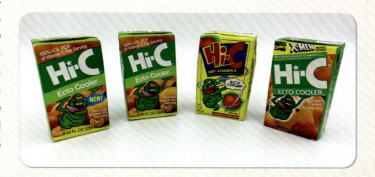

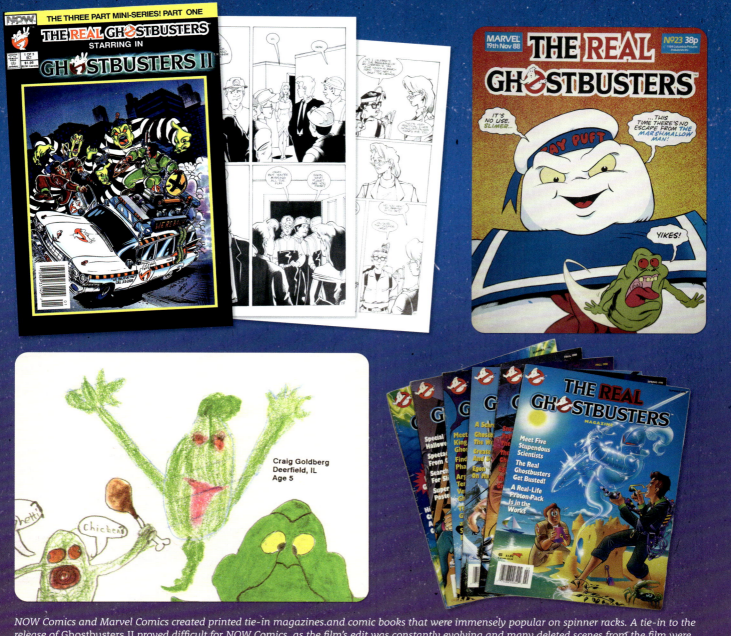

NOW Comics and Marvel Comics created printed tie-in magazines and comic books that were immensely popular on spinner racks. A tie-in to the release of Ghostbusters II proved difficult for NOW Comics, as the film's edit was constantly evolving and many deleted scenes from the film were written and illustrated but never released. Bottom left: Author Craig Goldberg's Draw a Slimer submission.

make jokes about copyrighted trademarks like *Star Wars* and the Death Star. We couldn't do that. But other than that, I would write a script and they would pass it along to the artist without changes."

The NOW Comics series was released monthly and moved at such a rapid pace that, just like its animated counterpart, it also experienced errors. "There would be mistakes in dialogue and lettering that weren't caught," says Van Hise. "But the biggest mistake was that in issue two, the moon was being drawn to the Earth. The penciler drew it as the moon. The inker inked it like it was the sun. And the colorist colored it like it was the sun. The editor didn't catch it. Also in issue two, there were pages out of order because the page numbers only existed on the original art or the proof, but it wasn't there from page to page. When IDW reprinted all the issues in paperback, nobody ever contacted me so that I could tell them they had to fix issue two. It was reprinted with the same mistakes."

NOW Comics also had the distinction of publishing the adaptation of *Ghostbusters II*. The comic "starred" the Real Ghostbusters in retelling the story of the movie, a way to circumnavigate likeness issues and provide continuity within the ongoing NOW series. Just as movie novelizations can be a challenge due to films being edited before release, the comic was originally written and drawn with scenes that were eventually omitted from the film. "I did the script that they had sent to me. And the artist was given that same script to begin drawing from. We were finished and sent it over to the studio

Chapter 4: The Franchise Rights Alone: Toys, Merchandise, and the Rise of Ecto Cooler

Highlight Episode: The Halloween Door

WRITTEN BY:
J. Michael Straczynski

FIRST AIRED:
October 29, 1989

PREMISE (FROM THE ORIGINAL *REAL GHOSTBUSTERS* WRITERS PACKET): The Ghostbusters are visited by the Chairman of "Citizens United Against Halloween," a man named Crowley, who wishes to hire them to assist him in his crusade. When they refuse, Crowley mistakenly opens up the Halloween door and breaks the underworld's ancient contract of imprisonment. With the help of a fearless little girl, the Ghostbusters must battle the "Boogaloo" and save the world before the door becomes permanently open at midnight!

With a tent pole staked in June of 1989 for Ghostbusters II's release, ABC and DIC knew that the following Halloween would be a perfect opportunity for a cross promotion. The time was ripe for The Real Ghostbusters to get a moment in the spotlight of primetime television on the network. A higher-budget half-hour, thanks to the higher advertising prices of a primetime slot, meant that the creative team could explore epic ideas and venture into places the Saturday morning and syndicated series could not. But finding the perfect premise proved elusive.

Two initial concepts were submitted to ABC just before the holidays in 1988, both penned by J. Michael Straczynski. The first was a New Orleans Carnival story. The second was a play on the hype machine that was Geraldo Rivera's opening of Al Capone's tomb in 1986, entitled "Live from Al Capone's Tomb!" This was to be presented as a "live-animation" special that would mimic the unflinching first-person camera perspective of a live broadcast. (That concept was later reworked for a future episode of the series.) ABC wasn't keen on either.

After the holiday break, more premises were explored at the start of 1989. Len Janson and Chuck Menville pitched an episode they called "Public Enemy No. 1," which took place in a haunted state prison for women—exactly what children want to see during prime time on Halloween. J. Michael Straczynski pitched a premise for "The Unhaunted House," a body-swap vehicle in which everyone on Halloween night is transformed into a supernatural entity, while all of the ghosts, including Slimer, become human. Again, neither was accepted by the network.

The concept that finally made it through the gauntlet was the most surprising. "'Halloween Door' came out of my being a bit pissed off at the network," says J. Michael Straczynski. "ABC had been riding my butt for a long time about satanic references in The Real Ghostbusters that existed nowhere except in their own heads. I was always getting dinged for these kinds of things by a person over my shoulder telling me, 'Don't do this' and 'Don't do that.' And I thought, you know what? I'm going to write a story about a network executive, but just change the situation slightly and use some of their own notes they had given me that they would never recognize. I named the main antagonist Crowley after Alistair Crowley, a Satanist. I thought they'd never figure it out, and they didn't. It was only afterwards that Broadcast Standards and Practices realized that I used some of the lines from their censorship notes and was making fun of them, and they were not amused."

"The way that Joe [Straczynski] gets back at you is he writes you into the next show," joked Michael C. Gross in the Time Life DVD commentary. "And you don't like what you see."

"The special was great. It had more money. Everybody got paid more," says Joe Medjuck.

A staple of the previous Halloween-themed episodes, the villainous Samhain was left on the bench for the primetime special. "I wanted something that would be more accessible," says Straczynski. "People tuning in to the primetime special may not necessarily know Samhain. Plus, I wanted this to be a singing demon, because we don't get to see a lot of those." The special featured two musical numbers, "Boogaloo's Back in Town" and "Touching Old Magic," both cowritten by J. Michael Straczynski and Brian O'Neal of the Bus Boys. O'Neal would also act as the musical director of the episode and voice talent for the Boogaloo himself.

"I think I suggested Brian O'Neal," says Medjuck. "He and I had kept in touch after we used his song in Ghostbusters. I knew he had this low voice, and he had been bugging me to do something else."

According to Broadcasting magazine, "The Halloween Door" scored a 7.6/12 share in the Nielsen ratings for the week of October 23 through October 29.

December 15, 1988

Ms. Ame Simon
Ms. Jennie Trias
ABC TELEVISION
2020 Avenue of the Stars
5th Floor
Century City, Calif. 90067

Dear Ame & Jennie:

Enclosed are two outlines for the GHOSTBUSTERS prime time special.

Please read and discuss.

Thank you,

Michael C. Gross

MCG/kf

Encl.

cc: Robbie London, DIC

THE REAL GHOSTBUSTERS
Prime-Time Special
"Midnight on the Lady M."

Premise

J. Michael Straczynski

...Orleans. Present.

...ast day before the start of Mardi Gras.
...partygoers. Floats being readied on
... Masques and sequins and satins and
...ittering the night like broken glass.

...lf-shell, cakewalks down the middle of
...s and singers and jugglers and mimes and
...corner. A kaleidoscope of colors and
...anything goes.

...is fantastic scene that we find our five
...ve of masked faces: Peter, eyes wide
...for anything; Ray, his face boyish and
...ston, who finds it all very comfortable
...as relaxed as a long-tailed cat in a

..., ISN'T IT?" Egon says.
...m with benign interest. "What did you

...ops. "You're toying with me again,

...those outside in the streets of New Orleans -- difference is, they're like this all the time. Swamis, gurus, healers, psychics, channelers, you name it, you'll find it. The Ghostbusters are scheduled to give a talk on scientific means of dealing with the supernatural -- which doesn't go down well with this crowd.

They find particular annoyance with the turbaned Swami Kishnu Wannabearichrich, who sniffs with great disdain at their

THE REAL GHOSTBUSTERS
"Live from Al Capone's Tomb!"
Premise/Outline

...prior to broadcast: TONIGHT! ABC TELEVISION
...L GHOSTBUSTERS IN THEIR FIRST-EVER TV SPECIAL!
...E FROM AL CAPONE'S TOMB! FIVE P.M. EASTERN,

...ction.

...Or the impression of it, in any event. A
...at is structured along the lines of a live
...r that illusion, camera angles throughout
...be through the "eyes" of the ABC cameras,
...nt eye of animation. We will even utilize a
...d angles when possible and necessary.
...mer going in the upper-right corner of the
...counting down the minutes in the program.

...where a platoon of trailers and ABC
...set up at Al Capone's tomb. Crowds line
...trying for a peek inside. Ghostbuster
...a sense of festival. Of mystery.
...OLL, FANFARE, and a VO ANNOUNCER
...moment, the hidden world of the
...led by none other than the
...Ghostbusters. "And now here's our host
...Peter Venkman!"
...itting up on a very, very attractive
...cue. A fast poke in the arm by
...ready to rock.

...-- that's Dr. Egon Spengler...
the brains behind the whole Ghostbusting ope... you tell the folks at home why we're here tonight?"

Egon blinks, clears his throat. "We're here tonight because you sold the TV rights before we could stop you and now we're stuck on national tv."

Peter's smile only flickers for an instant. "What a kidder, eh, viewers? Tell 'em the real reason, Egon." Egon looks at him. "The real reason," Peter repeats, and under his breath, "Read the card!"

Egon finds the cue-card. Begins reading in a fairly nervous, stilted fashion. "Oh. Uhm, we're here tonight because every ten years on this date, Al Capone's ghost is seen here at the site of his tomb, and we're going to catch him on live tv right before all you crazy guys and gals."

"And now with no further ado --"

"Peter," Egon interrupts quietly, "there must have been some sort of mistake -- no one's seen Al Capone's ghost --"

Chapter 4: The Franchise Rights Alone: Toys, Merchandise, and the Rise of Ecto Cooler

Credited as "John Smith," the vocalist behind the animated show's memorable theme song, chart topper Carl Anderson, has long remained a mystery.

for approval, and they said we had to take out the last four pages because they had changed the ending of the film," says Van Hise. "It was just a little coda at the end of the story, but we had those finished pages and they weren't published."

In the UK, Marvel picked up the *Real Ghostbusters* license and released issues of a magazine that included serialized reprints of the NOW Comics, articles, activities, and even long-form prose stories beginning in March of 1988. Writers like James Van Hise, Dan Abnett, and Steve White were involved in the writing of the Marvel series. The popular book ran until 1992.

The Music of *The Real Ghostbusters*

From the opening guitar riff and the sight of the No-Ghost logo's "Mooglie" strutting down the street, it was clear from moment one that *The Real Ghostbusters* was starting. "The theme song was such a material piece of the brand's success," says Andy Heyward. The familiar *Ghostbusters* theme song, originally written and performed by Ray Parker Jr., was slightly rearranged and featured a vocalist who was credited at the end of every episode as "John Smith," clearly a pseudonym used to hide the true identity of the singer. Urban legends said that Smith was a session musician who recorded just this theme song and nothing else in his career. Or that Ray Parker Jr. performed the vocals himself, throwing his voice slightly and taking on a nom de plume for some unknown reason. The vocalist behind *The Real Ghostbusters*' theme song has been an unsolved mystery for decades. That is, until now . . .

"It's definitely not me singing on it, and I don't know anybody named John Smith," says famed musician Ray Parker Jr., who himself is a storied session musician who played on tracks for Stevie Wonder, the Temptations, and many more. "I wasn't there when they redid my song, but I was always under the impression that it was Carl Anderson." Anderson, who famously played Judas in *Jesus Christ Superstar*—including the 1973 motion picture version—and topped *Billboard*'s sales charts with his duet with Gloria Loring, 1986's "Friends and Lovers," had signed a record deal with Columbia Records in 1982 and released his self-titled album with the label in 1986, when the theme song would have been recorded. He had also dabbled in performing theme songs for films and television shows throughout his career, including the theme song for the film *Her Alibi* in 1989 and the theme to *Equal Justice* in 1990. Anderson, who had a long battle with leukemia, passed away in 2004.

When the series was reimagined as *Slimer! And the Real Ghostbusters*, the theme song was once again rerecorded, this time by Chase/Rucker Productions: the combined duo of Thomas Jones Chase and Steve Rucker. The two were also responsible for the *Snorks* theme song, the score for *Little Nemo: Adventures in Slumberland*, and music for the *Alvin and the Chipmunks* series.

The Real Ghostbusters featured an earworm of a musical score, with energetic stock themes and motifs that were utilized throughout the series. Moments like the Ghostbusters returning to the firehouse or the final stages of a ghost entrapment in progress all had accompanying music cues that repeated over the course of the series. Responsible for the episodic score were longtime DIC collaborators Haim Saban and Shuki Levy. Haim Saban told *Variety* in 2006, "We met 25 years ago—Andy was the cartoon schlepper, and I was the music schlepper. I was a supplier to him—as music, post-production and international distribution."

The majority of day-to-day writing on the music fell to Shuki Levy, who had self-taught himself guitar by the age of fourteen and was a part of a pop-rock band in Israel before moving to the United States to work in the entertainment industry. "Shuki is delightful and a huge talent, absolutely huge. He was a big part of Haim Saban's success," says Andy Heyward. Saban and Levy would go on to cofound Saban, responsible for the *Mighty Morphin Power Rangers*, among many others. "They were partners together. Shuki did the theme song to *Inspector Gadget* in 1982, and in the six thousand half-hours of children's television I've made, everybody always remembers the *Inspector Gadget* theme song."

"When you've got a show where the emotions are tamped down and there isn't a great emotional range there to play with, the music tends to live in a very narrow paradigm," says J. Michael Straczynski. "But what *Real Ghostbusters* did was allow the music to explore a whole range of things,

The cassette soundtrack album by Tahiti.

from the scary to personal to emotional. Although we never talked about it, I think that Shuki really responded to having a show with genuine emotional range and was challenged to make that even stronger with the music. He demonstrated a range of styles that he really never got a chance to utilize before. So, I guess the reason why the music was so good was that Shuki was really thankful to go out and play."

"I'm such a fan of Shuki Levy," says James Eatock. "Obviously, his work on *He-Man* and *She-Ra* is iconic, but Levy was one of those great artists that could create a main score, and everything around it would relate in some way. Even in the most subtle of ways, you would still hear those main themes. What he had to do was listen to what Elmer Bernstein did and Ray Parker Jr.'s theme song and pull from those, use those as his theme that would inspire little notes.

I thought his work on the series was fantastic. I'd love to find a fan that doesn't shed a tear every time that bloody slow, emotional guitar solo kicks in when characters are walking away or, like, at the end of 'Egon's Dragon' when he goes into the well. It's so beautifully done."

Sometimes when episodes would require additional music, the episode writers would have to step in. When Dennys McCoy and Pamela Hickey were working on "Don't Forget the Motor City," they knew they had to include Aretha Franklin because of her connection to Dan Aykroyd. "The Ghostbusters took this job because they wanted to meet the Queen of Soul," says Dennys McCoy. "We have the gremlins destroying cars while singing a song called 'We Love to Trash Cars.' Straczynski calls Pam and asks how the song goes." Hickey, on the spot, hummed and made up the song over the phone. "To this day, we still get BMI residuals."

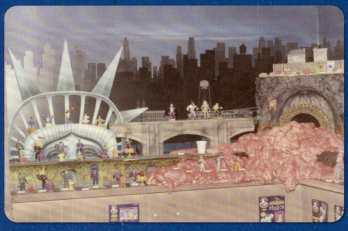

The annual Toy Fair in New York City is one of the most important dates circled on a toy company's calendar. Each year, Kenner and their competitors vie for the attention of retail purchasing agents, advertisers, industry insiders, and media to show off their upcoming offerings. Every year, The Real Ghostbusters was an opportunity for Kenner to go big, creating lavish walk-through experiences and impressive diorama showcases. Presented here are personal photographs from Toy Fair events throughout the years.

Though a score soundtrack of Levy's compositions has yet to be released, there was a *Real Ghostbusters* soundtrack album released by PolyGram Records on cassette tape in 1986. The original thirteen network episodes had ten original songs in them written and produced by Ollie Brown, another famed session musician who played drums on tracks for the Rolling Stones, Diana Ross, and more and performed the title track to the 1984 film *Breakin'*. "Ollie was someone who worked with Ray Parker Jr.," says Joe Medjuck. "I don't know if it was us or Columbia but someone said that it would be hip to have some pop songs in the show."

This wouldn't be Brown's first *Ghostbusters*-related project; the musician had already had a brief but memorable bout with the franchise back in 1984. "Ollie was in the *Ghostbusters* music video. He is one of my best friends," says Ray Parker Jr. To get a youthful and energetic sound to the album, Brown turned to the combined duo of Tonya Townsend and Tyren Perry and their group, Tahiti. "Tonya and Tyren sang really great. It wasn't just *Ghostbusters*; I had worked with them on other things too."

The Tahiti album was recorded at Ameraycan Recording Studios in North Hollywood, which was Ray Parker Jr.'s recording studio. It also holds the distinction of being the location where Parker cut the original track for the 1984 *Ghostbusters* film. "That studio has a pretty long history. I built it in 1979. The first client was Lionel Richie and Kenny Rogers, and it turned out to be one of the top ten studios in Los Angeles. We recorded everybody from Macy Gray to Wu-Tang Clan, Miles Davis, Clint Black, Billy Idol . . . everybody used to record there back in the day."

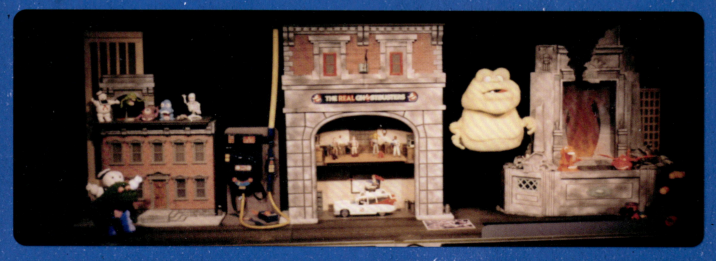

CHAPTER 5: SEQUELS AND SPINOFFS

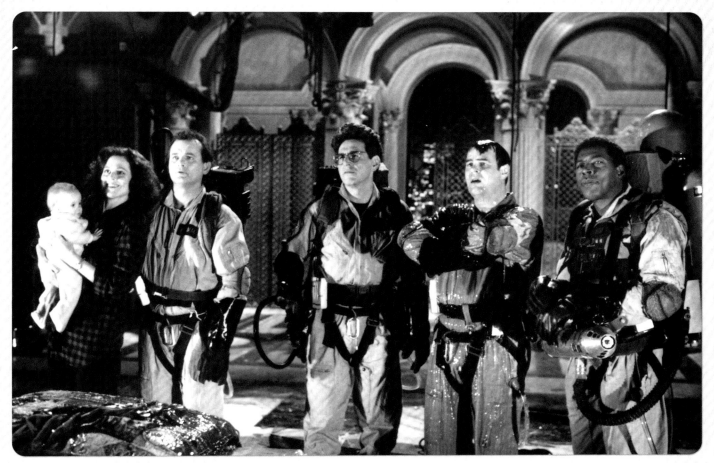

A second Ghostbusters *film carved out space in the summer of 1989.*

If the summer of the original *Ghostbusters* release in 1984 was a block party, the crowded landscape of summer 1989 was MTV's Spring Break. *Indiana Jones and the Last Crusade, Lethal Weapon 2, Licence to Kill, Star Trek V: The Final Frontier, Honey, I Shrunk the Kids, The Karate Kid Part III, When Harry Met Sally, Parenthood, Uncle Buck,* and *The Abyss* are just a small sampling of the movies released that summer. Amid it all, Batmania hit a fever pitch with the release of Tim Burton's *Batman* . . . just one week following the release of *Ghostbusters II*. To say that the long-awaited *Ghostbusters* sequel faced stiff competition is an understatement. The filmmakers and Columbia were banking on the continued popularity of *The Real Ghostbusters* to carry momentum into June of 1989. Unfortunately, that wouldn't turn out to be the case.

"In a way, the cartoon show may have hurt the sequel," says Michael C. Gross. "The sequel did well, but not as well as we hoped it would. For several reasons. Because the movie was five years later, and the animated show had been on the air for three years, it wasn't a new idea anymore—it had been a long time. I have a theory that if you were a teenager, your little brother had been playing with these toys for four years, and the edge was taken off of it. It had become a kids' product. And I think that kind of hurt it. The sequel would have done better if there was no animated show."

"I think there was some friction, because fans were saying the new movie wasn't as good as the show," says J. Michael Straczynski.

Says Andy Heyward, "I found that, after *Ghostbusters II* came out and was not the success of the first film, Ivan felt that the animated series had somehow diminished the franchise. The animated show was on ABC every Saturday morning, and Monday through Friday in syndication. That was two hundred–plus episodes. It was carpet-bombing the brand. There wasn't a kid anywhere that wasn't familiar with *Ghostbusters*. But kids were more familiar with the cartoon series than the movie."

Ghostbusters' unique formula of being a product written and intended for adults that resonates vividly with kids creates a delicate chemistry that the franchise still must re-create to this day. "It's a really hard target to hit tonally. The original film wasn't a kids' movie. But people want everything we do to be something that appeals to kids and adults the way that film did. It's a wide target to satisfy what everybody thinks *Ghostbusters* should be now," says Eric Reich. *Ghostbusters II* may have been the franchise's first foray into trying to figure out how to hit that target successfully. "I think that *The Real Ghostbusters*' impact on *Ghostbusters II* and the franchise itself was better for the long term than the short term. Ivan and the producers

Chapter 5: Sequels and Spinoffs

at the time made some conceits to pull elements that were working in the animated show into the movie. Obviously things like Janine's look and Slimer being more of a pet around the firehouse being the most obvious. Overall, the kids who were watching *The Real Ghostbusters* at the time may have been too young to go to the movie, but it's that generation of kids that have brought the franchise back and have supported the movies and all the content in the last fifteen years."

"It's so funny that the second movie was actually influenced by the show," says Kevin Altieri. "They changed the live-action characters around, which I don't think worked in all aspects. Having Slimer driving the bus didn't really work. It felt like all of a sudden the movie stopped and there was Slimer."

"Slimer was a character in *Ghostbusters II* because of the cartoon show," says Gross. "I doubt that he would have reappeared if not for the cartoon and toys."

"Slimer is indicative of our continued ongoing discussion," says Reich. "When we looked to bring the character back in *Ghostbusters: Frozen Empire*, Jason Reitman felt that he shouldn't be the firehouse pet. He should be a scary ghost that lives in Manhattan. But I think he compromised in some ways. We made Slimer look and feel pretty scary, like he did in the 1984 film. But he was also a bit like a pet in the firehouse like he was in the series. I think to this day there's still a balance we look to strike because of *The Real Ghostbusters*. That's what a lot of people remember, more so than the movies. It's hard."

The intense and fast turnaround of the second live-action *Ghostbusters* film also took resources away from *The Real Ghostbusters*, namely Joe Medjuck and Michael C. Gross, who were torn in different directions as they returned to their roles from the original film. Michael C. Gross acted as Ivan Reitman's supervisor for the *Ghostbusters II* special effects. *Ghostbusters II* faced an incredible time crunch to make its June 1989 release and budgetary constraints as

Highlight Episode: The Grundel

WRITTEN BY:
J. Michael Straczynski

FIRST AIRED:
November 14, 1987

PREMISE (FROM THE ORIGINAL *REAL GHOSTBUSTERS* WRITERS PACKET): After a school demonstration, Lee asks the Ghostbusters about a strange creature he has seen talking to his brother, Alec, and tells them of his brother's bad behavior. They can't give him any answers then, but later while looking through his books, Egon comes across a picture of the creature Lee described. It is a grundel who appears to young kids and turns them bad, until they become grundels and prey on other kids. The Ghostbusters scramble to the rescue and through daring and psychology Peter saves Lee and helps Alec break away from the grundel who is then captured in a trap.

reshoots added more and more special effects shots to the pipeline. Gross was constantly in the thick of damage control and prioritization for Industrial Light & Magic. Medjuck, who was the grease that kept all the wheels turning on the 1984 film, was again called upon for the heavy lifting of producing a big-budget film with a lot of challenges. "To be honest, Mike and I were probably paying a little less attention [to the show] than usual," says Joe Medjuck. "We filmed *Twins* and *Ghostbusters II* back to back. All we did was change the name on the editing room, and poor Shelly [Kahn] never got to leave. No vacation for Shelly. The schedule was insane. One of the great thrills of my life was that George Bush Sr. hosted a screening of *Twins* as a fundraiser [with] Arnold Schwarzenegger. Ivan and I were shooting the scene for *Ghostbusters II* on Liberty Island. As soon as we finished shooting for the day, we jumped on a boat, went across the river, got on a helicopter, which took us to Teterboro, and there was a private jet waiting to take us to Washington, where the screening was already happening and everyone was having a good time. Then we flew back that night to shoot the next day."

With Medjuck and Gross splitting their time, communication between the *Real Ghostbusters* writers and Ivan Reitman Productions also became strained. "We had this big idea that we wanted to do for an episode, and we knew it was perfect. We pitched it to everybody, and it got turned down," says Dennys McCoy. "We couldn't believe it, it's such a great idea, we wanted to know why."

"We were told that Gross and Medjuck didn't want to do it," says Pamela Hickey.

"Which was weird, because they let us do all this stuff. What we were pitching was the Statue of Liberty coming to life. We went to see *Ghostbusters II*, and you should have seen Pam and I, we were elbowing each other and like, why didn't they just tell us it's in the freaking film?"

"The Real Ghostbusters II" and Developing *Slimer! And the Real Ghostbusters*

Behind closed doors at DIC, as additional episodes were written and being produced for the 1987 season, development on what would follow (then known as "The Real Ghostbusters II") kicked into high gear. "*Real Ghostbusters* was too expensive to produce," says Winnie Chaffee. "At that time the overseas studios had a lot of shows. They didn't need to suffer through the complexity of our show. We kept losing overseas partners, and we kept trying to find new studios. There was always a learning curve. There were so many obstacles just because of the difficulty of the project."

To accommodate all of the changes required of the series by ABC (more on that in chapter 6), a new development phase would help create new bibles, character models, and other preproduction materials that would reflect the significant changes that would be happening to the show in its next cycle.

Simultaneously, spinoff series explorations began. It was ABC and DIC's goal to have an offshoot from *The Real Ghostbusters* launch somewhere around the time of the second film in 1989, hoping to capitalize on the spike in the brand's popularity. From the writers to the storyboard artists, everyone involved threw ideas into the ring for what they thought might make a great spinoff. The only mandate all were given was that Slimer *must* be the focal point of

Left: *Everett Peck's sketch for an unused animated Statue of Liberty concept.* Right: *Everyone on the creative team was solicited for potential animated-spinoff concepts. Dan Riba developed a classic monster high school concept, seen above.*

Chapter 5: Sequels and Spinoffs **221**

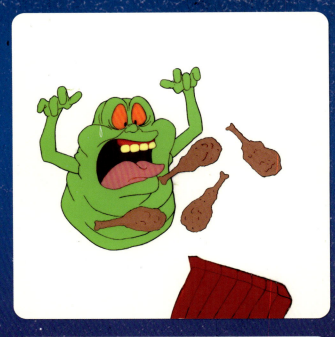

Slimer's increased popularity merited exploration of having him headline his own spinoff show.

any concepts they created. "Based on what I've known about long-running shows, at some point you've told all the stories you can tell, and you start to repeat yourself. You run out of things to say about these characters that you've done eighty episodes with," says Steve Perry. "Okay, so we're losing viewers. What do we do now? Well, how about this? This guy's popular. Why don't we bring him to the forefront?"

"At some point around 1986 or so, Richard asked us all to start thinking of ideas for a Slimer spinoff," says Dan Riba. "I can't remember if it was a premise that was given to me or just this thought that I had that he'd be sent to school with all these baby versions of classic monsters."

"I think everybody thought it was a great idea to do a spinoff and take advantage of Slimer's popularity," says Robby London. "Michael, Chuck, and Len all really enjoyed writing Slimer and thought he was a fun character. And it just seemed like a good idea that nobody had a good reason not to do."

By December of 1987, a creative direction had been chosen. A spinoff show would focus on Slimer living on the thirteenth floor of the Sedgewick Hotel, the original location where he was first encountered by the Ghostbusters. The concept would have been similar to the popular television series *Hotel* and would have had two eleven-minute segments fill a twenty-two-minute block of time on ABC. A full series bible was created, including character designs and backstories, sample premises, and log lines for other plots that might springboard ideas. A full pilot episode called "Scareface" was written by Charles (Charlie) Kaufman, who would go on to write the films *Being John Malkovich*, *Adaptation*, and *Eternal Sunshine of the Spotless Mind*.

Designer Michael Diederich was entrusted to create the original pitch designs for the hotel concept that sold the show. It was going to be something more horrifying and funny, to be in line with the *Real Ghostbusters* series. But suddenly, and without warning, there was a dramatic pivot. The hotel premise was abandoned, the series was simplified to be more like a newspaper Sunday funnies strip, and the designs were revised to look more like *Looney Tunes* than something from the *Real Ghostbusters* universe. "I didn't see that one coming," said Diederich on the Time Life DVD set. "Once it was out of my hands, that's when it changed."

In 1988, ABC carved out a full hour of time for *Ghostbusters*-related programming on Saturday morning. The network believed these quirky and short Slimer segments (either seven or twelve minutes in length) could be paired with either other *Slimer!* shorts or previous or newly produced

222 The Real Ghostbusters: A Visual History

episodes of *The Real Ghostbusters*. Only a select number of new *Real Ghostbusters* episodes would get a full twenty-two-minute run time. Others would be reduced to no longer than twelve minutes. The idea was that cutting the total running time on the main show would greatly reduce the cost of production and address concerns that the series had become too expensive to make. Mixing new and old episodes would also give the illusion of more content being created, as kids who might not have seen previously aired shows would see them paired with new segments and believe all of them were new.

It was a bold decision, but as dramatic design changes were made to the series, it resulted in odd inconsistencies. In one segment, Janine would have a bob haircut and rounded glasses. In another, she'd have a pixie haircut and triangular glasses.

"Len and Chuck got in touch with us saying they were going to do *Slimer!* episodes," says Dennys McCoy. "It was kind of cool, there were seven-minute episodes and there were fourteen-minute episodes, and it was more cartoony. So we came back to do that and . . . it wasn't the most fun."

"They turned down a lot of the old syndicated writers for the spinoff, and they were all outraged," says Pamela Hickey. "And I said, 'Well, why are you trying to write science fiction stories for Slimer?'"

"They couldn't come down to doing the child stories, that's really what it was," says McCoy.

In order to keep the animation stateside, a small upstart just down the street from DIC called the Great American Animation Company partnered on the *Slimer!* shorts. Character models were simplified. There was a lot more "squash and stretch" animation to emphasize the comedy, a very bouncy and fun way of animating compared to the action-adventure style in *The Real Ghostbusters*. Slimer himself was changed in the design process quite a bit to give him a hyperstylized Tex Avery appeal. "*Slimer!* was a far different show. It was all very cartoony," says Bruce Zick. "Under Art Vitello's direction, it was a much different show. I think *Slimer!* reflected Art's sensibility of being a little more laid back, a little more fun. He was inspiring people to do good work, but it was a far different managerial style than working for Richard Raynis."

Bruce Zick's initial background redesign for Slimer! And the Real Ghostbusters.

THE SLIMER SHOW

Series Bible

First Draft

12/11/87

DIC ENTERPRISES, INC.

HOTEL SEDGEWICK
Central Park South · New York, N.Y.

DEAR GUEST:

Welcome to the Hotel Sedgewick. We hope you will enjoy your stay with us. Our unique combination of Old World charm and modern convenience combined with our exclusive location just off beautiful Central Park keeps our guests coming back year after year.

These guests (we think of them as old friends, really) would be the first to tell you that there is absolutely no truth to those preposterous rumors you may have heard about hauntings, ghosts, goblins or any such nonsense.

It's a sad fact that success breeds jealousy, and the well-deserved success of the Hotel Sedgewick has led some of our competitors to stoop to spreading rumors about ghosts, the presence of a thirteenth floor and similar childish rubbish.

Let me assure you that there is no thirteenth floor at the Hotel Sedgewick, and there are no spooks, spirits or haunting apparitions. Any claims to the contrary are ludicrous! I tell you there are no ghosts in the Sedgewick. No ghosts, do you hear?!

Consequently, there will be no adjustments on your bill at check out.

Yours sincerely,

Morris Grout

Morris Grout
Manager

THE SLIMER SHOW

Slimer, who was first seen in the "Ghostbuster's" movie went on to become the irresistible star of the hit animated show "The Real Ghostbusters". Now in an animated pre-quel to the action in "Ghostbusters", Slimer has his own offbeat and irreverent show.

It takes place in the Hotel Sedgewick where Slimer lived before the Ghostbusters came along.

Slimer resides on the mysterious thirteenth floor populated exclusively by oddball, ill-willed ghosts and spirits.

This is why he spends most of his time in the hotel proper, driving the staff nuts while having fun, real-world adventures with a young brother and sister who live at the Sedgewick.

While the Real Ghostbusters primarily consisted of dramatic plots with a lot of comedy thrown in, THE SLIMER SHOW has a more broadly comical point of view. With the exception of Slimer, it features an entirely new cast of characters. It's set before the Ghostbusters and in an entirely different location. And, the tone, style and attitude of THE SLIMER SHOW will be even more outrageous and cartoony than THE REAL GHOSTBUSTERS.

Think of the Slimer Show as sort of a warped version of "HOTEL" for kids. People from all walks of life pass through the Sedgewick. Slimer and his friends will get involved in the colorful stories of our guests. At the same time these stories will be interwoven with the simple, ongoing conflicts of Slimer with both the snobbish hotel staff and the bizarre, mean-spirited ghosts of the 13th Floor.

If there really were 8 million stories in the Naked City, then the Hotel Sedgewick ought to be good for at least a couple hundred.

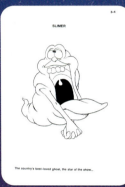

SLIMER

The country's best-loved ghost, the star of the show...

PENROD

"Pen" is a twelve year old boy who is learning a lot about ghosts.

STEVIE

Pen's sister is ten and very sophisticated — unless she's scared.

AUNT BABS

Pen and Stevie's lottery-lucky Aunt, she's always kind, socially aware, occasionally smooth, and very rich.

CHEF GASTON

He's temperamental and French, and well aware of how special this makes him.

MANX THE CAT

This collection of hair, eyes and claws belongs to Chef Gaston — and hates Slimer.

MORRIS GROUT

Cheap, pompous and dictatorial, the Hotel Sedgewick could not manage without Manager Grout — just ask him.

BUD

Bellboy Bud is well meaning, tries hard and is a very nice fellow. But, that doesn't make him smart.

GOOLEM

This evil demon presides over the mystic mayhem on the thirteenth floor.

ZUGG

Goolem's spooky stooge has less brains than a Jack o' Lantern.

SLIMER

Slimer, who emerged as the star of "The Real Ghostbusters", is a greenish ghost with a crazy, expressive physical flexibility, a garbled, excited, intense way of talking and a real deftness for slime-slinging.

His gluttonous appetite, his mischievousness, his curiosity, his broad, easily grasped emotions make him a warm and childlike figure. You might say he wears his slime on his sleeve... And kids have responded with a special affection for the little "spud".

Although Slimer's dialogue in "The Real Ghostbusters" consisted primarily of grunts, gurgles and snorts he'll become more intelligible in his own show. After eating a fifty-five pound turkey he has to be able to say something, even if it's only, "lovely appetizer, Chef, what time's dinner?"

Slimer's high energy level, his total lack of control (especially around food), his manic kindness make him certain to become the best friend of the kids who watch him, as he is already Pen's best friend...

PEN

"Pen", short for Penrod, is an inventive, intelligent, twelve year old who forms wild but somehow workable plans to insure that everything works out for the best. When necessary, he can flatter Hotel Manager Grout. "I used to think I wanted to be an astronaut when I grew up. Now I know I want to be a hotel manager — it's so glamorous!". He can cajole Chef Gaston — "No chef in the world is fit to lick your sauce pots, Chef Gaston." And he can wrap Aunt Babs around his finger too.

Pen is doing research on the supernatural and hopes one day to be the world's greatest authority on "Haunts and Haunting". He is keeping careful notes for this purpose and has already acquired a great deal of knowledge which can be helpful in tight spots.

Pen spends most of his time keeping his friends (especially Slimer) out of hot water. Sometimes, though, he needs a little help getting out trouble himself and often that help can come from his friend — and sister - Stevie.

STEVIE

Stevie is Pen's ten year old sister who is working hard to develop the sophistication she assumes a girl who lives at the Sedgewick with her wealthy Aunt Babs should have. Stevie does not share Pen's interest in ghosts. (Except for Slimer.) She wants to be a heavy metal drummer.

Stevie's sophisticated attitude falls apart when she is truly scared, and she reverts to the little sister Pen must look out for.

Stevie likes Slimer and would love him to be in her band. Slimer's not very musical, but Stevie insists he looks "very heavy metal". Almost as heavy metal as the ten pound necklaces worn by her Aunt Babs...

AUNT BABS

Aunt Babs was formerly a waitress at "Newark's top diner". The people she worked with there -- before winning the lottery -- are still her good friends and she speaks about them constantly in reference to situations in her new life. This habit drives Chef Gaston crazy especially when he hears "Fry-Cook Carl woulda' done it different!"

Aunt Babs loves to talk in a New Jersey accent as strong as her opinions. She lives in another world, but she can afford to.

Aunt Babs is nouveau riche and knowledgeable (or pretends to be) about etiquette. She often corrects Pen. "One is never slimed in the lobby of a major hotel. However, if one IS slimed in the lobby of a major hotel, one does NOT wipe the slime off on the drapes and scream 'truly disgusto!'"

She bosses Morris Grout around, even calls him "Morry". She infuriates Morris Grout on her forays into his kitchen, by telling him how things were done at her old diner, and over tips poor Bud, much to the jealous anguish of Morris Grout.

Aunt Babs loves both the kids, but is a little uncertain about Slimer, whom she believes to be an exotic breed of dog. "One of them Lazoo-Apsu's maybe?" Occasionally when in the Hotel's kitchen, she'll snatch an hors d'oeuvre: "A little treat for Stevie and Penrod's dog." This does not go down well with Chef Gaston ...

CHEF GASTON

Chef Gaston is a proud, temperamental, French chef. "Chef de Cuisine", he insists, when he is called merely "Chef". Chef Gaston speaks in broad, French-accented English when he complains -- as he frequently does -- about food missing from HIS kitchen.

Chef Gaston complains a fair amount in general. About Aunt Babs: "Mon Dieux eeet ees ze Piglet!" The Chef averts his eyes as Aunt Babs waddles past in a garish form-fitting outfit. About mysterious orders from the thirteenth floor -- shrimp fried lice, snake and onions, gross roast beast; "typical of zee tasteless persons 'ou stay 'ere!"

Chef Gaston suspects Penrod, Bud, Aunt Babs, Stevie, even his own cat Manx of periodic food thefts. These always happen at the worst possible time -- but they could not be the work of ghosts. "Ghosts in my kitchen"? Zey wouldn't dare!" says the Chef, twirling his pointed mustache and brandishing his cleaver.

The Chef is built like a brick cookhouse and this, combined with his arrogant temperamental personality make him resemble Paul Prudhomme with a behavioral disorder. Chef Gaston is someone that only a very hungry person could love. Or perhaps his cat Manx could...

MANX

Manx is Chef Gaston's nasty frazzle-tailed cat. Manx is proof that, unlike dogs, people look nothing like their cats. For, while Chef Gaston is overweight, Manx is emaciated -- thanks to the strict diet imposed by his master. Chef Gaston will not feed Manx because, "Zee hongree keetee he catches zee mice, zee fat keetee is lazee too much!" So says Chef Gaston.

Because he exists in a half-starved state, life to Manx is a series of "near miss" feasts. Just when Manx thinks it's possible he may get something to eat, circumstances (and often Slimer) conspire to thwart the poor puss.

Manx does not deal with frustration very well. He hisses, meows and growls an almost intelligible stream of fury through his clenched teeth, then sets out to get his claws on the cause of all the trouble -- Slimer!

Manx hates Slimer enough to risk knocking over anything up to and including Chef Gaston's precious "de jour" soup for him. These insane scrambling chases through the mine field of cooking gear (and the rest of the hotel) invariably end badly for poor Manx. Circumstances and timing never favor this feline, and he frequently ends up disgraced, embarrassed and covered with slime.

Yet Manx's hatred for the Slimy One is enough to keep him going back for more, even if it means, as it easily can, trouble with hotel manager Morris Grout...

MORRIS GROUT

Morris Grout is the stingy, officious hotel manager. He wrote "the book" on hotel management and can find a rule there that conveniently covers any situation whenever he wants. Of course, Morris is most interested in finding these rules when they'll make his employees' and often his guests' lives less pleasant and more difficult.

Morris can be a cringing, obsequious toad to a wealthy customer but if this should happen you can be sure he'll promptly pass along his humiliation -- usually to Bud the Bellboy. Bud is blamed for almost everything that goes wrong and lives perpetually on the brink of "ter-min-ation", as Morris Grout takes great delight in hissing out.

Morris would like to come down hard on Penrod and his sister too, but their connection to wealthy Aunt Babs makes that impossible. So when Morris sees Penrod careening through the halls on his skateboard he's got to grimace and bear it -- until he has a chance to take it out on Bud.

Morris resents rumors that the hotel is haunted. He blames "jealous creeps at the Waldorf!" When guests complain about supernatural events he assumes they are attempting to weasel out of paying their bills -- and pops a couple more of his ever-present headache tablets.

Grout will admit only that "alleged ghosts" that "supposedly haunt" the hotel are a minor annoyance. Very minor, compared to malingering employees, eccentric guests, and the day-to-day problems of doing a job you happen to be worse at than anyone else. Except for maybe the bellboy Bud...

BUD

Bud the Bellboy, is kind, well-meaning, good-natured, tolerant and innocent. So much for the good qualities. He's also incompetent, gullible and dumb.

Bud may be dumb, but even he knows the Hotel Sedgewick is haunted. It doesn't bother him. Ghosts are just another form of life he can't understand and so he treats them the way he treats humans -- politely and tolerantly.

Bud doesn't like being blamed for things he didn't do, but he doesn't really know what to do about it -- he is dependent on Pen, Stevie and Slimer to help him out of the jams he finds himself in.

When Morris Grout gives him instructions to take luggage upstairs he repeats it to himself in order not to forget -- which he does as soon as he's interrupted. When Morris balls him out he says, "ultra sorry boss." Sorry as he is, Bud is more impressed by how angry the manager gets than he is frightened. The same goes for raging demons; he is too dumb to be frightened, but he is smart enough to be impressed. "Jeez did you know there was fire coming out of your head?" he asks the enraged GOOLEM...

GOOLEM

The cigar-chomping gangland style boss of the thirteenth floor, Goolem is the worst of the other ghosts. He enjoys making trouble for the other ghosts -- egging them on to folly with sly wit and malicious sarcasm. His scolding ("Yah call yourself a ghost? Yer about as scary as steam from a teapot!") and his cajoling, ("I tell ya -- yer a ghost with a real future in the haunting game. You do me this little favor and we'll see about a promotion for you,") keep the thirteenth floor, and the rest of the hotel in turmoil.

Goolem finds slime and Slimer disgusting. "Dat stuff's repellent in da extreme," he says to his stooge Zugg. Goolem's hatred for Slimer (and, by association, Penrod, Stevie and Bud) is the reason Slimer spends so much time in the hotel and not on the thirteenth floor.

Goolem is afraid of only one thing. And the "thing" is Chlorella, a female spook with a decomposed look to her whose greatest wish is "to have my darling Goolem wrap me in his thick, short, arms and blow cigar smoke in my ear." When Goolem hears her coming he beats a hasty retreat, making transparent excuses to his stooge Zugg.

ZUGG THE IMP

Zugg the imp is a nasty, aggressive little stooge who hates Slimer and Penrod to the limit of his considerable ability to hate. He is willing to go to great lengths to make trouble for them -- however since Zugg is extremely stupid, his plans are not usually very effective.

Zugg was a boxer (once ranked no. 3 in the junior demon division) until doctors told him he "got hit in the head three-too-many times" and he retired -- punchy. Zugg still remembers his days in the ring and still tries to stay in shape -- working out on a "live" punching bag which he usually misses but which does not miss him when it strikes back -- hard.

Sometimes when he's over-excited, Zugg thinks he's back in the ring and relives some former fight, flailing the air all around him, grunting and threatening an imaginary opponent.

Because of Zugg's limited brain power he can often be convinced by Penrod, Stevie and Slimer to act against his own best interests, or his boss's. "Let me get this straight boss -- are you saying I've been tricked?" Zugg's discovery makes him all the madder and all the more desperate to even the score with the assistance of the other Ghosts of the Thirteenth Floor...

THE GHOSTS OF THE THIRTEENTH FLOOR

The most hauntingly memorable cast of ghosts ever assembled under one roof. You'll find no vampires, werewolves or man-made monsters here. Those common run-of-the-mill spooks couldn't hope to cut it at the Hotel Sedgewick (and we've seen them too much anyway.) Instead there are creatures like Glorp...

GLORP

A huge, shy, infantile ghost who babbles in baby-talk and loves to play. Even with Fiendo...

Opposite and above: Newly unearthed pages from the initial series bible for Slimer's spinoff. In the original concept, Slimer haunted the thirteenth floor of the Sedgewick Hotel in what was called a play on the TV series Hotel, *but for kids.*

Characters like Professor Dweeb were highly exaggerated in comparison to the main show's style.

realism," says Zick. "*The Real Ghostbusters* utilized pretty strict rules of perspective, mechanical illustration, and accuracy. If you look at the bible of all the key locations used in that show, they're pretty remarkable illustrations. As much as I appreciate that, as an artist, I tend to like a looser style. With the *Slimer!* backgrounds, I look back on the bubbly, cartoony designs, and it's some of the most fun and organic-looking art that I've done."

Response was decidedly mixed, but ratings remained high as late as October of 1989. The hourlong *Ghostbusters* program was still winning its time slot heading into 1990. Though Slimer was at the peak of his popularity among kids, the Ghostbusters being sidelined and the slapstick *Looney Tunes* tone of the show turned off audiences. The younger kids that *Slimer!* was geared toward didn't spark to the premise of the show, which no longer included the capture of villains and often focused on sitcom-like plots where Slimer had to deal with high jinks caused by the denizens of his world. Older audiences disappeared entirely, opting to only watch the *Real Ghostbusters* segments if and when they aired.

"I just remember we finished the last episode, and then one day I just heard that we're done," says Art Vitello. "Which is very normal in this business."

"I did warn them," says J. Michael Straczynski. "I was just profoundly disappointed. We put eighteen hours a day, every single day, into that show. When you see the show completely change, you think, why the hell did I bust my ass if it's just going to be taken and turned upside down for no good reason? I told them when I came back that I wanted nothing to do with the *Slimer!* show. I'm writing my episodes, and keep everything else away from me."

"Richard invited me to come onto the show and work with Len Janson and Chuck Menville on the series," says Art Vitello. "The idea was that it was a much 'cartoonier' version of *The Real Ghostbusters*. We started by taking the model packs from the other show and tuned them up to be more like caricatures. I had worked with Friz Freleng at DePatie-Freleng early in my career. My early directing was on *Pink Panther* shorts and the *Looney Tunes* characters. I think that, kind of just by osmosis, that fun and design found its way into *Slimer!*" Designers Keith Baxter and Everett Peck were tasked with overexaggerating the curves and features on both the human characters and the titular Slimer to bring them closer to the Warner Bros. aesthetic.

"*Slimer!* was easier to animate," says Winnie Chaffee. "Can you imagine the pencil mileage they had to spend on each of the four Ghostbusters? Four different bodies, four sets of gear? There's so much pencil mileage. Slimer was a lot simpler. We got a couple of really great storyboard artists in the industry, including Art Vitello, who was one of the first Disney Television Animation directors. I learned a lot about storyboarding looking at his boards. You don't need to read the dialogue; you just have to see the pictures."

"For me, as a designer, there was a lot more creative opportunity when you are freed up of the confines of

> "I look back on the bubbly, cartoony designs, and it's some of the most fun and organic-looking art that I've done."
> —BRUCE ZICK

"Slimer is always popular, and no matter what he's doing, people love him," says Eric Reich. "That's always the hard part . . . how much to lean in to him."

"And also, just how scary to make him. Slimer is a character that is so different as far as how you project your relationship onto the character," says Jason Reitman. "The first time you see him in the original film, he's such an unknown. You're given so little about him. And his voice is so scary. I think that's the big difference on the animated show is that his voice is so sweet."

Ironically, in 1995, after *Slimer! And the Real Ghostbusters* had come and gone, ABC's Jennie Trias told the *Lansing State Journal*, "Everyone went for softer comedy stuff. Then the

Highlight Episode: Attack of the B-Movie Monsters

WRITTEN BY:
Jules Dennis and Richard Mueller

FIRST AIRED:
September 28, 1991

PREMISE (FROM THE ORIGINAL *REAL GHOSTBUSTERS* WRITERS PACKET): Film cans from Japan's Yamani Studios, the home of the monster movie, come into contact with toxic waste creating spectral versions of the studio's most infamous creatures. The Ghostbusters are flown out to assist and are outfitted with the highest Ghostbusting technology Tokyo has to offer.

This standout from the later seasons that emerged as a fan favorite was the second-to-last episode to air. In the episode, the Ghostbusters are met with a hero's welcome in Japan and handed the keys to a high-tech "Ecto-Ichi" to get them around town. The car meets an unfortunate demise under Lizardo's foot.

"I was working with a writing partner, Julie Dennis, who had been assigned the episode, and we did the job. It really helped that my entire life, I have been a huge fan of Godzilla," says Richard Mueller. "I love Godzilla. By the time this episode came about, we were in the middle of the series and searching for stories that hadn't been done. Including crossovers. That's when ideas came popping to us. It was about this time that we also introduced our take on the Teenage Mutant Ninja Turtles, the 'Mean Green Teen Machine.'"

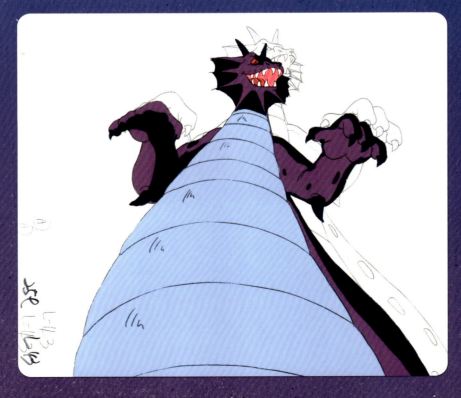

Chapter 5: Sequels and Spinoffs 227

Scares and frights were replaced with laughs in Slimer's spinoff.

Ninja Turtles came on, so it's cyclical. [Now] I think we're in a high action-adventure cycle." Sadly, it was after production on *The Real Ghostbusters* had shut down, and well after the action and adventure in the series had been left behind.

A Guide to the *Slimer!* Shorts

THIRTY-MINUTE PILOT (SHORTENED TO FOURTEEN MINUTES FOR BROADCAST)

"Scareface"	Production Number: 166001C

TWELVE-MINUTE EPISODES (1988–89)

"Out with Grout"	Production Number: 166001B
"The Dirty Half-Dozen"	Production Number: 166002B
"Sweet Revenge"	Production Number: 166003B
"Don't Tease the Sleaze"	Production Number: 166004B

SEVEN-MINUTE EPISODES (1988–89)

"Nothing to Sneeze At"	Production Number: 16601A
"Doctor Dweeb, I Presume"	Production Number: 16602A
"A Mouse in the House"	Production Number: 16603A
"QuickSlimer Messenger Service"	Production Number: 16604A
"Cruisin' for a Bruisin'"	Production Number: 16605A
"Show Dog Showdown"	Production Number: 16606A
"Slimer for Hire"	Production Number: 16607A
"Special Delivery"	Production Number: 16608A
"Go-pher It"	Production Number: 16609A
"Cash or Slime"	Production Number: 166010A
"Sticky Fingers"	Production Number: 166011A
"Monkey See, Monkey Don't"	Production Number: 166012A
"Pigeon-Cooped"	Production Number: 166013A
"Slimer's Silly Symphony"	Production Number: 166014A
"Space Case"	Production Number: 166015A
"Room at the Top"	Production Number: 166016A
"The Not-So-Great Outdoors"	Production Number: 166017A
"Dr. Strangedog"	Production Number: 166018A
"Class Clown"	Production Number: 166019A
"Unidentified Sliming Object"	Production Number: 116020A
"Movie Madness"	Production Number: 116021A
"Little Green Sliming Hood"	Production Number: 116022A
"Beach Blanket Bruiser"	Production Number: 116023A
"Rainy Day Slimer"	Production Number: 116024A
"Tea but Not Sympathy"	Production Number: 166025A
"Dog Days"	Production Number: 166026A
"Up Close and Too Personal"	Production Number: 115027A
"Slimer & the Beanstalk"	Production Number: 115028A

Slimer to the Rescue

In 1990, Slimer joined the ranks of Bugs Bunny, ALF, the Teenage Mutant Ninja Turtles, Alvin and the Chipmunks, Garfield, and even Kermit the Frog and the Muppet Babies for an unprecedented cross-promotional effort in the war on drugs to help educate children on substance abuse. The program, *Cartoon All-Stars to the Rescue*, was produced co-operatively by Walt Disney Studios, Warner Bros. Pictures, Marvel Productions, Henson Associates, Hanna-Barbera Productions, Murakami-Wolf-Swenson, DIC Enterprises, Film Roman, and Bagdasarian. It was funded in part by McDonald's, spearheaded by the Academy of Television Arts & Sciences Foundation, and executive produced by Roy Disney.

It is notable also that Q5's Corinne Rupert, who would play a major role in the future of *The Real Ghostbusters*, was a script consultant on the special.

The thirty-minute show, aimed at kids ages five through eleven, was a major event that aired across all the US, Canadian, and Mexican networks during their Saturday morning 10:30 a.m. block. The airtime was donated by the networks so that the program could run without commercials. McDonald's donated over a million dollars to promote the program and to purchase 250,000 VHS cassette tapes of the special that were sent to schools, libraries, and video stores, where they would be available for free rental. In total, it was estimated that the distribution of the special would reach at least twenty million kids.

In March, President George H. W. Bush touted the special as a catalyst for public action against drug abuse. "I hope that on Saturday, April 21, the day the show is first broadcast across the US and all over North America, every TV set is on—and every child is watching."

Prior to the April 21, 1990, broadcast, a section of the unfinished special was shown to Congress. In response, Senate Judiciary Committee Chairman Joseph R. Biden Jr. of Delaware told the *Los Angeles Times*, "The most powerful weapon that we know in politics is the cartoon, and we hope that the cartoon will be the most powerful tool to educate our children." Biden also told *Broadcasting* magazine, "Even if it sounds silly, cartoons may be able to beat the cartels."

The script for the series took six months to complete and get approved due to all of the stakeholders and

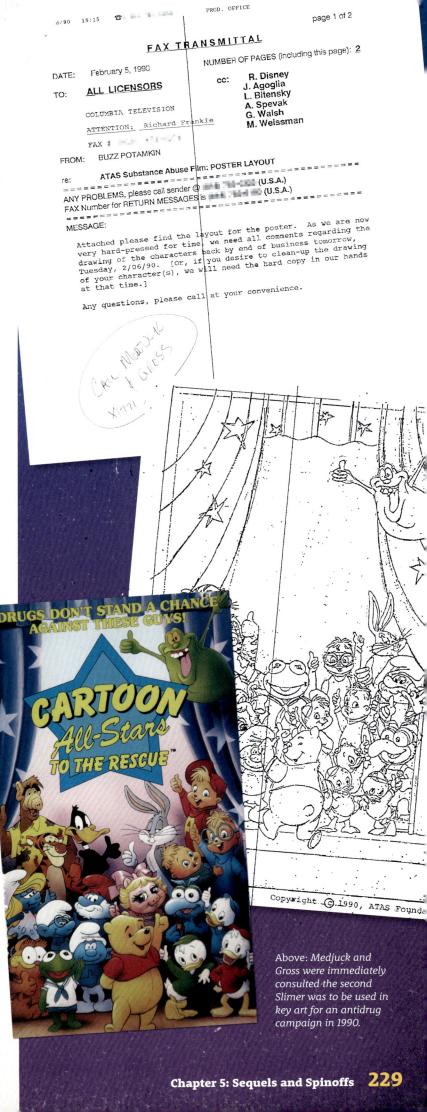

Above: *Medjuck and Gross were immediately consulted the second Slimer was to be used in key art for an antidrug campaign in 1990.*

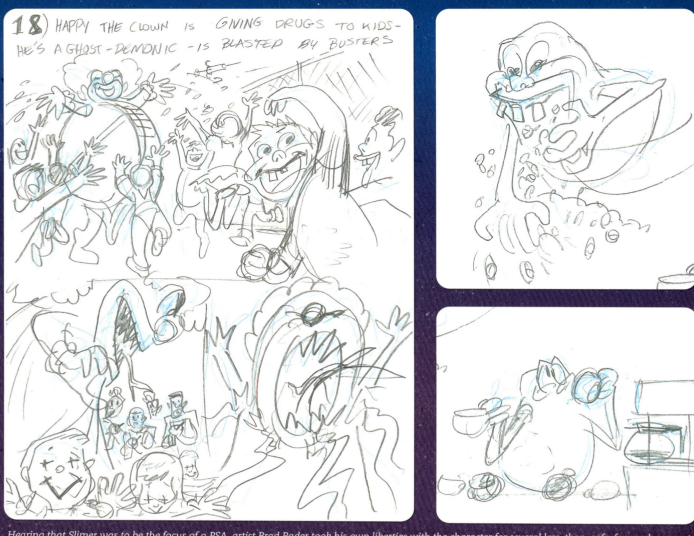
Hearing that Slimer was to be the focus of a PSA, artist Brad Rader took his own liberties with the character for several less-than-safe-for-work concepts.

eyes overseeing the project. Which meant the animation had to be completed in a lightning-fast eight weeks. In the end, Slimer's participation in the special was limited. But the character had a prominent position on the advertising and poster key art, which required the approval of Michael C. Gross. Artists on the series, upon hearing of Slimer's involvement, decided to conceptualize PSA advertisements similar to those popular at the time that . . . may not have had the effect the special intended.

The Unproduced Animated Feature Film(s)

Bill Murray notoriously told *Starlog* magazine he wished *Ghostbusters II* was called "The Last of the Ghostbusters," definitively ending the film series so that he would never have to make a third film. It was clear another live-action film was nowhere in the near future. But with so many industries relying upon *Ghostbusters* to remain evergreen, Ivan Reitman, Joe Medjuck, and Michael C. Gross found themselves in the crosshairs of multiple parties who saw an animated feature film as the future. DIC, Columbia Pictures, and even Kenner Products ambushed the filmmakers from all sides.

In December of 1989, Andy Heyward contacted Ivan Reitman Productions, imploring them to give their blessing on a DIC-produced feature. Several months later, Kenner sent a letter to Michael C. Gross, reasoning that an animated feature would be essential to keeping the toy line alive. Kenner tasked the toy designers to come up with ideas that would spark energy into the animation and, therefore, open new doors for different toys. Among those concepts was "Young Ghostbusters," intended to be a play on the *Muppet Babies* premise of telling stories about younger versions of popular characters.

Ultimately none of these concepts came to fruition. It wasn't until June of 2022 that Sony Pictures Animation and Ghost Corps would formally announce development on an animated *Ghostbusters* feature film.

December 5, 1989

Mr. Michael Gross
Ivan Reitman Productions
Producers Bldg. #7 - Rm. 8
Burbank Studios
Burbank, CA 91505

Dear Michael:

Ghostbusters has continued to be a major player in the toy industry, with sales of $130 million this year. Even next year, the 4th year for the line, current projections estimate that, with continued programming, sales could be just as strong.

We'd like to take this opportunity to explore additional programming options for The Real Ghostbusters. Given the popularity of the franchise with children, special programming to augment the currently successful animated series would seem beneficial to the Ghostbusters franchise and all its licensees.

Special programming would also give us a chance to expose our target audience to a new Ghostbusters adventure concept. This would establish a continued story line from which to draw more licensing opportunities. Some of the options we can consider for 1990 are a new animated feature film for in-theatre release, or the production of a new one hour network or syndicated cartoon special. Either one of these options would also lend themselves well to subsequent release at retail on video cassette. If you have some other ideas, I'd be very interested in discussing them.

As you know, Ghostbusters has a unique license with a broader audience than most other licensed brands. The marquee value of Ghostbusters would guarantee kids' interest in any sort of programming venture. These feature length program specials would allow kids to completely immerse themselves in the fantasy world of ghostbusting and The Real Ghostbusters heroes.

Please give some of the above special programming options some thought.

I'm sure you'll agree that any new programming would present a great opportunity to strengthen the Ghostbusters concept in 1990. Since the enterprise would be mutually beneficial, Kenner would be more than willing to discuss ways in which we can both participate in this venture.

I will call you in a few days to discuss next steps. Looking forward to your ideas.

Sincerely,

Liane Czirjak

cc: J. Block, J. Perez, J. Bohach, J. Black, M. Ihlenfeldt, L. Borden

TELEFAX TRANSMISSION

TO: Michael Gross
FAX#: ███-███-████
FROM: Andy Heyward
DATE: December 4, 1989

NUMBER OF PAGES INCLUDING THIS ONE: 1

***IF THERE ARE ANY PROBLEMS WITH THIS TRANSMISSION PLEASE CALL ███-███-████.

MESSAGE:

Pursuant to our conversation, the following animation theatricals are the only ones in production at this time to the best of my knowledge:

1. Rescuers II - currently in production with Disney.
2. Ducktales, the Movie - currently in production with Disney/Paris.
3. The Jetsons - currently in production with Hanna-Barbera, distributed by Universal.

As I told you, we will definitely do an animated theatrical in 1990-91. If we don't do Ghostbusters with you (which is my preference), we will do a Super Mario Brothers movie.

Andy
AH/vld

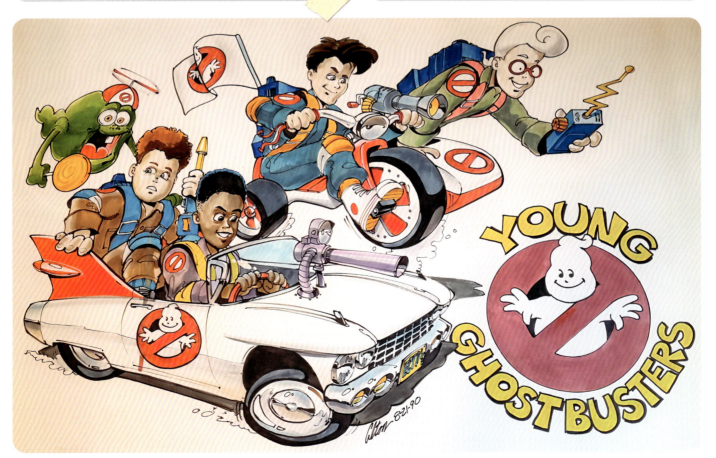

*In 1989, post-*Ghostbusters II*, Kenner thought that an animated feature or a special program might help inject new energy into the brand. Among those concepts created by the toy company was "Young Ghostbusters," seen here conceptualized by Alton Takeyasu. Top right: Andy Heyward saw* Ghostbusters' *feature-film future in animation and saw a window of opportunity in the next year to release it with very little competition.*

Chapter 5: Sequels and Spinoffs **231**

CHAPTER 6: TOTAL PROTONIC REVERSAL

Despite the release of a new live-action movie and high ratings in 1989 and 1990, the series came to an end. But why?

From September 1986 to 1990, *The Real Ghostbusters* enjoyed rising success. Shortly after the series' debut on ABC in December of 1986, Columbia Pictures Television reorganized. Under the new umbrella of Coca-Cola Telecommunications, there was a massive shift from the executive level down. Which meant resignations and eventual layoffs of 3,500 employees. Yet the show survived and thrived. In January of 1987, *The Real Ghostbusters* was a priority for Coca-Cola's television unit. It performed well in the ratings, was a hit with advertisers, drove sales of merchandise, and was performing exactly to the purpose it served: it kept the Ghostbusters alive in popular culture. Despite the stock-market crash in October 1987, *The Real Ghostbusters* continued to be successful through 1988. And 1989 looked to be a banner year for all things *Ghostbusters* with another tent pole feature film starring the original A-list stars marked on the calendar for that summer and a primetime slot carved out for Halloween of 1989 to put the spotlight on *Real Ghostbusters*.

But in fact, suddenly, and without warning, that trajectory took a steep downturn.

After the release of *Ghostbusters II*, there was a sudden stop in *The Real Ghostbusters*. The spinoff *Slimer! And the Real Ghostbusters* came to a crashing halt. Like a shorted stock that skyrockets, then plummets, the *Ghostbusters* brand stagnated into an inexplicably dormant state in 1991. Adding insult to injury, *The Real Ghostbusters* received an Emmy nomination while production on new episodes had halted just six months before the last original episode would air. On paper, it doesn't make sense. How did an animated series on such a meteoric rise so quickly lose momentum and crash back to the ground?

Fan sentiment over the years has maintained that the main culprit was a nebulous organization called Q5 and the changes that they forced on the show, but this is an oversimplification. In fact, it was a confluence of *several* forces that transformed the series and eventually led to cancellation. The television industry succeeded where Ragnarok, Samhain, and the Boogieman had all failed: it defeated the heroic Ghostbusters.

It took the combined effects of several factors to bring *The Real Ghostbusters* down:

• Economic strife and a decline in advertisers' spending resulting in budget reductions and production stoppages

• Saturday morning's transformation by the forthcoming Children's Television Act and older kids looking to live-action programming

Chapter 6: Total Protonic Reversal

In May of 1991, The Real Ghostbusters was nominated for an Emmy. Andy Heyward sent a celebratory and thankful fax (written by Robby London) to the filmmakers. The show ultimately lost out to Tom Ruegger and Tiny Toon Adventures *for Outstanding Animated Program.*

Newly formed Coca-Cola Telecommunications lasted only twelve months before being shut down.

- Marketplace confusion as competitors took advantage of the flaming out of *Filmation's Ghostbusters* to tout their own ratings, and ad buyers believed it to be *The Real Ghostbusters*

- Kids who watched *The Real Ghostbusters* as eight-year-olds turning thirteen and aging out of the programming

- Turnover as key figures left ABC, DIC, and the show's production itself

- And finally, amid all of those factors working against the show, ultimately the changes that Q5 and the network insisted upon made it less appealing for the audience that had come to know and love the series—especially those turning thirteen

Industry Turmoil

To understand the circumstances when *The Real Ghostbusters* was renewed for a second season of episodes, it's necessary to set the stage of the world at large. January of 1987 brought massive upheaval to the entire economy, and the entertainment industry was not immune to the financial strain. Recession fears were high leading up to the Black Monday stock-market crash in October of that year. As corporations reduced their workforces and their

spending, their marketing and advertising budgets were slashed dramatically or removed completely. Because of this, there was a huge downturn in television ad buys.

Broadcasting magazine proclaimed that TV networks had "entered a new cost-control era." Seeing a primary source of revenue drying up, networks and studios alike were monitoring the bottom line with a microscope. Any mistake could mean catastrophe. Affiliate television stations were declaring bankruptcy. Simultaneously, the Writers Guild of America planned a strike that eventually lasted 153 days from March to August of 1988, with residuals for syndication being a main sticking point in their argument. Bracing for the financial impact, MCA/Universal controversially announced a reduced forecast for their television programming, lowering their operating costs particularly in syndicated television series—which sounded an alarm to the syndication industry, and others followed suit. Hoping to control their own fate, studios created barter companies to help give them bargaining strength with advertisers.

Coca-Cola Telecommunications partnered with Paramount to solidify their position and create one of these bartering companies. Coca-Cola used *The Real Ghostbusters* as a bartering chip, along with *Punky Brewster* and *What's Happening Now!!* When paired with Paramount's syndication juggernaut offerings of *Star Trek: The Next Generation*, *Entertainment Tonight*, and others, *The Real Ghostbusters* became a highly valuable asset. But it was still an expensive show to produce, with a lot of licensing fees that needed to be paid out.

Not Today, Satan

The fear that secret forces were indoctrinating the youth of America to Satanism was at an all-time high. Conspiracy theories spread through very vocal parents and "crisis groups" who searched for satanic imagery and subliminal messaging in everything from toothpaste commercials to Saturday morning cartoons. Popular news programs like *20/20* were dedicating entire segments to satanic messages found in pop music, and Geraldo Rivera produced a primetime special in 1988 watched by 20 million people where he hypothesized that America was living above "Satan's Underground." Speaking of these riled-up parents, FBI agent Ken Lanning told the *New York Times*, "When people get emotionally involved in an issue, common sense and reason go out the window. People believe what they want and need to believe."

For television networks that had to field hundreds of phone calls and letters, it became easier to proactively think like these groups and remove anything remotely potentially offensive from their programming, much to the chagrin of J. Michael Straczynski, who always fought such notes with fervor.

The Real Ghostbusters, reliant upon being able to explore the unknown and the occult, was constantly at odds with these groups. "We got so much mail about 'The Devil to Pay,'" says Dennys McCoy. In the episode, the Ghostbusters unknowingly participate in a game show with a nefarious host who would much rather own their souls than hand out vacations to Tahiti.

"The parents were pissed off that the devil was in it," finishes Pamela Hickey. "But they didn't pay attention, because he wasn't the devil, he was a dybbuk. I think that's one of the best cartoons we ever wrote."

The microscope that children's television was put under by these groups and outspoken individuals drew the attention of the government. Ronald Reagan had relaxed regulations on commercialization and children's television, but the Children's Television Act (CTA) of 1990 was on the horizon; it would place even stricter regulations upon broadcasters.

The CTA required that commercial television broadcast licensees and cable operators must limit the amount of commercial matter that aired during programming directed toward kids under twelve years old to not more than 10.5 minutes per hour on weekends and not more than 12 minutes per hour on weekdays. The CTA also created a commission that would review and consider whether commercial television licensees complied with the commercialization limits and whether all television broadcast licensees had served "the educational and informational

At the height of "satanic panic," a game show host character drew the ire of parents.

needs of children through the licensee's overall programming, including programming specifically designed to serve such needs." While well intended, the regulations had a vise grip on Saturday morning blocks as programmers had to completely shift their lineups to adhere to the new rules.

"*The Real Ghostbusters* or *Slimer! And the Real Ghostbusters* weren't ever intended, pitched, or designated to be educational shows to fit the Children's Television Act," says Robby London. "The reason all shows go off the air is because ratings are slipping. And here's where the Children's Television Act might have come into play: Remember the network was required to have three hours a week of shows that would qualify as educational under the act. And you've got a four-hour schedule block. *The Real Ghostbusters* wasn't an educational show, so it was competing for the one hour available that the network had for purely commercially driven shows. Whatever ABC had for that fourth hour, they found it far better than *Ghostbusters*."

Too Cool for School

With the primary Saturday morning cartoon audience hitting their early teenage years, their tastes and preferences in programming were changing. Kids who had been running around with a Proton Pack strapped to their backs in 1986 were celebrating their thirteenth birthdays, heralding another natural developmental cycle in growing up: puberty. And the younger set could access animated programming anytime they wanted thanks to the widening reach of cable and satellite TV and networks like Disney Channel, Nickelodeon, and, in 1992, Cartoon Network. No longer did Saturday morning necessitate the appointment viewing that it once secured. Speaking to the *Chicago Tribune* in 1991, *The Real Ghostbusters*' ABC executive Jennie Trias called the Saturday morning children's landscape "a market that seemingly cannot get any tighter." Saturday mornings were losing their viewership. Change was required to keep viewers who had tuned in week in and week out glued to their screens, which meant finding a way to keep the older kids interested.

As a result, shows like *Saved by the Bell* became popular, and less animation was produced for Saturday morning blocks. Brandon Tartikoff of NBC defended programming live-action series like *Saved by the Bell* in his Saturday morning lineup to *Broadcasting* by saying, "If you pretend the world hasn't changed and you keep buying as the Saturday morning economic structure is set up to do—13 episodes of *Captain N*, 13 episodes of *Ghostbusters*, 13 episodes of *Pee-Wee Herman*—you're going to be out of the Saturday morning business. And it's not a question of if, but when. What I'm trying to do by moving into the field of live action is put some showmanship back in the game—figuring that what used to be unique about Saturday morning programming was that kids couldn't get quality cartoons, freshly minted, anywhere but on Saturday morning. Now they can get it Monday through Friday and the fact that you have cartoons on is not a distinctive service."

> "The parents were pissed off that the devil was in it. But they didn't pay attention, because he wasn't the devil, he was a dybbuk. I think that's one of the best cartoons we ever wrote."
> —PAMELA HICKEY

Trias told *Broadcasting*, "NBC has been quite open about wanting to counterprogram by going after teens, but their commercials are still for kids 2–11. So I don't know what they're trying to do." NBC's Saturday morning was skewing to an older crowd at the exact time that ABC had called in a consulting firm to mold *The Real Ghostbusters* into something that appealed to a far younger audience. Though the *Ghostbusters* animated show enjoyed solid ratings, there was marketplace confusion as new shows like King Features' *Defenders of the Earth* or *Dennis the Menace* could debut and then in the trades tout that they "bested *Ghostbusters*" in the ratings, talking of Group W's *Filmation's Ghostbusters* and not Columbia Television's *Real Ghostbusters*. Savvy programmers and creatives would understand the target of these claims. But it's possible others were now conflating the two *Ghostbusters* shows into one. *Defenders of the Earth*, which was developed by Marvel and King Features in conjunction with Q5, stood on a soapbox proclaiming victory over *Ghostbusters*, even if it wasn't the REAL *Ghostbusters*. It may have triggered an overreaction by ABC to look at what made *Defenders* so successful and try to implement those tactics in *The Real Ghostbusters*.

Essentially, there was a strange, if incorrect, misconception that *Ghostbusters* had become uncool. And changes on the horizon were about to make that misconception true. A revamped and softer *Slimer! And the Real Ghostbusters* looked for a young audience that just wasn't there. The competition catered to early teens identifying more with *Saved by the Bell*'s wisecracking Zack Morris than Peter Venkman. And the competition around the animated *Ghostbusters* show was about to get fierce due to the impending CTA regulations, which led networks to use their commercialized noneducational blocks of programming in ways that allowed them to get the biggest bang for their buck.

A Q5 Full-Roaming Vapor

In October of 1986, even though artists and postproduction were forgoing sleep to finish out the remainder of the

In later seasons, the Ghostbusters encountered phenomena including a singing Mount Rushmore.

syndicated package, the development and writing team turned their attention to what was next. "All the scripts had been written for the syndicated and network episodes, we had been highly rated, we got all these great reviews, we were the number one show in that time slot for ABC, and we're told we're going to have a creative meeting before launching into the writing process for the second season," says J. Michael Straczynski. "I'm like, great. We'll get some applause. Maybe I'll get a raise. Who knows? We walked in, and Q5 was there. I had never heard of them before. I was like, who the hell are these guys?"

"Andy Heyward had been trying to hire me for quite a while, and I kept telling him I was really happy at Filmation," says Robby London, who had similarly just finished up the remainder of his work on the competitor's show.

"Robby was a very close friend of mine from high school," says Andy Heyward. "I had introduced him to Lou Scheimer, and he went to work at Filmation, but I was constantly trying to get him to come work for us."

"I just kept turning him down. It was kind of a running joke. He called me up in 1986 after he had just completed a leveraged buyout of DIC. It was his company now, essentially. He was in a position to make me a really incredible offer I couldn't resist. It was a hard decision, because I really was happy and I was working directly for Lou, who I adored. Telling him I was leaving was really one of the hardest professional moments of my life. But he couldn't have been more gracious about it. I left Filmation on a Friday, and started at DIC on Monday. One of the very first meetings I went to at DIC was with the network for the second season of *The Real Ghostbusters*. Suddenly, I'm wearing a tie to work, which I fucking hate. I've gone from being a creative person to being a suit in a way. But that meeting . . . there was an edge to it."

"Andy Heyward tells Robby, 'ABC is sending over these people who have done research on the show and have suggestions. You go to the meeting and make sure we keep ABC happy and the show on the air,'" says Joe Medjuck. Medjuck believed the meeting would be harmless, just data analysts wanting to share their findings.

"That's a common thing at a network. They'll bring in consultants, they'll bring in people to do focus groups and research and this and that," says Heyward. "I was not so big on that, personally."

"I'd become a bit of a believer in research because of a man at Columbia named Marvin Antonowsky," says Medjuck. "Ivan and I would go to his office for various things, because he was the head of marketing, and he would always talk about what movie was opening that weekend. Ivan and I were really excited about this movie with Sean Connery called *Outland*. We said, 'Oh, it's gonna be huge. We can't

Chapter 6: Total Protonic Reversal

wait to see it.' And Marvin said, 'Nope, it's not gonna open between the coasts.' And we left and said, 'Those old farts, they don't know anything, we're the ones with our fingers on the pulse.' And of course, *Outland* came out and it did exactly what Marvin said. Marvin also told us that the audience was going to tear the doors off for Richard Pryor's latest movie. And in San Francisco, they tore the doors off the theaters. Marvin really knew. So I became a firm believer in data and tracking. I went into this meeting with Q5 thinking, 'These people have sat with kids, they've done research.' But no. What I quickly realized was they had a concept about what kids want to see and they were trying to fit *The Real Ghostbusters* into that."

"They started laying out their spiel. The more I heard them talk about it, the angrier I got," says Straczynski. "It meant not just dumbing down the show, which is bad enough. But it also meant the show had to adhere to a series of standards that seemed, to me, sexist, misogynist, and racist."

The Q5 Corporation operated on the psychographics principle of VALS, a "values and lifestyle" market research tool that was developed in 1978 to examine the "fragmentation of US society in the 1960s and the implications of those changes." VALS is often criticized for reinforcing stereotypes and not translating well to cultures or ethnicities outside of those of its developers. For example, psychographics provided by Q5 to cosmetics companies directed them to serve those with fair to olive skin tones, leaving people with darker skin complexions out of their plans. Essentially, if only a certain group is tested and questioned, the results and findings will correspond to that group.

Diane Haithman was a journalist at the *Los Angeles Times* who stumbled onto Q5 and their methods by chance. "Nineteen eighty-seven was my first year at the *LA Times* and I had to go over to ABC to talk to someone about kids' television. This person was working on a show and mentioned the Q5 Corporation was really helping them out. My ears go up. What is Q5? I've got to figure out what that is. I called them up and they were very gracious and invited me in, and we had these conversations. They were very proud of themselves. And I think it backfired. When the *LA Times* story came out, everybody was like, 'Whoa. Who is this Q5 Corporation that's messing with our kids' heads?'"

"Regardless of what your problem is, we can solve it," Q5 president Thomas J. Heinz told Haithman in the 1987 article. "We have worked on (items from) breath mints to car wax to 976 phone numbers. It doesn't matter—if there's a product and a target, we can provide a totally unique insight." Corinne Rupert, who was vice president of Q5 (and later worked directly for ABC following her tenure with the company), was lauded by the *New York Times* in 1988 as someone who "combined expertise in market research and social responsibility into one person." A child psychologist with a marketing background in "child-directed products," Rupert was the main conduit of Q5 and ABC's notes and changes.

In many ways, her feedback was an amped-up conservative perspective that echoed the Broadcast Standards and Practices notes that J. Michael Straczynski so solidly resisted. "I know you can run a focus group to tell you whatever you want to hear. How you phrase the questions will determine the answers you get back," says Straczynski. "You can't focus group this kind of thing if it's not done in an authentic way. I don't believe they were trying to improve the show or make it more kid friendly. I think they had an agenda they walked into the focus group with, and everything that came out of that room matched their agenda. Whenever I challenged them, asking to see their data, they'd tell me they didn't have it. Or they would tell me that I wouldn't understand it because I don't have a degree in psychology. I *do* have a degree in psychology; show me your data. They didn't care for that at all."

> **"I went into this meeting with Q5 thinking, 'These people have sat with kids, they've done research.' But no. What I quickly realized was they had a concept about what kids want to see and they were trying to fit *The Real Ghostbusters* into that."**
> —JOE MEDJUCK

"Andy was at the meeting and said, 'Joe, these people really know what they're doing. That woman has a PhD,'" says Medjuck. "I said, 'Andy, I have a PhD and you don't always listen to me.'"

"The political climate was somewhat conservative in the '80s," says Haithman. "Phyllis Schlafly had this organization called the Eagle Forum and she was out marching, telling people things were inappropriate on television and they shouldn't be watching it. That may have had a huge influence on why the networks would have responded to or even reached out to an organization like Q5. I came out of writing the article agreeing with Straczynski. If this show were targeted for four-year-olds, I would understand the changes. But it doesn't sound like it was. That's where the

disconnect comes in. And they weren't just introducing psychological developmental notes, but they were introducing notions of not being comfortable with people of certain races doing certain things."

Haithman's LA Times article even quoted an anonymous source that claimed Q5 was socially engineering kids, and it made them uncomfortable. "For some reason, Q5 and ABC decided to try to 'fix' The Real Ghostbusters when it wasn't broken," says Kathryn Drennan. "They decided, in essence, to do the exact opposite of what had been working so well. The result? Well, in my opinion, ABC and Q5 basically broke The Real Ghostbusters."

Q5 suggested a multitude of changes that included, but weren't limited to:

- **Each member of the Ghostbusters team must be given a clearly defined role. Peter must become the leader. Egon must be strictly the thinker. Ray would be the builder making creations dreamed up by Egon (if the character is not omitted and combined into one with Egon). Winston should drive and maintain the car.**

"They wanted to make our *one* Black character the driver, instead of doing interesting stuff," says Straczynski. In an article Straczynski wrote for *Penthouse* in June of 1991 (more on that later), he wrote that Q5 suggested high-profile and admirable positions for all of the team members except Winston—who would be given an insulting low-profile and low-intelligence job. Obviously problematic. "I said, 'Let's go down to South Central, walk into a bar, and have you repeat that note to me there. It was just the worst kind of thing that we're seeing now in the right wing trying to tell everyone what's harmful to children. Trying to reinforce the show with their own personal point of view.'"

"They told us Venkman was too mean to Ray, and they're all too mean to Slimer, and that Janine wasn't motherly enough," says Dan Riba. "They wanted us to try to find ways to make sure the show had no highs and no lows. When you're focus testing a kid, they're going to react to what they're seeing, but that doesn't mean they don't like the show. They're reacting to what they're watching in that given moment. Conflict is the nature of entertainment. You have to have conflict, or else you make things bland and not interesting. When a kid sees conflict, they react accordingly. Q5 tried to flatten everything down so there weren't those particular moments that kids were reacting to in the testing. It ended up they kind of had their stupid way with us, and the networks listened to them because they were scientists. They'd come in and mess up shows because they were the experts, and the ratings would improve. The networks figured they all knew what they were doing."

- **Janine Melnitz must take on a "more nurturing mother figure" role. The character's design must be "less slutty" and in retooling, her sharp and angular glasses appear threatening, and must be removed.**

Perhaps the second most offensive note given to the show, after Winston's, this received a great deal of pushback. Said Q5's Heinz in the LA Times article, "It [the change of Janine] was not done on anyone's gut feeling about what's creative and what's not creative, or what's sexist and what's not sexist. It's back to how we can involve more girls when we have primarily men characters. The female was not working for the female target, and we're sorry she's not the way she was originally designed, but she's not." The creative team countered the note to remove Janine's glasses entirely by suggesting they round them out, which was ultimately the compromise made.

But Q5 flagged that "people who wear glasses are perceived as colder and less open than people who don't wear glasses." "I really liked our Janine," says Richard Raynis, "We gave her pointed glasses to sort of support that she was an edgy character. It just seemed like our design captured the Annie Potts character better. She just became something different, which I don't think was a great choice."

In the fall of 1986, Q5 suggested problematic changes for some characters, including Winston.

Chapter 6: Total Protonic Reversal 239

 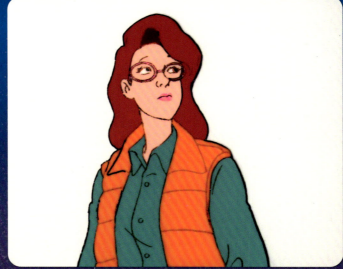

Janine's transformation under Q5's guidance was the most dramatic, both in her physical appearance and her attitudes and personality.

"I'm not sure kids understand what 'slutty' is, which is what they said the character was," says Straczynski. "When I challenged them on it, they told me they said specifically that the kids were frightened of her glasses. Again, 'Show me your data. Don't just say that bullshit. Back it up.' They refused. That told me everything I needed to know about it. It had nothing to do with data. It had nothing to do with science. It was their racist, sexist, misogynist points of view they were trying to embed inside of science to try and stomp through that way."

"Gabi was heartbroken," says Riba. "Janine was a very personal design to her."

"It wasn't until years later that someone told me to go online and look up Janine, so I did," says Gabi Payn. "I was blown away by all of the love that character design had. It just took off on its own like *Ghostbusters* did. I wasn't aware of that. I had kind of divorced from it. I just sort of left it there, that hurt, feeling like it was time to move on."

Laura Summer was still waiting to hear if *The Real Ghostbusters* had been picked up for another season when she received a phone call. "My girlfriend called me up and said that I was on the cover of the Calendar section of the *Los Angeles Times*. It was an image of Janine with notes and things crossed out saying her skirt is too short, she's too trashy, her glasses need to be changed . . . but I didn't really know the show was continuing. Some time later, somebody told me they were up for the part of Janine, and I knew I was being replaced," says Summer. To address the note to soften the character, the voice casting was changed. Laura Summer was let go and replaced by Kath Soucie.

"When the changes start to happen, and Janine starts acting like everyone's mother, you're like, 'What the fuck is this show?' It's one of the most mind-blowing changes ever. These days, social media could have a field day with that," says James Eatock.

- **The show must contain less satire, and should include sophisticated verbal humor.**

"We couldn't even use whoopee cushions, you couldn't do anything that was funny," says Dennys McCoy. "Chuck stood up in a meeting and just said, 'Why do we even bother?' and walked out. It was like they didn't want kids to have fun; they just wanted kids to learn not to hit each other."

- **Add a group of children as main characters into the show to give viewers a proxy from which they could live vicariously.**

This led to the creation of the Junior Ghostbusters for the series, which was met by most of the creative team with dismay. The third-season bible credits Ivan Reitman himself for the creation of the junior team, but the catalyst for their creation was clearly the Q5 findings. "I have no memory of the Junior Ghostbusters. Were there Junior Ghostbusters in the show?" jokes Joe Medjuck.

"Len Janson called Dennys, myself, and Michael Reaves into his office and tells us he wants us all to work up this new thing they want at ABC, the Junior Ghostbusters," says Pamela Hickey. "Q5 wanted to insert children so that they could control children. Telling them how to think about things. It was like the Cold War and Estes Kefauver over again."

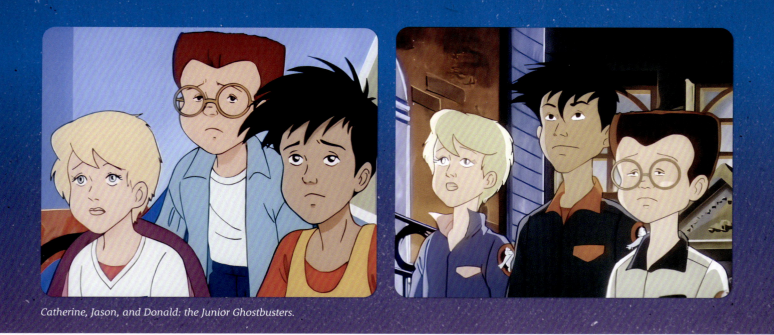
Catherine, Jason, and Donald: the Junior Ghostbusters.

"They would always tell you that the kids need a character to identify with. Actually, kids just need to be entertained. It was the dirty little secret in animation that we all knew. Anybody who ever denies this is lying to you. We all knew that all the kids wanted to see were burping and farting jokes," says Dennys McCoy.

"On 'Don't Tease the Sleaze,' we wanted him to fart but they won't let us," says Pamela Hickey. "We fought with Len for a week over that. I mean, we were very angry. We had to have him take his shoe off and stick it in Slimer's face. That was the compromise."

"The network loved the foot joke," says McCoy. "They thought it was nothing harmful but, you know, it was a foot fart. Cut the fart, keep the foot. It's still just a stink joke, okay?"

The Junior Ghostbusters were composed of Jason and Catherine (named after Ivan Reitman's two eldest children) and a third kid named Donald. "Whoever that is," jokes Jason Reitman. To date, if the third Junior Ghostbuster was named after a child from the creative team, it remains a mystery. But Jason Reitman is tickled by the fact the third-season bible proclaimed his character the world's youngest nerd at age ten. "I wish I was that smart at age ten. I would have been a nerd had it not been for my lack of acumen. I don't think I fit that part, but I only aspired to."

As a ten-year-old himself at the time, Reitman always found it difficult to explain what his father did for a living. "It's hard to jump back into my ten-year-old brain, but I remember my dad being responsible for *Ghostbusters*, and I remember loving *Ghostbusters*. But I don't think I could connect how he was responsible. The idea that he would have named a character after me, I think, is similar to your dad having your photo on their desk at work or something. It just felt like part of what his job was."

"The ideas they came up with were just stupid," says Richard Raynis.

"We didn't do a lot of the stuff they wanted," says Medjuck. "They wanted to get rid of the Ray Stantz character entirely. We thought we were just giving them a little bit by saying, okay, we'll change Janine and give in to these other small changes."

"The whole time I'm sitting there listening and I'm thinking that Joe, Michael, Ame, and Jennie are never going to go for this. I can just sit back and let them deal with these turds," says Straczynski. "When Q5 was done, Ame and Jennie told us we had to incorporate this into the show, and my heart broke. I knew there was no way on God's green earth that I was going to be able to work within those contexts."

"I had never been in a meeting like that before. Joe Medjuck starts laying into Corinne Rupert, and I know nothing about anything," says Robby London. "I left the meeting thinking to myself, oh my god, this guy is horrible. But the irony is that over time, I got to know Joe and really liked and respected him. Once I learned how the networks were and how intrusive they were, if I'd have been in that meeting a year later, I would have been silently rooting Joe on. I learned exactly where he was coming from and why he was the way he was. In retrospect, I applaud him. He was my hero."

"Mike and I both said, 'No, fuck that. We're not gonna do that,'" says Medjuck. "But the network executives from ABC

told us that if we didn't make the changes, they weren't going to put the show on the air. And of course, Mike and I said, 'Fine. We've got other things to do. We don't care. We don't need this show on the air. We could use the free time.' Robby London almost fainted."

"My blood pressure went up twenty points in that first six months at DIC," says London. "It was really intense for me. One of the things that Lou Scheimer did at Filmation was insulate his creative staff from any of the business. He dealt with the networks, the syndicators, the toy companies. He kept all that shit away from us. At DIC, suddenly I was the person dealing with all that. These people are intense. I was a lamb being thrown to the wolves at first."

"ABC had already made up their minds, and that was the end of the discussion," says Straczynski. "That's why I pulled out my last card and told them that if they made these changes, I was going to have to go. I didn't want to go. It was a great job. But I was going to have to walk away. Michael and Joe said, 'You're not going to walk away from a hit TV series.' And I said, 'Watch me.' In that meeting, I said, 'I'm gone.' And I walked away." While Straczynski walked away from his main responsibilities, he would still continue to pitch and write scripts for the series. But the die had been cast, and the changes were to be implemented at the start of the next production cycle.

"Q5 wanted all these changes made, and we were well into the second season," says Dan Riba. "We couldn't have Janine turn into a totally different character halfway through."

"I've written a few shows for this season, and they weren't as much fun as last season," lamented *The Real Ghostbusters* writer Michael Reaves to the *LA Times*. Reaves also famously wrote into the script of "Camping It Up" a rural highway sign the Ecto-1 passed that read "Exit Q-5," as many on the show, including himself, had grown so frustrated by their interference.

J. Michael Straczynski wrote an article about his experiences with Q5 and ABC's Broadcast Standards and Practices and was looking for an outlet to publish it, much to the chagrin of his agent. "She said, 'If you publish this anywhere, you will never work in animation again, I guarantee it,'" says Straczynski. "So I sent it to *Penthouse*. And the nonfiction editor calls me and says that it's an amazing article, but is curious why I brought it to *Penthouse*. I told the editor because I wanted the tight-asses at Q5 who want to read what's being said about them to have to flip past pages of naked ladies to get to the article. The editor started laughing and didn't stop for ten minutes before they said they'd publish it."

"I was no longer writing for the show when all of that happened. My involvement stopped with my three syndicated episodes, and I merely watched the whole debacle from the outside and what Joe [Straczynski] experienced," says Kathryn Drennan. "While I think that the many talented actors, writers, animators, producers, and staff that continued to work on the show under all the new guidelines, new characters, changes in old characters, and many shifts in focus still managed to produce some good episodes, I believe that for most fans, like me, it just wasn't the same anymore. By trying too hard to make it more suitable for 'children,' as defined in the Q5 research, they made it far less appealing for both adults *and* children."

> "But the network executives from ABC told us that if we didn't make the changes, they weren't going to put the show on the air. And of course, Mike and I said, 'Fine. We've got other things to do. We don't care. We don't need this show on the air. We could use the free time.' Robby London almost fainted."
> —JOE MEDJUCK

"My story came out and suddenly I started getting calls from radio stations wanting me to come on their show and talk about Q5," says Diane Haithman. "And all of a sudden, Q5 disappears. The company goes out of business."

"What ended up happening was that CBS gave them enough rope to hang themselves," says Dan Riba. Seeing the perceived success that Q5 had in consulting on the *Defenders of the Earth* series, CBS hired the group to oversee the creation of a new show from its origins. "They figured these guys are experts, they should be in charge of a show. So they focus tested a show and did this thing called *Little Clowns of Happytown*. And it was the biggest bomb ever. Their expertise was gone. Nobody listened to them again."

As of 2024, Q5 and all remnants of the company have vanished. Corinne Rupert did not respond to interview requests for this book.

Animated Ragnarok

"The show began to tank after all the changes were implemented," says J. Michael Straczynski. "I got a call from Michael, who said they were in trouble on the show and asked if I could come back and write some episodes to try and save it. I told him I'd be happy to, not telling

him that I was also broke at the time. But I told him that I had several conditions. The Junior Ghostbusters did not exist in my universe, unless I get to run a truck over them. Slimer is not the star of the story; he'll just be there if I want to put him in there. I don't want any network notes. And I want to do something that deals with the whole unexplained change in Janine's appearance. I could hear Michael's sphincter tightening over the phone. Interesting sound, by the way. Like a balloon animal. He told me that he would make some phone calls and get back to me. It was probably two or three hours later, possibly even the next day, when he called back and said, 'Okay, I got you everything you want except they still want you to have input from Broadcast Standards and Practices. But I'll let you argue [on] the things you don't agree with.' So the first script back that I wrote was 'Janine, You've Changed,' specifically to poke my finger in the eye of everyone for what they had done to her and, more or less, correct what those fuckwits had done to that character. I actually even used some of the notes as dialogue in the episode."

In the episode, Egon Spengler proclaims to his colleagues, "Whatever's changed Janine, it's not human. The question is, what's doing it? Why?" The villainous "fairy godmother" is also a creature Egon defines as a "Makoveris Lotsabucks."

"Once they leave and move on to go someplace else, someone comes in and tries to do the same thing, but it's not gonna be the same," says Steve Perry. "Straczynski was ready to move on and went someplace else, and they tried to bring other people in and keep that same level of energy, but I think it just differs for different episodes. You just run out of steam. It seemed to me like the level of quality and the level of story wasn't the same. Not that it was better or worse, but it was different."

Richard Raynis, who had left and returned to the show, found a different atmosphere from the one that fostered the original seventy-eight episodes under his watch. "I think I'd become less invested in it, to tell you the truth," says Raynis. "Andy said everybody wanted my team on their shows, and he figured out a way to do that. He put me in charge of all the shows as VP of production. A couple of years later, I left DIC. Which I think was the right decision for me. I have a lot of respect for Andy. But I knew the kind of effort that we put into *The Real Ghostbusters* was hard to sustain. It was a great group that worked on the show; it was a great place that we all got started. We did these shows for ourselves. We did it the way we wanted. We created a show that we wanted to watch. I really have fond memories of that time because, for a lot of us, it was our first animation jobs. We brought something different that was personal to the group of artists who we were, and I think you can see that in *The Real Ghostbusters*." Raynis returned to the world of *Ghostbusters* with 1997's *Extreme Ghostbusters*, a series that he developed from scratch and for which he acted as executive producer.

"I loved doing the animated show," said Michael C. Gross on the Time Life DVD. "It was so freewheeling. It was like doing improv radio. We had very talented people writing it. Very talented people doing the voices. It was just a kick to do. But I never felt like I was in control of *Ghostbusters*' success in any way. I knew how to maintain its integrity. I knew what worked and what didn't work for it. I knew how I thought people perceived it, which changed over time. What do you say about something that you made, that people perceive in a way that you're uncertain of, or if it becomes popular and influential beyond all expectations? I'm not sure. I can guess after the fact. Its popularity with children had a lot to do with it. Its family involvement had a lot to do with it. It broke ground at the time we made it. But we didn't make it to break ground."

"It's hard to believe that it's been forty years," says Andy Heyward. "The networks stop ordering even the most successful shows at some point. It was a very expensive show to produce, and it was almost as if CAA and Herman Rush negotiated too good of a deal. There were increases every single year in the license fee. There's only so much money these shows can make. The difference between the highest-rated show and the lowest-rated show is not going to justify the license fees at the time. Perhaps they just decided that they had two hundred–plus episodes, and with new kids cycling every three or four years they can be introduced to those."

"*The Real Ghostbusters* made the franchise even bigger than the first film," says Violet Ramis Stiel. "Back then, it wasn't like it is now, where everything is on demand. Sure, you could rent the VHS tape of *Ghostbusters*, but it was the cartoon that

Frustrations with Q5's interference boil over into the animation.

Chapter 6: Total Protonic Reversal **243**

SLIMER - the little green glob who has emerged as the star of the show with kiddie viewers. In testing, they voted him their favorite over all the Ghostbusters...by a landslide. All of his traits were hits: His garbage-disposal appetite; his penchant for getting into mischief; his broa... most popular of all, his habit of ' Ghostbusters -- whether with kisse... "Sliming" is truly Slimer's claim morning set.

In view of Slimer's success, it ha... play a stronger role in the storie... were a few episodes last year that... and even one or two that gave him... main, Slimer was relegated to the... more. He is a definite member of... such, must play a vital part each... visibility in the stories as do t...

Slimer idolizes Peter. The "fea... is someone Slimer dreams of bein... Peter whenever possible.

Also this season, in addition to... grunts and snorts, a few underst... phrases will pop out of his mout...

JANINE MELNITZ - the Ghostbusters' secretary. She runs the store.

Janine turned out to be the first season's least successful, least liked character, according to audience testing. This reaction seems to be the result of several factors: Her voice, which has a nasal, New York quality that frequently comes off as whining; and her appearance, which was interpreted as harsh due to her sharply pointed eyeglasses and hair-do. In a child's eyes, there is nothing soft or nurturing about her. She's brassy, strident, hard-edged. As a result, she alienates the audience.

For the second season, Janine is being revamped. Visually, she will get a softer, more feminine look. And her voice will be recast with a warmer, friendlier sound. The New York accent will remain, but the whiney quality is history. In its place will be a sense of humor, something she never displayed before. Janine will play more of a mother to Slimer, rather than harangue him. There is a genuine bond of affection between these two now. They even become conspiratorial at times.

Last season, Janine was often played as a foil rather than as an active participant. Then she would complain about her situation, which resulted in the whining. This season, she should be more directly involved in the goings-on, not to the point of strapping on a proton pack and riding with the guys (although she's done this in more than one episode), but by being more of an actuator on the homefront, rather than a victim.

THE JUNIOR GHOSTBUSTERS

In the Second Season, Ivan Reitman wanted to have more kid characters in the series. To accomplish this, the "JUNIOR ...duced -- THREE YOUNGSTERS who live in the ...house. They are eleven year-old DONALD ...NE and JASON. They idolize the Real ...em at the firehouse. Slimer is their ...to learn ghostbusting, they ...oblems that require the Ghostbusters' ...none of us wants to turn this series ...e kids only appeared in two of last ...ince they will be showing up this Thrid ...series, the necessity for having them ...es is lessened. If a story seems to ...hree kids, great. If not, no sweat.

...skinny eleven year-old. All legs and ...o be a bit on the clumsy side.) Never ...sneakers. A true-blue New Yorker, on ...nd wears his emotions on his sleeve. ...books which he scours for information ...He has an encyclopedic knowledge ...lassic to schlock. Big movie buff, ...ually the lead in school plays. ...le about the spirit world than he ...after Donald to read him a "scary" ...lad to do, really getting into the

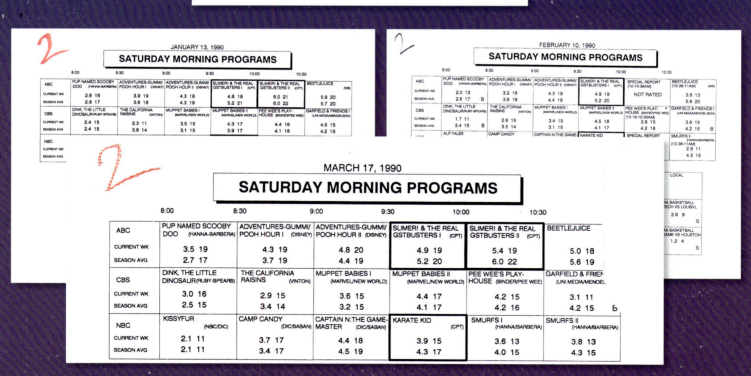

Top: *The third-season series bible from March of 1988 begins by detailing the major changes to the series, including Slimer's push to the forefront and the introduction of the Junior Ghostbusters. Bottom: Ratings for* Slimer! And the Real Ghostbusters *continued to remain strong in 1990, with the series usually winning its time slot.*

November 6, 1989

Michael Gross
Joe Medjuck
Ivan Reitman Productions
4000 Warner Boulevard
Producers Building 7, Room 8
Burbank Studios

Dear Michael and Joe,

 Herewith some initial premises for the GHOSTBUSTERS scripts, submitted for your perusal and scornful disbelief.

 If you like more than one, that'd be great, so that I can plan out my writing time accordingly. Robby would also be grateful. But it'd be a good thing in spite of that part.

 If you like none of them...it's back to the drawing board.

 Sincerely,

 Joe

 Joe Straczynski

American Broadcasting Company
DEPARTMENT OF BROADCAST STANDARDS AND PRACTICES • WESTERN DIVISION • HOLLYWOOD

DATE: April 5, 1990
STUDIO: DIC Enterprises, Inc.
CONTACT: Will Meugniot/Stan Phillips
SHOOTING DATE:
PROGRAM TITLE: SLIMER AND THE REAL GHOSTBUSTERS
EPISODE TITLE: "Janine, You've Changed" (Storyboard)

The above indicated shooting script, received this date, has been reviewed by the Department of Broadcast Standards and Practices under current ABC broadcast standards.

Kindly forward such revisions as are necessary to effect the modifications requested below. If revisions are acceptable upon receipt by the Department of Broadcast Standards and Practices, no supplementary review will be forthcoming.

This review does not constitute a Broadcast Standards approval of subsequent script changes or changes in method of treatment in production. A separate screening report will be issued upon viewing the Rough Cut film. Kindly advise me at such time as this episode is available for Rough Cut and First Trial screening. Final approval is based on viewing the completed film.

COMMENTS (Confidential):

Page 3: Use caution when the "boarded window up bursts". Ensure that dangerous debris does not strike any on-lookers.

Page 25A: Please re-establish facade of building to avoid the shattering glass windows as a result of the explosion. We suggest 1) boarding up windows as a result of the explosion, 2) melting windows, 3) having windows void of any glass, or 4) restructuring building so there are no windows.

Page 37: Please delete "sheesh".

Page 110: Please do not have Janine's hands clasped in prayer as she summons the Fairy Godmother. This may be interpreted as demonic worship.

Page 133: Delete Fairy Godmother's "devil's horns" hand formation as this is synonymous to invoking the devil in satanic worship.

Page 211+: Use caution when costuming the Fairy Godmother and the "transforming" Janine. All material must be appropriate for the Saturday morning audience. Outfits must not be transparent or must not reveal anatomical detail (i.e. breast contour, crotch delineation) [note: Page 238 particularly].

Page 253: The new dialogue "That thing has possessed you" is unacceptable. The word "possessed" is commonly linked to satanic worship. We suggest "You are turning into that thing" or "That thing is taking over you".

Editor

cc: Hikawa, Conley, file
 Trias, Simon
 Gross, Medjuck (IRP)
 London, Janson, Menville, Straczynski (DIC)

"Janine, You've Changed"

 The guys are going through one of their earlier scrapbooks, and in so doing they come across one of the few photos taken of them with Janine. And they're startled to see that the Janine in the photo, taken early on, doesn't really look much like the current Janine. The features were sharper, the glasses pointed, the face narrow, the hair different, the clothes different, even the height a little different. They can't believe they failed to notice this.

 They begin to investigate, and discover that Janine's desk is directly over the containment unit. She's been exposed to ectoplasmic energy since the day they moved in. As a result, her form has become fairly elastic, as malleable as ectoplasm. A whim of displeasure at her appearance results in a change -- and the supernatural power behind it keeps them from noticing. Even she isn't aware of it. But you can't fool a camera.

 When they tell her, she starts to worry, and thus -- like a centipede asked which foot goes first -- loses total control of her form. She gets VERY long, elastic, bouncing all over the station, wrapping around the pole, getting more frantic until she finally escapes, heading into town, hardly recognizing anyone anymore. They have to try and stop her and restore her to something resembling human form before she gets stuck. (Just like your mom used to tell you.) They figure out that the problem is based in the fact that she is very insecure about the way she looks. She wants to be liked, by Egon in particular, and this was manifested in the changes.

"Janine, You've Changed" presented J. Michael Straczynski with an opportunity to explain some of the changes to the popular character. The writer originally pitched the idea to Medjuck and Gross in November of 1989 with a far different premise. When the script was revised to give Janine a fairy godmother responsible for the changes, ABC's Broadcast Standards and Practices took issue with several elements, particularly those that could be construed as "satanic worship."

made *Ghostbusters* an immediate everywhere-and-everyday thing. Making the original film was such a process of reining in Dan Aykroyd's original concept and bringing it to earth that I think the expansiveness that *The Real Ghostbusters* opened up was surprising to my dad. He was just so excited about it. It wasn't something that he ever expected."

Forty years later, following the tent-pole live-action releases of *Ghostbusters: Afterlife* and *Ghostbusters: Frozen Empire*, *The Real Ghostbusters* continues to be seen by new generations for the first time. Those who grew up with the series in the 1980s are now showing it to their kids and finding the storytelling and characterizations anything but antiquated. Just as their parents did, those kids also have the ability to go out and buy fun and engaging toys from Hasbro through the retro releases, among others. The show lives on, much to the delight of its creators. "We knew with *Ghostbusters: Frozen Empire* we were going to have a new mythology and new villain and that we were going to sort of open the cupboard and let the spirits out," says Gil Kenan. "The show was incredibly helpful in liberating us and charging us to go weird and scary and off the map in terms of the sources and the wildness of supernatural elements that we were drawing into the writing. There is such an open conversation between the original films and *The Real Ghostbusters* that they have been sort of synthesized by the audiences over the years to where they can't separate any of those elements. It's a living, breathing story world and something we're very aware of. Part of the way we have conversations about new stories is by looking at it as a larger storytelling world rather than drawing too narrow of a line. I think that makes it a richer experience."

"*The Real Ghostbusters* took all kinds of chances that made us feel like we could take and try any road," says Jason Reitman. "The TV show gave us options, particularly when it came to the variety of the villains and the tone of them."

"Until *Ghostbusters: Afterlife*, there were really only two films with these characters. That's not much screen time. Not a lot of character development. Not a lot of time to interact with them as an audience member," says Kenan. "I used to watch the show after school every day in syndication. There were so many episodes of this series that had such depth, it was a much more sustainable relationship with these characters."

"On a movie, you're given such a strict access to who these characters are. Films are built way more around a rhythm,"

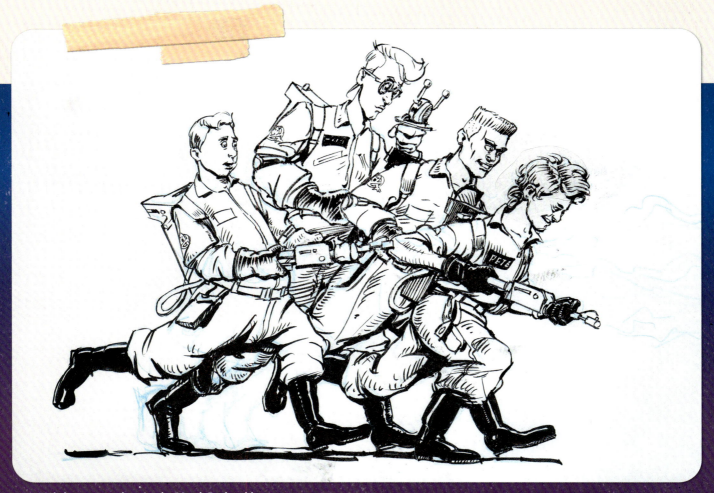

An initial character exploration by Marek Buchwald.

says Reitman. "With television and an animated show, you're just hanging with them. You get a much fuller understanding of who a character is and how they would react to everything. Like that weird chicken episode—you just start to understand them as more complete human beings."

"My kids and my grandkids still listen to some of the music I listened to when I was a teenager, because it's still good music, and it still holds up," says Steve Perry. "If you're a writer, you create this stuff, and when it's done you think it's okay. And sure, someone will read it and say it sucks. That's fine. Or they'll read it and say it's great. Not everybody is going to be happy, but some people will be. When I'm talking to people who watch the stuff that I wrote way back in the day who like it, that's cool. It really is."

"We had some of the best writers in television animation writing for us," Maurice LaMarche told the *Ghostbusters Interdimensional Crossrip* podcast in 2017. "Between the sixty-five syndicated episodes and the thirteen network order, we really had to crank. I'm amazed the quality of the scripts stayed as good as they were."

"It holds up because it was the intention of the team to do something high quality," says Bruce Zick. "Everybody just tried so hard. The studio gave this team a lot of leeway because DIC wanted it to be good too. I think it was a convergence of a lot of great people at the right time. And I have to give Richard Raynis a lot of credit. He was the guiding force of it all. His ideas came through in his direction. He really pulled off something amazing."

"I think *The Real Ghostbusters* tapped into a lot of what made the movie so special," says James Eatock. "These very structured characters, who were endearing and charming and funny. They could have gotten it so wrong, and no one would be talking about it forty years later like some of the other cartoons based on popular films. But they created a show with *Real Ghostbusters* that appeals to the youngest child, to the oldest adult. Just like the film, it appeals to a multigenerational audience."

"I think that it endures because it's good stories, smart stories, scary stories, and in a medium that our kids didn't really get much of," says J. Michael Straczynski. "For me, in every single episode, I wanted to feel the relationships between the characters. I wanted to feel that warmth and those friendships, even when they fractured. I wanted the show to have a sense of hope. No matter how bad things got, there was always hope. Most of my work has been about hope in one way or another. We, as a culture, have been factionalized and marginalized and tribalized to an inch of our lives, and there's no one out there to sort of try and pull it all together. Hope is the ultimate way of unifying us. And the beauty of animation is a way of doing it as well. That's my mission. If there's a cause I wear on my sleeve, it's to give people hope that things could be better. It may require strapping on a Proton Pack and getting into trouble. It may require stepping outside your comfort zone. It may require self-sacrifice—staring at the end of the world and realizing you've got to do what you've got to do for a noble cause. I think those relationships and those messages come through in the show, because they're embedded into the genetic tissue of the story."

"When preparing to write the script for *Ghostbusters: Frozen Empire*, Jason Reitman and Gil Kenan watched every episode of *The Real Ghostbusters*. At the end of the day, what I think they took from that was . . . there's just something innate about *Ghostbusters* that empowers you to face your fears, and squash those fears or capture those fears and put them away. Each week, these heroes were facing new fears and new things in the world that were unknown and scary to them. And they did it as a team with a laugh. Ivan always credited *The Real Ghostbusters* for making the franchise such a huge success," says Eric Reich. "The film was obviously huge, but I think the series really cemented it as an iconic brand period. Funny enough, Ivan never took a lot of credit for the show other than it being inspired by the work they did on the film. He never really claimed ownership over the series. He gave that to the creative team working on the show. He always empowered the people. He loved working with new creative people and new directors. I think he was involved just enough to set the tone and the look in the early scripts, but then really let Joe Medjuck and Michael C. Gross fly."

"The thing I feel most about my father's contribution to the show is the dedication to simultaneous horror and comedy," says Reitman. "My dad made horror films before he made comedies, and that was definitely a part of his DNA. I don't think he saw any reason why a movie shouldn't scare you legitimately, then make you laugh legitimately. He probably thought the same thing about an animated show. There's no reason it should pull its punches."

"That's what really held up when we revisited the show," says Kenan. "It's just quality storytelling. You do feel like there is depth to the plotting, within the confines of the format of the series. These were great stories, well told. I think that picked up on the tradition that Ivan set in place with the first film and continued with the second. And that we work really hard to live up to: Sterling characters. Good stories. That's all we can hope for."

> "The film was obviously huge, but I think the series really cemented it as an iconic brand."
> —ERIC REICH

Acknowledgments and Contributors

The Real Ghostbusters: A Visual History was a collaborative effort and would not have been possible without the time, support, and contributions of so many dedicated people around the world. The eye-popping visuals and never-before-seen items in this book have been provided with generous support and contributions from (in alphabetical order):

Kevin Altieri, Robert Barbieri, Josh Blake, Barbara Bogart and the University of Wyoming American Heritage Center, Winnie Chaffee, Dexter, Ryan Doell, Ken Duer, James Eatock, Abigail Gardner, Matthew Brett Ham, Andrew Hopps, Liz Kalodner, Scott Lacey, Ryan Lehmkuhl, Sean Lehmkuhl, Andy Mangels and the Time Life DVD team, Adam Marish, Joe Medjuck, Brandon Mindel, Dušan Mitrović, Tom Neiheisel, Beau Obremski, Joe O'Brien, Derek Osborn, Brad Rader, Richard Raynis, Eric Reich, Dan Riba, Paul Rudoff, Chris Stewart, J. Michael Straczynski, Tony Taylor, Jacob Walsh, James Zahn and *The Toy Book*, Bruce Zick

Craig would like to thank: Troy Benjamin, not only for hopping onto this book and molding it into the incredible project it's become but also for being a mentor, friend, and human encyclopedia. A welcoming collaborator and supporter of *Yes Have Some* (*YHS*) from the beginning, you have always given me the time of day, even when I was cold messaging you on Instagram and babbling on about how much your fan site meant to twelve-year-old Craig. None of this happens without you. A giant thank-you to Ian, Anastasia, Jennifer, and Annie from Dark Horse for taking on this project and making it a fun, collaborative, and rewarding experience. The opportunity to partner with you and bring *The Real Ghostbusters* back in a big way is monumental. Thanks to my life partner and fellow Ghostbuster, Abigail Gardner. Your support, creativity, and unequivocal ability to make me laugh has helped me every step of the way. There's not a day that goes by that I am not floored by what you have accomplished; you are the true definition of inspiration, and I love you more than you know. Thank you to Jacob Walsh for your friendship, partnership, and drive that has kept the *Yes Have Some* engine running strong for the last decade. You continue to inspire me to challenge my own abilities to write and produce content that matters, and your love and passion for *Ghostbusters* is only matched by your wit and generosity. Thank you to Eric Reich, Jason Reitman, Gil Kenan, and the entire team at Ghost Corps. You've always gone out of your way to make me feel like I'm part of the *Ghostbusters* family and have entrusted Troy and me to tell the *Real Ghostbusters* story to the world—for that, I will be forever grateful. Thanks to Emily and Patrick at Hasbro for being amazing people and for helping us tell the Kenner story in a way that we wouldn't have been able to otherwise.

Thanks to my small circle of trusted *Ghostbusters* advisers—AJ Quick, Hal Clay, Ryan Doell, John Yurcaba IV, Jay Glatfelter, and Austin Young. You are collectively the funniest, most creative, and best group of friends that anybody could ask for. Thanks to my mom for braving a Chicago winter morning in 1987 and waiting outside of a Toys"R"Us at 5:00 a.m. for the new shipment of Kenner Stay-Puft figures, and to my dad for showing me *Ghostbusters*, *Stripes*, and *Caddyshack* at way too young of an age. I was literally two years old. Thanks to Andrew and Jenna for giving me two awesome nephews in Brooks and Jones. I can't wait to give them each a copy of this book. Thank you to the *YHS Podcast* community of listeners, watchers, and supporters! Thank you to each and every person who took time out of their lives to talk to us, send us photos, let us into their homes, and share their stories. You've made this experience special. And lastly, thank you to the creators who gave *Ghostbusters* to the world. Dan Aykroyd, Harold Ramis, and Ivan Reitman inspired an entire generation of writers, actors, directors, and toy collectors, and I will continue to love this franchise with every particle of my being, until the day I fade away into the fabric of the universe.

Troy would like to thank: My amazing coauthor, Craig Goldberg, for being the coach, champion, and visionary behind this book. Thank you so much for making me a part of it. Ian Tucker, Anastacia Ferry, Jennifer Wurtele, and Annie Gullion at Dark Horse for being amazing partners from moment one—and enormous thanks to designers David Nestelle and Skyler Weissenfluh for their patience and dedication. Jason, Gil, Eric, Erica, Amie, Danielle, and Amanda—the family at Ghost Corps—for occasionally letting me drive the very expensive car up and down the driveway. Each and every person we interviewed, emailed, cold-called, asked for contact information, and pestered with this project, especially Joe Medjuck, who was graciously always a quick message away. Dan Riba, for your guidance and an insightful walk down memory lane at the Sherman Oaks Galleria. James Eatock, for your endless enthusiasm and support through the entirety of the process. Ken Duer, for his overwhelmingly generous assistance, including acting as our proxy to get the band back together. And I'd be remiss not to thank Don Shay and Jody Duncan, the original *Ghostbusters* making-of maestros, for inspiring the entirety of my career and giving me footsteps to follow. And finally, a very special thanks and dedication with gratitude to the late Herman Rush, who had been corresponding with us for the book while recuperating from his illness, trying valiantly to participate as much as the doctors and nurses, and his body, allowed him. Ever the salesman and champion of *The Real Ghostbusters* to the last, he told us this could be an exciting story . . . and he was right.